Photographic Possibilities

Photographic Possibilities:
The Expressive Use
of Ideas, Materials,
and Processes

SECOND EDITION

Robert Hirsch

and

John Valentino

Focal Press
An imprint of Butterworth-Heinemann

Boston Oxford Auckland Johannesburg Melbourne New Delhi

Front Cover
© Robert ParkeHarrison. *da Vinci's Wings*, 1998. Gelatin silver print with mixed media on panel. 45 × 36 inches. Courtesy of Bonni Benrubi Gallery, New York.

Back Cover
© Maggie Taylor. *Poets House*, 1999. Iris inkjet print. 15 × 15 inches.

Focal Press is an imprint of Butterworth–Heinemann.

Library of Congress Cataloging-in-Publication Data

Hirsch, Robert.
 Photographic possibilities : the expressive use of ideas, materials, and processes / by Robert Hirsch and John Valentino.—2nd ed.
 p. cm.
 Includes bibliographical references and index.
 ISBN 0-240-80362-0 (pbk. : alk. paper)
 1. Photography. I. Valentino, John. II. Title.
TR145.H54 2001
771—dc21

 00-069505

British Library Cataloguing-in-Publication Data

A catalogue record for this book is available from the British Library.

The publisher offers special discounts on bulk orders of this book.
For information, please contact:
Manager of Special Sales
Butterworth–Heinemann
225 Wildwood Avenue
Woburn, MA 01801-2041
Tel: 781-904-2500
Fax: 781-904-2620

For information on all Butterworth–Heinemann publications available, contact our World Wide Web home page at: http://www.focalpress.com

10 9 8 7 6 5 4 3 2

Printed in the United States of America

To our parents and everyone who helped us get to where we are now.

"Life for a photographer cannot be a matter of indifference and it is important to see what is invisible to others."

—Robert Frank

Contents

Preface

In any act, the primary intention of him who acts is to reveal his own image.

—Dante

This book is designed for the person who has rudimentary knowledge of photographic history and has successfully mastered the basic technical processes of black-and-white photography: film developing, printmaking, and image presentation. It is for the individual who has acquired a keen interest in photography and desires to learn a variety of processes as a means of reaching new visual goals.

It has been ten years since I wrote the above paragraph. Although Focal Press had been requesting a revised edition for some time, other commitments have kept me from it. To keep this book relevant I brought on a co-author, John Valentino, with whom I have previously collaborated on photographic and book projects. Together we mapped out a new table of contents, and then John did the basic research of updating all the materials and processes. I then edited and rewrote his new draft. The most apparent changes from the first edition are the collapsing of Chapter 1 and Chapter 2 into a new single chapter. A new feature in this edition is a series of questions and answers, based on my teaching experiences, about why people make photographs. We broadened our coverage of digital imaging from one chapter to two chapters and eliminated the Polaroid chapter, although some Polaroid materials are still covered. We

placed an even greater emphasis on the conceptual thinking that makes up good analog and digital images, and did a major revision of the art program with expanded captions that give each artist a voice in the proceeding.

The book presents a variety of ways of working with analog and digital photography in a concise, straightforward manner. This is significant because people rarely grow when the only example they have to model on is themselves. We selected the diverse subjects and themes covered based on our experiences in teaching photography. We have found that these areas constantly provoke interest and questions from people in our classes.

The book begins with a brief history of the major concepts that have affected how photographers make their images and a discussion about why we make photographs. Safety is stressed in Chapter 2. The book then follows the sequence of traditional black-and-white working processes used in the making of analog silver-based photographs. It starts with different types of film and their processing methods, and proceeds with a variety of printmaking options. Conventional silver-based color materials have been intentionally omitted, but they can be used in place of black-and-white materials in many instances. Next, unusual cameras and specialized equipment are discussed. A discussion of nonsilver and hand-altered processes and techniques follows. Finally, the last chapters look at the expanded role

that the computer has been playing with the creation, circulation, and understanding of photo-based images.

Electronic imaging is the fastest growing and one of the least understood areas in photography. It has revolutionized the aesthetic, ethical, and technical working methods used since the beginning of photography. We felt that it was necessary to address these issues. John Valentino's expertise and teaching experience at SUNY Buffalo, Rochester Institute of Technology, and The Center for Exploratory and Perceptual Art (CEPA Gallery) enable him to deliver the hands-on blend of concepts and techniques for which this book has become known.

Knowledge of materials is necessary if one is to achieve the self-confidence and satisfaction that can come with the ability to create. Technique is not offered merely for the sake of technique. Importance is placed on having something concrete to express with each application of the methods discussed. The photographs that accompany the text demonstrate how thinking artists can apply different approaches with insight and aesthetic concern. The satisfaction of artists hinges on their ability to create and share their work. Understanding of materials is needed to accomplish fine craftsmanship, which goes hand in hand with the creation of meaningful photographs.

My basic philosophy is to open different paths for readers to travel so they can successfully solve their visual quests. This book is a point of departure and should not be taken as the final authority on photography.

The text provides brief historical background for some of the major processes covered. Terms that may be unfamiliar are defined on their first appearance. Additional sources of information and supplies are provided at the end of each major section. Telephone numbers and Website addresses have been omitted because they change frequently and are easy to locate through directory assistance and Web search engines.

An important part of being a good photographer is taking the time to wonder. Wonder allows one to consider possibilities, which can lead to new ideas and new courses of action. Discovering the possibilities of wonder means being curious about the world. In the process of becoming adults, we tend to forget how to learn and the marvelous feeling that learning can convey to us. As children we will consider almost anything, but as we age, fear and worry often dispel this process. By reclaiming our childhood curiosity, we can embark on a continuous process of discovery that can lead to the creation of images that astound and arouse viewers to take notice.

A note of caution: Many of the techniques covered in this book require the use of a wide variety of chemicals. All chemicals pose a possible threat to your health and to the environment. By using common sense and following some standard working procedures, health and environmental problems can be avoided. Read Chapter 2 on health and safety before attempting any of the processes described in this book.

The art program has been put together with the intent of providing the reader with visually stimulating images that illuminate concepts and techniques discussed in the book. We have steered away from the traditional photographic textbook illustrations that show what equipment looks like or how to agitate film because we believe the readers of this book are already familiar with the basics. Instead, we stress the concerns of contemporary photographers from across North America. We acquired these images by doing a national call for work and also by contacting specific artists. We have made an effort to present works from professionals and students that have not been widely published in other photographic texts. We communicated with the imagemakers about how they used materials and processes to realize their visual ideas. We have distilled this dialogue into caption material that allows the imagemakers to speak directly to our readers.

We would like to acknowledge the assistance we have received in revising this book from the following people: Karen Speerstra, at Butterworth–Heinemann, for her continued confidence and support; Marie Lee, publisher, for helping us through the rough spots; Jennifer Plumley, assistant editor at Focal Press, for her ideas and patience; Kevin Sullivan, production editor, who helped us realize our vision into ink; Adele Henderson, Professor of Art at SUNY Buffalo, for her assistance in updating the transfer section in Chapter 11; Ellen

Steigman for her tireless proofreading; and the members of numerous Internet photo listserves who have answered questions and helped us keep current with changes in traditional and electronic imagemaking.

We wish to thank all the photographers who submitted their work and formulas for this project and engaged us in a running dialogue about the relationship between their ideas and technique. Without their cooperation this book would not exist. We regret that we could not use all the excellent contributions due to budget and page constraints.

Finally, we want to pay tribute to all our teachers, students, and past authors who have provided us with the knowledge that we hope to continue to convey.

Readers are invited to send us their comments and suggestions. The learning process is cyclical, with good students instructing and surpassing their teachers. We hope this book encourages readers to make photographs and to enjoy themselves in the process.

Robert Hirsch and John Valentino
Buffalo, New York

1 Why We Make Photographs: Ideas and History That Affect Photographic Printmaking

People make photographs for a multitude of reasons. One fundamental motive is to record a specific moment that represents someone or something of importance. For most people the standard, automatic type of photographic record keeping is enough, but for others it is not. This small group finds it necessary to control, interact with, and manipulate the photographic process and to interpret and actively interject their responses to the subject. It is for these expressive imagemakers that this book has been written. People make photographs because words often fail to adequately describe and express their relationship to the world. Pictures are an essential component of how humans observe, communicate, celebrate, and remember.

It is often assumed that all pictures are signs that stand for something and possess an innate semiotic (pertaining to signs) structure and value. But it is also possible that pictures are simply pictures which represent circumstances that cannot be expressed in any other way. The French writer and thinker Albert Camus said, "If we understood the enigmas of life, there would be no art." Pictures possess their own native structure that may defy explanation regardless of how many words are wrapped around them and thus remain a purely visual phenomenon. Those of us who are compelled to keep making pictures understand this.

Reactions to a photograph are uniquely personal experiences. Although people are conditioned to believe that the purpose of a photograph is to provide commentary about a subject, it is possible that a photograph may not make a concrete statement or answer a specific question. A photograph is not necessarily about something; rather it is something in and of itself. A photograph may be enigmatic or it may allow a viewer access to something remarkable that could not be perceived or understood in another medium. It is analogous to dancer Isadora Duncan's statement: "If I could explain to you what I meant there would be no reason to dance."

Some people think of a photograph as a conversation between the photographer, the subject, and the viewer. During a conversation the participants not only exchange words but formulate meaning based on how the words are spoken, who they are spoken to, the body language of the participants, and the environment in which the conversation takes place. When the participants think about a particular subject or image, a distillation of meaning becomes possible. Thinking involves the creative interaction among the participants in the visual conversation and can lead to definition. Definition allows people to acknowledge and take responsibility for solving a problem or reaching a conclusion about what an imagemaker deemed significant.

During the early part of the twentieth century Albert Einstein's concept of relativity, the idea that discards the Newtonian concept of absolute reference, began to

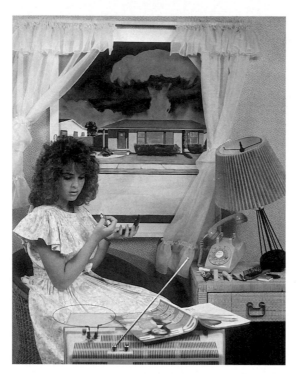

Figure 1.1 Nagatani and Tracey combine their individual skills and strengths as artists in different media to translate scenes of biting political and social satire from their imaginations to physical reality.

© Patrick Nagatani and Andrée Tracey. *Sioux City, Iowa*, from *Radioactive Inactive Portraits*, 1988. Chromogenic color print. 20 × 16 inches. Original in color.

inform how people depicted and interpreted their world. This fluid interaction between the observer and the observed offers different frames of reference to create meaning. This can occur through symbolic manipulation (mathematical, verbal, and visual) and a reliance on analogy, insight, and myths to draw attention to the significant elements in an otherwise chaotic flow of sensory input. Such a process involves the artist, the object, and the viewer in an ongoing venture of reciprocal creation and interpretation. As the artist/photographer Man Ray once said, "Perhaps the final goal desired by the artist is a confusion of merging of all the arts, as things merge in real life."

THE LANGUAGE OF PHOTOGRAPHY

A Derivative Process

Photography is a derivative process. When knowledgeable viewers look at a photograph they can usually trace it back to its technical origins. The final image is the culmination of the properties of the original subject, the specific materials used in the creation, the method of production, the artistic vision of the photographer, and the presentation method.

Photography does not imitate nature, but permits the manifestation of personal realities through the action of light. There is no security in nature. Two photographers can photograph the same subject and produce entirely different results. Photography can provide people with the physical means to create or invent ideas from their imaginations. By gaining an understanding of a wide range of photographic processes, readers can expand their visual vocabulary and place themselves in a better position to control the outcome.

Learning to control a process is the first step an imagemaker must master to transform an abstract idea into a physical reality. This text introduces a variety of photographic methods, gives examples of how and why other photographers have applied them, provides basic working procedures, and encourages readers to experiment and make modifications to the process to achieve their own results. Once a basic understanding of a process is obtained, control over it can begin. To acquire the maximum benefit from this book, the reader should begin thinking about how photography can be used to fabricate a meaningful destination. This puts process in service of concept to create meaningful content. This can occur when the heart and the mind combine an idea from the imagination and find the most suitable technical means of bringing it into existence.

Ideas Affecting Photographic Printmaking

Ever since Louis-Jacques-Mandé Daguerre made his daguerreotype process public in 1839, people have been discovering new photographic materials and methods to present the way they see the world. Photography provided an automatic mechanical method for transferring what was seen in nature into a two-dimensional form with Renaissance perspective. Within a short period of time, photographs were confused

with and substituted for reality. Photography proved so able at reality substitution that many people came to think that this was photography's sole purpose. The photographer was supposed to act as a neutral observer, an operator of a piece of machinery, while the camera performed and did the work of properly recording the subject.

But there are no neutral photographs. All depictions have an inherent bias. Photography has three distinct kinds of bias. The first bias comes from the people who create and manufacture the commonly used photographic systems, which include the cameras, lenses, films, papers, chemicals, and darkroom equipment relied on by most people to physically produce a photographic image. These companies set up the physical boundaries and the general framework within which most photographers operate. The second bias comes from the prejudices of the photographer, who uses these systems to create specific images. Every photograph reveals the photographer's point of view—a combination of the subject, the photographer, and the process. The third bias is in the life references that viewers bring to determine what a photograph means to them.

EARLY PRINTMAKING MODIFICATIONS

Even at the dawn of photography, methods that could alter the photographic reality were widely practiced and accepted. Practitioners of photography had no qualms about modifying a process to fit their aesthetic and technical requirements. Miniature painters painted directly on daguerreotypes and paper prints to meet the demand to reproduce color, setting the precedent of hand-applied synthetic color. In the 1840s William Henry Fox Talbot sometimes chose to wax his paper calotypes (the first negative/positive process) after development to make them more transparent. This increased their visual detail, made them more contrasty, and made them easier and faster to print. In 1848 Gustave Le Gray introduced a waxed paper process in which the wax was incorporated into the paper fibers before the paper was sensitized. This chemically and physically altered the speed and tonal range of the paper negatives and produced a

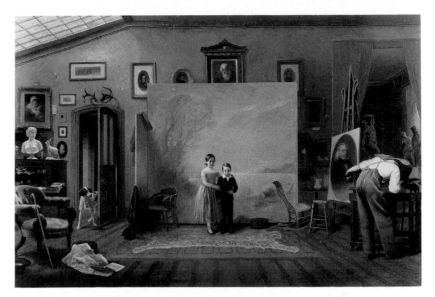

Figure 1.2 Painters such as LeClear utilized photography's ability to deliver an immediate, two-dimensional substitute for reality. Both full-length portraits in this painting were posthumous, executed from a daguerreotype. It is believed that the artist included himself as the photographer, seen at right from the rear, bending over a collodion wet-plate camera.

© Thomas LeClear. *Interior with Portraits*, circa 1865. Oil on canvas. $26\frac{1}{4} \times 40\frac{1}{2}$ inches. Courtesy of Hirschl & Adler Galleries, New York. Original in color.

result different from the waxed calotype. Photographers like Charles Nègre and David Octavius Hill and Robert Adamson used a pencil on calotype negatives to alter tonal relationships, increase separation of a figure from the background, accent highlights, add details or objects not included in the original exposure, and remove unwanted items.

Combination Printing

Combination printing from multiple negatives became fairly common in the mid to late 1800s. The collodion, or wet-plate, process, which became the major commercial photographic method of the 1850s, possessed a low sensitivity to light that made group portrait making difficult. The wet plate's limited sensitivity to blue and ultraviolet light made it impossible to make naturalistic, full tonal range landscapes. If the exposure for the subject or landscape was correct, the sky would be grossly overexposed, and when printed would appear, at best, as a mottled white. Combination printing was developed to overcome these inherent technical problems. Separate exposures

were made for the subject and the sky and were then, through the use of masking, printed on a single piece of paper. This technique received a great deal of attention with the unveiling of Oscar Gustave Rejlander's *Two Ways of Life* (1857), an image made from 30 negatives. Through the photographs and writing of Henry Peach Robinson in *Pictorial Effect in Photography* (1869), combination printing became the method of choice for serious photographers of artistic intent.

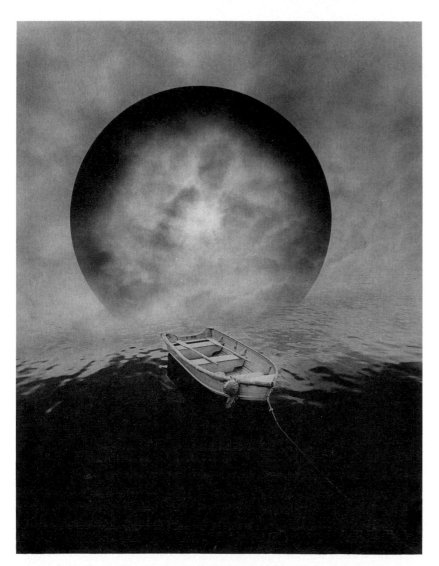

Figure 1.3 In the pre-digital 1960s, Uelsmann revived the manual process of combination printing. With magician-like craftsmanship, he creates surreal juxtapositions that the viewer knows cannot reflect reality. Yet these pictures remain believable because of the general belief in the truth of the photographic image. Uelsmann writes: "For me the darkroom (containing eight enlargers) functions as a visual research laboratory.... I believe that almost anything you can think of is worth trying. It is difficult to make a qualitative judgment in the initial stages of the creative process."

© Jerry N. Uelsmann. *Untitled*, 1982. Gelatin silver print. 16 × 20 inches.

Beginnings of Straight Photography

Major objections to these working methods were raised in Peter Henry Emerson's *Naturalistic Photography* (1889), which attacked the concepts of combination printing. Emerson called for simplified working procedures and "selective naturalistic focusing." This visual approach was supposed to allow the photograph to more closely replicate human vision, in which not everything is seen clearly and sharply.

Emerson thought it was the obligation of the photographer to discover the camera's own codex. He saw photography as a blending of art and science. He stated that through one's selection of framing, lighting, and selective focusing, good images could be made. Emerson emphasized photographing subjects in their natural surroundings without any of the artificial manipulations of the combination printers. He came under heavy attack for these ideas and recanted with *The Death of Naturalistic Photography* (1890), but the seeds of what would become the movement known as "straight" photography had already been sown.

The Pictorialists

The 1890s were the heyday of many manipulative methods, such as gum printing. This type of printing was favored by the Pictorialists and championed through the work and writing of Alfred Maskell and Robert Demachy in *Photo Aquatint, or The Gum Bichromate Process* (1897). The Pictorialists stressed the atmospheric and formal effects of the image over those of the subject matter. Composition and tonal values were of paramount concern. Soft-focus lenses were used to emphasize surface pattern rather than detail. Pictorialists did not want to be bound by the tyranny of exactitude. These expressive printmakers favored elaborate processes to show that photography was not a mere mechanical process, but could be controlled by the hand of the maker and therefore be a legitimate visual art form. The Pictorialists' attitudes and procedures dominated much commercial portrait and illustrative work throughout the first part of the twentieth century, with an emphasis on constructing beauty as opposed to finding it in nature.

The Photo-Secessionists

In the United States, the Pictorialists were followed by the Photo-Secessionists, under the leadership of Alfred Stieglitz. The active group included Joseph Keiley, Gertrude Käsebier, Frank Eugene, Edward Steichen, Alvin Langdon Coburn, and Clarence White. In their quest to have photography recognized as an art form, they experimented with a wide variety of printmaking methods.

The Photo-Secessionists' ideals culminated in the *International Exhibition of Pictorial Photography* (1910), at the Albright Art Gallery in Buffalo, New York. But by this time, a number of the group's members, including Stieglitz, had abandoned the ideas and working concepts of the manipulated image. The Pictorialists did not update their working concepts, and faded as an innovative art movement by the mid-1920s.

The Arrival of Straight Photography

Influenced by avant-garde artists such as Picasso, whom Stieglitz showed for the first time in the United States at his 291 Gallery, Stieglitz began to promote a straight photographic aesthetic in the final issues of his publication, *Camera Work*, as exemplified in Paul Strand's photographs made around 1916.

Strand had successfully incorporated the concepts of painterly abstraction directly into the idea of straight, sharp-focus, non-manipulative photography. Strand believed that photography's raison d'être was its "absolute unqualified objectivity," and that this could be found by investigating photography's own inherent characteristics. The emphasis of the art of photography switched from postexposure methods to creating the image in the camera at the moment of exposure and maintaining a much narrower range of simplified printmaking techniques.

MODERN APPROACHES IN PRINTMAKING

Straight Photography and Previsualization

Edward Weston's work, from the 1930s on, represents the idea of straight photography through the use of what has been referred to

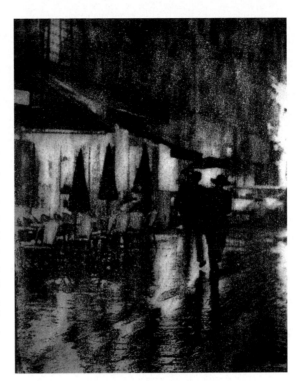

Figure 1.4 Schramm enlarged a 35 mm negative onto 11 × 14 inch ortho litho film to make a positive. Kodak Dektol at 1:8 was used to produce a continuous-tone positive. This positive was then contact printed onto 11 × 14 inch ortho litho film, to make the negative, using a contact print frame, and developed in Dektol 1:5 for additional contrast. The atmospheric effect was created using brush development for this gum print (see Chapter 10). Schramm states that "after exposure the print is soaked in warm water for about 5 minutes and then placed face up on a sheet of plate glass. A soft #12 brush is wetted and brushed across the surface to gently remove pigment while water is poured across the surface. This technique creates 'brush strokes' and allows me to be in control of how much pigment is removed and from what part of the image."

© Robert W. Schramm. *A Rainy Night on Rue Ste, Opportune*, 1998. 14 × 11 inches. Gum print.

as previsualization or visualization. By this concept, Weston meant that he knew what the final print would look like before he released the camera's shutter. The idea of seeing the final image ahead of time would bring serious printmaking full circle, back to the straightforward approach of the 1850s, when work was directly contact printed onto glossy albumen paper. Weston simplified the photographer's working approach by generally using natural light and a view camera

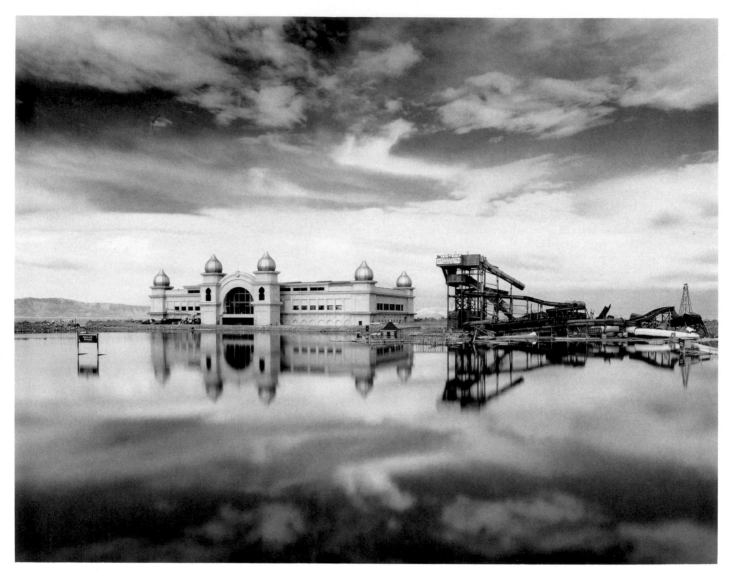

Figure 1.5 Dawson's work comes out of the ideas put forth in Peter Henry Emerson's *Naturalistic Photography*. Photographers such as Alfred Stieglitz and Paul Strand later expanded these ideas into straight, sharp-focus, nonmanipulative photography. In straight photography, the work is created (previsualized) at the time of exposure rather than through various postvisualization techniques.

© Robert Dawson. *Flooded Salt Air Pavilion, Great Salt Lake, Utah*, from *Water in the West Project*, 1985. Gelatin silver print. 16 × 20 inches.

with its lens set at a small aperture. He produced a large-format negative that was contact printed (no enlarging) with a bare light bulb. Photographic detail and extended tonal range were celebrated in a precise black-and-white translation of the original subject on glossy, commercially prepared paper. By eliminating all that he considered unnecessary, Weston wanted to get beyond the subject and its form and uncover the essence or life force of "the thing itself."

Group F/64 and the Zone System
In 1932, a band of California-based photographers, including Weston, Ansel Adams, Imogen Cunningham, Sonya Noskowiak, and Willard Van Dyke, founded Group f/64. Their primary goal was to create photographs of precise realism without any signs of pictorial handwork. The name of the group reflects the fact that the members favored a small lens aperture that enabled them to achieve images with maximum

detail, sharpness, and depth of field. They concentrated on natural forms and found objects that were representative of the naturalistic West Coast style.

The ideas from Group f/64 were refined and expanded by Ansel Adams in his Zone System method. The Zone System is a scientifically based technique for controlling exposure, development, and printing to give an incisive translation of detail, scale, texture, and tone in the final photograph. Adam's codification of sensitometry continues to set the standards for pristine wilderness landscape photography. The Zone System, as taught by Minor White and others, was so popular and successful that it dominated serious photographic printmaking throughout the 1960s and 1970s.

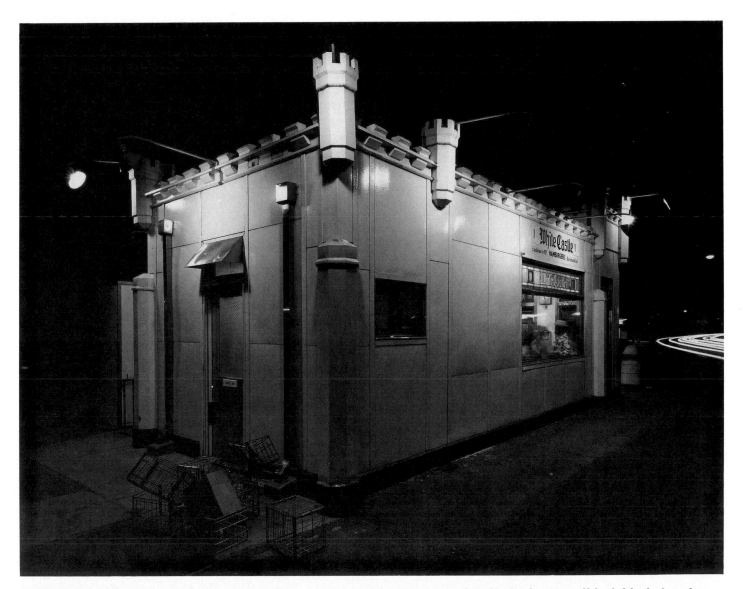

Figure 1.6 Tice's imagery is based on the idea of previsualization, knowing what the final print will look like before the camera's shutter is released. He used a wide-angle lens on his 8 × 10 inch Deardorff camera to give the diner more angularity. The 30-second exposure was sufficient to provide shadow detail in the milk crates piled up at the back of the diner. The photographer anticipated the pattern of lights produced by the cars rounding the curve of the highway, and made it an important compositional element.

© George Tice. *White Castle, Route #1, Rahway, New Jersey*, 1973. Gelatin silver print. 8 × 10 inches.

The antithesis of Group f/64 can be found in the images and writings of William Mortensen, as in his essay "Fallacies of 'Pure Photography'" (1934), which rejected the doctrine of the straight print and the singular aperture as being mechanistic. A master craftsman, Mortensen taught imagemakers that they have the right to manipulate their negatives and prints in any manner to achieve their vision goals. However, despite his expressive ideas on photography, Mortensen's work has been in eclipse for decades because it often featured naked women in sadomasochistic situations being dominated by men.

Postvisualization

The mid-1960s sparked a renewal of interest in numerous forgotten photographic printmaking processes. This was a time of experimentation in many aspects of Western society: questioning how and why things were done, trying new procedures, and eliciting fresh outcomes. A rising interest in countercultural ideas sent many photographers back into photographic history to rediscover alternative techniques and encouraged new directions in imagemaking. A revival of historical methods surfaced with the national recognition Jerry Uelsmann received for his use of combination printing, and this spread to nonsilver approaches like cyanotypes and gum printing. The concept of postvisualization, in which the photographer could continue to interact with the image at any stage of the process, was reintroduced into the repertoire of acceptable practices. Photographers such as Robert Heinecken, Ray Metzker, Bea Nettles, and John Wood began to reject the notion of a single fixed perspective and actively sought alternative viewpoints.

Electronic Imaging: New Ways of Thinking

Digital imaging started to surface in the scientific community during the mid-1950s, when Russell A. Kirsch made one of the first digital images. Along with other scientists working at the National Bureau of Standards, Kirsch created one of the first digital scanners. By the 1960s, the National Aeronautics

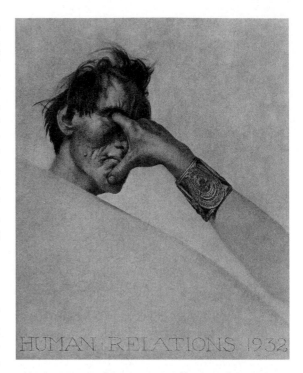

Figure 1.7 In his essay, "Fallacies of 'Pure Photography,'" Mortensen challenged the assumptions of Group f/64 by stating, "Purists and puritans alike have been marked by a crusading devotion to self-defined fundamentals, by a tendency to sweeping condemnation of all who over-step the boundaries they have set up, and by grim disapproval of the more pleasing and graceful things in life" (*Camera Craft* 1934;41:260–261). Mortensen etched the original negative to remove unwanted detail. He elongated the image during the enlargement process and made the projection through a texture screen. For details about his printmaking methods, including the Abrasion-Tone Process that he used to make this image, see William Mortensen, *Print Finishing*, San Francisco: Camera Craft Publishing, 1938.

© William Mortensen. *Human Relations*, from *Monsters and Madonnas*, 1932. Abrasion-Tone gelatin silver print. 10½ × 8¼ inches. Collection of Robert Hirsch.

and Space Administration (NASA) was using digitized images produced from its *Surveyor* landing craft in 1966 and 1968 to formulate never-before-seen composite photographs of the moon's surface, which were of great interest to artists and the public. Yet it was not until the late 1980s, with the advent of affordable home computer graphics workstations, that digital image manipulation became a viable means for creating photographs. Digital image manipulation

has removed the burden of absolute truth from photography. By doing so it has revolutionized how images are created and caused a conceptual shift from photography as a medium that records reality to one that can transform it. In the late 1960s, Sonia Landy Sheridan incubated the notion of a Generative Systems Department at the School of the Art Institute of Chicago. It was conceived as a way to provide artists and scientists the opportunity to investigate new means of image production which included electrostatic photocopy machines, video, and computer-generated images, and it offered its first course in 1970. What followed has been an explosive new set of technical possibilities that have enabled a vast extension of new and diverse voices like Dinh Q. Lê to be seen.

HAVING A SENSE OF HISTORY

Some people have no sense of the history of photography and no interest in studying past models. These people may act the part of the photographer, but they seldom appreciate how they are using photography intellectually. Part of the creative process involves research and comprehending how one mind can revise another. A grounding in photographic history allows an imagemaker to see what has already been done. Look at the work of other imagemakers who have covered similar ground and ask what they did that allows you to connect to their work, what you would do similarly, and what you would do differently.

There is much to be learned from extraordinary photographers of the past. They pos-

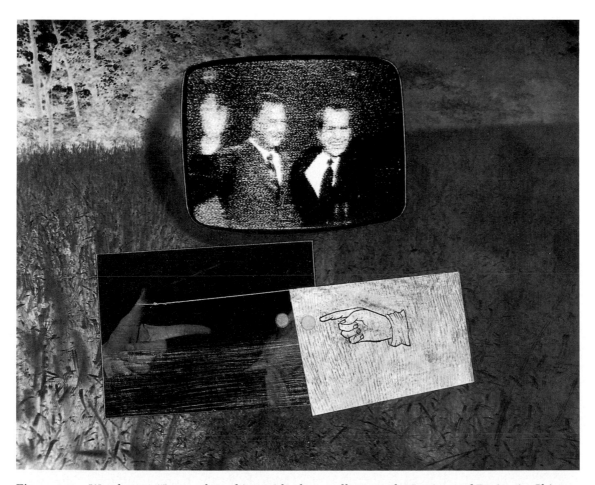

Figure 1.8 Wood says, "I started working with photo collages at the Institute of Design in Chicago in the early 1950s. My work in the 1960s was process oriented. I used images from newspapers, magazines, television, and my own resources. Generally, the collages were carefully dry mounted to archival board and invariably had a political commentary. This activity continues up to the present time."

© John Wood. *Nixon and Agnew* (*Pop Goes the Weasel*), circa 1960s. Gelatin silver print with mixed media. 7¾ × 9¾ inches.

sessed powerful hearts and minds. They utilized the range of materials that the medium had to offer. The possibilities of photography excited them, and the complexity of the process fired their imaginations. The care that remarkable work reveals suggests the mastery of tasks needed to perform visual feats. Accomplished practitioners are not afraid to work. Their images are produced out of knowledge and commitment. This enables them to create complex works with the power to endure because the photographers do not hold anything back. Going forward from a foundation of knowledge, the imagemaker is in a position to carry out the Irish writer Oscar Wilde's aphorism: "The duty we owe to history is to rewrite it," or in the photographic sense, to re-image history.

ROLES PHOTOGRAPHY CAN PLAY

The equipment, materials, and processes covered in this book take the reader away from the widely accepted notion that photography's major purpose is to recreate a recognizable version of outer reality. Most of the material presented in this book is designed to let readers discover for themselves the possibilities within the medium of photography. This information can help bring into existence that which never was. It starts to supply answers to the question "Why not?" It raises the question "How can I do more than record the reflections of the surface?" This type of thinking disrupts many traditional assumptions and conventions. If the work is unfamiliar, it can make

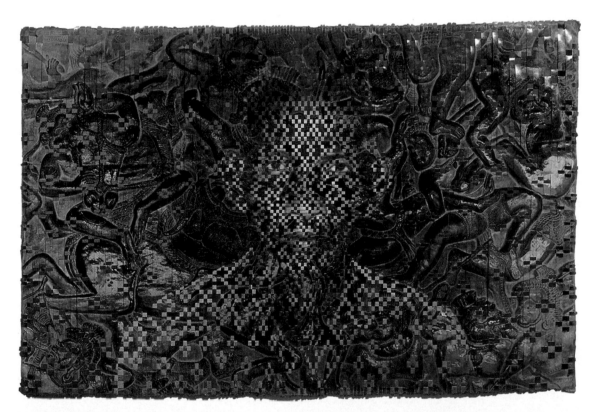

Figure 1.9 Born in Vietnam, where the Khmer Rouge invaded his own village, Lê now divides his time between Vietnam and the United States. Lê, who learned grassmat weaving from his aunt, acts as a meditative observer who creates dichotomies by combining images of stone carvings from the Cambodian temples of Angkor Wat with stark frontal portraits of men, women, and children murdered by the Khmer Rouge. The source of these images is a photographic archive compiled by the perpetrators who killed two million of Cambodia's seven million people. Just as erosion threatens the Angkor temple carving, Lê's beautiful images reflect on the instability of memory and the contractions of history in the hope that photo-based imagery will help people remember the barbaric fate of these nameless lost individuals.

© Dinh Q. Lê. *Untitled*, #11, from the series *Cambodia: Splendor and Darkness*, 1999. Woven chromogenic color prints and linen tape. 40¼ × 58¼ inches. Courtesy of the Shoshana Wayne Gallery, Santa Monica, CA. Original in color.

some people uncomfortable because there are no prescribed guidelines on which they can base their responses. Be prepared for challenges when presenting unconventional work.

Imagemakers can meet such challenges and use them to their advantage by engaging with critical thinking, by making images they truly believe in, and by learning to control their technique, both analog and digital, so that it becomes a vital, yet not predominant part of the visual statement. If the situation permits, consider taking on the role of a teacher. Seek ways that encourage people to set aside their fear of the unknown and allow them room to reconsider their former thought patterns. Nobody learns more about the subject than a well-prepared teacher does. It is also possible that response to questions will help viewers to see a subject differently and open new doors of perception.

This book offers numerous alternative photographic approaches. This information allows an expressive printmaker to understand how photography has evolved and to be ready to explore future possibilities in imagemaking. The text makes no particular distinction between work that has been created through analog or digital means. One exciting development has been in the way that photographers have been integrating numerous processes that zigzag through traditional media boundaries to achieve their visual ends.

The following questions and answers are designed to encourage readers to gain a larger overview of fundamental concepts, images, and issues that can inform creative work. By thinking through these questions, readers can expand and deepen vision potential and latent interests rather than following a current style or trend. The responses provided do not preclude other answers. They offer an initial pathway to form the basis of a discussion, to provoke, and in turn to help readers formulate thoughtful solutions.

QUESTIONS

1. Who is a photographer?

A photographer is a person who has decided to become and pursue the life of a photographer.

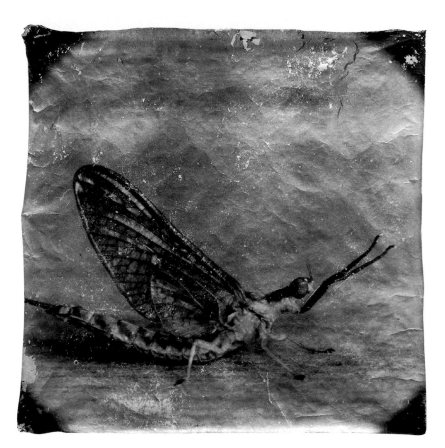

Figure 1.10 According to Mike Starn, the sun controls this species of butterflies. When it shines they fly and when there are clouds they fall to the ground. "Up and down all day long, they seem to create an idiotic poetry of puppets, creating an embarrassing metaphor for ourselves. Enlarging our perspective, we see the dominance of the sun over the earth and humanity, revealing that we are nothing more than a meaningless silhouette, a shadow, and shadows have no control." The butterfly was illuminated with a ring flash and photographed with extension tubes to get sufficient enlargement onto Polaroid Positive/Negative film, printed onto a hand-coated Luminos silver emulsion, and toned in Kodak Brown Toner.

© Mike and Doug Starn. *Attracted to Light*, 1997–1999. Silver emulsion on Thai mulberry paper. 16 × 16 inches.

2. What can one do to become a photographer?

Looking at photographs can be a primary activity. Photographs are made from other photographs, as well as drawings, paintings, and prints. Look at what drives your curiosity. Look at the classics. They have been preserved because the patterns recorded in them have proved to be invariably useful over time. Look at contemporary work that is wrestling with new and different ways of expressing ideas. Read, study, and practice different methods of photography, not for the

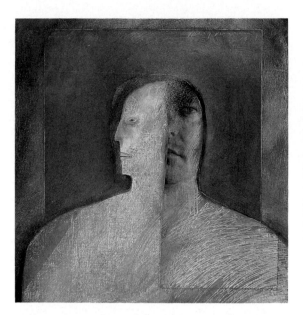

Figure 1.11 The addition of color to meet aesthetic requirements is one of photography's oldest modifications. Here Roberts cut the photograph and attached it to a gessoed canvas. After allowing it to dry, she painted it with oils.

© Holly Roberts. *Man Listening to Himself*, 1988. Oil on gelatin silver print on canvas. 20 × 18½ inches. Original in color.

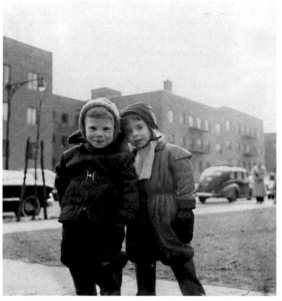

Figure 1.12 Snapshots provide blocks of personal memories that can help us to express and understand the world around us. A slight smile on my face hints that I am quite content with our attachment, but Karen seems more pensive and less certain. Within a few years my friend moved away and I have never seen her again. What has happened in my playmate's life? What would happen if we met today? If it were not for this snapshot, I doubt I would be thinking about these possibilities. I also wonder if I would even be able to consciously recall these memories without the power of this small photograph. In any case, I am grateful that my father commemorated us on the winter day in Kew Garden Hills, Queens, for it gives me the power to remember.

© Edwin Hirsch. *Bobby and Karen, Kew Garden Hills, Queens, NY*, 1953. 3 × 3 inches. Gelatin silver print.

sake of technique, but to discover the means to articulate your ideas. Step back from the familiar to better understand it. One big peril facing photographers is lack of commitment, which translates into indifference in their work. Talking, thinking, and writing about photography are vital components of understanding the process, but these activities do not make one a photographer. Ultimately, to be a photographer one must fully engage in the process and make photographs (usually lots of them).

3. What does a photographer do?

A photographer contemplates the nature of making photographs, the cerebral and emotional drive of working with a subject and process. Once this is accomplished, the photographer can then act to provide a physical form in which time can be manipulated or suspended to allow a subject to be thoughtfully examined.

Good photographers also take the time to wonder about their world and ponder how they can best analyze and express their thoughts and feeling to others. Wondering is part of the thinking process that lets one meditate on the possibilities. Wondering is a form of questioning old ways of knowing and can result in new ideas and different directions. Wondering encourages image-makers to summon the courage to take untested courses of action. Without wonder there is no speculation, which makes art and life boring and static.

4. Why is photography important to us as individuals and collectively as a society?

Recently a reporter asked a group of tornado survivors what their most irreplaceable object had been. One after another said the same thing. The one thing that they wanted

to recover from their ruined homes was their snapshots. Their other material possessions eventually could be replaced. This reveals the crux of why people photograph: to save and commemorate a subject of personal importance. The image may be a memory jog or an attempt to stop the ravages of nature and time. Regardless of motive, this act of commemoration and remembrance is the critical essence of both amateur and professional photographic practice.

What does this mean in terms of artistic practice at the beginning of a new century? There are more options than ever to pursue. Whether the images are found in the natural world, in a book, or on a screen, part of an imagemaker's job is to be actively engaged in the condition of "looking for something." How this act of looking is organized, its particular routines, uncertainties, astonishments, and quixotic complexities, is what makes photographers unique.

5. Why is it important to find an audience for your work?

Part of a photographer's job is to interact with and stimulate thinking within the community of artists and their world at large. Without an audience to open a dialogue the images remain incomplete and the artist unsatisfied.

6. What can images do that language cannot do?

An accomplished photographer can communicate visual experiences that remain adamantly defiant to words. The writer Albert Camus stated, "If we understood the enigmas of life, there would be no need for art." We know that words have the power to name the unnamable, but words also hold within them the disclosure of a consciousness beyond language. Photographs may also convey the sensation and emotional weight of the subject without being bound by its physical content. By controlling time and space the photo-based images allow viewers to examine that which attracts us for often indescribable reasons. They may remind us how the quickly glimpsed, the half-remembered, and the partially understood images of our culture can tap into our memory and emotions and become part of a personal psychic landscape that makes up

an integral component of identity and social order.

7. What makes a photograph interesting?

A significant ingredient that makes a photograph interesting is empathy, for it gives viewers an initial path for cognitive and emotional comprehension of the subject. Yet the value of a photograph is not limited to its depiction of people, places, things, and feelings akin to those in our life. An engaging image contains within it the capacity to sensitize and stimulate our latent exploratory senses. Such a photograph asserts ideas and perceptions that we recognize as our own but could not have given concrete form to without having first seen that image.

8. How is the meaning of a photograph determined?

Meaning is not intrinsic. Meaning is established through a fluid cogitative and emotional relationship among the maker, the photograph, and the viewer. The structure of a photograph can communicate before it is understood. A good image teaches us how to read it by provoking responses from the viewers' inventory of life experiences. Meaning is not always found in things, but sometimes between them. An exceptional photograph creates viewer focus, which produces attention, which can lead to definition. As one meditates on what is possible, multiple meanings may begin to present themselves.

9. Are the issues surrounding truth and beauty still relevant to photographers of the twenty-first century?

During the past 25 years, issues of gender, identity, race, and sexuality have been predominant because they had been previously neglected. In terms of practice, the artistic ramifications of digital imaging have been an overriding concern. But whether an imagemaker uses analog silver-based methods to record reality or pixels to transform it, the two greatest issues that have concerned imagemakers for thousands of years—truth and beauty—have been conspicuously absent from the discussion. In the postmodern era irony has been the major form of artistic expression.

Although elusive, there are certain patterns that can be observed that define a

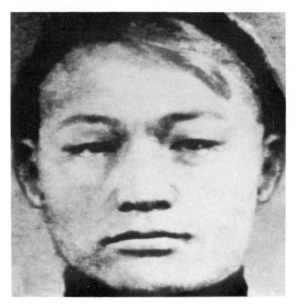

Figure 1.13 Computers have opened new paths of exploration in imagemaking. Burson's composite human is made up of Caucasian, Negroid, and Oriental features. The result, having no original body but only a digital representation, is representative of our media-saturated society in which the image (the perception of reality) can be more important than reality itself. Like a conjurer, Burson shows us that appearances are nothing.

© Nancy Burson with Richard Carling and David Kramlich. *Mankind*, 1983–1985. Gelatin silver print. 7¾ × 7½ inches.

personal truth. When we recognize an individual truth it may grab hold and bring us to a complete stop—a total mental and physical halt from what we were doing—while simultaneously experiencing a sense of clarity and certainty that eliminates the need for future questioning.

Beauty is the satisfaction of knowing the imprimatur of this moment. Although truth and beauty are based in time and may exist only for an instant, photographers can capture a trace of this interaction for viewers to contemplate. Such photographs can authenticate the experience and allow us to reflect on it and gain deeper meaning.

Beauty is not a myth, in the sense of being simply a cultural construct or creation of manipulative advertisers, but is a basic hard-wired part of human nature. Our passionate pursuit of beauty has been observed for centuries. The history of ideas can be represented in terms of visual pleasure. In pre-Christian times Plato stated: "The three wishes of every man: to be healthy, to be rich by honest means, and to be beautiful." More recently American philosopher George Santayana postulated that there must be "in our very nature a very radical and widespread tendency to observe beauty, and to value it."

10. How has digitalization affected photography?

Digitalization has shifted the authority of the photograph from the subject to the photographers by allowing them to extend time and incorporate space and sound. Photography is no longer just about making illusionistic windows on the material world or collapsing events into single moments. The constraints on how a photograph should look have broken down; they no longer have to be two-dimensional objects that we look at on a wall. This elimination of former artificial barriers is also good for those who wish to practice the art and craft of photography because it encourages makers to open the doors of perception to new ideas and methods for making photographs.

11. What are the advantages of digital imaging over silver-based imagemaking?

As in silver-based photography, digital imaging allows truth to be made up by whatever people deem to be important and whatever they choose to subvert. While analog silver-based photographers begin with "everything" and often rely on subtractive composition to accomplish these goals, digitalization permits artists to start with a blank slate. This allows imagemakers to convey the sensation and emotional weight of a subject without being bound by its physical conventions, giving picturemakers a new context and venues to express the content of their subject.

12. What are the disadvantages of digital imaging?

The vast majority of digital images continue to be reworkings of past strategies that do not articulate any new ideas. Manufacturers promote the fantasy that all it takes to be an artist is just a few clicks of a mouse or applying a preprogrammed filter. The challenge remains open: to find a native syntax for digital imaging. At the moment, this appears to be one that encourages the hybridization and commingling of mediums.

On the practical side, having a tangible negative allows one to revisit the original vision without worrying about changing technology. One could still take a negative that William Henry Fox Talbot made to produce his first photographic book, *The Pencil of Nature* (1843–1846), and make a print from it today. In 150 years will there be a convenient way for people to view images saved only as digital files? Or will they be technically obsolete and share the fate of the 8-track audio tape or the Beta video system which most people can no longer access?

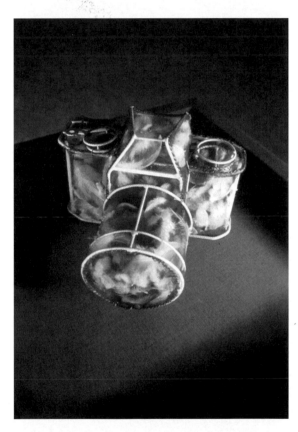

Figure 1.14 Abeles's artists' book, *Encyclopedia Persona A–Z* (1993), demonstrates the artist's dedication to the physical aspect of creation. *Camera Desiros* is an exact replica of Abele's 35 mm camera and is an ancillary piece to the series, *Mountain Wedge,* a 14-month attempt to photograph a clear view of the San Gabriel Mountains located 16 miles north of Los Angeles. The piece is made of welded steel rod covered with sheer mosquito netting and filled with pigeon feathers. Abeles says, "As its title and presence suggest, it speaks of a photograph's ethereal desire to capture images."

© Kim Abeles. *Camera Desiros*, 1987. Pigeon features, metal, and netting. 3¾ × 5½ × 4¼ inches. Courtesy of Art Resources Transfer, New York.

One does not have to be a Luddite to continue making analog prints. One reason to keep working in a variety of analog processes is that digital imaging tends to physically remove the maker from the photographic process. This is not a romantic notion or a nostalgic longing for the ways of the past. What often is lost is the pure joy of the atmospheric experience of being alone in a special darkroom with an orange glowing light, the exhilaration of being physically creative as your body and mind work together to produce a tangible image. The making of an analog photograph is a haptic experience that does not occur while one is seated in a task chair, but involves the smell of chemicals, the sensory experience of running water as an image emerges in the developing tray from a white nothingness. A silver-based photograph never looks better than when it is glistening wet from its final wash. And regardless of how long one has been making prints in the darkroom, there is still that small thrill that your photograph "has come out" and now can have a life of its own.

13. Some beginning photographers complain that there is no artistic subject matter in their locale.
Today a central characteristic of imagemaking is not only to create objects (photographs), but also to escape the restrictive parameters of their "objectness" through content. However, it is a common misconception to link content solely with the subject matter being represented. Photographs that affect people may have nothing to do with the apparent subject matter itself, and everything to do with the subsequent treatment of that subject. This realization creates limitless potential for subject matter.

Light and shadow are vital components of every photograph. This was recognized early in the medium's history by William Henry Fox Talbot's image *The Open Door* (1843), which demonstrated his belief that subject matter was "subordinate to the exploration of space and light." The quality of light striking a subject can reveal or conceal its characteristics, which will make or break a photograph. Light may be natural or artificial, but without the appropriate type of light even the most fascinating subjects become inconsequential. Ultimately, light is

a principal subject of every photograph that imagemakers must strive to control and depict. As Talbot stated: "A painter's eye will often be arrested where ordinary people see nothing remarkable. A casual gleam of sunshine, or a shadow thrown across his path, a time-withered oak, or a moss-covered stone may awaken a train of thoughts and feeling, and picturesque imaginings." This is the realization that the subject in front of the lens is not always the only subject of the photograph.

14. It's already been done before.

To accept the notion that it has all been done before is to embrace clichés. The problem with clichés is not that they are erroneous, but that they are oversimplified and superficial articulations of complex concepts. Clichés are detrimental because they encourage photographers to believe that they have done a sufficient job of recording a situation when in fact they have merely gazed at its surface. The simple act of taking a photograph of Niagara Falls or a pepper is no guarantee that one has communicated anything essential about that subject. Good photographers provide visual clues and information about their subject for the viewer to contemplate. They have learned how to distill and communicate what is essential to them about their subject. By deeply exploring a theme and challenging clichés, photographers can reconstruct their sight of distorted, neglected, or other aspects of a situation and gain a fresh awareness and understanding.

15. I'm not in the right mood to make photographs.

Responding to life with joy and sorrow is part of the human condition. At times when pain and suffering are inescapable, it is important to remember that this is part of the process by which we acquire knowledge. This does not mean that one must be in discomfort to make art, but stress can be channeled into a creative force if it produces a sense of inquisitiveness and an incentive for change. Thinking through making pictures can allow us to place our pain in context. The images we make can help us understand its source, catalog its scope, adapt ourselves to its presence, and devise ways to control it. There are things in life, once called wisdom, which we have to discover for our-

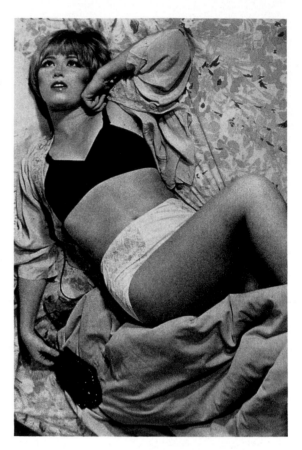

Figure 1.15 Sherman established herself as the only subject in the *Film Still Series*. The work points out that photographic truth is a myth and that media-generated imagery is as staged as her own. Through self-portraiture, it is possible to be actor, director, and producer, living out your personal fantasies and fears. Sherman uses it to unmask sexual stereotypes and to examine her own identity. By saying little about her work, Sherman encourages viewers to interpret her work based on their own life experiences.

© Cindy Sherman. *Untitled Film Still*, 1979. Gelatin silver print. 10 × 8 inches. Courtesy of Metro Pictures, New York.

selves by making our own private journeys. Stress can open up possibilities for intelligent and imaginative inquiries and solutions that may have otherwise been ignored, overlooked, or refuted.

16. I have no idea how I am going to make a photograph of this subject.

When you get stuck and cannot find a solution to your problem, try changing your thinking patterns. Instead of forcing the issue, go lie down in a quiet and comfortable dark room, close or even cover your eyes,

and allow your unconscious mind a chance to surface. Other people may take a bath or go for a walk. The important thing is to find something that will change your brainwaves. Anecdotal history indicates that this can be an excellent problem-solving method. Turn off the cognitive noise and allow your internal "hidden observer" to scan the circumstances, then return to your normal state with a possible solution. Keep paper and pencil handy.

17. Why is it important to understand and be proficient in the skills of your medium?

Understanding the structure of the photographic medium allows one the freedom to investigate new directions. When first seen, an image may be exciting and magical. However, the photograph needs to be objectively evaluated. To do this one must have the expertise of craft to understand the potential for that photograph. Mastery of craft allows one the control to be flexible, to sharpen the main focus, and to discard extraneous material. This evaluation process permits imagemakers to reexamine and rethink their initial impulse and jettison inarticulate and unadorned fragments, and to enrich and refine their work by incorporating new and/or overlooked points of view. An artist who invests the extra time to incubate fresh ideas, learn new technical skills, try different materials, and experiment with additional approaches can achieve a fuller aesthetic form and a richer critical depth. These qualities are often attained by reaching into another part of ourselves than the one we display in our daily demeanor, in our community, or in our imperfections.

18. How can a photographer make a difference in the world?

The desire to "see" implies that our sense of focus and *beauty* is not immobile and can be sensitized by an appreciation of previously neglected aesthetic qualities. The history of artistic photography is a succession of imagemakers who have used their intellectual and intuitive skills to convey what amounts to: "Isn't this fascinating!" Photographers who make a difference are those who are able to open our eyes and make us more aware.

19. Why is it important to make your own photographs?

The physical act of making a photograph forces you into the moment and makes you look and think more than once, increasing your capacity for appreciation and understanding. This not only allows you to see things in new ways, but can also be physically and psychologically exhilarating. It reminds us that life is not mediocre, even if our daily conception of it is. Making your own images allows you to forge your own connections between the structure of the universe, the organization of your imagination, and the nature of the medium.

20. How much visual information do I need to provide a viewer with in order to sustain meaning?

There are two basic stylistic approaches for transmitting photographic information. One is the straight, open frame approach in which much visual data is presented. It allows viewers to then select and respond to those portions that relate to their experiences. The second method is the expressionistic or closed form. Here the photographer presents only selected portions of a subject with the idea of directing a viewer toward a more specific response. Photographers should select which technique is most suitable for a particular subject and their specific project goals. Consciously selecting an approach also provides a basic template for organizing your thoughts and producing work with a tighter focus of concentration.

21. How much of a photographer's output is likely to be "good"?

In an apt metaphor for artistic inspiration, the American poet and writer Randall Jarrell wrote: "A good poet is someone who manages, in a lifetime of standing out in thunderstorms, to be struck by lightning five or six times, a dozen or two dozen times and he is great." When Ansel Adams was photographing on a regular basis he said he was satisfied if he made one "good" image a month. Much of any artistic practice is working through the process. Good artists take risks but also recognize that not everything they do needs to be shared with the public. Skillful artists learn to edit their own

work (or get assistance) and present only their most thought-out solutions for public consideration.

22. How can a photographer explore the complex relationships of time, space, and scale?

Work with photographs and the process of making pictures. Explore single and serial constructions, narrative and non-narrative formats, and in-camera juxtapositions. Examine how one image may modify the meaning of the next. Seek the most effective form of presentation: the gallery, a visual book, the screen, the Web, or a combination of approaches. Regardless of what anyone says, people make photographs because of the way something looks.

23. Why study the history of photography?

Encountering new photographs presents the opportunity to see something in yourself that previously you had been unable to articulate, and/or raise by assembling visual experiences that may never have been more than semiconscious. This process symbolizes what all images can do for viewers: to resurrect, from the deadness of routine and lack of concentration, valuable yet overlooked aspects of experience.

24. What are the limitations in studying the images of others?

The French novelist Marcel Proust stated: "There is no better way of coming to be aware of what one feels than by trying to recreate in oneself what a master has felt." While viewing the work of others can help us learn what we feel, it is our own thoughts we need to develop, even if it is someone else's picture that aids us through this process. Regardless of how much any image opens our eyes, sensitizes us to our surroundings, or enhances our awareness of social issues, ultimately the work *cannot* make us aware enough of the significance of our predilections because the imagemaker *was not us*. Looking at work can place you at the threshold of awareness, but it does not constitute cognizance of it. Looking may open deep dwelling places that we would not have known how to enter on our own, but it can be dangerous if the work is seen as material that we can passively grab and call our own. We become photographers

because we probably have not found pictures that satisfy us. In the end, to be a photographer, you must cast aside even the finest pictures and rely on your internal navigational devices.

25. Can too much knowledge interfere with making photographs?

Beware of those who do not think independently, but rely upon established aesthetic pedigrees as a guide to eminence. You do not have to know all the answers before you begin. Asking questions for which you have no immediate answers can be the gateway for a new dynamic body of work. Do not get overwhelmed by what you do not yet know. There is always more to know, and learning should be a lifelong process. Use your picturemaking as a discovery process, but do not allow the quest for data to become the central concern or a deterrent to making pictures. Knowledge of a subject can offer points of entry for visual explorations. Learn what you need to begin your project and then allow the path of knowledge to steer you to new destinations.

26. Is it necessary to explain my photographs?

Yes, it is vital to give viewers a toehold to your work with an artist's statement. This process also allows a photographer to learn if the audience agrees with the stated intentions of the work. However, while useful, an artist's intention offers only a single perspective for understanding the work. By remaining open to different interpretations, imagemakers may discover meanings that were not in their own conscious mind.

Enigma also remains an essential quality of making art. English painter Francis Bacon, whose work was strongly influenced by photography, believed that the power of a work lay in its ability to be alluring yet elusive. Bacon thought that once an image could be explained, sufficiently approximated in words, it became an illustration. He believed that if one could explain it, why would one go to the trouble of painting it? According to Bacon, a successful image was by definition indefinable, and one sure way of defining it was by introducing a narrative element.

For centuries, storytelling was the backbone of Western art. Yet the bourgeois coziness and shallow academic conventions of nineteenth-century narrative painting made storytelling an anathema to the aesthetic vocabulary of modern art. Bacon took the existential position that his pictures meant nothing, said nothing, and he himself had nothing to say. Bacon believed that painting was the pattern of one's nervous system projected on the canvas. He claimed he wished to "paint like Diego Velázquez but with the texture of a hippopotamus skin," achieving the tonal subtlety inspired by the Spanish master whose paintings encompassed the rough, grainy immediacy of a news photo. Bacon sought to exalt the immediacy of camera vision in oil, like a portrait in the grand European manner.

27. What is the role of critics and critique?

"Unless you are one critic in a hundred thousand," wrote the critic and teacher Randall Jarrell, "the future will quote you only as an example of the normal error of the past." The real importance of criticism is for the sake of the work that it criticizes. Good critics do not set up rigid agendas and templates or try to impose their own prescriptive notions, but allow the work and the experience of it to set the general expectations to which the criticism conforms. The only thing we know about the future is that it is not what we think it will be.

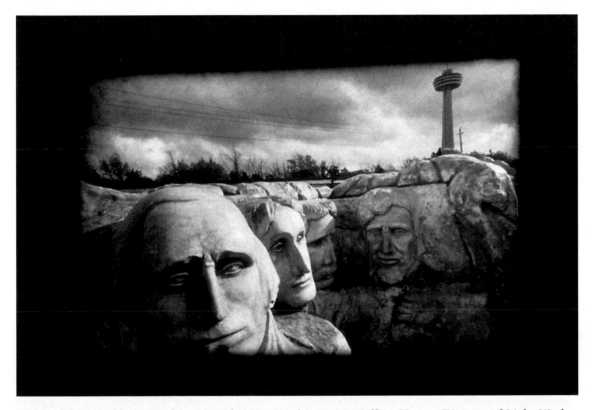

Figure 1.16 Addressing the issue of enigma and meaning, Jeffrey Hoone, Director of Light Work, said that this "series would be difficult to classify using conventional criteria in regard to subject matter; yet they all appear to be ambiguously related from the heroic to the prosaic. When presented in their original form each image measures a mere 1¾ × 2¾ inch floating in a black background on a 20 × 16 inches sheet of paper. The edges of the image are blurred and irregular, and combined with the scale and dark background each image appears as if it were being viewed in a darkened theater from way back in the aisle. In a gallery setting the images must be viewed at a very close distance, establishing an intimate relationship between viewer and photograph that heightens the sense of memory and emotion that each image conveys. Hirsch gives the viewer a variety of issues, concerns, and techniques to think about and digest. He massages meaning out of every nuance in the series from the choice of subject to the scale of the images, and each decision that he has made seems to open up opportunities for further investigation."

© Robert Hirsch. *Untitled* (detail), from the series *The Architecture of Landscape*, 1999. Toned gelatin silver print. 20 × 16 inches. Courtesy of Light Work, Syracuse, New York.

28. What is the role of theory in relation to contemporary photography?

It is a matter of perspective and priority. Do you want to be concerned with the object of study or with constructing a cohesive conceptual system? At its best, Postmodernism's agenda of inclusion creates a permissive attitude toward a wide range of interpretive possibilities. At its worst, it encourages a nihilistic solipsism where all expression resides in an undecidable haze of indeterminate value. As a student, one does not expect to learn and unlearn photography all at once, but regardless of one's personal inclinations, one should become informed about past and present artistic theory, from John Ruskin to Jacques Derrida.

29. What are the qualities of a good teacher?

A good teacher provides guidance and leadership that prepare individuals to tap into their own creativity. Good teachers are well organized, care about the subject and their students, and work to create an atmosphere of give and take. This openness and trust can produce a dynamic that encourages a two-way dialogue between the instructor and the class. Good teachers are enthusiastic, patient, and well prepared with good learning materials, and establish clear long-term goals. They are accountable and honest in their responses to student work. They do not tear students down just to be provocative, but have students present and defend their ideas to understand the intention of the work. Good teachers focus on everyday assumptions and encourage experimentation, and they realize that taking chances and stepping into unknown territory may result in temporary failure that can often prepare one to go on to the next level. Good teachers are resourceful people who may teach by example but continue to advocate that students find their own voice and not just imitate that of the teacher or a popular trend. They ask adroit questions and listen carefully in order to steer students toward information that will generate further development of aesthetic and critical thinking. Most importantly, good teachers build confidence in the student's mind by instilling the belief that if they focus on the task at hand, think critically, and act specifically they can succeed.

30. What are the qualities of a good student?

Good students have the will to learn. They are self-motivated and work for themselves, not to please others. They are alert, curious, and enthusiastic, pay attention, keep an open mind to new ideas, and enjoy the learning process. They set personal goals, maintain an organized work schedule, and manage their time properly. They assume responsibility for their actions and accept the challenge to think critically about the material. They prepare their minds by completing their reading and writing assignments so that they can ask questions and actively participate in group discussions in order improve their base of knowledge. At the conclusion of their study they are able to demonstrate their knowledge and integrate it into their lives. With good fortune this can lead to a realization of where they are at the moment, where they would like to be in their future, and how to adjust their lives to make it happen.

31. How do photographers earn a living?

Living as an artist depends on what you want to do and how much money you require. Less than one percent of artists can live on what they earn from their artwork. Do not expect to get a full-time teaching job in higher education even if you are willing to work for years as an adjunct faculty member at numerous institutions. However, there are career opportunities in arts and cultural organizations as well as in primary and secondary education. Take advantage of being a student—do an internship that will give you first-hand experience in an area you would like to work within. Successful internships can lead to entry-level jobs. The visual arts community is still a relatively small field. Hard work and networking skills can benefit you and the organization that you serve in terms of letters of reference and bridges to your future that are at present unimaginable.

32. Now it is your turn. Add a question and answer to this list.

ADDITIONAL INFORMATION

Adams, Ansel. *The New Ansel Adams Photography Series.* Boston: Little, Brown, 1981.

Adams, Robert. *Why We Photograph: Selected Essays and Reviews*. New York: Aperture, 1994.

Beckley, Bill (Ed.), with David Shapiro. *Uncontrollable Beauty: Toward a New Aesthetic*. New York: Allworth Press, 1998.

Crawford, William. *The Keepers of Light: A History & Working Guide to Early Photographic Processes*. Dobbs Ferry, NY: Morgan and Morgan, 1979.

Davis, Keith. *An American Century of Photography: From Dry-Plate to Digital*. The Hallmark Photographic Collection. Second Ed., Revised and Enlarged. Kansas City, MO: Hallmark Cards in Association with Harry N. Abrams, 1999.

Frizot, Michel (Ed.). *A New History of Photography* (English version). Cologne: Könemann, 1998.

Gardner, Howard. *The Disciplined Mind: What All Students Should Understand*. NY: Simon and Schuster, 1999.

Goldberg, Vicki (Ed.). *Photography in Print: Writing from 1816 to the Present* (reprint). Albuquerque: University of New Mexico Press, 1988.

Green Jonathan. *American Photography: A Critical History 1945 to the Present*. New York: Harry N. Abrams, 1984.

Hirsch, Robert. *Seizing the Light: A History of Photography*. New York: McGraw-Hill, 2000.

Newhall, Beaumont. *The History of Photography*. Revised Ed. New York: The Museum of Modern Art, 1982.

Rosenblum, Naomi. *A World History of Photography*. Third Ed. New York: Abbeville Press, 1997.

Stiles, Kristine, and Peter Selz (Eds). *Theories and Documents of Contemporary Art: A Sourcebook of Artists' Writings*. Berkeley and Los Angeles: University of California Press, 1996.

Taft, Robert. *Photography and the American Scene: A Social History, 1839–1889*. New York: Dover Publications, 1964.

Safety 2

Photographers must be aware of certain health and environmental concerns to ensure a safe and creative working atmosphere. Before beginning to work with any of the processes mentioned in this text, it is essential to follow the basic precautions and procedures outlined in the next section.

BASIC SAFETY PROCEDURES

1. Read and follow all instructions and safety recommendations provided by the manufacturer before undertaking any process. This includes handling, mixing, storage, and disposal.

2. Become familiar with all the inherent hazards associated with any chemicals being used. When acquiring chemicals, ask about proper handling and safety procedures.

3. Know the antidotes for the chemicals you are using. Prominently display the telephone numbers for poison control and emergency treatment centers near the telephone in your working area.

4. Many chemicals can be flammable. Keep them away from any source of heat or open flame to avoid a possible explosion or fire. Keep a fire extinguisher that can be used for both chemical and electrical fires in the work area.

5. Work in a well-ventilated space. Hazardous chemicals should be mixed under a vented hood or outside.

6. Protect yourself. Wear thin, disposable plastic gloves that are suitable for handling the chemicals you are working with, along with safety glasses and a plastic apron. Use a disposable face mask or respirator when mixing chemicals, especially if you have had a previous allergic reaction. If you have any type of reaction, immediately consult a physician and suspend work with all photographic processes.

7. Precisely follow mixing instructions.

8. Keep all chemicals off your skin, out of your mouth, and away from your eyes. If you get any chemicals on your skin, immediately flush the area with cool running water.

9. Do not eat, drink, or smoke while handling chemicals.

10. Always pour acids slowly into water; never pour water into acids. Do not mix or pour any chemical at eye level, as a splash could easily hit your eyes. Wear protective eye wear when mixing acids.

11. Avoid touching any electrical equipment with wet hands. Install shockproof outlets in your darkroom.

12. Follow instructions for proper disposal of all chemicals. Wash yourself and any equipment that has come into contact with any chemicals. Launder darkroom towels after each session. Dispose of gloves and masks to avoid future contamination. Keep your work space clean and uncontaminated.

13. Store all chemicals properly. Use safety caps or lock up chemicals to prevent other people, children, and pets from being exposed to their potential dangers. Store chemicals in a cool, dry area away from direct sunlight.

14. If you are pregnant or have any preexisting health problems, read the pertinent materials under "Additional Information" at the end of this chapter before carrying out any process described in this book.

15. People have varying sensitivities to chemicals. If you have had allergic reactions to any chemicals, you should pay close attention to the effects that darkroom chemicals have on you, and be ardently careful about following all safety procedures (see following section on chemical sensitivities).

Specific safety measures and reminders are provided in the chapters on each process. These guidelines are not designed to produce paranoia but to ensure that you have a long and safe adventure in uncovering the many possibilities of photography. Remember that your eyes, lungs, and skin are porous membranes and can absorb chemical vapors. It is your job to protect yourself.

CONTACT ALLERGIES AND CHEMICAL SENSITIVITIES

Although most people work with photographic chemicals and materials with no adverse effects, a small number of people have an abnormally high sensitivity to certain substances. This group of people may have a reaction to substances like household cleaners, latex, matches, paints, rubber, wool, and even some types of jewelry. All chemicals used in photography should always be treated with care.

The symptoms of chemical sensitivity vary from one person to another. These symptoms can include redness, itching, or swelling when skin comes in contact with a chemical. The skin may form blisters that later break. A chemical sensitivity reaction does not require contact with the substance. Inhalation or skin contact with fumes may be enough to trigger the reaction. Note that an individual chemical may not be particularly toxic in liquid form but may be highly toxic if inhaled while in powder form.

Chemical sensitivities are not allergies but they often cause many of the same symptoms, such as light-headedness, fatigue, headaches, and recurrent illnesses that seem to have no explanation. Reactions may vary widely, but the treatment is the same: avoidance of the substance causing the reaction.

Chemicals used in photography that most often cause chemical sensitivity reactions include: Metol, para-phenylene diamine, potassium aluminum sulfate, gold and platinum salts, selenium salts, potassium persulfate, potassium dichromate, and potassium chlorochromate.

This is only a partial list. Generally, all of the chemical formulations listed in this book can be safely used with only a few precautions such as a pair of gloves and good ventilation.

DISPOSING OF CHEMISTRY

As environmental regulations are made stronger, what may have been disposable by pouring down the drain ten years ago may require careful disposal today. As the beneficiaries of cleaner air and water, photographers are responsible for following local regulations.

Municipal waste treatment plants can handle most photochemical solutions under a certain volume and concentration. Local sewer authorities regulate the concentrations and the volume of chemicals released per day into sewer systems. Most individual home photographic processing will not exceed these regulations. Before setting up a darkroom, contact the local sewer authority for information about disposing of your photographic solutions.

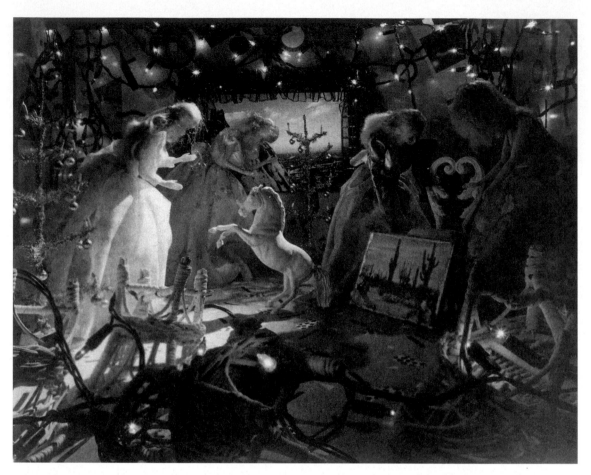

Figure 2.1 Danielson is representative of artists who interchangeably work with analog and digital methods. Regardless of working techniques, artists need to follow safety instructions to protect themselves, those around them, and our environment. Here Danielson's studio still life plays the antique look of platinum printing off her postmodern fascination with feminine stereotyping. She uses the subtle tonalities of platinum, a quality associated with early twentieth-century pictorialism, to lure viewers into her allegorical compositions. Yet on closer inspection viewers realize that her subject matter, popular decorative objects from the 1940s and 1950s, evokes and draws into question feminine stereotypes from more recent times.

© Deborah Danielson. *Rearranging the Furniture*, 1990. $3\frac{3}{4} \times 4\frac{3}{4}$ inches. Platinum/palladium print.

Disposing of Fixer

Fixing baths can contain high concentrations of silver thiocyanate. It is usually acceptable to pour small amounts of fixer down the drain with running water. The U.S. Clean Water Act allows no more than five parts per million (ppm) of silver ion to be deposited in municipal wastewater treatment plants. This concentration can easily be achieved in a good printing session. Large amounts of used fixer (more than a few gallons per day) should therefore be treated with a silver recovery system. These systems come in a variety of styles and sizes. The precipitated silver must be sent to a company that will recover the silver.

Septic Systems

Because household septic systems use bacteria to break down waste they can be damaged easily by photographic chemistry disposal. Most septic systems can handle a few pints of chemistry at any one time. Some munici-

palities now require a permit to dump photographic wastes into septic systems.

PROTECTING YOURSELF AND YOUR COMPUTER

The computer does not expose the user to possibly hazardous chemicals or fumes, but an artist working at a computer should be aware of the possible health effects.

ELF/VLF

Extremely low frequency (ELF) and very low frequency (VLF) emissions are types of electromagnetic radiation created by monitors. Some research studies have linked these emissions to an increased risk of cancer or miscarriage. Keep your eyes at least 18 inches away from the screen and avoid prolonged exposure. Low-emissions monitors are available as well as filters for the screen.

Eye Strain

Working in a well-lit room, keeping the screen free of dust and clear of reflections can reduce eyestrain.

Taking Breaks

Taking a 15-minute break every one or two hours will help keep you sane and prevent fatigue. Try mixing non–computer-related activities into your digital routine.

Carpal Tunnel Syndrome

Carpal tunnel syndrome, caused by repetitive movements and improper keyboard and mouse use, is characterized by numbness and tingling in the wrists and hands. In advanced stages, the syndrome can cause permanent nerve damage. Keeping your wrists flat, straight, and at a height equal to your elbows will help prevent injury.

Lower Back Problem

Make sure you are comfortable, with your feet on a footrest or flat on the floor.

The top of the monitor should be at eye level.

Surge Protection

Power surges, called *spikes*, occur when the power to your home or studio is restored after an interruption. These surges can damage the sensitive circuitry in your computer. Surge suppression devices are designed to protect a computer and peripherals from spikes.

ADDITIONAL INFORMATION

Books

McCann, Michael. *Artist Beware.* Second Ed. New York: The Lyons Press, 1993.

Rempel, Siegfried, and Wolfgang Rempel. *Health Hazards for Photographers.* New York: The Lyons Press, 1993.

Rossol, Monona. *The Artist's Complete Health & Safety Guide.* Second Ed. New York: Allworth Press, 1994.

Shaw, Susan, and Monona Rossol. *Overexposure: Health Hazards in Photography.* Second Ed. San Francisco: The Friends of Photography, 1991.

Spandorfer, Merle, Jack Snyder, and Deborah Curtiss. *Making Art Safely: Alternative Methods and Materials in Drawing, Painting, Printmaking, Graphic Design, and Photography.* New York: John Wiley & Sons, 1995.

Tell, Judy. *Making Darkrooms Saferooms,* 1989. Available from National Press Photographers Association, 3200 Croqsdaile Drive, Suite 306, Durham, NC 27705.

Other Sources

Center for Occupational Hazards, 5 Beekman Street, New York, NY 10038; (212) 227-6220.

Ilford, North America, 24-hour hotline, (914) 478-3131.

Kodak, Australia/Asia/Western Pacific, 24-hour hotline, 03-350-1222. Kodak, North America, 24-hour hot line, (716) 722-5151.

Kodak, United Kingdom/Europe/Africa, 24-hour hotline, 01-427-4380.

Emergency Numbers

Numbers for the local poison control hotline are usually listed in the first few pages of your telephone directory. Keep this number along with the following phone numbers close to the telephone in case of an emergency.

Local Poison Control: _____

Kodak Emergency Number: (716) 722-5151

Ilford Medical Emergency Number: (800) 842-9660

3 Special-Use Films and Processing

FILM AND THE PHOTOGRAPHER

Being a photographer requires more than making a decision to use a camera. It involves learning how to make the camera and photographic materials function to fulfill your purposes and learning to see in the way the lens sees. Traditionally, the camera has used a light-sensitive substance on a support base called film to accomplish this task. In the 1980s, cameras that were capable of recording an image electronically, without silver-based film, became available for commercial use. Computers and digital cameras can perform most of the functions of traditional cameras. But because they record images differently than film does, the effect and overall character of the image may differ. Although electronic imaging is a revolutionary breakthrough in imagemaking and is gaining in popularity daily, film continues to be the method and measuring stick that the vast majority of photographers rely on to record their subjects. (Electronic imaging is covered in Chapters 12 and 13).

Readers should feel confident in camera handling, exposure, and in processing a wide variety of general-purpose black-and-white films before proceeding. If you have any problems in these areas, a review of working procedures is in order. (This chapter will not cover color films. For information on this subject consult the latest edition of *Exploring Color Photography* by Robert Hirsch, McGraw-Hill Publishers, 1997; new edition is being planned).

Film Selection

Film is the agent that records an image, and its basic characteristics are crucial in determining the look of the final image. Brands and types of film differ in contrast, grain structure, sensitivity, sharpness, and speed. These characteristics are manufactured into film and are difficult to alter to any large degree. For these reasons, it is important for photographers to base their selection of film on the aesthetic and technical requirements of the situation.

Manufacturers regularly alter existing films, discontinue old favorites, and introduce new films at a rapid rate. It is difficult for any photographer to keep up with all these changes. The life span of technical information has been greatly reduced. It can become obsolete almost as soon as it is printed. The Internet now makes it easier to get up-to-date information, but manufacturers are often slow to publish information even online. As there is no way to gauge the truth of any information obtained on the Internet from nonmanufacturers' sites, such data may be a treasure trove or just fool's gold—untested and inaccurate blather. To deal with this problem, a photographer needs a sound conceptual understanding of a wide array of photographic processes. A

process or product may change, but the underlying principles remain the same. Many photographers find that refining their working methods with one film-developer combination can be effective for most general situations. But a photographer must be willing to test new films in noncritical situations and make a judgment based on personal experience.

Selecting a film is an individualistic matter in that many subjective concerns take precedence over technical matters. As you will learn by reading this book, film image quality is also affected by the method of development. The same roll of film can produce a wide range of characteristics based on how it is treated before, during, and after exposure and processing. It can be helpful to talk with other photographers and read widely. Remember, you can discuss and read about photography all night, but this is not photography. Being a photographer means being involved in making images. The only way to know what is going to work in photography is to do it yourself. The multiplicity of human experience shows that reality is not an inert and simple matter. Let your selection of film reflect what actually works for you.

Compiling Sources of Information

The information provided in this chapter is designed to offer aesthetic and technical possibilities that cannot be achieved through the use of conventional films. The information has been compiled through the personal working experiences of professionals, teachers, and students. The technical information was up-to-date at the time of writing, but you should check it against the manufacturer's data sheet before beginning to work with the film.

These methods have been successful for others. If the results you obtain with them are not satisfactory, do not hesitate to alter them. Make these working procedures your own by changing them to suit your personal requirements. Keep a detailed notebook of procedures, ideas, and sources. Record keeping can save time and act as a springboard for new directions in your work.

GENERAL WORKING PROCEDURES FOR FILM PROCESSING

Certain general working procedures can be followed in all film processing to ensure consistent high-quality results. These include the following:

- Read, understand, and follow all technical and safety data before processing the film.

- Be certain that all your equipment and your general working area are clean, dry, and in proper working order.

- Make sure there are no light leaks in film-loading and film-processing areas.

- Lay out all the equipment you will need in a location where you can find it without the aid of a light.

- Plastic funnels, graduates, mixing pails, stirring rods, and bottles should be durable, easy to clean, inexpensive, and applicable to almost any process. To avoid possible contamination, use separate graduates and containers for developer and fixer. Rinse all mixing equipment before and after each use.

- Once a developer is mixed into a working solution, store it in a clean brown plastic container, with as much air as possible removed from the container, to ensure maximum life.

- Do not exceed the working capacities (the amount of film that may be processed) of any of the solutions.

- Mix the developer with distilled water to ensure consistency, especially in areas with problematic water.

- Use an accurate thermometer for processing consistency. This is necessary to ensure that all solutions are at their proper operating temperatures.

- Presoaking film removes the wetting agent incorporated into the emulsion, increasing the potential for streaking. Because the developer has to displace the water absorbed by the emulsion during the presoak, you may have to extend the developing time. Many people feel that presoaking your film for one to two minutes before beginning to process prepares the film for developer and eliminates air bubbles, thus helping deliver

superior quality. Try it and see for yourself.

- Follow recommended agitation patterns for each step of processing.

- Stop bath rapidly changes the pH of film, causing the action of the developer to cease. Recent manufacturers' testing has found that this rapid change in pH can cause the formation of tiny pinholes in the emulsion. This damage will be apparent in the final print. Therefore, using stop bath in film processing is no longer recommended. Instead, rinse the film twice in the processing tank, with water. If you decide to use stop bath, mix it from a 28 percent stock solution to avoid the problems that can occur when working with the highly concentrated 99 percent glacial acetic acid. Dilute the 28 percent stock solution to its working strength. Use it one time (one shot) and dispose of it. If you want to reuse the stop bath, get one that contains an indicator dye that changes color to inform you when the solution is becoming exhausted. Discard the indicator stop after its orange color disappears. If you wait for it to turn purple, it may already be exhausted. Indicator stop bath may be used to make all film and paper stop baths.

- Fixer or hypo comes in two forms: regular, which consists mainly of sodium thiosulfate powder, and rapid, which is usually ammonium thiosulfate in a liquid form. Either may be used for most processes. Check to make sure the dilution is correct for the process being carried out. Both types may be reused. Keep a record of the number of rolls processed or use a hypo test solution that will indicate when the fixer has become exhausted due to silver saturation. Hypo test will not test accurately for exhaustion through age (oxidation) or other contamination. This test solution can be purchased commercially or made following this formula: 100 milliliters distilled water to 2 grams potassium iodide. This solution can be stored in a dropper bottle, available at most drugstores. It should keep indefinitely. To use this solution, put one or two drops into the used fixer. Wait a few seconds. If any cloudiness is visible within about ten seconds, replace the print fixer.

- Film may be washed in the processing tank. Make certain that the water is changed often, at least 12 complete changes of water, or get a film washer that does this automatically.

- Use a hypo clearing agent to help remove fixer residue and reduce washing time.

- Place the film in a wetting agent for about two minutes with light agitation before hanging it to dry in a dust-free area. Always mix the wetting agent with distilled water. Dispose of the used solution after each use.

- If there are problems with particles drying on the film, try this procedure: On removing the film from the wetting agent, shake off excess solution in the sink. Hang film up and clip it on the bottom. If your fingers are clean and smooth, put your index and middle fingers in the wetting solution and shake them off. Now use these two fingers to gently squeegee both sides of the film. With a lint-free disposable towel, such as a Photo-Wipe, carefully wipe the nonemulsion (shiny) side of the film from top to bottom. Do not wipe the emulsion side, as it is still soft and can be damaged easily. Hold the film at a slight angle with one hand. Using the other hand, slowly bring the disposable towel down the full length of the film. Keep your eye on the film just behind where the towel has passed to check for any spots, streaks, or particles. If any are visible, go back and remove them. A rainbow effect on the film surface indicates that you are carrying out the procedure correctly. Do not use any heat or forced air to speed film drying.

- After the film is dry, place it in archival plastic sleeves or acid-free paper envelopes. Store it in a cool, dry place. Do not use glassine, kraft paper, or polyvinyl chloride materials for storage, because they contain substances that can be harmful to film over time.

- Keep a notebook of all the procedures. List the date, type of film, developer, time, and temperature; any procedures that are different from normal; the outcome; and the changes to be made in working methods if a similar situation is encountered in the future.

- Refrigerate or freeze the film before and after exposure for maximum quality. Let the film reach its operating temperature before loading, exposing, or processing it.

KODAK HIGH SPEED INFRARED FILM 2481 AND 4143

Black-and-white infrared (IR) film is sensitive to all wavelengths of the visible spectrum of light but also extends into the IR region. IR film is sensitive to radiation that the human eye cannot detect. Conventional panchromatic film, sensitive to the visible spectrum, is designed to record a subject in tones that approximate those of human perception. IR film sees and records beyond human parameters but also has a reduced sensitivity to green wavelengths of light. These two factors combine to render objects differently than panchromatic film does and can cause dramatic shifts in tone, producing images that appear unreal, and sometimes almost hallucinatory.

To understand this film, it is necessary to experiment with and test it. This will make you familiar with the changes it can produce in the sense of pictorial space by altering the tonal relationships of a scene. This distinct set of tonal relationships can distort the normal sense of photographic time and space. All the information discussed in this section refers to Kodak High Speed Infrared Film 2481 and 4143, which are the most readily available IR films. They come in 35 mm cassettes, 150-foot rolls, and 4 × 5 inch sheets.

Handling

IR film is sensitive to IR radiation, so should be handled in total darkness when loading or unloading either the camera or the developing tank. The felt strips of the film cassette can permit IR radiation leaks. Check the darkroom to make certain it is light-tight. When a darkroom is not available, use a high-quality changing bag. Keep the bag in an area shaded from direct sunlight. Be aware that changing bags can leak IR radiation; check the bag with a test roll. IR film can also be fogged by heat. Whenever possible, keep it refrigerated before and after exposure.

Focusing

IR radiation has longer wavelengths than those of the visible spectrum. Regular camera lenses are not designed to focus IR wavelengths. To correct this problem, most lenses have an IR focusing index marker engraved on the lens barrel. It is often a red dot or the letter R located close to the normal focusing mark on the lens. Check the camera manual to ascertain the location of the marking.

When using IR film, focus the camera in the normal manner. Note the distance indicated by the regular focusing index mark, then manually rotate the focusing ring to place that distance opposite the IR focusing index mark. The image may be fuzzy in the

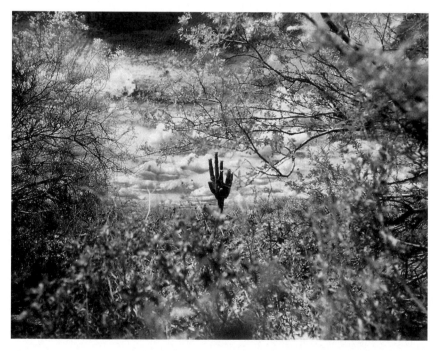

Figure 3.1 Ginsburgh Hofkin used Konica black-and-white infrared 120 film to accentuate the lonely cactus standing against a dramatically clouded sky. The photographer says, "Experience has taught me to look for those objects reflecting significant concentrations of infrared energy in order to selectively register greater density on the negative, thereby causing those respective counterparts in the print to appear lighter or more ethereal. The resulting shift enables me to emphasize those dream-like and surrealistic feelings I seek to express in my images." She processed the film in Ilford Microphen 1:1 and printed using an Aristo Cold Light on Kodak Elite Glossy #3. The image was toned in Kodak Rapid Selenium Toner (6 ounces per gallon for 10 minutes).

© Ann Ginsburgh Hofkin. *Arizona–94-2*, 1994. Toned gelatin silver print. 18 × 23 inches.

viewfinder, but the IR film will record it sharply. It is not necessary to make this adjustment when using a wide-angle lens or a small lens aperture, as the increase in depth of field will compensate. It is necessary to do this at distances of five feet or less and with all telephoto lenses. View camera corrections can be made by adding 25 percent of the focal length to the lens-film distance.

Filters

Because IR film is sensitive to visible and IR spectra, filters can be used to alter and control the amount of spectrum that the film records. The following sections describe some of the filters commonly used with IR film.

Wratten No. 87
The Wratten No. 87 filter absorbs all visible light, allowing only IR radiation to pass through and be recorded. With a single lens reflex (SLR) camera, it is necessary to remove this filter to focus, as it appears opaque to the human eye. Subjects will be recorded in tones proportional to the amount of IR radiation they reflect. Those reflecting the most IR radiation will appear in the lightest tones. Objects that appear to be the brightest to the human eye are not necessarily those that reflect the most IR radiation. For this reason, the tonal arrangement of the scene recorded by the IR film will often seem unreal when compared with the same scene recorded on a panchromatic film that is sensitive to the visible spectrum. Other filters that block UV and most or all visible radiation are Wratten No. 89B, 88A, and 87C. Each of these filters removes different wavelengths of light, creating different effects.

Red Filters
The Wratten No. 25 filter (red) is the most commonly used filter with IR film. It prevents blue and green light from passing through but transmits red and IR radiation. It enables the photographer to focus through the SLR viewfinder. This filter can produce bold visual effects. The sky may appear black, with clouds seeming to pop out into the third dimension. Caucasian skin can lose detail and take on an unworldly glow.

Surface veins in the skin can become extremely noticeable. The Wratten No. 29 (deep red) filter can produce an even greater effect, but requires one f-stop more exposure than the Wratten No. 25.

Polarizer
IR film is excellent for use in penetrating haze when using a polarizer in conjunction with a No. 87 or No. 25 filter.

Other Filters
Almost any colored filter will block certain wavelengths of visible light and permit IR radiation to pass through. A polarizer and the Wratten No. 12 (yellow), Wratten No. 58 (green), and Wratten No. 15 (orange) filters offer varying effects by removing part of the blue wavelengths of light. Try different filters and see what happens. Keep notes so that you can replicate the results.

No Filters
Without filtration, IR film reacts more strongly to the visible spectrum. This produces less dramatic images than those produced with filters and results in a noticeable increase in graininess.

Exposure

Determining the correct exposure for IR film requires experience. It is impossible to determine the precise film speed needed to set the exposure meter. This is because the ratio of IR to visible light is variable and most metering systems do not respond to IR radiation. Table 3.1 lists starting points that are useful in determining the exposure under average conditions with Kodak High Speed Infrared Film. If possible, use a hand-held meter or remove the filters from in front of through-the-lens (TTL) metering systems, as the spectral sensitivity of the meter can be affected by the filters.

Table 3.1 Meter Settings for Kodak High Speed Infrared Film

Wratten Filters	Type of Illumination ISO for Daylight*	ISO for Tungsten*
No filter	80	200
No. 25, 29, 70, and 89B	50**	125
No. 87 and 88A	25	64
No. 87C	10	25

*Film processed in Kodak D-76.
**When in doubt, use this ISO rating as a starting place.

Changes in exposure cause noticeable differences in how IR film records the image. A correct exposure delivers a scene with a wide contrast range that is easy to print. Underexposure causes the scene to lose depth and appear flat. Details in the shadow areas are lost. Overexposure produces a soft, grainy image often possessing a sense of visual weightlessness when compared to the original scene.

The amount of IR radiation will vary depending on the time of day, season, altitude, latitude, and distance of the camera from the subject. As a general rule, the lower the sun is on the horizon, the greater the amount of IR light. Faraway scenes such as a landscape often require less exposure than a close-up such as a portrait. This is due to the increased amount of IR radiation that is reflected and scattered by the atmosphere over greater distances. Since variations are likely and unpredictable, it is initially advisable to bracket exposures by at least two f-stops in each direction to ensure the desired aesthetic and technical results with IR film.

Processing

Handle IR film with care, as it seems to be more prone to damage from handling than conventional film. Handle IR film only by its edges when loading it onto a processing reel, as it has a remarkable ability to capture and incorporate fingerprints into the processed image.

Process the film in closed stainless steel tanks with stainless steel lids. Some plastic tanks can leak IR radiation and fog the film. Test them to be safe.

Table 3.2 lists suggested beginning processing times for the most commonly used developers with Kodak IR film. D-76 pro-

duces a tonal range similar to that of a panchromatic film. D-19 greatly increases contrast and graininess. After development, follow standard processing procedures. Do not hesitate to modify these recommendations.

Flash

IR film can be used with an electronic flash in a variety of ways, including the following:

- Use a Wratten No. 25 filter and normal flash methods.

- Cover the flash tube with Wratten No. 87 gel. This will make the flash almost invisible to the human eye, enabling the photographer to use a flash without people being aware of it.

- Get a special IR flash unit designed to emit light at the wavelengths to which IR film is most sensitive. Some flash units have detachable heads that can be replaced with the infrared type.

Getting Experience

Obtain three rolls of IR film. Try photographing a number of different subjects —people, buildings, plant life, and landscapes—at different distances and at different times of the day. Bracket your exposures. Process one roll in D-76 and another roll in D-19. Keep a record of what you do. Make contact sheets of each roll. Now take the third roll and apply what you have learned.

EXTENDED RED SENSITIVITY FILM: ILFORD SFX 200

Ilford's SFX 200 is not a true black-and-white infrared film, but can give similar effects. The emulsion of this panchromatic black-and-white film is sensitive beyond the visible spectrum into the infrared (about 740 nm) as opposed to a true IR film, which goes farther (about 900 nm). SFX has a useful speed rating of 200 ISO and is available in 35 mm and 120 mm formats and can be processed in a wide range of conventional developers.

Table 3.2 Development Times for Kodak High Speed Infrared Film

Developer	65°F (18°C)	68°F (20°C)	70°F (21°C)	72°F (22°C)	75°F (24°C)
D-76 (for pictorial effect)	13	11	10	9½	8
HC-110 (Dilution B)	7	6	6	5½	5
D-19 (for high-contrast effect)	7	6	5	5	4

Development time in minutes for small tanks. Initial constant 30-second agitation; 5-second agitation every 30 seconds thereafter.

Filters

With a Wratten 25 (red) or 89B (very deep red) filter you can get image effects similar to IR film. The extended red sensitization allows the film to record the infrared fluorescence of chlorophyll, the effect that turns foliage bright white and darkens skies. With these filters the film relies on the extended red sensitivity for exposure, so testing and experience are helpful.

Focusing

No focusing correction is needed as the film is not sensitive much beyond the visible spectrum and therefore does not record the wavelengths that are out of the designed operating range of the lens. As a result, Ilford SFX generally produces sharper images, with less flare, than IR film. The film also does not need to be loaded in complete darkness, although it is still recommended.

Additional Information

IR film is also available in color stock. For further information on IR film, see *Applied Infrared Photography*, Kodak Publication No. M-28. Konica also makes an IR film in 120-roll size that is slower than Kodak IR film. You may have to order the Konica film from a large photographic supplier.

KODAK RECORDING FILM

Kodak Recording Film is a very fast panchromatic stock with extended red sensitivity. It was designed for low-level light situations such as indoor sports, press work, police and surveillance photography, or any time when a flash cannot be used. Until recently, this film was one of the fastest black-and-white film stocks available. Today there are films that are faster, produce less grain, and deliver a wider tonal range. Why would a photographer still want to try Recording Film? If the aesthetic interpretation of the subject calls for visibly heightened grain, this film can produce this effect in either a close-to-normal or high-contrast tonal range.

Table 3.3 Development Times for Ilford SFX Film (Meter Setting ISO/200)

Developer	65°F (18°C)	68°F (20°C)	70°F (21°C)	72°F (22°C)	75°F (24°C)
D-76 or ID-11	11½	10	9	8	7
T-MAX 1:4	9	8½	7¾	7	6
ILFOTEC HC (1:15)	5½	5	4½	4	3¼
HC-110 (Dil. B)	10	9	8	7¼	6¼

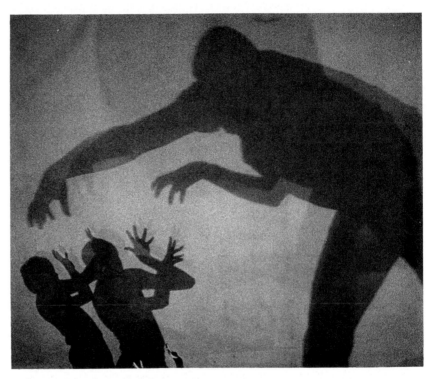

Figure 3.2 Kodak Recording Film is useful for producing much larger than normal grain size. While doing an album cover, McJunkin observed band members playing with their shadows cast by his lighting equipment. He quickly made this shot, which was used for the back cover of the album.

© James McJunkin. *Shadow Play*, 1985. Gelatin silver print. 11 × 14 inches.

The film is available in 36-exposure cassettes and 125-foot rolls.

Handling and Storage

Due to Recording Film's sensitivity to light, it is advisable to load it in total darkness or in very subdued light. A changing bag can be used for fieldwork. Keep this film refrigerated before and after exposure.

Exposure

Kodak Recording Film should be tested under typical working conditions. It has a

useful speed rating of 1,000 to 4,000 ISO. The film's rating will determine its development time. For general pictorial work, begin with a speed of 1,000 and bracket, in one-half f-stops, two full f-stops in the minus direction (underexpose). This will provide exposures at 1,000; 1,500; 2,000; 3,000; and 4,000. Based on this visual test, select the exposure that best represents the subject. Exposures need to be calculated with care, as this film does not have much leeway for error. Continue to bracket and analyze the results until confidence and experience are gained.

To use Recording Film in conventional lighting situations, it is helpful to have a camera with high-speed shutter capabilities. The shutter speed should at least be able to equal the film's speed rating. If it is not possible to use such a camera, neutral density (ND) filters can be used to reduce the amount of light reaching the film.

Processing

Table 3.4 suggests film speeds, developer types, and development times for Kodak Recording Film. You will probably have to modify these for individual situations. Use only fresh developer and an acid stop bath to reduce the chance of dichroic fog that is produced when excess silver is deposited on an already developed portion of the image. It causes interference between the wavelengths of transmitted and reflected light. While this deposit is still wet, you can try to wipe it off the negative with a lint-free tissue like Photo-Wipe. Once dry it can be difficult to remove. A very brief treatment with Farmer's Reducer also might remove the fog (see Farmer's Reducer in Chapter 4).

Recording Film can be processed in a high-contrast developer such as D-19 to yield a much grainier image with a marked increase in contrast. D-19 does not give the film as much speed as DK-50. The film speed tends to be about one f-stop less than your established norm. Dektol is a paper developer, but can be used to produce a much coarser grain than normal and an increase in contrast, though not as much as D-19. Table 3.5 provides a starting point for these proce-

Table 3.4 Developing Kodak Recording Film for Pictorial Results

Speed	Developer	Time (Minutes)*
1,000	DK-50	7
1,000	T-MAX (1:5)	12
1,500	DK-50	7½
2,000	DK-50	8
3,000	DK-50	8½
4,000	DK-50	9

*Time based on a temperature of 68°F (20°C).

Table 3.5 High-Contrast Processing of Kodak Recording Film

ISO	Developer*	Time (Minutes)**
500	DK-19	8
1,000	Dektol (1:1)***	5

*Follow standard agitation patterns.
**Time based on a temperature of 68°F (20°C).
***Dektol must be fresh.

dures. After development is complete, follow standard film-processing procedures.

Additional Information

See Recording Film 2475 (ESTAR-MI Base), Kodak Publication No. G-160.

ADDITIONAL METHODS TO HEIGHTEN GRAIN AND CONTRAST

Kodak TRI-X in Dektol

Generally, the faster the film, the more grain it will produce. Using a conventional, moderately fast film such as Kodak TRI-X, you can increase the amount of grain by altering the standard processing method. Developing TRI-X in Dektol produces much coarser grain than normal, with an increase in contrast. This combination works well in both flat and average contrast situations, but there is a noticeable reduction in the tonal range.

Exposure
Rate TRI-X at 1,600 for daylight and 800 for tungsten. Bracket your exposures—one f-stop under and two f-stops over. Developing TRI-X in Dektol reduces the film's exposure latitude, but this method allows a wider margin for exposure error than developing Kodak Recording Film in DK-50.

Table 3.6 Development Times for Kodak TRI-X
 in Fresh Dektol*

Temperature	Time (Minutes)
68°F (20°C)	4
72°F (22°C)	3

*Use continuous agitation for the first 15 seconds and
 then agitate for 5 seconds every 15 seconds to avoid
 potential streaking, which may be caused by the high
 activity and strength of the developer.

Development

Table 3.6 gives a starting point for develop-
ment. After development is completed, con-
tinue to process normally.

Kodak TRI-X and Sodium Carbonate

Another way to increase the grain pattern in
films like TRI-X is to use sodium carbonate.
Expose the film normally, then soak the film
in a 10 percent solution of sodium carbonate
for two to five minutes before putting it in its
normal development. The amount of soaking
time determines the increase in the grain
pattern. The sodium carbonate is a moderate
alkali that increases the pH of the film,
causing the action of the developer to accel-
erate. If the film carbonic absorbs too much
sodium carbonate, gas bubbles can form in
the emulsion when an acid stop bath is used.
These gas bubbles will create pinholes in the
emulsion; for this reason it is advisable
to avoid using an acid stop bath with this
procedure.

KODAK TECHNICAL PAN
ROLL FILMS

When you need a film to deliver extremely
fine grain and high resolution, Kodak Tech-
nical Pan Films (2415 and 6415) are the
answer. Technical Pan is a high-contrast
scientific film with applications in photomi-
crography, astrophotography, laser record-
ing, slide making, and copying procedures.
By using a low-contrast compensating devel-
oper, you can produce incredibly sharp
normal-contrast pictorial images. An 8 × 10
inch enlargement from a 35 mm Technical
Pan (2415) negative is difficult to distinguish
from the same scene photographed on a tra-
ditional 4 × 5 inch negative.

Figure 3.3 "The act of remembering combines fact and fiction. These
pictures utilize diverse materials to simulate how the mind intermingles
and blurs the boundaries of reality. They fabricate depictions that reflect
the authenticity of the original memory. This visual strategy allows
events and thoughts to be rearranged out of their original context and
progression." To achieve these ends, the original scene was photographed
with TRI-X and a red filter and developed in Dektol for four minutes to
heighten the contrast. With the enlarger light on and a red filter in place
under the enlarging lens, square masks were overlaid on a grade #4
photographic paper. The enlarger light was then turned off, the red filter
removed, and the exposure was made. During the enlarging exposure the
image was painted with light using fiber optics and small flashlights.
Light painting also continued while the print was in the developer to
achieve different tonal effects (see Chapter 11).

© Robert Hirsch. *Untitled*, from the series *Remembering and Forgetting*,
1983. Toned gelatin silver print. 16 × 20 inches. Courtesy of the Stefan
Stux Gallery, New York, NY.

Pictorial Procedures

Kodak Technical Pan Film is a high-contrast
line film that can be used for continuous
tone imaging. It is necessary to choose the
correct combination of film and developer to
produce pictorial results.

Exposure

For pictorial photography, begin with an ISO
of 25 and bracket, in either one-third or one-
half f-stops, one f-stop in each direction to
determine which film speed works best in
your situation. Normal seems to be between
ISO 25 and 32. Determining the proper expo-
sure is important because Technical Pan film
does not have much exposure latitude. Keep
accurate exposure notes so that you will not

have to bracket under similar conditions in the future.

Development

Technidol Liquid must be used within one week after it is prepared. It may be reused one time by increasing the suggested development time by one minute. Carefully follow the mixing and storage instructions that come with each developer. The use of distilled water for mixing this developer is recommended.

Processing

Table 3.7 lists suggested development times for 35 mm Technical Pan Film using Technidol. The big problem in working with Technical Pan Film is the failure to follow the special agitation pattern that the developer requires. Technical Pan is subject to nonuniform processing effects that include streaking and variations in density, especially near the film edges, when proper agitation procedures are not carried out. Difficulties can be avoided by following these steps:

1. Pour the mixed solution of Technidol Liquid into the empty processing tank.

2. In total darkness, quickly and smoothly drop the loaded reel of Technical Pan Film directly into the tank. Do not pour the developer onto dry film through the light trap in the top of the tank. Do not use a presoak. Both of these procedures may result in nonuniform processing effects.

3. Secure the tank lid and gently tap the bottom of the tank on the work surface to dislodge any air bubbles from the film.

4. Immediately agitate the tank by vigorously shaking it with an up-and-down motion about 10 to 12 times for about 2 seconds. Do not rotate the tank.

5. Let the tank sit for the remainder of the first 30 seconds.

Table 3.7 Development Times for 35 mm and 120 Film Rated at ISO 25 in Technidol Liquid*

Temperature	Time (Minutes)
68°F (20°C)	9
77°F (25°C)	7½
86°F (30°C)	6½

*Special agitation techniques are required for Technidol Liquid. This developer may be reused one time by increasing the development time by one minute during the second processing procedure. Store used developer in an airtight opaque container and use within one week.

6. Repeat this agitation pattern every 30 seconds for the rest of the development cycle.

After development is complete, process the film as usual, keeping the temperature of the remaining steps within 3°F of the development temperature and the temperature of the wash within 5°F.

Technical Pan Film and Landscapes

This film can be very useful in landscape photography. It allows the photographer to work with a smaller format camera, rather than a view camera, under a variety of working situations. The extended red sensitivity has a haze-cutting effect that makes distant objects appear sharper.

Technical Pan Film and Portraits

Due to Technical Pan Film's sharpness, some people may find it unsuitable for portrait work, as defects in the sitter's face are recorded in great detail. Others say that Technical Pan Film's extended red sensitivity, which allows flesh tones and areas of red to appear lighter than they would with conventional black-and-white film, makes up for this characteristic. Shooting Technical Pan Film in sunlight (where red light is in abundance) will sometimes conceal slight blemishes and add a luminous quality to the skin.

If accurate conventional panchromatic tones are required, the red sensitivity of the film may be corrected by using color com-

pensating (CC) filters. Begin correction with either a CC40 cyan or CC50 cyan and remember that the filter factor of these (CC) filters requires an increase in exposure of one to two f-stops. Technical Pan Film can also reveal minor faults such as camera movement, slight errors in focusing, and lens distortion that may not be visible with traditional black-and-white films.

Differences in Printing

Properly exposed and processed Technical Pan Film may appear to be thinner than what you are accustomed to seeing. Technical Pan Film has a neutral density base that is one-third to one-half thinner than those of conventional 35 mm films. Take this into consideration when evaluating your negatives. Make certain the film is properly seated and flat in the negative carrier, as the thinness of the film's base results in a tendency to curl.

Due to its extremely fine grain, you may have trouble focusing the negative with a grain focuser. If so, switch to a focusing magnifier that simply magnifies the image.

Expose Technical Pan to a variety of different subjects to see what it will deliver. Try developing it in different types of developer and compare the results.

Additional Information

For detailed information on all the applications of Technical Pan Film, read *Kodak Technical Pan Films*, Kodak Publication No. P-255.

ILFORD PAN F PLUS ULTRA-FINE GRAIN B/W FILM

Ilford PAN F PLUS is an extremely fine-grain film that can be used to produce mural size enlargements with minimal grain. With an effective ISO of 50, the film is available in 35 mm and 120-roll sizes and can be developed using standard film-processing techniques. The film has a relatively good exposure latitude but does not have the exposure latitude of higher-speed films.

Table 3.8 Developing Technical Pan Film for Continuous Tone in Different Developers

Contrast	Developer	ISO	Time (Minutes)
High	D-76 or ID-11	50	6
High	D-76 or ID-11	125	12
High	HC-110 (Dil. B)	100	6
Normal	HC-110 (Dil. F)	50	9
Normal	Rodinal (1 + 150)	25–64	7

Table 3.9 Effects of Different Ilford Developers Used with PAN F PLUS Rated at 25

Results	Developer	65°F (18°C)	68°F (20°C)	70°F (21°C)
Normal	ID 11 (stock)	7½	6½	6
Fine grain	Perceptol (stock)	10½	9	8
Maximum sharpness	ID-11 (1:3)	16	14	12½

Processing

Ilford PAN F PLUS is a moderate-contrast film and can be processed with a variety of different developers to achieve pictorial results. Different developers can be used to adjust the film to produce finer grain or maximum sharpness (greater contrast).

KODAK PROFESSIONAL B/W DUPLICATING FILM SO-132

When you need to make black-and-white copy negatives or positives, Kodak Professional B/W Duplicating Film SO-132 (Dupe Film) is a simple solution. Dupe Film is a direct positive orthochromatic (not sensitive to red light) film designed for this purpose. It provides for one-step duplication from black-and-white continuous-tone negatives or positives by contact printing or enlarging. It can deliver duplicates, also known as dupes or second originals, with a quality and sharpness comparable to those of the original. The dupes are formed with a single exposure and with conventional development. Dupe Film is available in 4 × 5 inch and 8 × 10 inch sheets.

Applications

Dupe Film allows you to make duplicates of any size from a small-format camera, such as a 35 mm, up to 8 × 10 inch. These dupes can be used to make contact prints or enlargements in a number of the printing processes discussed later in this book. Other applications include copying negatives from glass plates or from nonsafety stock, such as a nitrate base, in order to preserve them. Dupe Film enables you to recycle or give new purpose and meaning to old negatives by incorporating them into your present working scheme. Dupes also allow you to work within any process or to alter the negative without the worry of damaging the original.

Handling

This orthochromatic film can be handled under a 1A safelight filter with a 15-watt bulb at a distance of at least four feet from the film. This allows you to develop Dupe Film by visual inspection.

Speed

Dupe Film does not conform to the ISO testing procedures and has no assigned film speed rating. Exposure must be determined by testing.

Exposure

Dupe Film can be exposed with any conventional tungsten, fluorescent, or tungsten-halogen light source. An enlarger is an ideal source of exposure. This film's lack of an ISO rating makes visual testing a necessity. Dupe Film behaves differently than conventional negative films when exposed. It is preexposed in manufacturing, so the density of the final image is inversely proportional to the length of exposure. This means it behaves like transparency film in that the longer the film is exposed, the lighter the resulting image will be. To produce more density with Dupe Film, give it less exposure. To make it lighter, give it more exposure.

Thinking in Reverse

Remember to think in reverse from your normal working procedures. A 10-second exposure will produce more density than a 20-second exposure. On a test strip, the lightest area has received the greatest amount of exposure and the darkest area the least amount of exposure. Burning will produce less density, and dodging will produce greater density. The other principles of development remain the same: the longer the development, the greater the density and contrast. A reduction in development time will decrease the contrast and density.

Determining the Emulsion Side of the Film

Many people who do not work regularly with sheet film have a problem determining the emulsion side. To make this determination, hold the film vertically with the coded notches at the top right or bottom left. In either position, the emulsion will be facing toward you.

Basic Procedures to Make an Enlarged Continuous-Tone Negative

1. Set up the darkroom for normal tray processing under proper safelight conditions. Use a tray that is at least slightly larger than the film being processed.

2. Place a clean negative in the enlarger. If you plan to use the dupe negative with its emulsion side against the surface of the paper—for example, to make a nonsilver print—reverse the original negative in the carrier, or the final print will be reversed from right to left.

3. Open the enlarging lens aperture to maximum and focus the image on the easel. If the easel has not been painted black, tape a piece of black matte paper on it to reduce halation from the light reflected off the easel. Use a piece of white paper the same thickness as the film as a focusing target. After focusing, remove the white paper.

4. If you have a foot-candle meter, place the probe on the easel under the projected image and adjust the lens aperture to give a reading of three foot-candles. Make a trial test strip at that lens opening at 10, 20, 30, 40, and 50 seconds. If you do not have a foot-candle meter, stop the lens down to f-8 or f-11 and make a test strip at 10, 20, 30, 40, and 50 seconds.

You can copy an original positive the same way you produce a dupe positive.

Basic Procedures to Make a Contact Continuous-Tone Negative

You can produce contact negatives or positives using a contact frame or a clean piece of clear glass and a piece of opaque paper. Remember, the image that has been exposed emulsion to emulsion will come out reversed unless you reverse the negative before exposure.

1. Thoroughly clean all materials.
2. With a contact frame, place the negative, emulsion side down, on the glass. Cover it with a sheet of Dupe Film, emulsion side facing the nonemulsion side of the original. Attach the back of the contact frame and expose the film in the same manner as is recommended for enlarging from a negative.
3. Without a contact frame, place a piece of opaque paper, larger than the film size being used, directly under the light source. Put the Dupe Film emulsion side up on top of the paper. Put the original over the Dupe Film, with its emulsion side facing up. Place the glass over the entire sandwich and expose.

Processing

The suggested starting point for processing Dupe Film is in Dektol (diluted 1:1) at 70°F (21°C) for two minutes with continuous agitation. Development time can be extended to up to eight minutes, and the developer can be diluted up to 1:5 or even used straight. A presoak can be effective in preventing uneven development patterns at short times.

Table 3.10 Developing Kodak Professional B/W Duplicating Film at 68°F

Contrast	Developer	Time (Minutes)
High	DK-50	4–6
High	Dektol (1:1)	4–6
Normal	D-76 (1:1)	10
Normal	XTOL	5
Normal	ILFOTEC HC	6

Controlling Contrast

Dupe Film has wide exposure latitude that allows you to vary the processing time to control the contrast of the dupe. The contrast of Dupe Film can be also be manipulated to a limited extent through the use of different developers.

Enhancing Image Stability

After completing the normal processing steps, you can treat Dupe Film with Rapid Selenium Toner to increase its image-keeping properties. This treatment will protect the silver image from oxidizing gases, high temperatures, humidity, and high-intensity illumination. This process may be carried out as a direct extension of the normal processing methods or at a later time. This treatment can be carried out as follows:

1. If film is dry, presoak it in distilled water for several minutes to resoften the emulsion before beginning the treatment.
2. Put the Dupe Film in a solution of Rapid Selenium Toner diluted 1:29 (1 part toner to 29 parts water) at 70°F (21°C) for three minutes with occasional agitation. You can reuse this solution, which has a capacity of about fifteen 4 × 5 inch sheets per quart.
3. Rewash the film in running water at 65°F to 75°F (18°C to 24°C) for 20 to 30 minutes.
4. Dry and store the film.

The Rapid Selenium Toner should be used after the hypo clearing solution. The use of drying aids such as Photo-Flo is not recommended after the toning treatment. These can reduce the image stability of the toner. The toning treatment should be the last step before drying the film.

Additional Information

For more detailed information, see *Kodak Professional B/W Duplicating Film SO-132*, Kodak Publication F-11.

HIGH-CONTRAST LITHO FILMS

High-contrast litho films are orthochromatic (not sensitive to red) and can be handled under a red safelight. They are designed primarily for the production of halftones (they create a dot pattern, based on tonal graduations, that allows a photograph to be reproduced using printer's inks) and line negatives and positives for use in photomechanical reproduction. They can be used for dramatic pictorial effects because of their ability to drop out most of the midrange tonal gradations of a subject. This creates a composition that relies on graphic black-and-white shapes for visual impact.

High contrast can be produced in two general ways. First, the effect can be achieved by exposing Kodak Ektagraphic HC Slide Film directly in a 35 mm camera. Second, it may be produced later from a continuous-tone negative in the darkroom through the use of a graphic arts litho film such as Kodalith Ortho Film Type 3 in conjunction with high-contrast litho

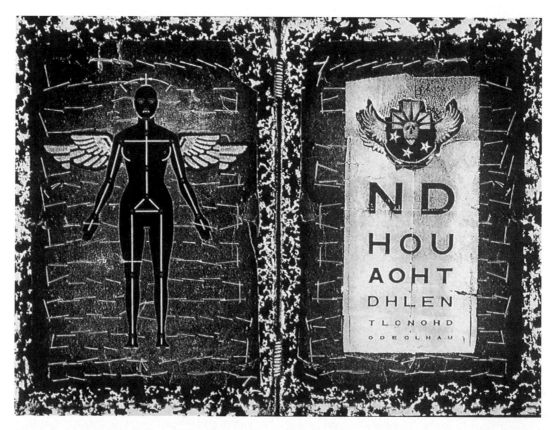

Figure 3.4 To fashion this image Seeley used an office copier as a camera. A drawing template, an eye chart, and assorted military patches were placed directly on the copier glass. The paste-up was then exposed to a large sheet of ortho litho film, which in turn was exposed to an aluminum waterless lithographic plate. After processing, the plate was rolled up in adhesive rather than ink. Carbon powder was brushed into the tacky areas, and then blown off the dry areas of the print. Seeley says that he likes "this method of printing because it creates the densest, flattest black possible. The construction of the image from copies is inexpensive and allows for a looseness of form that is not always possible in other forms of printing. I like the crude effect of the copy process and often make copies of copies to exaggerate the effect. I retouch the paper positive with fine and broad-tipped marking pens and the litho film with liquid opaque."

© J. Seeley. *Chart*, a 21 Steps Edition, 1994. Carbon dusted photographic litho. 30 × 22 inches.

developers like Kodalith Super RT. Most commonly used by the offset and screen printing industry, litho films are manufactured by a number of firms and are available in rolls and sheets. A variety of sizes and brands of litho films can be found at offset printing suppliers and through photography dealers.

Applications

Litho films offer an extensive visual array of effects that cannot be achieved with conventional films. Litho films also offer a quick and convenient method for producing many generations, in different forms, from an image on a negative or transparency. A normal negative can be used to make a high-contrast positive that can be used to form a new high-contrast negative, which in turn can be reversed back to a positive. This film

can be drawn or painted on, sandwiched together with other film images, scraped, scratched, cut up, collaged, or used directly as a final image itself. Litho film can also be presented in a light box. Small-format images can be enlarged to be contact printed in a variety of other processes.

Images from other sources also can be incorporated into the process. For instance, a magazine picture can be contact printed, ink side down, on litho film. Both sides of the image will be visible. If this is not acceptable, try one of the transfer methods discussed in Chapter 11. Litho films may be exposed directly in a 35 mm, view, or pinhole camera. Photograms can be created by placing objects on top of the film and exposing it. A bas-relief print can be made by combining a contact-size positive, slightly out of register, with the original continuous-tone negative. For instance, a high-contrast bas-relief can be produced if a

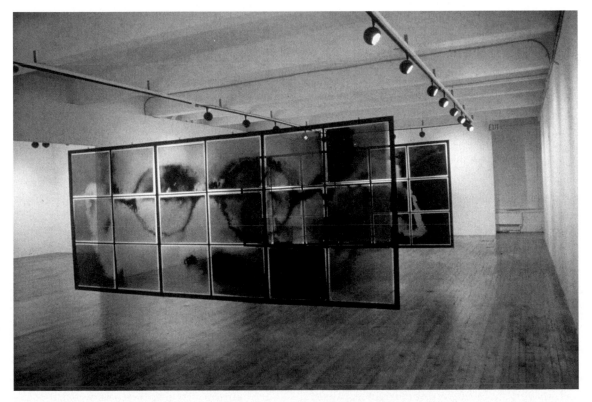

Figure 3.5 For this large-scale installation Valentino tiled his images using 20 × 24 inch litho film. "The piece examines how memory and thought combine and change one another. I printed on a transparent material so that the image in front of the viewer is altered by images on successive panels and by the passing of the audience through the installation." Using computer-generated negatives, Valentino produced continuous-tone positives by overexposing the litho film during the enlarging process and then underdeveloping in Dektol diluted at 1:6 to for two minutes.

© John Valentino. *In-visible Portraits* (installation detail), 1998. Litho film, wood, and wire. 4 × 15 feet.

litho negative and positive of the same size are sandwiched slightly out of registration. A high-contrast black-and-white positive can be used to make a high-contrast positive print. The original negative and the contact litho positive and negative can all be sandwiched together and printed. Posterizations are possible by making a series of positives and negatives to be combined and printed.

Unfortunately, some people have abused litho films' ability to transform a subject. For example, someone might try to make a boring and trite image magically daring and strong by converting it to a high-contrast print. An image that is dull to begin with will not become new and exciting by transferring it to a litho film.

Do not force the process on an image. Use only an image that will be enhanced by the process. Do feel free to experiment with this type of film, however, for it offers the thinking photographer an abundant source of possibilities.

Litho Production and Materials

One can make litho negatives and positives by contact or projection methods starting with a negative or a positive (transparency). You need these basic materials:

- An original continuous-tone negative or slide (black-and-white or color)
- A contact printing frame or clear glass
- Litho film, such as Kodalith Ortho Film Type 3
- Litho film developer, such as Kodalith Super RT
- An orthochromatic safelight filter, such as Kodak's IA (red)

The darkroom setup, with the exception of the litho developer and IA safelight, is the same as for processing a regular black-and-white print. Follow the manufacturer's instructions for mixing the litho developer. Mix all chemicals in advance and allow them to reach a processing temperature of 68°F to 72°F (20°C to 22°C). Due to its rapid oxidation, a working solution of litho developer is generally prepared by combining equal amounts of mixed stock solutions at the time of processing. Use trays that are slightly larger than the size of the film being processed. Have enough solution to cover the film completely during each step. One quart of working litho developer solution will process about fifteen 8 × 10 inch sheets before exhaustion.

Making an Enlarged Litho Positive

1. Place a clean original continuous-tone negative in the enlarger.

2. Project the image onto a clean opaque surface like a paper easel that has been painted with a black matte finish. Black paper may be attached to the easel instead. Adjust for the desired enlargement size. Focus on a piece of white paper.

3. Place the litho film on the opaque surface, emulsion side up. The emulsion side is lighter colored and more reflective than the base side. Cover it with a clean piece of glass.

4. Litho film, like any type of film, will attract dust more than photographic paper. Use air or a soft brush to clean off any dust that may be clinging to the surface of the film. The use of a static brush on unexposed litho film is not recommended as it may cause fogging.

5. Set the lens to about f-11 and make a test strip at 3-second intervals. The times should be similar to those used for making test strips with black-and-white paper of the same size.

6. Develop the film by sliding it, emulsion side up, into the developer solution. Agitate by lifting one corner of the tray slightly and setting it down. Repeat by lifting the opposite corner. Standard development time is between $2\frac{1}{4}$ and $2\frac{3}{4}$ minutes. Development time can be altered to change the contrast and tone. Development can be carried out by visual inspection. To duplicate the results, use the same developing time. Normal development is complete when the dark areas are completely opaque. Not enough development time can produce pinholes and streaks. If the image appears too quickly, reduce the exposure time. If it looks too light after two minutes, increase the time. You can reduce the contrast of

litho film by developing in Dektol 1:2 instead of litho developer.

7. After development is complete, follow normal processing procedures. Fixing time should be twice the time required for the film to clear.

8. Based on the test, determine the correct exposure and make a new high-contrast positive.

This process can be carried out by contact printing the original negative, emulsion to emulsion, with the litho film, following the procedures outlined in the section on Dupe Film.

Making a Litho Negative

To make a litho negative, take the dried positive and contact print it, emulsion to emulsion, with an unexposed piece of litho film. Follow the same processing procedures as in making a litho positive. Starting with a positive (transparency film) will enable you to make a direct litho negative, thus eliminating the need to make a litho positive. Bear in mind that litho film is orthochromatic and may not properly record the reds and oranges from the transparency.

Continuous Tones from Litho Film

You can produce a usable continuous-tone negative or positive by overexposing litho film and underdeveloping it in Dektol diluted from 1:6 to 1:15 at 68°F (20°C) for 1½ to 3 minutes. You can create an interesting visual mix by developing the positive in litho developer and the negative in Dektol. Combine the two slightly out of register for an unusual bas-relief effect.

Retouching

Litho film is highly susceptible to pinholes, which can be blocked out by opaquing the base side of the film. Opaque also conceals scratches or unwanted details. Place the litho film, emulsion side down, on a clean light table. Apply the opaque with a small, pointed sable brush (size 0 to 000). Opaque is water soluble, so mistakes can be corrected with a damp Photo-Wipe.

OTHER GRAPHIC ARTS FILMS

Ilford Ortho +

Orthochromatic films were once widely used to produce dramatic portraits. By eliminating the red sensitivity of the film, flesh tones take on a rich gray hue and lips become very dark. Once a number of continuous-tone orthochromatic films were on the market; today only Ilford Ortho + remains. An effect similar to Ilford Ortho + can be achieved by using panchromatic film with an 80A filter.

Kodak Ektagraphic HC Slide Film

This film has the same base and emulsion as Kodak Ortho Film 6556 Type 3, but comes in 36-exposure 135 magazines. Its applications and processing methods are the same as those for Kodalith Ortho Film Type 3. This film has a suggested ISO of only 8, so additional lights may be needed to make an exposure. Shoot a test roll and bracket to determine your proper film speed. Starting development time is 2¾ minutes at 68°F (20°C) in Kodalith Developer. Slight changes in exposure and developing time will greatly affect contrast. This film may be inspected during development with a Kodak IA safelight filter. Ektagraphic HC can also be developed in Kodak D-11 with a starting ISO of 25 for 2½ minutes at 68°F (20°C). Bracketing is also highly recommended.

Additional Information

Hirsch, Robert. *Exploring Color Photography*. Third Ed. New York: McGraw-Hill Publishers, 1997.
Stone, Jim. *Darkroom Dynamics: A Guide to Creative Darkroom Techniques*. Boston, MA: Focal Press, 1985.

HIGH-SPEED FILMS: KODAK T-MAX P3200 AND ILFORD DELTA 3200 PROFESSIONAL

When extremely fast film speeds are required without sacrificing image quality and tonality, Kodak T-MAX P3200 and Ilford Delta 3200 are films to consider. Both 3200 films are multispeed black-and-white

panchromatic negative films available in 35 mm cassettes and in sheet sizes up to 11 × 14 inches. Kodak T-MAX P3200 is capable of delivering high to ultrahigh film speeds with a fine grain and broad tonal range, good shadow detail, and open highlights. It is the fastest of any of the films in the T-MAX group. Ilford's Delta 3200's grain structure is slightly different than Kodak's T-MAX P3200, with the grains being slightly smaller but with a greater overall surface area. The result is a film that shows more grain but is both faster and slightly sharper than T-MAX P3200.

The fast speeds of T-MAX P3200 are possible through the T-grain technology, which improves the silver halide sensitivity by the use of tabular (T) silver grains. These grains provide a larger surface, enabling the emulsion to capture more light than was possible using the conventional pebble-shaped silver crystals. Delta 3200 Professional is based on Ilford's proprietary core-shell crystal technology, a complex four-part emulsion package. This emulsion gives the film heightened tonal rendition and wide exposure flexibility. The technology of these two films allows exposure at very high ISO ratings while still retaining a fine grain structure and a great amount of sharpness that permits the retention of detail in large-scale enlargements. The larger grain size does cause higher contrast but offers good tonal separation, wide exposure latitude, and minimal reciprocity failure.

Applications

Both Kodak's T-MAX P3200 and Ilford Delta 3200 are designed for:

- Low-light situations in which it is not possible to use a flash or additional sources of illumination
- When subjects require a high shutter speed while retaining good depth of field
- When holding long telephoto lenses
- For nighttime and indoor events
- For surveillance applications requiring ultrahigh-speed films

These remarkable films enable the photographer to make images in previously impossible situations without the disadvantages of push processing conventional film.

Handling and Storage

The high-speed emulsions of these films make them extremely sensitive to environmental radiation which can fog and degrade the latent photographic images. This increased sensitivity gives the films a shorter life span than conventional film, and consequently they should be exposed and processed promptly. Both Kodak's T-MAX P3200 and Ilford Delta 3200 should always be hand-inspected rather than X-rayed at airport security stations. To ensure quality, refrigerate the films when the temperature is above 75°F (24°C).

Exposure

As T-MAX P3200 and Delta 3200 are multi-speed films, their rating depends on their application. T-MAX P3200 has a nominal speed of 1,000 when processed in Kodak T-MAX Developer and 800 with other black-and-white developers. Its amazing latitude permits exposure at 1,600, which results in high-quality negatives with no apparent change in grain size and only a slight loss of detail in the shadow areas. P3200 film can easily be exposed at speeds of 3,200 or 6,400 by increasing the development time. This will produce a slight increase in contrast and grain size, as well as a loss of detail in shadow areas. Testing is necessary to determine the correct speed for your equipment and circumstances. For general high-speed applications, begin rating the film at 3,200 and bracket two f-stops over (1,600 and 800) and four f-stops under (6,400; 12,500; 25,000; and 50,000). There is a big increase in contrast and graininess, with a distinct loss of shadow detail at speeds above 6,400, but image sharpness remains surprisingly good.

Some older cameras have ISO settings that go up to only 1,600. If your camera does not have ISO settings above 1,600 but has an exposure compensation dial, set it at minus 1 to get a speed of 3,200 or minus 2 to achieve an ISO of 6,400. With both long and short exposures, T-MAX F3200 requires less

compensation than traditional films. There is no correction at speeds between 1 and 1/10,000 second. At 10 seconds, the lens aperture needs to be opened an additional two-thirds f-stop, or the time must be increased by 5 seconds to provide a total exposure of 15 seconds.

Darkroom Handling

T-MAX P3200 and Delta 3200 must be handled in absolute darkness and cannot be developed by inspection. Timers and watches with fluorescent faces should be turned away from the unprocessed film. Even the afterglow of certain white lights (incandescent bulbs) can fog these films. Double-check to be sure the darkroom is totally dark before handling unprocessed film.

T-MAX P3200 Development

T-MAX P3200 was designed to be processed in T-MAX Developer or T-MAX RS Developer and Replenisher to provide improved shadow detail in both normally and push-processed T-MAX films. Both T-MAX developers are all-liquid formulas that can be used to process and push process other black-and-white films that are not in the T-MAX group. T-MAX films also may be processed in other developers.

Processing

Table 3.11 lists starting points for developing T-MAX P3200 to produce a normal contrast negative for use in printing with a diffusion enlarger. With a condenser enlarger, a lower contrast negative may be desirable. This is done by using a development time for a film speed rating of one f-stop lower than the speed used to expose the film. For instance, if the film was exposed at 6,400, develop it at the time indicated for 3,200. Drop the loaded reel of T-MAX P3200 directly into the developer and put the lid on the tank. Tap the tank on a flat surface at a 30-degree angle to dislodge any air bubbles. Give an initial agitation of five to seven inversions within five seconds by extending your arm and twisting your wrist

Table 3.11 Development Times* for T-MAX P3200 Film

Developer	Film Speed	70°F (21°C)	75°F (24°C)	80°F (27°C)	85°F (29°C)
T-MAX	400	7	6	5	4
	800	7½	6½	5½	4½
	1,600	8	7	6	5
	3,200	11	9½	8	6½
	6,400	13	11	9½	8
	12,500	15½	12½	10½	9
	25,000	17½	14	12	10
	50,000	20	NR	NR	NR
T-MAX RS	400	7	6	5½	5
	800	8½	6½	6	5½
	1,600	9½	7½	7	6
	3,200	12	10	9	8
	6,400	14	11	10	9
	12,000	16	12	11	10
	25,000	NR	14	13	11
D-76	400	9½	7½	6	4½
	800	10	8	6½	5
	1,600	10½	8½	7	5½
	3,200	13½	11	8½	7½
	6,400	16	12½	10½	9
HC-110 (Dilution B)	400	6½	5	4½	3½
	800	7	5½	4¾	4
	1,600	7½	6	5	4½
	3,200	10	7½	7	5¾
	6,400	12	9½	8	6¾
XTOL	400	7½	6¾	6	5¼
	800	8¼	7½	6¾	5¾
	1,600	9¼	8¼	7½	6¾
	3,200	11	10	9	7½
	6,400	12½	11¼	10	8¾
	12,500	15¼	13¾	12½	10½
	25,000	18½	16¾	15	12¾

*All development times are in minutes.
NR = not recommended.

180 degrees to the right and then to the left. Repeat this procedure at 30-second intervals for the remaining development time.

Additional Processing Differences

After development is complete, process T-MAX P3200 in the normal fashion with the exception of the fixing step. P3200 requires careful fixing using a rapid fixer for three to five minutes with vigorous agitation. This film will exhaust the fixer more quickly than conventional films. If the film shows a pinkish magenta stain or is blotched or streaked with an intense purple, the fixing time is too short or the fix is nearing exhaustion. These problems can be corrected by

refixing the film in fresh fixer. If the stain is still present after proper fixing, it is often eliminated through the use of a hypo clearing agent. A slight stain, caused by the increased amount of residual sensitizing dyes used to make the film panchromatic, should not affect the film or its printing characteristics even with variable-contrast paper. This slight stain tends to fade with time and exposure to light.

Table 3.12 Development Times* for Ilford Delta 3200 Film

Developer	Film Speed	68°F (21°C)	70°F (24°C)	75°F (27°C)	80°F (29°C)
ILFOTEC DD-X (1:4)	400	6	5½	4	
	800	7			
	1,600	8			
	3,200	9½			
	6,400	12½			
	12,500	17			
T-MAX (1:4)	400	5½	5	3½	NR
	800	6½	6	4½	3½
	1,600	7½	6¾	5¼	4
	3,200	8½	7¾	6	4¾
	6,400	11	10	7½	6
	12,500	14	12½	9¼	7¾
T-MAX RS	400	NR	5½	4	NR
	800	NR	6	4½	NR
	1,600	NR	6½	5	3¾
	3,200	NR	8½	6½	5¼
	6,400	NR	10	8½	6¾
	12,500	NR	13½	10½	8
D-76/ID 11	400	7	6½	5	3¾
	800	8	7¼	5½	4¼
	1,600	9½	8½	6½	5¼
	3,200	10½	9½	7¼	5¾
	6,400	13	11¾	9	7
	12,500	17	15¼	11¾	9
HC-110 (Dilution A)	400	NR	NR	NR	NR
	800	NR	NR	NR	NR
	1,600	5	4½	NR	NR
	3,200	8	7¼	5½	4¼
	6,400	13	11¾	9	7
HC 110 (Dilution B)	400	6	5½	4	NR
	800	7½	6¾	5¼	4
	1,600	9	8	6¼	5
	3,200	14½	13	10	7¾
	6,400	NR	NR	NR	NR
XTOL	400	5	4½	NR	NR
	800	6	5½	4	NR
	1,600	6½	6	4½	3½
	3,200	7½	6¾	5¼	4
	6,400	10	9	7	5½
	12,500	12½	11¼	8¾	7

*All development times are in minutes.
NR = not recommended.

Ilford Delta 3200 Development

Delta 3200 Professional does not require any special development steps. The film can be processed in all types of processing equipment including spiral tanks, rotary processors, dishes or trays, deep tanks, and automatic processors. Standard capacity figures and replenishment rates can be maintained. Like P3200, Delta 3200 requires careful fixing using a rapid fixer (1:4) without a hardener for three to five minutes at 68°F/20°C with vigorous agitation. This film will also exhaust the fixer more quickly than conventional films. Ilford recommends a hardener only when processing at high temperatures (above 86°F/30°C).

Some General Characteristics of T-MAX P3200 and Ilford Delta 3200 Films Rated at Different Speeds

400: This produces an extremely solid, not quite bulletproof (opaque) negative that results in a mushy print lacking in sharpness and having blocked highlights. It is not recommended for general pictorial use.

800: One f-stop faster delivers much better results but still lacks good tonal range and sharpness.

1,600: This speed produces gorgeous quality. Shadows are fully separated and highlights are open and unblocked. Tonal range is excellent, with grain and sharpness compatible with conventional 400 films. A slight increase in contrast results in a snappy print and is useful with low-contrast subjects.

3,200: The negative has a full tonal range with a tiny loss of detail in the shadow areas. Grain and sharpness are outstanding. The results at this speed were unattainable until recently. The two 3,200-speed films dispense with the technique of "cooking" film in exotic developers, which often produces chalky and extremely grainy images at this speed.

6,400: This speed still produces a highly acceptable negative, but the loss of shadow detail is more apparent. Contrast and grain

size start to pick up, but highlight retention and tonal range remain good.

12,500: Tonal range is compressed, contrast starts to become excessive, and granularity is worse. Pictorial print quality begins to degrade, but good press prints can be made.

25,000: This is about the outer limit for a printable negative. Highlights begin to become chalky, and shadows lack detail. Subtleties disappear as the tonal range becomes greatly compressed. Image quality remains sharp but grainy. Prints are still reproducible for newspapers and some magazines.

50,000: This astronomical speed pushes the film's capability to the edge. Try it when a picture is a "must" and traditional print quality is not a major factor. Contrast and grain are way up, but the image is still sharp. Shadow detail is almost nonexistent. Printing requires expert care and patience, with dodging needed to make shadow areas recognizable.

PAPER NEGATIVES AND POSITIVES

Today most photographers use clear-base flexible film to record images in the camera. This was not always the case. Photographic pioneer William Henry Fox Talbot invented a process called photogenic drawing. This process used paper sensitized with salt and silver nitrate to make photograms and contact-print copies of drawings and objects. By 1835, Talbot was using this paper process to record images in a camera obscura. The process relied on a printing-out exposure (light made the complete image) for camera negatives and prints. In 1841, Talbot patented an improved process called the calotype. It was much faster because the light was used to create a latent image that was completed during the development process. This process has served as the model for all current analog negative/positive imagemaking systems.

Compared with clear film negatives, paper negatives are less sensitive to light, do not record as much of the visible spectrum, record less detail, and have a reduced tonal range and higher contrast. Since the final image is printed through the fibers of the paper, the completed photograph has a soft, highly textured, impressionistic appearance.

Applications

Any paper may be treated with a light-sensitive emulsion and exposed (see Chapter 6). Regular photographic paper is usually used. Paper can be exposed directly in a view or pinhole camera. The processed paper negative can be contact printed with an unexposed piece of photographic paper to make a positive print. An image from a normal negative can be used by enlarging it on a piece of photographic paper at the desired size. This paper positive is contact printed onto another piece of photographic paper to form a paper negative. The paper negative is now contact printed onto another

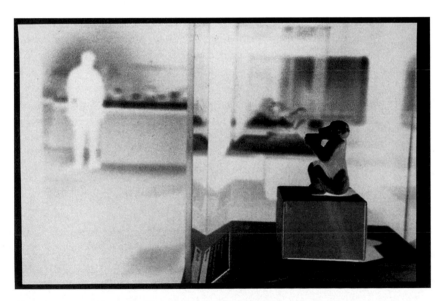

Figure 3.6 *Site/Unseen* is about unseen people in public places. In this series the unseen people are the guards at a major art museum. Pinkel says, "I was struck by the contrast between the trappings of wealth and class at the museum and the realities for the guards working there. The guards' employment had changed from being directly employed by the museum to being hired by a private company through which the museum then contracts for guard services. In the process the guards lost their union representation and other benefits. This story is an excellent example of the effect of contract employment on the working conditions for the poorest paid sector of the culture." Since the museum did not allow flash, Pinkel shot with ISO 3200 film, which resulted in very grainy images. Using her computer she converted her images into negative prints so that the guards became "ghost-like figures symbolizing their transparency in the workplace."

© Sheila Pinkel. *Site Unseen/Museum Guards: Monkey*, 1998. Ink jet print. 11 × 17 inches.

piece of photographic paper to create the final print.

A transparency image can be used to make an enlargement on a piece of photographic paper. Since the transparency image is a positive, it can be used to produce a paper negative that is in turn used to produce a paper contact print. Images on any type of translucent surface, such as the paper used in magazines, newspapers, and posters, can be contact printed and used in this process. Paper negatives can be combined with normal negatives to make a multi-image composition. Paper negatives and positives are easy to retouch. The photographer can make additions such as clouds or remove unwanted items.

Paper Negative and Positive Process

1. Place a continuous-tone negative in the enlarger and make a print at the exact size of the final image. The print should be flatter in contrast and darker than normal, having discernible detail in both key highlight and shadow areas. Use a low-contrast single-weight paper. Variable-contrast papers are handy for this process. Avoid papers that have the manufacturer's name imprinted on the back. Resin-coated (RC) paper can be used because the plastic diffuses the trademark so it is not visible in the final print. RC paper makes good contact when two pieces are placed together for contact printing.

2. Tape the corners of the completed print, image side down, to a light table for retouching. Dark areas can be intensified by adding density on the back of the print, thereby giving the printmaker control over the shadow areas. Soft pencils, pastels, or even a ballpoint pen can be used. If retouching materials do not adhere properly, coat them with Mc-Donald's Retouching Spray.

3. Contact print the retouched print onto a piece of unexposed photographic paper to make a paper negative. Remove the enlarger's lens board to reduce exposure time. Make sure the two pieces of paper are in as close contact as possible. If you are having trouble making good contact, try soaking the paper positive and the unexposed paper in water and pressing them together with a squeegee or roller.

4. After processing and drying the paper negative, tape it, image side down, to the light table for retouching. During this stage, added density from retouching will block out and intensify the highlight areas.

5. Contact print the retouched negative onto unexposed paper. The choice of paper will determine the amount of control the printmaker has over contrast and surface texture. Coating the back of the paper negative with a thin layer of oil often increases the contact, makes the negative more transparent, and reduces exposure time.

Control of Detail and Texture

For maximum texture in the final print, expose the paper normally, emulsion side up. For minimum texture and maximum detail, briefly flash light from the enlarger through the paper's base side (emulsion side down). Turn it over (emulsion side up) and contact print it with the paper negative. For minimum detail and texture, expose the paper through its base side with no flash exposure.

Paper Negatives Using a Digital Process

Paper negatives can also be created using a digital process. Desktop printers connected to a computer are affordable, quick, and offer a variety of print attributes. Negatives from an inkjet, color, or black-and-white electrostatic printer (photocopier) can also be used as negatives (see Chapter 12). Although the quality of these desktop printers is not suitable to create a negative for enlargement printing, unique and high-quality results can be achieved through contact printing. Check with the device manufacturer for details about the weight and consistency of paper put through the printer.

REVERSING BLACK-AND-WHITE FILM

Lantern Slides

Today most photographers present prints as their finished product. This has not always been the case. At the turn of the nineteenth century, lantern slides were most popular in photographic clubs and salons. A lantern slide is a positive transparency, named after the nineteenth-century projectors called magic lanterns, made or mounted on glass for projection. With slides, what you see is what you get. There is no second step needed to arrive at the final image as in the negative/positive process. This enables the slide to depict a greater amount of detail and a wider range of tones than can be expressed by a traditional print. This is because film (the lantern slide) has a wider tonal range than paper. Lantern slides were fragile, heavy, thick, and larger than their 35 mm heirs. The glass ensured image flatness during projection, giving the scene incredible sharpness. The bigger formats added to the retention of detail and the luminosity of the original subject.

Current Uses for Black-and-White Slides

A modern photographer could still choose to work with black-and-white positives when making photographs expressly for the following purposes: reproduction in the print media, when images are needed for a slide presentation, for copying any continuous tone material, when a complete darkroom with a printing facility is not available, or simply for the sheer beauty the slide image is capable of bestowing on the subject.

Kodak Direct Positive Film Developing Outfit

The Kodak Direct Positive Film Developing Outfit is an all-liquid kit that delivers black-and-white slides from Kodak T-MAX 100 Professional Film and Technical Pan Film. With T-MAX 100, this outfit provides continuous-tone slides of the original subject.

This film is recommended for making copy negatives from black-and-white or color negatives, for duplicating black-and-white slides, for making black-and-white slides from color slides, or for general pictorial purposes. When used with Technical Pan Film, the kit can be used to make high-contrast title slides or slides of computer-generated graphs and line art. Kodak no longer makes Direct Positive Panchromatic Film 5246, which was designed to make black-and-white transparencies.

Exposure

For normal contrast use, such as producing slides from continuous-tone photographs or artwork, and for general pictorial work, set the ISO for T-MAX 100 at 50. For high-contrast use, such as making slides from line art, set the ISO for Technical Pan Film at 64. For initial use, make a series of exposures in which you bracket, in small increments of one-third f-stop, one full f-stop over and under the indicated exposure to determine the correct speed for your situation.

Processing

Film must be handled in total darkness until bleaching is completed, after which the film can be examined under a Kodak OA safelight filter. Do not use white light until the film has been fixed.

Table 3.13 lists the tank processing steps for the Direct Positive Film Developing Outfit. Read the instructions supplied with the developing kit before mixing and processing. Wash, hypo clear, final wash, Photo-Flo, and dry following normal procedures.

Contrast Control

It is not possible to alter the contrast of the final positive image to a large extent by changing the temperature or time of the first developer. An increase in time or temperature in the first developer will produce an effect similar to overexposure of slide film. There is a general loss of density, as the

Table 3.13 Tank Processing Steps for Kodak Direct Positive Film Developing Outfit at 68°F (20°C)

Step	Time (Minutes)
First developer	7*
Rinse	1/2
Bleach	1½
Rinse	1/2
Clearing bath	2
Redeveloper	7*
Rinse	1/2
Fixer**	5

*This time is for fresh solutions. For partially used solutions, you must adjust the times in both the first developer and the redeveloper, using the tables provided in the kit, to compensate for the number of rolls already processed. Using this method, each 1-quart outfit allows up to 12 rolls of 35 mm film (36 exposures), 12 rolls of 120 film, or twelve 8 × 10 inch sheets to be processed. Follow suggested agitation patterns.

**The processing outfit does not include fixer. Any rapid or regular fixer may be used.

entire image is lightened, with highlight detail becoming washed out. A decrease in the time or temperature of the first developer produces a result similar to underexposure. The overall density is increased, and the highlights begin to darken.

Contrast is controlled most effectively at the time of initial camera exposure by bracketing, in one-third f-stops, within an effective range of about one f-stop in the plus or minus direction. Slight changes in contrast can be achieved with T-MAX 100 by modifying the first developer solution. This will produce something similar to the result of printing a black-and-white negative on the next higher or lower contrast grade of paper (see outfit for details). This procedure has very little effect on the contrast of Technical Pan film.

The blacks can be intensified by combining 20 milliliters of Rapid Selenium Toner with 1 liter of hypo clear solution.

One-Step Enlarged Negatives

One-step enlarged negatives can be produced with T-MAX 100 film processed in the Kodak Direct Positive kit by following these guidelines:

1. Expose film in the same way you would to make a print. As the film is panchro-

matic it must be handled in total darkness.

2. Place the original negative, emulsion side up, in the enlarger.

3. Use a black easel surface or cover it with a piece of opaque paper to reduce fog and flare.

4. Use brief exposure times. Set the enlarging lens to f-22 or f-32 (a neutral density filter may be needed to reduce the amount of light). Set the timer for 1/2-second intervals (a digital timer is recommended for repeatable results).

5. Make a series of eight 1/2-second exposures (from 1/2 to 4 seconds).

6. Process normally following the instructions supplied with the kit.

Reversing Other Black-and-White Films

It is possible to perform reversal processing on other black-and-white films. Other reversal films and kits are available, and some conventional films also can be reversed. Check the reversal kit you are using before processing, as certain films and film sizes do not yield good results.

Additional Information

Pamphlet
Kodak T-MAX 100 Direct Positive Film Developing Outfit, Kodak Publication No. J-87.

Other Source
Photographers' Formulary, P.O. Box 950, Condon, MT 59826.

FILM FOR CLASSIC CAMERAS

Manufacturers stopped making film for most classic cameras years ago. If you would like to do more than admire these machines, you can use a black-and-white ortho copy emulsion rated at ISO 32 in many of the older cameras. This film is available in five sizes corresponding to Kodak 101, 116, 122, 124, and 616. Depending on the size, film is also available in Verichrome Pan, VPSIII, Plus-X,

STEAM TRACTOR AND OWNER : CANANDAIGUA , NEW YORK

Figure 3.7 Often working around people whom he does not know, Stone appreciates Polaroid's Positive and Negative Film. In twenty seconds, he has a small print and a negative against which he can check his expectations. The print can be shared or given away to his subject, thus bringing the subject into the process. The final image pays homage to the family album, with its handwritten titles giving the specific location and circumstance of the photograph.

© Jim Stone. *Steam Tractor and Owner, Canandaigua, NY,* 1984. Gelatin silver print. 20 × 24 inches.

TRI-X, T-MAX-100, T-MAX 400, Pro 100, or Ektachrome 100 Plus. Film sizes are 101, 103, 116, 122, 124, 127, 616, 620, and 828 on spools and 2¼ × 3¼ inches and 3¼ × 4¼ inches. Five-by-seven–inch sheets and custom film sizes under 5 × 7 inches can be cut to order. For more information, contact Film for Classics, P.O. Box 486, Honeoye Falls, NY 14472, (716) 624-4945.

PROCESSING BLACK-AND-WHITE FILM FOR PERMANENCE

Most serious photographers would like their efforts to last at least as long as their lifetime. To accomplish this goal, one must follow working procedures that deliver maximum permanence from the materials being processed. With archival methods, it is possible for contemporary black-and-white film to last thousands of years. Table 3.14 lists the basic working procedures to process film for maximum permanence.

POLAROID INSTANT FILMS

There are many advantages to working with instant materials. These include: no need for a darkroom or wet processing solutions; rapid feedback, allowing corrections and changes to be made while still shooting; a reliable way to test equipment, lighting, and

Table 3.14 Steps for Processing Black-and-White Film for Permanence*

Step	Time
Presoak (optional)	1 minute
Developer	As required
Acid stop bath	1/2 minute
Fixer (one or two baths)	Twice clearing time
Selenium toner (1:20) (optional)**	Until a slight change in color occurs (about 6 minutes)
First wash	2 to 5 minutes
Washing aid	2 minutes
Final wash	10 minutes minimum
Wetting agent in distilled water	1 to 2 minutes
Air-dry	As needed

*Use fresh solutions at 68°F (20°C).
**Film is immersed in toning solution directly from the fixer with no water rinse. Toner is used only once and then discarded.

subject poses; and a good icebreaker which can help establish a rapport between the photographer and the subject.

Positive and Negative Film

One of the most versatile Polaroid materials is black-and-white positive and negative material. Polaroid Positive and Negative (P/N) Film (Type 55) has an ISO of 50 and a standard development time of 20 seconds at 75°F (24°C). The processing of this material is different from that of other instant films in that the negative must be cleared in a sodium sulfite solution, then washed and dried before printing. (Polaroid provides the chemical with the film.) The negative can be stored for up to 72 hours in a holding tank before it is dried. The sodium sulfite removes the processing gel and makes the image visible.

Polaroid P/N film can be archivally processed. After the sodium sulfite bath, the photographer fixes the negative for two minutes in a rapid acid-hardening fixer and then continues to process the film following the same procedures as are used in regular black-and-white archival film processing.

The problem with this film is that the perfect exposure may be slightly different for the negative and the print, with the negative sometimes requiring more time. The negative is more fragile than a conventional film negative and must be handled carefully. These negatives can deliver beautiful prints and can be used in many nonsilver processes.

ADDITIONAL INFORMATION

Books

American National Standards Institute (ANSI) Catalog of Photographic Standards. Contact: ANSI, Sales Department, 1430 Broadway, New York, NY 10018.

Anchell, Stephen G. and Bill Troop. *The Film Developing Cookbook.* Boston: Focal Press, 1998.

Eaton, George. *Conservation of Photographs.* Kodak Publication No. F-40, 1985.

Hicks, Roger, and Frances Schultz. *The Film Book: Choosing and Using Color and Black and White Film.* London, UK: David & Charles, 1996.

Hirsch, Robert. *Exploring Color Photography.* Third Ed. New York: McGraw-Hill, 1997.

Kodak Black-and-White Darkroom Dataguide. Kodak Publication, No. R-20.

Stone, Jim. *Darkroom Dynamics: A Guide to Creative Darkroom Techniques.* Boston, MA: Focal Press, 1985.

Sources of Archival Equipment and Supplies

Calumet, 890 Supreme Drive, Bensonville, IL 60106 (archival washers).

Conservation Resources International, 1111 North Royal Street, Alexandria, VA 23314.

Darkroom Aids Company, 3449 North Lincoln Avenue, Chicago, IL 60657 (new and used archival equipment).

Light Impressions, P.O. Box 940, Rochester, NY 14603-0940.

Lumiere Photo, 439 Monroe Avenue, Rochester, NY 14607-0940.

Salthill Photographic Instruments, Wildcat Road, Chappaqua, NY 10514 (archival washers and dryers).

Summitek, P.O. Box 520011, Salt Lake City, UT 84152 (archival washers).

TALAS Division, Technical Library Services, 130 Fifth Avenue, New York, NY 10011.

20th Century Plastics, 20th Century Direct, PO Box 2393, Brea, CA 92822-2393 (archival storage).

University Products, Inc., P.O. Box 101, Holyoke, MA 01041.

Sources of Photographic Chemicals

Artcraft Chemicals, Inc., P.O. Box 583, Schenectady, NY 12301 (bulk chemicals).

Bostick & Sullivan, P.O. Box 16639, Santa Fe, NM 87506.

Bryant Laboratory, 1101 Fifth Street, Berkeley, CA 94710 (bulk chemicals and photographic formulas).

Fisher Scientific, 200 Park Lane, Pittsburgh, PA 15230 (chemicals and equipment).

Photographers' Formulary, P.O. Box 950, Condon, MT 59826 (bulk chemicals and classic formulas that are no longer commercially available).

Formulas of Your Own 4

PREPARED FORMULAS VERSUS MIXING YOUR OWN

Commercially Prepared Chemistry

A wide variety of commercially prepared formulas are available for use in photographic processes. These prepared formulas are accurately compounded and easy to mix, and they provide consistent purity and uniformity that ensures high-quality results.

Why Mix Your Own?

It can be valuable to any photographer to know how to prepare a formula from scratch. Mixing your own formulas can provide a clear, concrete cause-and-effect demonstration of how various photographic processes work. This understanding can be applied to achieve better control of the medium. Mixing your own formulas also can be less expensive than buying packaged preparations. This process offers you a chance to experience further visual adventure, and it is fun.

You do not have to be an expert in mathematics or science to get involved in this area of photography. This chapter provides the basic information needed to begin conducting experiments in controlling and heightening the final image with non-prepared photographic formulas. Specific details and formulas are included in the appropriate chapter sections dealing with specific processes.

Before attempting to mix any formula, read and follow all handling, mixing, and safety instructions included with the chemicals being used. Also read and follow all the general safety guidelines outlined in Chapter 2 of this book. Wear protective equipment such as safety glasses, a plastic apron, rubber gloves, and a mask to avoid allergic reactions, burns, and irritation to the skin or lungs.

BASIC EQUIPMENT

Many photographers have most of the items needed to prepare their own formulas. These include graduates, mixing containers, stirring rods or paddles, a funnel, an accurate thermometer, opaque storage bottles, protective gear, and a well-ventilated area that is not used for preparing food and is free from children and animals. The items that may be lacking are a scale and a mortar and pestle. All equipment must be made of nonporous and easy to wash materials.

Scales

A small, accurate scale is essential for weighing chemicals. Scales are available in a variety of sizes, styles, and price ranges. Balance scales are recommended because they are reliable, affordable, long-lived, easy

Figure 4.1 To get the results he wanted from printing-out paper, Hunter needed a negative with much greater than normal contrast. He achieved this by rating 8 × 10 inch TRI-X film at 100 and developing it in modified Pyro ABC developer. The printed-out image was treated with Gold Chloride Toner. This reduces the image and plates it with gold, producing a lavender tone.

© Frank Hunter. *Frank Ross's Barber Shop, Lebanon Jct., Kentucky*, 1985. Printing-out paper. 8 × 10 inches.

to use, and do not require batteries or electricity. When purchasing a balance scale, be sure the sliding scale is easy to read and that the scale has removable pans for convenience of use and cleaning. The Ohaus Scale Corporation makes a triple-beam balance scale that is superb for photographic purposes. The scale's standard capacity range is suitable for most individual needs and can be extended by using attachment weights. It is sensitive to 0.1 gram. If you plan on doing a good deal of your own mixing, this scale is a good investment.

Electronic scales are replacing many of the lower priced triple-beam balance scales. These scales, often battery powered, are available for those who want a simple digital readout. Most electronic scales will calculate Tare weights with a push of a button. Tare weight is the mass of the container that holds what is being weighed. The Tare weight button automatically subtracts the weight

of the container so that only the actual substance (chemical) is weighed. The Acculab Company makes different sized digital scales, some the size of a credit card. The Acculab GS200 is a portable electronic scale that is simple to use and has multiple weighing modes and a removable plastic platform. The prices for these electronic scales are comparable to balance scales.

Scales can be ordered over the Internet, through mail-order photo and scientific houses, from chemical supply houses, or directly from the manufacturer. Here are a few distributors to contact (many have toll-free phone numbers and Websites):

- Edmund Scientific, 101 East Gloucester Pike, Barrington, NJ 08007-1380
- Lab Safety Supply Inc., P.O. Box 1368, Janesville, WI 53547-1368
- Ward's Natural Science, P.O. Box 92912, Rochester, NY 14692-9012

Mortar and Pestle

A mortar and pestle made out of glass or porcelain can be useful for breaking up chemicals that are not in powder or grain form. Do not use marble or wooden sets, as they will absorb chemicals and could contaminate other formulas.

Spoons

A set of plastic or stainless steel spoons for transferring chemicals from the bottle to the scale can prevent messy spills that are wasteful and can cause contamination.

Mixing Equipment

Accurate, easy-to-read graduates in small and large sizes, clearly marked in both milliliters (ml) and ounces (oz), are essential. Plastic containers of various sizes make good mixing pails, and stirring paddles are helpful for mixing.

Storage Containers

Different sized brown or opaque bottles made of glass or plastic make excellent storage containers for mixed solutions. Opaque containers prevent deterioration caused by light. Plastic is more durable than glass and can be squeezed to eliminate most of the air to lessen the effects of oxidation. Remember that all plastic containers absorb chemistry over time. Keep similar chemistry in the same containers and replace plastic containers periodically. Medicine-dropper bottles, available at drugstores, are excellent for keeping small amounts of expensive solutions.

Certain chemicals are *hygroscopic* (absorbing water from the air) and can form a hard crust upon exposure to air. Others are *efflorescent*, losing their normal water content when exposed to air. Either of these conditions can make accurate weighing impossible. Still other chemicals can evaporate or fume. Avoid these problems by tightening the lids on all bottles. Clearly label every bottle with its contents and the date it was mixed.

CHEMICALS

Obtaining Chemicals

One can obtain many of the chemicals used in contemporary processes from large photography stores. When working with some of the more unusual or older processes, obtaining the required chemicals can be more problematic. Check with a local chemical supply company. Some companies may not sell chemicals in small quantities for individual use. If possible, represent yourself through a business or educational facility. You also may be able to obtain chemicals from the photography or chemistry department of a local college, or through mail-order photography stores. A few companies specialize in stocking photographic chemicals. Check the ads in photography publications or do an Internet search for information on suppliers.

If time permits, shop around, as the prices of chemicals can vary dramatically. In addition, manufacturers often give different trade names to the same chemical. For example, the developing agent methylaminophenol sulfate is known as Kodak Elon, Agfa Metol, Pictol, and Rhodol. Spelling also can vary. For instance, the British spelling of sodium

sulfite is sodium sulphite, and the British spelling of sodium sulfate is sodium sulphate. Chemicals come in different grades or classifications. Be sure the price obtained is for the exact grade of the chemical required.

Chemical Classification
Chemicals are given the following three standard classifications that reflect their purity:

1. *Analytical Reagent* (AR) is the highest standard for purity and uniformity. This grade is the most expensive and is not needed for most photographic purposes. It is usually labeled ACS (American Chemical Specification). In the United Kingdom, it is labeled ANALAR.

2. *Pharmaceutical* or *Practical* is about 97 percent pure and can be used for almost all photographic work. It is labeled USP (United States Pharmacopoeia) or NF (National Formulary). In the United Kingdom, it is labeled either BP (British Pharmacopoeia) or BPC (British Pharmaceutical Codex).

3. *Technical* or *Commercial* is approximately 95 percent pure and is subject to variations that could alter the visual outcome. It is not recommended for important work.

Sources of Supply
The following are reliable supply sources of photographic chemicals (many have toll-free phone numbers and Websites):

- Artcraft Chemicals Inc., P.O. Box 583, Schenectady, NY 12301
- Bostick and Sullivan, P.O. Box 16639, Santa Fe, NM 87506
- Bryant Labs 1101 Fifth Street, Berkeley, CA 94701
- Gallard Schlesinger Chemical, 584 Mineola Avenue, Carle Place, NY 11514
- Photographers' Formulary, P.O. Box 950, Condon, MT 59826-0950
- Rockland Colloid, 44 Franklin Street, Piermont, NY 10968
- VWR Scientific (International Headquarters), P.O. Box 7900, San Francisco, CA 94120 (can provide you with a regional distributor)

Storage
Keep all chemicals away from all living creatures. If necessary, lock them up. Label and date all bottles of mixed solutions. Be sure storage bottles have a secure cap. Protect all chemicals from air, heat, light, moisture, and contamination from other chemicals.

Disposal and Safety
When working with any chemical, you assume the responsibility for its safe use and disposal. Follow any special instructions included with each chemical or process being used as well as the safety recommendations in Chapter 2. Laws concerning disposal of chemicals vary widely. Check with your local health department to get advice. Hazardous liquids can be poured onto kitty litter and placed in a plastic bag. Dry chemicals or contaminated materials can be disposed of by sealing them in a plastic bag. Both should be put in a closed outside dumpster. Do not mix liquid and solid wastes together, as dangerous reactions might occur.

PREPARING FORMULAS

Weighing Chemicals
Place your scale on a level surface, protected from spills with newspaper or plastic, and zero it. Put a piece of filter paper, any clean paper, or a paper cup in the middle of the balance pan. For critical measurements with a triple-beam scale, weigh the paper or cup first and include its weight plus that of the chemical. On electronic scales this procedure can be done automatically by pressing the Tare button after the paper or cup is placed on the scale and before the chemical is added. When using a double-pan scale, place the same size paper in both pans so their weights will cancel each other out. Line up the needed chemicals in an orderly fashion. Put the chemical to be measured in the center of the pan to avoid any leverage errors. Use fresh paper for each chemical to prevent contamination and facilitate cleanup. Immediately recap the bottles to

avoid confusion, spills, or contaminating one chemical with another.

Temperature

Closely follow the temperature recommendations given with each formula. If the chemicals need to be heated, carry out this procedure in a double boiler, not in a pan directly over the heat source. Direct heat can alter or damage a chemical. The solubility of many chemicals is increased with heat. For this reason, the mixing temperature of the water may vary from the solution's working temperature. Other chemicals may release heat when dissolved, creating an exothermic reaction, and need to be mixed in cool water. Endothermic chemicals absorb heat when mixed and may require hotter water for complete mixing.

Mixing Chemicals

Always follow the prescribed order of chemicals given in the formula, as any changes may prevent the solution from being properly mixed. Follow specific recommendations provided with the formula. In general, start with two-thirds to three-quarters of the total amount of water at the correct mixing temperature. Slowly pour the first properly measured chemical into the water while stirring vigorously, not permitting any chemical to settle at the bottom of the container. Wait until each chemical has been completely dissolved before adding the next one. When the correct sequence has been followed and all the chemicals are thoroughly mixed, cold water can be added to bring the solution to room temperature. If you are not confident of the purity of the water being used, mix all developers with distilled water.

- When you are mixing an acid, always pour the acid into water. Do not pour water into an acid, as splattering can cause dangerous burns. Be sure to wear eye protection.
- Use a funnel when pouring mixed solutions into bottles. Tightly secure the top and label the bottle with the name of the solution and the date. Most developers are good only for a few months after they have been mixed.
- Keep a written record of what you do so that you can judge the results. This permits easy adjustment and customization of the formulas.

Percentage Solutions

In some formulas the amount of a chemical may be too small to be weighed accurately, so the amount is given as a percentage solution, or in terms of weight per volume. For photographic purposes, this can be simply stated as how many grams of a chemical are dissolved in 100 milliliters of water. For instance, a 5 percent solution has 5 grams of a chemical dissolved in 100 milliliters of water. Regardless of the amount needed, the percentage (how many parts of the chemical to be mixed into 100 parts of water) is always the same.

When making a percentage solution, mix the chemical in less than the total volume of water required. After the chemical is dissolved, add the remaining water. For instance, in preparing a 7 percent solution, dissolve 7 grams of the chemical in about 75 milliliters of water. After mixing is complete, add more water so that the final volume is exactly 100 milliliters.

Formulas in Parts

Older photographic formulas were often given in parts. Parts can be converted into the equivalent number of grams and milliliters or ounces and fluid ounces. For example, a formula calling for 10 parts of a chemical and 80 parts of water can be translated as calling for 10 grams of the chemical and 80 milliliters of water or 10 ounces of the chemical and 80 fluid ounces of water.

pH Scale

Most photographic solutions have a definite pH (potential of hydrogen), which is a way to measure the acidity or alkalinity of a chemical. Acidity is measured by the

number of hydrogen ions present, and alkalinity is measured by the concentration of hydroxide ions in a solution. The scale runs from 1 to 14, with 7 being neutral. Pure distilled water has a pH of 7. Chemicals with a pH below 7 are considered to be acids. Chemicals with a pH above 7 are alkalines. The change of one whole increment in the pH scale indicates a tenfold change (plus or minus) in the intensity of the acid or alkaline reaction.

All photographic processing solutions perform best within a specific pH range. For example, developers must be alkaline to work, stop baths must be acid, and fixers are normally neutral to slightly acid. The pH of most of the commonly used working solutions in today's photographic processes is between 5 and 9. The pH can be measured with pH test paper or with a pH meter. The paper is inexpensive but not very reliable. A pH meter, which is expensive, is required for accuracy. Fortunately, most black-and-white formulas do not require stringent pH monitoring. Small changes produced by variations in pH usually do not cause severe visual defects. Most of these changes can be corrected during the printing of the negative. The use of distilled water will eliminate most difficulties in controlling pH as long as the chemicals are good and the procedures being followed are correct.

Chemicals possessing either a high or low pH should be handled with care. Acids on the low end of the pH scale get progressively stronger. Acids can dehydrate the skin and, in high concentrations, produce burns. Highly alkaline substances, such as calcium hydroxide, can degrease the skin and cause burns.

Acetic acid is the most commonly used acid in photography. It is a relatively weak acid and does not react as vigorously as other acids, but it can cause tissue damage in a concentrated form.

Prolonged exposure to photographic chemicals can cause allergic reactions, cracking, dehydration, or discoloration of the skin. Allergic reactions tend to be cumulative. When mixing or working with any concentrated chemicals, wear full protective gear.

U.S. Customary Weights and Metric Equivalents

When preparing your own chemicals, you will probably encounter formulas given in both the U.S. customary and metric systems. The scientific world has adopted the metric system, but the United States at large has not followed suit. Older formulas in British publications use still another system called British Imperial Liquid Measurement. These systems are not compatible. Many older formulas may be written in only one system, so it is often necessary to translate from one system to the other.

ADDITIONAL INFORMATION

Books

Anchell, Stephen G. *The Darkroom Cookbook*. Second Ed. Boston: Focal Press, 2000.

Anchell, Stephen G., and Bill Troop. *The Film Developing Cookbook*. Boston: Focal Press, 1998.

Donofrio, Diane (Ed.). *Photo Lab Index, Lifetime Edition*. Keene Valley, N.Y.: Morgan and Morgan, 2001.

Stroebel, Leslie, Richard D. Zakia, Ira Current, and John Compton. *Basic Photographic Materials and Processes*. 2nd ed. Boston: Focal Press, 2000.

Other Source

Chemical Manufacturers Association, 1300 Wilson Boulevard, Arlington, VA 22209.

Black-and-White Film Developers 5

Choosing a film developer requires intelligent consideration. You have a wide range of possibilities to choose from in selecting a developer that is appropriate for the film and its intended application. A developer is not a magical concoction that can correct mistakes made at the time of exposure, but it does play a vital role in determining a number of key factors in the making of the final negative. These include acutance (sharpness), contrast, useful density range (the difference between the brightest highlight and the darkest shadow areas from which detail is wanted in the final print), fog level, grain size, speed, and the progression, separation, and smoothness of the tonal values.

The developer formula selected—its dilution; degree of exhaustion; temperature of use; frequency, duration, and degree of agitation; and time the film is in the solution—are all controls that the photographer can use to adjust the results obtained from any developer.

WHAT HAPPENS TO SILVER-BASED FILMS DURING EXPOSURE AND PROCESSING?

Upon exposure, the light-sensitive emulsion produces an electrochemical effect on the silver halide crystals of the emulsion. This changes the electrical charge of the silver halide crystals, making them responsive to the developer. The exposure produces an invisible latent image made up of these altered crystals. The developer reduces these exposed crystals to particles of metallic silver, forming the visible image on black-and-white film. The extent of this reaction is determined by the amount of light received by each part of the film. The more light striking an area, the more reduced silver there will be, resulting in a higher density.

Chromogenic Film Differences

In chromogenic black-and-white film, as in most color films, the developing process creates both silver particles and dyes. During processing, the silver is removed in a bleaching process, leaving a negative image formed only by the dyes. Ilford and Kodak both make chromogenic black-and-white films that are developed in the C-41 color negative process.

Remaining Processing Steps

After being developed, the negative has tiny particles of metallic silver and residual silver halide that were not exposed and therefore not developed. This halide must be removed, or it will discolor the negative when it comes in contact with light.

To complete the developing process, plain water or a mild acid stop bath

(sometimes called a short-stop) is used to neutralize the alkaline developer still in the emulsion. The film is then transferred into an acidic fixing bath to remove any of the unreduced silver halide in the emulsion. Fixer or hypo (once known as sodium hyposulfite) is usually made up of sodium thiosulfate. Rapid fixer generally contains ammonium thiosulfate as its fixing agent. After fixing, the remaining thiosulfate compounds must be eliminated. The film is rinsed and treated with a hypo clearing solution, which changes the thiosulfate into a compound that washes off the film more easily. Any residual fixer will discolor, stain, and ultimately destroy the image. Finally, the film is thoroughly washed and dried.

IMAGE CHARACTERISTICS OF FILM

Grain

The silver particles that make up the image structure are called grain. The grain size is determined by two major factors. The first is the inherent natural characteristics of the film. Generally, the faster the film is, the coarser the grain. Fast films have a thicker emulsion, permitting more vertical clumping of the grain. The second factor determining grain size is development. During development the individual silver grains tend to gather together and overlap, creating larger groups that form a pattern. This is not very noticeable in the negative but becomes visible in an enlarged print. The grain we see in the print is not the individual grains but the spaces between the grains on the negative. These grains hold back the light during printing, so they appear white in the print.

The number and size of the grains in any part of the negative give it density. Graininess is increased by excessive density, which can be produced by overexposure or overdevelopment. Improper film processing, including rough agitation, temperature shock, excessive fixing, and lengthy wet time, increases the size of the grain. Visible grain also increases as the contrast of the print increases.

Acutance

Acutance describes the ability of film to record the edges of objects. The standard test measures film's ability to form a sharply defined image of a knife edge when exposed to a point light source. The nature of the grain and how it is distributed affect the film's acutance. Fine-grain films with a thin emulsion have a high acutance value. They produce less spreading of the light because there is not as much emulsion through which light must travel.

Developers do play a role in how we perceive a film's acutance. An acutance developer develops less of the faintly exposed portions of the knife line, reducing the gradient width and giving the impression of increased edge sharpness, even though the film may not measure out as having a higher acutance. The sharper the grain is, the greater the appearance of acutance. Softer grain produces a diffused edge, giving the impression of less acutance.

Resolution

The film's ability to reproduce fine detail is called resolution. The camera equipment, film, and printing equipment determine resolving power. These factors include lens sharpness and freedom from aberrations, the graininess of the emulsion, the contrast of the subject, the contrast characteristics of the film, and the degree of light scattering throughout the system. Slow, fine-grain films have a greater resolving power than faster films containing larger grains. Fine-grain films have a greater acutance, producing sharper outlines and higher contrast. The thinner emulsion yields less irradiation (internal light scattering), which can blur distinctions between details. Excess density produced by overexposure or overdevelopment increases light scattering in the emulsion. This reduces edge sharpness and contrast, which results in less overall resolving power.

The sharpness of the grain produced by the developer influences resolution. Grain that is not very sharp can reduce the resolution of an image made through a first-rate optical system. The sharper the grain, the higher the degree of apparent resolution.

Fog

Fog is any tone or density in the developed image that is produced by stray, non-image-forming light or by an unwanted chemical action. Fog adds density and is first noticeable in less dense areas. In a negative, it results in a loss of contrast and detail in the shadow areas. Light fogging is caused by lens flare, camera light leaks, improper handling, loading or unloading of film, light leaks in the darkroom, poor safelight conditions, or exposure to X-rays. The latter most commonly occurs in the baggage check-in systems used in airports (ask for hand inspection of your photographic equipment and do not put exposed film in your luggage). Lead-lined film pouches can be used to reduce X-ray exposure.

Chemical fog results from the development of unexposed halides. This happens all the time in small amounts, causing what is known as the base-plus-fog density of film. Fog amounts greater than base-plus-fog degrade the image. A restrainer, often potassium bromide, is added to the developer to reduce fog. Improper storage or outdated film often produces high levels of fog because the silver halides become more developable with age. High development temperature, excessive agitation, or chemical activity increases the fog level. Fog and other visible stains can result from fine-grain developers used with fast films or from the use of nearly exhausted chemicals. Letting the emulsion come in contact with an excessive amount of air during development produces an oxidation effect called aerial fog. Chemical dust, from the mixing of chemicals, also is a source of fog. To prevent fog, make sure both camera and darkroom are light-tight, use fresh films and solutions, follow proper operating procedures and temperatures, maintain clean working conditions, and avoid airport X-ray machines.

COMPONENTS AND CHARACTERISTICS OF BLACK-AND-WHITE DEVELOPERS

Developer formulas contain a number of different chemicals required to perform specific functions in the development of the film. Getting to know the basic ingredients and the roles they perform enables the photographer to make adjustments to meet individual requirements in different situations.

Developing Agent

The role of the developing agent is to reduce the silver halide salts in the emulsion to metallic silver. The developing agent is oxidized during this process. Since the dawn of photography, countless chemicals have been tried in the hope of producing a developing agent with improved properties. Most of the developing agents currently in use were discovered before the turn of the century, although new developing agents are probably being used in proprietary formulas that manufacturers have not revealed to the public.

The most common contemporary developing agents are Metol (Kodak's Elon), hydroquinone, Phenidone, and ascorbic acid (vitamin C). Older formulas are amidol, glycin, and pyrogallol (pyro). Most general-purpose developers are compounded pairs of developing agents that complement each other's action during the development process. The most popular combinations are Metol and hydroquinone, known as an *MQ developer*, and Phenidone and hydroquinone, sometimes called a *PQ developer*. The *M* stands for Metol, the *Q* comes from Quinol, the old Kodak trade name for hydroquinone, and the *P* represents Phenidone. The characteristics of these developing agents are discussed later in this chapter.

Metol and Phenidone provide good low-contrast shadow detail in the negative but produce very little density in the highlights. Hydroquinone acts more intensely in the highlight areas, adding density and contrast. The combination of the two developing agents results in greater development of the entire negative than the sum of the development given by equal amounts of the individual developing agents. In effect, when MQ or PQ combinations are used, $1 + 1 = 3$. This effect is called *superadditivity* and is used in the majority of contemporary formulas. The MQ and PQ combinations yield good shadow and mid-range detail, while still retaining easily printable density in the highlights.

Metol should be handled with care, as it can cause skin irritation that resembles poison ivy. If you have a reaction to Metol, use a Phenidone-based developer. Note that most of Kodak's developers have Elon (Metol) in them.

Phenidone behaves much like Metol. It is more expensive, but it is used in smaller quantities. Phenidone has a low oral toxicity and is considered nontoxic. With normal use, it is unlikely to cause dermatitis. In combination with hydroquinone, it can produce higher useful contrast. It is not as sensitive to bromide, giving the solution more constant and longer keeping properties. Phenidone can be more difficult to dissolve and can require very hot water (175°F or 80°C) to go into solution easily. Check the formulas carefully before mixing. Many people use a percentage solution when mixing their own Phenidone-based formulas, since only a small amount is required.

Some popular commercial developers that claim to be Metol free include Edwal's FG-7, Acufine, Agfa's Rodinal, Ilford's Microphen, and Kodak's HC-110.

Accelerator

Developing agents used alone can take hours to produce useful density, are quickly oxidized by air, and yield a high level of fog. An alkaline accelerator creates an environment that greatly increases the developing agent's activity, dropping processing times from hours to minutes. The amount of alkalinity in the accelerator determines how much of an increase takes place in the developer. Alkalinity is measured on the pH scale: the higher the pH, the greater the alkalinity. Some commonly used alkaline chemicals are borax or Kodak Balanced Alkali (sodium metaborate), with a pH value of 9; sodium carbonate, with a pH of 10; and sodium hydroxide, also known as caustic soda, with a pH of 12.

A developer containing sodium hydroxide, which has a high pH, greatly accelerates the action of the developer. It increases contrast and is often used for high-contrast applications such as graphic arts films. The higher the pH value, the more quickly the alkalinity drops off when used in a solution. Developers with a high pH accelerator

oxidize extremely rapidly and have a very brief life span. To combat these difficulties, the developer and alkaline (accelerator) are stored as separate A and B solutions that are mixed immediately before use.

A developer with a low-pH accelerator such as borax produces less contrast and takes longer to work, but it remains stable for a longer period of time in a working solution.

Preservative

When a developing agent is dissolved in water, especially with an alkaline chemical present, it oxidizes rapidly, causing the solution to turn brown, lose its developing ability, and produce stains on the emulsion. To prevent the developing agent from oxidizing, a preservative is added, usually sodium sulfite. This increases the working capacity of the developer. It also can act as a silver solvent during the long developing time, and in large quantities, as in D-23, it produces the mild alkalinity needed to make

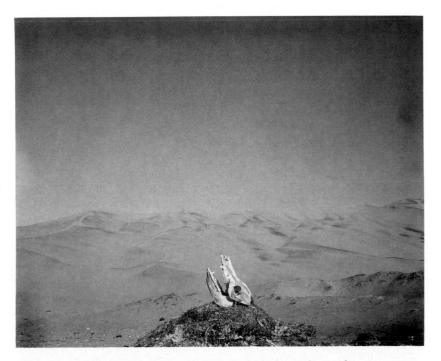

Figure 5.1 Connor holds to the maxim of Robert Bly: "Whoever wants to see the invisible has to penetrate more deeply into the visible." Connor likes to keep her technical operations simple. Her 8 × 10 inch Ektapan film is processed in Kodak HC-110, a convenient, one-shot liquid developer. This image was contact printed using the sun on printing-out paper toned with gold chloride.

© Linda Conner. *Skull, Peru*, 1984. Toned printing-out paper. 8 × 10 inches.

the developer work. In the A solution of the Pyro ABC formula, sodium bisulfite prevents the oxidation of the pyro developing agent. Potassium metabisulfite is sometimes used in two-solution formulas instead of sodium sulfite.

Restrainer

During the development process, some unexposed silver halides are reduced to black metallic silver before development is complete, producing unwanted overall fog. A restrainer is added to the developer to reduce the fog level. Bromide, with derivatives of either potassium or sodium, is the primary restrainer found in most developers. Potassium bromide is more commonly used. The restrainer increases contrast by preventing the reduction of the silver halides; hence, the production of metallic silver, in the slightly exposed areas, giving a lower overall density to the shadow areas. This inhibiting of silver halide reduction also tends to produce a fine-grain pattern. A potassium bromide restrainer is used only in small amounts, as it holds back the overall developing action, reduces the speed of the film, and has a greater effect on the low-density areas, diminishing the amount of useful density created in the shadow areas. Some low-alkaline developers do not produce much fog and therefore do not require a restrainer.

As the emulsion is developed, soluble bromide is discharged into the developer, increasing the proportion of restrainer in the solution and thereby slowing the action of the developer. If these soluble bromides are not removed through proper agitation of the solution, they can inhibit the developing process.

Some developer solutions use benzotriazole (formerly marketed as Kodak Anti-Fog No. 1) instead of potassium bromide. These two restrainers cannot always be interchanged, as the benzotriazole does not have the same effect with all developing agents.

Other Ingredients

Alcohol solvents can be found in certain concentrated liquid developers to increase the solubility of specific chemicals and to prevent freezing. Sulfates are sometimes added to a developer to reduce emulsion swelling, which keeps the grain size down.

Keeping Qualities

The keeping qualities of any developer will be affected by the following factors:

1. Purity of water. Use distilled water and avoid water that has been softened.

2. Chemical makeup. All developers should be protected from the air. Most normal developers containing sodium sulfite are slow to oxidize. High-energy and pyro developers oxidize quickly after a working solution has been prepared and should be used immediately.

3. Storage containers. Use dark brown or opaque containers. Glass or stainless steel is best for long-term storage because they will not interact with film developers. However, the breakability of glass does not make it safe or suitable for all situations. Plastic can be used, but be aware that some plastic containers allow oxygen to pass through their walls and interact with the developer. This speeds up the oxidation process and leaves brownish stains inside the container. Plastic is not recommended for long-term storage.

4. Contamination. Follow the preparation instructions and mixing order carefully. Do not allow the developer to come into contact with other chemicals. Wash all equipment completely after use.

Basic Factors in Selecting a Developer

The photographer must bear in mind the nature of the subject, the type of enlarger light source, and the size of the final print. For a subject calling for maximum retention of detail, as in architectural work, traditional landscapes, or photographs for reproduction, a normal developer with maximum acutance is preferred, even at the expense of increased grain size. For a subject requiring a softer look with less sharply defined grain and a flowing progression of tones, as in

some portrait work, a fine-grain developer that gives the grain a more rounded look might be appropriate.

Photographers using condenser enlargers, which emphasize contrast and crispness, may wish to use a softer negative with lower grain acutance. Those using a diffusion enlarger generally prefer maximum sharpness, since the diffused light softens the image slightly. Many photographers who use diffusion enlargers extend the development time to create a slightly denser negative than they would use with a condenser enlarger. This is done to retain some of the contrast that is lost in diffusion systems.

The development time of most developers can be varied to compensate for high-contrast or flatly lit scenes. For example, if the entire roll of film was exposed in brighter than normal lighting conditions, the photographer may wish to decrease the normal development time by 10 to 25 percent to reduce the overall contrast. This narrows the distance between the key highlights and shadows, giving the negative a tonal range that will be easier to match with the paper to make a normal print. If a roll of film is exposed in flatter than normal light, the photographer can increase the normal development time by about 25 percent to produce added contrast in the image.

LIQUID VERSUS POWDER CHEMISTRY

Developers are available in liquid and powder form. Neither is better than the other, as both are valuable in various situations. Most photographers work with both types, although extra safety precautions should be taken when mixing chemistry in powder form. It is a good idea to experiment with both in noncritical situations to see the visual results they can deliver.

Liquid Developers

Many liquid developers are proprietary formulas—that is, not published for use by the public—and cannot be obtained in any form other than those the manufacturer provides. Some proprietary formulas include Kodak's

HC-110 and T-MAX developers, Edwal's FG-7, and Agfa's Rodinal. These formulas are convenient, consistent in quality, and high in price. Many of the liquids are extremely concentrated and can be difficult to measure out in small quantities. Rodinal, sometimes used at dilutions of 1:100, can be accurately measured by using a hypodermic needle. HC-110 is too syrupy for this technique and can be measured in small amounts in a 1-ounce graduate. With this method, always measure on a level surface. Pour the developer into a mixing container filled with half the water required for the proper dilution. Add the remaining water by pouring it, an ounce at a time, into the small graduate and then into the working solution. This ensures

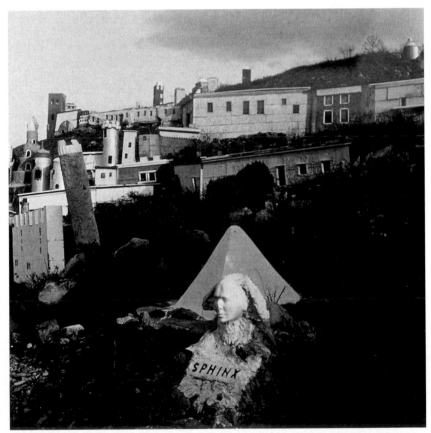

Figure 5.2 Johnson wanted to create a dark and moody look at this crumbling, folk art tribute to the power of religion. "As the graffiti and vandalism became more pervasive through the place over time, the original intent became subverted. I felt compelled to balance this place with my understanding of it. I was not content to document it, but rather used it to make a response to the notion that religion is a means to explaining the unexplainable." The use of FG-7 developer with its additional sulfite and Ilford FP-4 film provided the combination he was after to achieve maximum sharpness and rich tonality.

© Keith Johnson. *Untitled*, from the series *Holy Land, USA*, 1980. Toned gelatin silver print. 10 × 10 inches.

that none of the developer will remain in the graduate. Other people prefer to make a stock solution from these concentrated liquids that is later diluted to make a working solution. Most of these developers are intended to be used one time (one shot) and then discarded.

Powder Developers

Powders can be more difficult to mix, and their dust can contaminate the darkroom. Prepare the solutions where the chemical dust will not land on surfaces where film is handled. When mixing powders, wear a mask to avoid breathing in the dust. Clean the mixing area with a damp paper towel. Ideally, powders should be mixed 24 hours before use to ensure that all the chemicals are dissolved and stable. This lack of convenience is offset by the fact that the formulas for many contemporary and older powder developers are available. The photographer who takes the time to mix a formula from scratch can save money and customize the formula for individual needs. He or she is not restricted to what is available commercially, will gain a better understanding of what happens in the process, will learn how to influence the development process, and will increase visual possibilities.

BASIC DEVELOPER TYPES

Categorizing developers can be difficult. The visual results one photographer considers normal might be unacceptable to another. This chapter offers some basic characteristics of developers, how they are typically applied, and their formulas, if they are available. This information is intended as a starting point from which photographers can conduct experiments to see which film-developer combinations offer visual satisfaction.

Generally, developers are divided into four categories: normal, fine-grain, high-energy, and special-purpose. Formulas for the nonproprietary developers—that is, formulas that are published for public use—mentioned in this section are presented at the end of this chapter.

Normal

The normal developer is one that provides high acutance, a moderate grain pattern, and a good range of clearly separated tones; maintains the film's regular speed; and is simple to use. These developers can be used with roll or sheet film in a tank or tray. Common examples include HC-110, D-76, and FG-7. The key difference between a normal developer and a fine-grain developer is how the grain looks. A normal developer yields a sharp, toothy grain, similar to the shape of a pyramid. A fine-grain developer produces a softer grain, similar to a rounded dome.

Many developers can be classified as either normal or fine-grain. D-23 is one such formula. D-23 is a Metol developer yielding a moderately fine grain due to the solvent action produced by its higher than normal content of sodium sulfite. In the case of D-23, the sodium sulfite's main purpose is not to create a finer grain but to produce the alkalinity needed for development to take place. The finer than normal grain is a by-product of this action. D-76 contains the same amount of sodium sulfite as D-23, but its MQ formula of Elon and hydroquinone gives it more energy. This reduces the developing time, so there is less silver reduction and the grain remains better defined. HC-110, D-76, and FG-7 are available from the manufacturer in packaged form. D-23 is not and must be mixed from scratch (see formula later in this chapter).

Fine-Grain Developers

Fine-grain developers increase their silver halide solvent power by chemical means, usually with a higher level of sodium sulfite. This increased solvency yields a reduction in graininess. Unfortunately, this is accompanied by a reduction in film speed and acutance, producing a negative in which the grain is actually softer than that of a normal developer. Instead of the grains looking like the well-sharpened point of a pencil, they appear to have been rounded off. The negative will actually deliver a less well-defined grain pattern. This is not good or bad, it is simply different from the results obtained with a normal developer. It is a matter of

how the photographer wants the final print to look. Prints made from such negatives are softer and smoother looking.

D-25 is a classic example of such a developer. Its basic formula is the same as that for D-23, but sodium bisulfate is added as a buffer to reduce the developer's pH value (alkalinity). This buffering effect increases the development time, resulting in increased solvent action of the sulfite on the silver, giving it a fine-grain effect. D-25 must be mixed from scratch.

Kodak's Microdol-X is a fine-grain, Metol-only, high-sulfite developer that is similar to D-25. Microdol-X is available in liquid and powder form.

Other fine-grain developers, such as Acufine and Ethol Blue, are designed for push processing film to achieve maximum speed.

High-Energy Developers

High-energy developers are often used for graphic arts work or rapid processing. They tend to produce high contrast, eliminating the middle tones and giving areas either a black or clear density. They are generally not intended for normal pictorial use, but they can be diluted and the exposure time manipulated to produce continuous-tone results. In many of these formulas, such as Kodalith Liquid Developer, the developing agent and the alkali are stored separately and mixed only at the time of use. Once they are combined into a working solution, they rapidly oxidize. The level of bromide in these formulas is generally increased to keep the fog level down. This also helps to produce the completely clear areas on the film for high-contrast effects. Other widely used high-energy developers include Kodak's D-8, D-11, and D-19 and Ilford's ID-13.

Special-Purpose Developers

Special-purpose developers are designed for specific uses such as direct-positive, high- or low-temperature, and low-contrast/low-energy processing; reproduction work; X-ray development; nonstandard visual effects; and monobath or two-solution development methods.

Two-Solution and Water-Bath Development

Both these procedures can be effective in reducing overall contrast while maintaining useful density in the key shadow areas. They permit the developer to soak into the emulsion before the film is placed in a bath of mild alkali or water. When the film is taken out of the developer and placed in the second solution, the developer in the highlight areas rapidly exhausts itself, while the developer in the shadow areas continues to act. The cycle may be repeated to achieve the desired range of contrast. Either method works well with fast, thick-emulsion films such as TRI-X and HP-5 Plus. The alkaline solution method is more effective with a broader range of films, including slower, thin-emulsion ones. When working with either method, one may have to give about one f-stop more exposure than normal.

Diafine is a commercially available two-bath formula designed to produce the highest effective film speed, ultrafine grain, maximum acutance, and high resolution. It is usable over a wide temperature range (70°F to 85°F, or 21°C to 29°C) with a single developing time for all films. Diafine permits a wide latitude of exposure without having to adjust the time or temperature of the developer.

Processing with D-23 and Kodak Balanced Alkali

The Single-Cycle Method

Film is developed in D-23 for 3 to 7 minutes at 68°F (20°C) and then allowed to soak, without agitation, in a 1 percent solution (10 grams per liter) of Kodak Balanced Alkali (sodium metaborate). The process raises the film's base-plus-fog level, but this fog can usually be printed through without difficulty. The fog level can be combated by adding a 10 percent potassium bromide solution to the Balanced Alkali or by adding benzotriazole at the rate of 30 grains per liter of Balanced Alkali. The resulting negative will appear to be soft but will contain fully developed shadow area detail. Other developers such as Microdol-X may also be used.

The Multicycle Method

The multicycle method can produce a more completely developed negative, with addi-

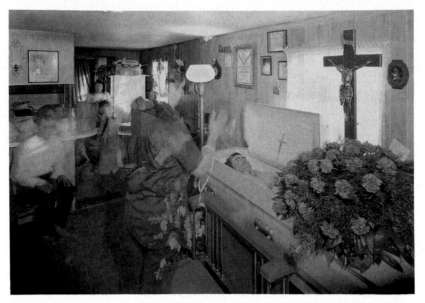

Figure 5.3 Here 5 × 7 inch TRI-X was exposed for about 1 minute at f-22. Two flashbulbs were fired during the exposure to paint the subjects at appropriate and unpredictable points in time. To compensate for the long, imprecise exposure with mixed lighting, Feresten used a double-bath development of exhausted Kodak Microdol-X followed by a Kodalk solution (now called Kodak Balanced Alkali). This reduced the overall contrast while maintaining detail in the key shadow areas. Feresten likens his method to casting a net into unknown waters. The results contain a collection of nonsimultaneous truths connected by time.

© Peter Helmes Feresten. *Javier Garcia Wake, Fort Worth, Texas,* 1987. Gelatin silver print. 12⅝ × 18 inches.

tional compensating effects, than the single-cycle procedure. In this process, the film is developed in D-23 for 30 to 60 seconds, then put into the 1 percent Kodak Balanced Alkali (sodium metaborate) solution for 1 to 3 minutes with no agitation. The film is then put into a weak acid stop bath and completely rinsed in water. After these procedures, the film is returned to the D-23 for the second cycle. This entire procedure may be repeated three to five times to achieve the desired contrast range.

POSTDEVELOPMENT PROCESSES

Replenishment

A developer loses its potency as it carries out the task of reducing the exposed silver halides. During this process, contaminants, mainly soluble bromides, which are a by-product of the chemical reaction, build up in the solution. A replenisher is a chemical solution added to the original developer to restore it back to its original strength, allowing it to be reused many times. Not all developers can be replenished. Check with individual manufacturers to find out whether a specific developer can be replenished.

Generally, for replenishment to be economical and effective, the developer must be used in at least one-gallon tanks. Also, the solution must have film run through it regularly (preferably daily) to keep the developer at working strength. Careful records of the amount of film processed must be maintained to determine the amount of replenishment required. For these reasons, large-volume users primarily use replenishment.

Many photographers prefer one-shot (non-replenishable) developers because of their consistency and ease of use. If the volume of work is great enough, however, replenishing is more economical. Some photographers like the look of a negative processed in a replenished solution. This preference derives from the fact that during long development times, some of the residue silver in the solution attaches itself to the developed emulsion in a process called *plating*, which adds a slight amount of contrast and density. In 1989, with the introduction of Kodak T-MAX RS Developer and Replenisher, replenishing became easier for people processing small amounts of film.

T-MAX RS Developer and Replenisher

The T-MAX RS Developer and Replenisher is an all-liquid system designed to provide a number of advantages over traditional replenisher methods. The mixed T-MAX RS acts both as a working solution and as a replenisher. No starter solution or separate replenisher solution is required. At its recommended temperature of 75°F (29°C), RS gives better shadow detail than regular T-MAX Developer. This makes it an excellent choice for both normal and push processing. It is suitable for low-volume, small-tank processing because it can be mixed in quantities as small as one gallon, does not require a daily run of film, and has a good storage life. A working-strength solution will keep for six months in a full, tightly closed bottle, and a half-filled bottle will last

for two months. T-MAX RS can be used to process any T-MAX or conventional black-and-white film, such as TRI-X. It also may be used in an unreplenished system, one-shotted, and dumped. Kodak says not to use RS to replenish regular T-MAX Developer.

T-MAX RS Developer is easy to replenish. You simply mix one gallon of RS and pour the required amount of solution into the developing container. After the film is developed, save the used developer in a separate bottle. For each 135–36, 120 roll, or 8 × 10 inch sheet processed, 1½ ounces (45 milliliters) of fresh RS Developer is added to the used solution. For example, if four rolls of 135–36 film were processed, you would add 6 ounces (180 milliliters) of fresh RS Developer to the used solution. All future development is done in the used solution after it has been replenished with fresh RS Developer. Check the RS Developer instructions for detailed processing information, or get *Kodak T-MAX Developers*, Kodak Publication No. J-86.

Reticulation

Excessive swelling of the emulsion during processing causes reticulation. It wrinkles the emulsion into a random web-like pattern that is more visible than the grain itself. The major cause of reticulation is temperature fluctuations between the different processing steps. Traditionally, reticulation has been considered a mistake that destroys the detail and uniformity of a negative. However, reticulation can be purposely induced for a graphic, textured effect. Improvements in contemporary emulsions have reduced the likelihood of accidental reticulation. In fact, it can be very difficult to induce reticulation with most modern films. Induced reticulation methods are covered in Chapter 11.

Intensification

Intensifiers are used to increase the density and contrast of an already processed underexposed or underdeveloped negative or positive. An intensifier cannot create something from nothing. Some density must be present for the intensifier to have any effect. An intensifier will not save a grossly underexposed negative. When using any intensifier, read and follow all safety and handling instructions.

The safest, simplest, and most permanent intensifier is selenium. It is called a proportional intensifier, and it has a greater effect in the high-density areas than in the low-density ones. Selenium can add up to the equivalent of one f-stop of density to the upper highlight regions, which also increases contrast. This added density drops off through the mid-tone areas and falls drastically as the shadow areas deepen. Selenium intensification is an excellent choice with roll film because it does not increase grain size.

The Selenium Intensification Process
1. Soak the processed and completely washed film for a few minutes in distilled water.
2. Refix with plain hypo (no hardener) for 2 minutes. This is easy to do with liquid fix by not mixing any of the hardener into the solution.
3. Place the film in the selenium toner solution diluted 1:2 or 1:3 with Kodak Hypo Clearing Agent or Perma-Wash for 2 to 10 minutes at 68°F (20°C) with constant light agitation. Dilution and time are determined by visual inspection and will vary depending on the amount of intensification required. Some hypo clearing baths may produce discoloration when mixed with selenium toner. Test your hypo clear with some unwanted film before using it with important work.
4. Put the film in a plain hypo clearing bath, at normal working strength, for 2 minutes with constant agitation.
5. Wash the film for a minimum of 5 minutes.
6. Dry the film.

Chromium and Silver Intensification

Photographers' Formulary makes a chromium intensifier that increases the density of black-and-white negatives. Like selenium, it is a proportional intensifier. Negatives intensified with chromium are stable and the process can be carried out in room light.

Chromium Intensifier at 70°F (21°C):

1. Fix the film in an acid hardening fixer and wash well. If the film is dry, soak it for 10 minutes in distilled water before carrying out the next step.

2. Immerse only one piece of film at a time in the bleach for 8 to 10 minutes with agitation. Chemicals are used once and discarded.

3. Rinse the film in running water for 5 minutes.

4. Redevelop the film in a low-sulfite developer such as Dektol or D-72 (1:3) until the image is totally black (about 5 minutes). Do not use a high-sulfite fine-grain developer such as D-76 or Microdol-X.

5. Rinse the film in running water for 1 minute.

6. Fix for 3 to 4 minutes.

7. Wash the film for 10 to 20 minutes.

8. Repeat the process if desired for greater effect.

9. Dry the film.

Negatives intensified with this process are not considered to be permanent.

Photographers' Formulary also makes a silver intensifier, which acts by depositing additional silver on an underdeveloped negative. The results are permanent, but the new grain is predictably not as fine as the original image. The chemicals in the kit make four stock solutions that are mixed together just prior to use to make a single working solution. The stock solutions are stable for several months, but the working solution is usable for only 1/2 hour after mixing. The negative is intensified in room light to the desired degree and then washed. This intensifier contains both Metol and silver nitrate in a solid form and should be handled with care.

The Silver Intensification Process

1. Mix the four stock solutions according to the manufacturer's instructions. The solutions are mixed 1 part solution A to 1 part solution B to 1 part solution C to 3 parts of solution D. Exercise safety precautions as silver nitrate is an oxidizer and is caustic and in solid form can cause a chemical burn.

2. If the film is dry, soak it for 10 minutes in distilled water. Immerse only one piece of film at a time in the intensifier. Intensification is done by visual inspection. You will see a slow darkening as the intensification occurs. The longer the film is in the solution the darker it will get. Chemicals are used once and discarded.

3. Remove the negative and rinse in running water.

4. The film will have excess silver nitrate that must be removed by fixing in a 30 percent sodium thiosulfate solution for 2 to 3 minutes.

5. Put the film in a plain hypo clearing bath, at normal working strength, for 2 minutes with constant agitation.

6. Wash the film for a minimum of 5 minutes.

7. Dry the film.

Reduction

Reducers are used to subtract density from completely processed film that has been overexposed or overdeveloped. Reduction can be tricky. Before attempting this process on an important piece of film, make some dupes and run tests to determine the correct procedures before undertaking a reduction of the original. A negative can undergo the reduction process more than once but overreduction cannot be undone. A negative can be reduced slightly, a test print can be made, and if it's not satisfactory the negative can be reduced again. Reducers are classified into three general types:

1. *Cutting* or *subtractive reducers* act first on the shadow areas and then on the midrange and highlights. They are excellent for clearing film fog. The net effect is to increase the overall contrast. Kodak R-4a (also known as Farmer's Reducer) is the most widely used and easiest to control cutting reducer. It is recommended for film that has been overexposed.

2. *Proportional reducers* decrease the image density throughout the film in proportion to the amount of silver already deposited. The effect is similar to that achieved by giving the film less development. Kodak R-4b is an example of a proportional

reducer. It is suggested for use with overdeveloped film.

3. *Super-proportional reducers* have a considerable effect on the highlight areas but hardly act on the shadow densities. They are the trickiest and most unpredictable reducers and are not often used.

Farmer's Reducer (Kodak R-4a) Procedure

Prepare stock solution A:

Water	250 milliliters
Potassium ferricyanide (anhydrous)	37.5 grams
Cold water to make 1/2 liter (500 milliliters)	

Prepare stock solution B:

Water	1,500 milliliters
Sodium thiosulfate (hypo)	480 grams
Cold water to make 2 liters	

To use, take 30 milliliters of solution A, add 120 milliliters of solution B, and add water to make 1 liter. Immediately put the film in this working solution. Watch the reducing action very carefully. After about 1 minute, remove and wash the film. Examine it. If it needs more reduction, return it to the solution. Repeat the examination steps every 30 seconds or so thereafter. Transfer the film to a water wash before the desired amount of reduction has taken place. (To slow the activity of the reducer, making it easier to control, cut the amount of solution A by 50 percent.) When the reduction is complete, wash the film for 5 minutes. Fix the film with an acid hardening fixer and give it a final wash before drying. Any residue left on the film can be removed during the final wash with a Photo-Wipe or cotton ball.

Farmer's Reducer (Kodak R-4b) Procedure

Prepare solution A:

Water	750 milliliters
Potassium ferricyanide (anhydrous)	7.5 grams
Cold water to make 1 liter	

Prepare solution B:

Water	750 milliliters
Sodium thiosulfate (hypo)	200 grams
Cold water to make 1 liter	

Place the film in solution A for 1 to 5 minutes at 68°F (20°C) with constant agitation. Transfer it to solution B for 5 minutes, then wash it. This process may be repeated if necessary. After the desired degree of reduction has been achieved, place the film in an acid fixer for about 4 minutes. Follow with a hypo clearing bath and a final wash.

FILM DEVELOPER FORMULAS AND THEIR APPLICATIONS

This section provides a number of useful formulas and their general applications. They are listed by their major developing agent and are offered as points of departure. Photographers should feel free to experiment and modify these formulas to reach their full visual potential. Tests should be carried out with all formulas before attempting to use them for critical work. Read and follow the information in Chapters 2 and 4 before using any of the formulas presented here. Many of the chemicals used are dangerous if not properly handled. Mix all formulas in the order they are given. Formulas are presented in both U.S. customary units and metric (when available).

Amidol Developer

Amidol (2,4-diaminophenol hydrochloride) was a popular developing agent in the first half of the twentieth century because of its high reduction potential. It was often used in a water-bath combination, since a small amount of amidol is capable of efficiently converting the silver halides into metallic silver. It contains no alkali, so there is minimum softening of the emulsion. Amidol does have a tendency to produce stains. It is used more today as a paper developer noted for its beautiful blue-black tones. Wear gloves at all times when working with amidol to avoid absorption of this substance through the skin. Ilford ID-9 is an easy-to-use amidol developer.

Ilford ID-9 Formula

Water (125°F or 52°C)	24 ounces (750 milliliters)
Sodium sulfite (desiccated)	3 ounces (100 grams)
Amidol	1/2 ounce (20 grams)
Potassium bromide	88 grains (6 grams)
Cold water to make 32 ounces (1 liter)	

This developer should be used as soon as possible after being mixed. Starting development time with a medium-speed film is 8 minutes at 68°F (20°C). Its standard useful range is 6 to 10 minutes.

Glycin Developer

Alfred Stieglitz and Joseph T. Keiley used glycin in the early part of the twentieth century as a contrast control for a developing technique used in making platinum prints. Glycin has since been used in modern fine-grain developers such as Ilford ID-60.

Ilford ID-60 Formula

Water (125°F or 52°C)	24 ounces (750 milliliters)
Sodium sulfite (desiccated)	291 grains (20 grams)
Potassium carbonate	2 ounces (60 grams)
Glycin	1 ounce (30 grams)
Cold water to make 32 ounces (1 liter)	

Dilute this formula at a ratio of 1:7. Starting development time with a medium-speed film is 15 minutes in a tank and 12 minutes in a tray at 68°F (20°C).

Hydroquinone Developer

Hydroquinone is usually used as a developing agent in combination with Metol (MQ formula) or Phenidone (PQ formula). It can be used as the sole developing agent in conjunction with an alkali, found in a B solution, to produce extremely high-contrast images. It loses much of its activity at a temperature of 55°F (12°C) or lower. It is used for line and screen negatives or for special high-contrast visual effects. Ilford ID-13 and Kodak D-85 are hydroquinone developers.

Ilford ID-13 Formula

Stock Solution A

Water (125°F or 52°C)	24 ounces (750 milliliters)
Hydroquinone	365 grains (25 grams)
Potassium meta-bisulfite	365 grains (25 grams)
Potassium bromide	365 grains (25 grams)
Cold water to make 32 ounces (1 liter)	

Stock Solution B

Sodium hydroxide	1¾ ounce (50 grams)
Cold water to make 32 ounces (1 liter)	

Caution: Sodium hydroxide generates heat when mixed and should be mixed only in cold water. If mixed in warm water, it can boil up explosively. Do not handle this chemical without full safety protection.

Equal parts of Stock Solutions A and B are combined immediately before use. This solution should be discarded after each use. Normal development time is 2½ to 3 minutes at 68°F (20°C).

Kodak D-85 (Kodalith developer)

Water (not over 90°)	1,500 cc
Sodium sulfite (desiccated)	90 grams
Paraformaldehyde	22.5 grams
Sodium bisulfite	6.6 grams
Boric acid crystals	22.5 grams
Hydroquinone	67.5 grams
Potassium bromide	9 grams
Water to make 3 liters	

Due to its rapid oxidation, mix the developer immediately before use and discard after each use. Normal development time is 2½ to 3 minutes at 68°F (20°C).

Metol Developers

Metol, also known as Elon and Pictol, is most often used in combination with a contrast-producing developing agent such as hydroquinone in an MQ formula. By itself it is used as a fine-grain, low-contrast, soft-working developer yielding excellent highlight density. If you have any allergic reactions to Metol, try switching to a Phenidone-based developer. Agfa 14, Kodak D-23, and Kodak D-25 are classic metol developers.

Agfa 14 Formula

Water (125°F or 52°C)	24 ounces (750 milliliters)
Elon	65 grains (4.5 grams)
Sodium sulfite (desiccated)	3 ounces (85 grams)
Sodium carbonate (monohydrate)	18 grains (1.2 grams)
Potassium bromide	7½ grains (0.5 gram)
Cold water to make 32 ounces (1 liter)	

Development time at 68°F (20°C) is 10 to 20 minutes, depending on the contrast desired. During development use a 15-second water rinse instead of an acid stop. An acid stop may cause the sodium carbonate to release CO_2 bubbles within the emulsion.

Kodak D-23 Formula

This Elon-sulfite developer is suitable for low- and medium-contrast applications. It produces negatives with grain and speed comparable to those developed with Kodak D-76.

Water (125°F or 52°C)	24 ounces (750 milliliters)
Elon	1/4 ounce (7.5 grams)
Sodium sulfite (desiccated)	3 ounces (100 grams)
Cold water to make 32 ounces (1 liter)	

Average development time for a medium-speed film is 12 minutes in a tank or 10 minutes in a tray at 68°F (20°C).

Kodak D-25 Formula

This is a fine-grain developer for low- and medium-contrast uses. The grain is softer than that produced with D-23.

Water (125°F or 52°C)	24 ounces (750 milliliters)
Elon	1/4 ounce (7.5 grams)
Sodium sulfite (desiccated)	3 ounces (100 grams)
Sodium bisulfate	1/2 ounce (15 grams)
Cold water to make 32 ounces (1 liter)	

With a medium-speed film, an average starting development time in a tank is about 20 minutes at 68°F (20°C).

Metol-Hydroquinone Developers

These MQ agents make up one of the most popular combinations for normal developers. The soft-working Metol (Elon) and the density-providing hydroquinone act together to create a phenomenon known as superadditivity—that is, the energy of the combination of the two is greater than the sum of the energies of the individual parts. This combination can deliver a good balance between the shadow and highlight areas while maintaining the film's speed, a tight grain pattern, and good tonal separation. Kodak D-19, DK-50, D-76, and D-82 are all metol-hydroquinone developers.

Kodak D-19 Formula

When mixed in the correct proportions, Metol and hydroquinone can produce a high-contrast, high-energy developer. Kodak D-19 was originally used to process X-ray film, but is now used for continuous-tone scientific and technical work requiring higher than normal contrast, as well as for special effects, including infrared processing.

Water (125°F or 52°C)	16 ounces (500 milliliters)
Elon	30 grains (2 grams)
Sodium sulfite (desiccated)	3 ounces (90 grams)
Hydroquinone	115 grains (8 grams)
Sodium carbonate (monohydrate)	1¾ ounces (52.5 grams)
Potassium bromide	75 grains (5 grams)
Cold water to make 32 ounces (1 liter)	

Average starting development time is 6 minutes in a tank or 5 minutes in a tray at 68°F (20°C).

Kodak DK-50 Formula

DK-50 is widely used in commercial and portrait work to produce a crisp negative.

Water (125°F or 52°C)	16 ounces (500 milliliters)
Elon	37 grains (2.5 grams)
Sodium sulfite (desiccated)	1 ounce (30 grams)
Hydroquinone	27 grains (2.5 grams)
Kodak Balanced Alkali (sodium metaborate)	145 grains (10 grams)
Potassium bromide	7½ grains (0.5 gram)
Cold water to make 32 ounces (1 liter)	

For commercial work, DK-50 is generally used without dilution. An average starting time would be 6 minutes in a tank or about 4½ minutes in a tray at 68°F (20°C). For portrait work using tank development, DK-50 is often diluted 1:1 and used for about 10 minutes at 68°F (20°C). In a tray, it is used undiluted for approximately 6 minutes at 68°F (20°C).

Kodak D-76

Formula D-76 was introduced in 1927 as a fine-grain developer for motion picture and still-camera films. This developer has remained so popular that most film manufacturers optimized their products for development with it. Pictorial photographers use D-76 for its ability to deliver full emulsion speed, its handling of low-contrast scenes, and its provision of maximum detail in shadow areas.

Water (125°F or 52°C)	24 ounces (750 milliliters)
Elon	29 grains (2 grams)
Sodium sulfite (desiccated)	3 ounces (100 grams)
Hydroquinone	73 grains (5 grams)
Borax (decahydrate)	29 grains (2 grams)
Cold water to make 32 ounces (1 liter)	

Average development time with D-76 undiluted in a tank is 8 to 10 minutes and in a tray 6 to 9 minutes at 68°F (20°C). With certain films, D-76 may be diluted 1:1 for greater sharpness and increased grain.

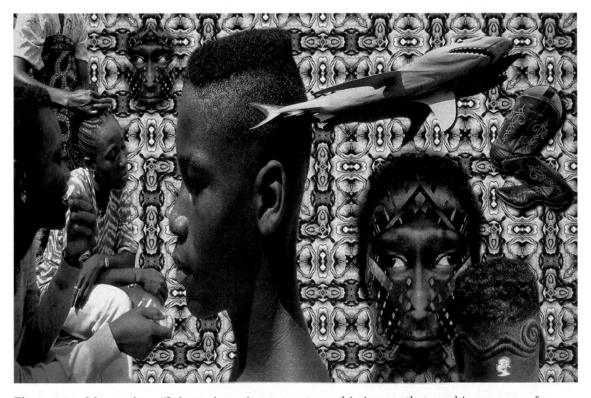

Figure 5.4 Marc writes: "It is my intention to create mythic images that combine a sense of implied narrative with the presence of ritual. The montages address cultural coding and private enigma. They usually contain elements that reflect an African American identity and refer to the complex relationships with mainstream society. Self-portraiture remains an important element in the work, which I recognize as a romantic search of my ancestral roots and cultural heritage. The montages are meant to function as a visual crossroads. They are made from film recorder 4 × 5 inch negatives of photos taken from my work, the family archives, and found antique photos. Some montages include objects placed directly on the scanner. I created the patterns using sections of photos, scanned objects, and drawings on paper and directly on the computer, and made analog prints using D-76 developer."

© Stephen Marc. *Untitled*, from the series *Soul Searching*, 1997. Gelatin silver print. 12 × 18 and 24 × 36 inches.

Development time will be about 1 minute longer.

Kodak D-82

Formula D-82 is a high-energy formula for underexposed negatives. It provides the utmost density with a minimum of exposure.

Water (125°F or 52°C)	24 ounces (750 milliliters)
Wood alcohol	1½ ounces (48 grams)
Elon	200 grains (14 grams)
Sodium sulfite (desiccated)	1¾ ounces (52.5 grams)
Hydroquinone	200 grains (14 grams)
Sodium hydroxide (caustic soda)	125 grains (8.8 grams)
Potassium bromide	125 grains (8.8 grams)
Cold water to make 32 ounces (1 liter)	

Caution: Dissolve sodium hydroxide only in cold water, as a great deal of heat is created when it is mixed. It is best to dissolve sodium hydroxide in a separate container of water and then add it to the solution after the hydroquinone. Stir vigorously.

Starting development time in a tank is 6 minutes and in a tray 5 minutes at 68°F (20°C).

Phenidone Developers

People who are allergic to Metol (Elon) should use Phenidone developers, which deliver results very similar to those produced by Metol developers. In combination with hydroquinone, a Phenidone developer becomes a superadditive PQ formula. Unlike Metol, Phenidone is actively regenerated by the hydroquinone, resulting in a developer that retains its activity longer.

The activity of Phenidone is about ten times that of Metol. Phenidone developers produce a denser fog than Metol developers. Since the type of fog created cannot be eliminated with potassium bromide, an organic restrainer such as benzotriazole is used. The purpose of the potassium bromide in Phenidone formulas is to stabilize the developer against the changes produced by the release of bromide during the development process.

Ilford Microphen Formula

Microphen is a fine-grain Phenidone developer that can also produce an effective increase in film speed without yielding a corresponding increase in grain size. Its high speed/grain ratio permits an increase of one-half f-stop without a change in the grain pattern. For example, HP-5 PLUS can be rated at 650 ISO instead of 400.

Water (125°F or 52°C)	24 ounces (750 milliliters)
Sodium sulfite (anhydrous)	3 ounces (100 grams)
Hydroquinone	77 grains (5 grams)
Borax	46 grains (3 grams)
Boric acid (granular)	54 grains (3.5 grams)
Potassium bromide	15 grains (1 gram)
Phenidone	3 grains (0.2 gram)
Cold water to make 32 ounces (1 liter)	

Starting development times range from about 4½ to 6 minutes at 68°F (20°C). Microphen can be diluted 1:1 or 1:3. The greater the dilution, the greater the acutance. Diluted developer works well for retaining key shadow and highlight details in subjects possessing a wide tonal range. Depending on the film and dilution of the developer, development times can range from 5 to 21 minutes, with an average being about 8 to 11 minutes, at 68°F (20°C).

Ilford ID-62

Formula ID-62 is a good general-purpose Phenidone developer.

Stock Solution:

Water (125°F or 52°C)	24 ounces (750 milliliters)
Sodium sulfite (anhydrous)	1¾ ounce (50 grams)
Hydroquinone	175 grains (12 grams)
Sodium carbonate (desiccated)	2 ounces (60 grams)
Phenidone	7½ grains (0.5 gram)
Potassium bromide	30 grains (2 grams)
Benzotriazole	3 grains (0.2 gram)
Cold water to make 32 ounces (1 liter)	

For tank development, dilute 1:7 and develop 4 to 8 minutes at 68°F (20°C). For tray development, dilute 1:3 and process 2 to 4 minutes at 68°F (20°C).

Ilford ID-68

Formula ID-68 is a low-contrast, fine-grain Phenidone developer.

Water (125°F or 52°C)	24 ounces (750 milliliters)
Sodium sulfite (anhydrous)	3 ounces (85 grams)
Hydroquinone	75 grains (5 grams)
Borax	92 grains (7 grams)
Boric acid	29 grains (2 grams)
Potassium bromide	15 grains (1 gram)
Phenidone	1.9 grains (0.13 gram)
Cold water to make 32 ounces (1 liter)	

Use undiluted. Starting times for tank development are 7 to 11 minutes and for tray development 4 to 7 minutes at 68°F (20°C).

Ilford ID-72

Formula ID-72 is a high-contrast Phenidone developer.

Water (125°F or 52°C)	750 milliliters
Sodium sulfite (anhydrous)	72 grams
Hydroquinone	8.8 grams
Sodium carbonate (monohydrate)	57 grams
Phenidone	0.22 gram
Potassium bromide	4 grams
Benzotriazole	0.1 gram
or	
Benzotriazole 1% solution	10 milliliters
Cold water to make 1 liter	

Use undiluted. Starting development time is approximately 5 minutes at 68°F (20°C).

POTA Developer

POTA is a very low-contrast developer originally designed to develop images of nuclear blasts, where the light ranged over 20 f-stops. Presently it is used primarily to develop Kodak Technical Pan Film to normal contrast for general pictorial use.

Water (100°F or 38°C)	750 milliliters
Sodium sulfite	30 grams
Phenidone A	1.5 grams
Cold water to make 1 liter	

Use immediately, as the solution deteriorates very quickly after it has been mixed. Starting development times range between 11½ and 15 minutes in a tank and 6½ minutes and 8 minutes in a tray at 68°F (20°C).

Pyro Developers

Pyrogallol, known as pyro and pyrogallic acid, has been used as a developing agent since the 1850s. Pyro creates a yellow stain in proportion to the metallic silver formed in the negative. Wear protective gloves, as pyro also will stain your fingers and nails. This yellow stain will block some of the blue light during the printing process. Although the negative may look flat, it will print with good contrast. Pyro also has been useful in developing underexposed film because the stain reinforces the silver image enough to make the thin negative more printable. It is even possible to bleach the silver away and print only from the stain, yielding a very fine-grain image. Pyro also has a tanning effect on the emulsion, hardening it during development. This reduces the lateral movement of the silver, producing a high degree of acutance. The tanning effect is more pronounced in fast, thick-emulsion films.

Pyro oxidizes swiftly. This can make it unpredictable when using the standard time/temperature method of development, as the amount of image stain depends on the degree of oxidation. For this reason, traditional workers, such as Edward Weston, developed the film by visual inspection under a faint green safelight. Presently pyro is rarely used. With fast, highly sensitive modern films, this process of visual inspection is not recommended, as the fog level might become too high.

Pyrocatechin (catechol) can be used with contemporary films to create a staining and tanning effect similar to that produced by pyro. It works well with fast, thick-emulsion films, especially when dealing with high-contrast scenes. It provides excellent separation in the highlight areas but reduces the speed of the film by about 50 percent. To make up for this speed loss, metol is sometimes added to the formula. The metol will not change the character of the developer.

Kodak D-1/Pyro ABC Formula

Stock Solution A

Water (65°F or 18°C)	24 ounces (750 milliliters)
Sodium bisulfite	140 grains (9.8 grams)
Pyrogallol	2 ounces (60 grams)
Potassium bromide	16 grains (1.1 grams)
Water to make 32 ounces (1 liter)	

Stock Solution B

Water (65°F or 18°C)	24 ounces (750 milliliters)
Sodium sulfite (desiccated)	3½ ounces (105 grams)

Water to make 32 ounces (1 liter)

Stock Solution C

Water (65°F or 18°C)	24 ounces (750 milliliters)
Sodium carbonate (monohydrate)	2½ ounces (90 grams)

Water to make 32 ounces (1 liter)

Mix and use fresh developer immediately. For tray development, the normal dilutions are 1 part each of stock solutions A, B, and C with 7 parts water. Develop for 6 minutes at 65°F (18°C). With a tank, take 9 ounces (285 milliliters) of solutions A, B, and C and add water to make 1 gallon (about 4 liters). Develop for about 12 minutes at 65°F (18°C). To minimize oxidation, mix solution B, solution C, and the water, and then add solution A immediately before using. If there is any scum on the surface of the developer, remove it with blotting paper before developing or unwanted stains may result.

PMK Formula

The PMK (Pyro-Metol-Kodak Balanced Alkali) formula solves two of pyro developer's problems: reduction in speed and rapid oxidization. Adding Metol to the formula combines the high degree of acutance and image stain of traditional pyro and adds stability and repeatability. PMK developers have an extremely long shelf life.

Solution A

Water (68°F or 20°C)	24 ounces (750 milliliters)

Add a few crystals of sodium bisulfite, then add the following:

Metol	145 grains (10 grams)
Sodium bisulfite	291 grains (20 grams)
Pyrogallol	3 ounces (100 grams)

Water to make 32 ounces (1 liter)

Solution B

Distilled water (68°F or 20°C)	48 ounces (1.4 liters)
Kodak Balanced Alkali (sodium metaborate)	21 ounces (600 g)

Water to make 64 ounces (2 liters)

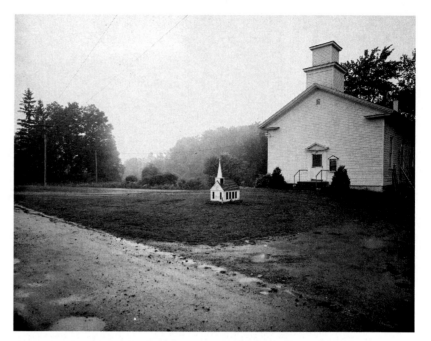

Figure 5.5 Using printing-out paper, which works well with a strong, contrasty negative (TRI-X at 100), Hunter achieved the results he wanted by using a modified Pyro ABC developer. This developer was a favorite when printing-out paper was most popular (1850 to 1920). The paper was exposed in sunlight until the highlights were slightly degraded and then fixed in two baths of rapid fix. The image was toned with gold chloride until the darkest shadows lost their green cast and took on a lavender color.

© Frank Hunter. *Methodist Church, Mexico, New York*, 1985. Toned printing-out paper. 8 × 10 inches.

Mix solutions A and B in the following proportions: 1 part A and 2 parts B to 100 parts water. While mixing parts A and B the solution will change color from green to a pale yellow. The Photographers' Formulary makes both a powdered and liquid PMK formula consisting of stock A and B solutions.

An alkaline fixer solution is necessary to achieve maximum pyro stain. An acid rapid fix may diminish staining effects of both pyro and PMK formulas. You can increase the yellowish stain by putting the processed and fixed negatives back into the developer.

Pyrocatechin Compensating Developer Formula

Solution A

Water (68°F or 18°C)	100 milliliters
Sodium sulfite (desiccated)	1.25 grams
Catechol (pyrocatechin)	8 grams

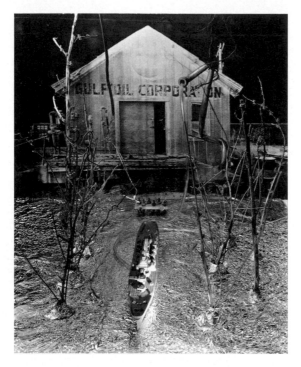

Figure 5.6 In this series Dru Germany uses the framework of a character study to explore gender, power, technology, and free will. The still life setups are done in the studio with backdrops that have been digitally produced from photographs she makes in the town where she lives. The negatives are scanned, manipulated, and outputted on a digital printer using 11 × 17 inch photo-quality paper. The prints are then enlarged on an architectural photocopy machine and become the backdrop for the scene. The setup is proofed with a digital camera and then shot with an 8 × 10 inch camera. The negatives are processed in PMK developer from the Photographers' Formulary to achieve the high degree of acutance needed to make mural size prints.

© Robin Dru Germany. *#78, James*, from the series *The Palimpsest Portraits*, 1998. Toned gelatin silver print. 8 × 10 inches and 48 × 38 inches.

Solution B
Sodium hydroxide 1 gram
Cold water to make 100 milliliters
Caution: Mix sodium hydroxide only in
 cold water.

Immediately before use, mix solutions A and B in the following proportions: 20 parts A and 50 parts B to 500 parts water. Starting development times are 10 to 15 minutes at 68°F (20°C).

Paraminophenol/Rodinal Developers

Paraminophenol, better known by its trade name, Rodinal, has been used as a developing agent since the 1890s. It can be prepared in a very concentrated solution that lasts for a long time, and diluted with water to create an excellent general-purpose developer. When used with fast film having an ISO of 400 or more, Rodinal produces a visible but very tight, sharp-edged grain pattern.

Paraminophenol Formula

Stock Solution A
Boil 10 ounces (625 milliliters) of water,
 then allow it to cool for 5 minutes.
Add a few crystals of potassium
 metabisulfite, then add the following:

Paraminophenol hydrochloride	384 grains (50 grams)
Potassium metabisulfite	2 ounces (150 grams)

Stir until dissolved.

Stock Solution B

Sodium hydroxide (caustic soda)	3 ounces (215 grams)
Cold water	8 ounces (500 milliliters)

Caution: Use cold water only.

Add 6 ounces (350 milliliters) of the B solution to the A solution, stirring constantly. A precipitate of the paraminophenol solution will form but will dissolve as more sodium hydroxide is added. Put in enough sodium hydroxide to almost dissolve this precipitate.

Add cold water to make 16 ounces (1/2 liter). Place in a tightly closed opaque bottle and allow to cool. If any of the paraminophenol crystallizes, add more sodium hydroxide to nearly dissolve it. It is necessary to leave some of the paraminophenol undissolved to make the developer work properly.

Mix 1 part of the bottled solution with 10 parts of water for use with negatives. Starting development times are about 6 to 10 minutes at 68°F (20°C).

Rodinal Highlight Formula
This is a modified formula based on commercially prepared Rodinal that can deliver better performance in the highlight areas with contemporary films.

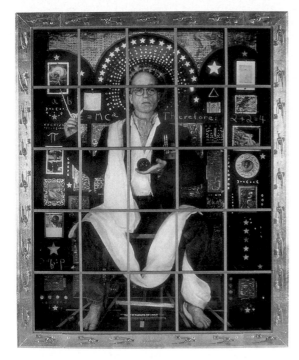

Figure 5.7 Campbell's work refers to the sacred artistic tradition of the West to examine contemporary beliefs. Here, she creates a "chapel" in the form of an artificial universe dedicated, tongue-in-cheek, to Western rationalism, ironically critiquing its effects on nature and ourselves. The light boxes connote the stained glass windows of medieval cathedrals. The portraits are photographed with a 6 × 7 cm format camera on TRI-X film and processed in Rodinal to achieve a sharply defined grain pattern. She hand-painted the black-and-white prints and rephotographed them using color negative film. The final images are on color Duratrans, a positive transparency material. (See Color Plate 1.)

© Kathleen Campbell. *Rational Being*, from the series *Modern Theology Or a Universe of Our Own Creation*, 1996. Color Duratrans and mixed media. Light box installation. 4 × 5 feet. Original in color.

Water (70°F or 21°C)	350 milliliters
Rodinal	7 milliliters
Hydroquinone	1.3 grams
Water to make 500 milliliters	

This formula is for only one roll of film to be developed in a two-reel tank. For two rolls, double the amount of Rodinal and water and process in a four-reel tank. Starting development times at 70°F (21°C) are as follows: one roll of Plus-X or FP-4, 11 minutes; two rolls, 12 minutes; one roll of TRI-X or HP-5 PLUS, about 15 minutes.

Agitate the film for the first complete minute, then 10 seconds for each minute after, allowing the tank to stand still between agitations.

XTOL

One of the newest developers is based on a vitamin C derivative (sodium isoascorbate) and a modified form of Phenidone. For decades it was known that ascorbic acid (vitamin C) acts as a reducing agent and can be used as a developing agent in a high-alkalinity solution. As early as the 1940s, Kodak chemists worked with an ascorbic acid-based developer. Ascorbic acid made its commercial debut in 1996 as Kodak XTOL. XTOL has been hailed as the replacement for D-76 because of its low toxicity, superior speed, finer grain, excellent sharpness, and ease of use and replenishment. The formula provided gives a close approximation to Kodak's patented process (US Patent 5,756,271, 1998).

XTOL Approximation Formula

Part A

Sodium sulfite anhydrous	10 grams
Diethylene-triamine-pentaacetic acid, pentasodium salt (40%)	1 gram
Sodium metaborate (8 mole)	4 grams
4-Hydroxymethyl-4-methyl-1-phenyl-3-pyrazolidone (Phenidone)	0.2 grams

Part B

Sodium sulfite anhydrous	75 grams
Sodium metabisulfite	3.5 grams
Sodium isoascorbate	12 grams

Add part A to 750 ml of water at room temperature; follow with part B and water to make 1 liter. Depending on the dilution, starting development time is between 6 and 8 minutes at 68°F (20°C).

MYTOL

Paul Lewis developed another formula using ascorbic acid and Phenidone as developing agents. The Phenidone provides good low-contrast shadow detail and is superadditive with ascorbic acid. Called MYTOL, the developer can be used straight, but a 1:2 dilution is recommended. Increasing the

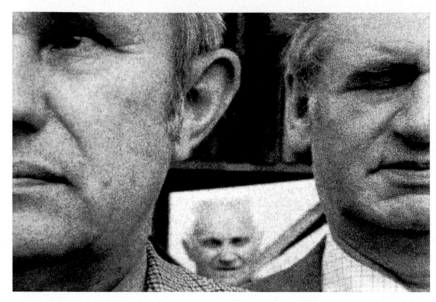

Figure 5.8 Friedman says, "While the original full-frame 35 mm black-and-white depicts the Holocaust survivors in an objective manner, the cropped version is a grim, claustrophobic, and confrontational picture." Processing in Edwal FG-7 with extra sodium sulfite gave Friedman the acutance to enlarge a small portion of the negative. Today commercial developers like Kodak XTOL provide a more convenient and environmentally friendly way of achieving similar results.

© James Friedman. Survivor's Reunion, Majdanek Concentration Camp near Lublin, Poland, *#42*, from the series *12 Nazi Concentration Camps*: 1983. Toned gelatin silver print. 20 × 24 inches.

dilution increases the relative speed of the developer but dilutions of 1:1 or 1:2 are recommended. Average starting development time is 9 minutes in a tank or 8 minutes in a tray at 68°F (20°C).

MYTOL Formula

Distilled water (80°F or 27°C)	750 ml
Sodium sulfite anhydrous	60 grams
Kodak Balanced Alkali (sodium metaborate)	4 grams
Sodium ascorbate	13 grams
Phenidone	0.15 grams
Sodium metabisulfite	3 grams
Water to make 1 liter	

WHY BOTHER?

You may ask, "Is all this really necessary? What difference does it make whether I know the components of a developer and how they work?" The information provided in this chapter increases your visual options. In many photographic situations, you cannot control the circumstances under which you make the picture. On the contrary, you are forced to work with conditions as you find them. This additional information will help you to make the most out of what has been dealt you. Mixing your own formulas is another way for you to educate yourself. This knowledge can give you the flexibility and power to repudiate conformity. It provides an alternative to mediocrity and stagnation by helping you realize the full potential of your vision. Strong feeling and passion are not enough to make the complete statement. Photographers also need craftsmanship and precision. The blend of spirit and knowledge can result in the organization of chaos, enabling photographers to picture what is inside their hearts and minds.

ADDITIONAL INFORMATION

Adams, Ansel, and Robert Baker. *The Negative*. Boston: Little Brown, 1995.

Anchell, Stephen G. *The Darkroom Cookbook*. Second Ed. Boston: Focal Press, 2000.

Anchell, Stephen G., and Bill Troop. *The Film Developing Cookbook*. Boston: Focal Press, 1998.

Donofrio, Diane (Ed.). *Photo-Lab-Index, The Lifetime Edition*. Keene Valley, NY: Morgan and Morgan, 2001.

Wall, E.J., and F.I. Jordan; rev. and enlarged by John S. Carroll. *Photographic Facts and Formulas*. Englewood Cliffs, NJ: Prentice-Hall, 1976 (out of print).*

6 Analog Printmaking: Equipment, Materials, and Processes

THE ANALOG PRINTMAKING PROCESS

The analog printing process offers the photographer countless ways of interpreting what has been recorded on film. It is not a mechanical process of simply translating what is on the negative into a print. The negative is a point of departure. It provides the photographer with the raw material to prepare the final product. If nine different photographers were given the same negative to print, the chances are that nine different renditions would be made. Ansel Adams said that "the negative is like a musical score and the print is the performance." When the photographer makes a print from the negative, it begins a life of its own.

The negative provides the basic construction information for the creation of the print. Although printing offers the photographer a second chance to correct for technical errors in exposure and processing, defects such as poor lighting or unsharp focus cannot be corrected. Most important, however, printing gives photographers the opportunity to further express themselves by defining their relationship to the subject.

To make a good negative one must comprehend that the human eye has a range of only about ten f-stops and photographic paper has a limit of about three f-stops. In practice, the photographer must decide how to expose the film to obtain the desired range of tones within these physical limits. The

Zone System (see Chapter 1) applied sensitometry to the nineteenth-century maxim, "Expose for the shadows and develop for the highlights" to deal with this situation.

Generally, a properly exposed negative having good shadow detail provides the information needed to permit a successful visualization of the subject. Continued difficulties with weak, underexposed negatives indicate the need to (1) make sure all equipment is functioning properly, (2) review exposure methods, and (3) go over film processing procedures. Without a good negative, printmaking is a difficult, frustrating, and joyless chore.

Most photojournalists do not make their own prints. The process is carried out by others because their pictures are primarily designed to be seen as inky reproductions in magazines and newspapers and not as fine art on a gallery wall. However, for many photographers, this is not an acceptable practice. The act of printmaking offers them the final degree of personal satisfaction in dealing with the subject. Printmaking means taking control, making decisions, and becoming emotionally and physically involved in the process of determining the final outcome of the image.

The printmaking process brings together all a photographer's ideas, knowledge, equipment, and technique to express in a concrete form what was seen and felt. A good print demonstrates both the objective and subjective experience, conveying a

sense of the physical reality and the photographer's reaction to it. Good printing reflects a combination of the underlying concepts behind the image, technical knowledge, practice, and patience and is constantly open to reevaluation.

Styles in Printmaking

Beginning in the 1930s and going through the late 1960s, the "straight" aesthetic dominated printmaking. The straight style is reflected in the work of photographers such as Paul Strand and Edward Weston. Generally, their prints are made on a silver-based glossy paper from a negative that is not altered except to correct for technical shortcomings. Their prints express a complete range of clearly separated tones that reveal form and texture in the key highlight and shadow areas that were visualized at the time the negative was exposed.

A movement in alternative printmaking that started in the 1960s has expanded the definition of printmaking practice. The alternative printmakers revived old processes and experimented with new ones, often blurring the distinction between the two boundary lines. They used different types of papers and emulsions, manipulated the negative for subjective reasons, combined photography with other media, combined new and old images, appropriated images from other sources, and in general dispensed with the rules of what was considered acceptable. This chapter deals with the printing of traditional silver-based materials. The other styles of printmaking are discussed in later chapters.

Learn What Is Available

It is vital for photographers to become acquainted with the numerous avenues available to express their vision. Imagine how boring it would be if all photographs were required to be printed according to the same set of guidelines. Tremendous visual possibilities lie in producing quiet, soft, subtle prints with a limited range of tones. In other cases, snappy renditions with strong contrast, stressing deep blacks and solid whites, may be required. It is up to the photographer to decide which style best expresses the situation.

There is no right or wrong style of printmaking. Photographers should consider making prints in a variety of ways to expand their personal expression. Printmaking is a highly personal and subjective response to the factual and emotional experience of the subject. The temporal relationship between the negative and the print is in flux, altering the aesthetic response each time a print is made. In the past there were those who advocated that negatives and prints should be made as quickly as possible to elicit the "purest" response to the subject. But other expressive printers like Josef Sudek had a different approach in which the negative has to be put "to one side" and time is allowed to pass before one knows the appropriate way to make the print. Sudek stated: "It takes me some time to realize if a photograph is any good or not. . . . If you do the positives right away you'll probably be disappointed; my memory still retains too vivid an image of the real landscape, with which you cannot compare a photographic image, because it is impossible to photograph things as they are. Only when the memory fades am I capable of finding out how someone who has not seen the reality with me may see the photograph. I think that for photographs like mine haste is a poor counselor."[1]

What Makes a Good Printmaker?

One becomes a good printer by printing and discovering what methods and techniques allow your personal vision to be realized. This involves making lots of prints to see what happens. The best way to see visual possibilities is to make one more print and compare it with the previous ones. This means following through with additional ideas and not worrying that everything you do turns out to be a "success." Part of the course of discovery and learning is coming to terms with failure, for without it knowledge would be static. Becoming a good printer means overcoming fears and prejudices, temporarily suspending judgment, and trying a different approach to see what

[1]Otakar Chaloupka. The artist Josef Sudek speaks. *Ĉs. fotografie* 1963;11:373.

occurs. In black-and-white printing, the amount of sensitivity displayed in rendering the scale of tones in relation to the aesthetic and emotive concerns of the subject determines how well the print succeeds.

The best printmakers learn all they can about their craft and then forget it. They have mastered and can control the process but are not bound to a set of established rules. Good printers use their knowledge as a point of departure to travel into the unknown. The German philosopher Friedrich Nietzsche said, "The powerful man is the creative man, but the creator is not likely to abide by the previously established laws." A good printmaker is like a magician who is able to amuse, amaze, astonish, enchant, and reveal.

To help ensure that you do not overlook possibilities, closely inspect your negatives on a light table and make contact sheets. In the darkroom, through visual trial and error, make a series of test prints to determine the correct exposure time for the grade of paper that will yield the desired amount of contrast.

Do not hesitate to crop or enlarge portions of your negatives. There is nothing written in stone stating that a negative must be printed full frame. Alfred Stieglitz had no qualms about cropping when it would deliver the visual results he desired, as in *Winter on Fifth Avenue*, 1892. It is also permissible to return to old negatives and give them a new interpretation. Ansel Adams printed *Moonrise, Hernandez, NM*, 1941, for decades, even altering the original negative through intensification to achieve more dramatic renditions. A good print visually articulates a particular set of circumstances at a given time and place. Later it is possible to discover significant things we did not originally recognize and see how each negative can hold numerous interpretations, recollections, and identities. William Henry Fox Talbot's Cambridge tutor, William Whewell said, "Of all the visits of old friends the most agreeable and the most affecting is the visit form a man's former self." Ultimately the goal should be to let photography be photography and not overburden the process with unnecessary dogmas or rules. Nor should one sanctify the moment of taking over the moment of making. The journey that a photographer makes to find a satisfac-

tory pictorial representation should be given the same credence as the origin of the photograph.

Good printmakers maintain their sense of wonder. They retain the ability to be astonished, and continue to get excited every time the image emerges in the developer. For them printmaking is more than completing the process of transforming negative tones into positive ones. It is a creative, expressive, and flexible act that requires thought, feeling, and control. The camera provides the appearance of the subject, and the intelligent printmaker supplies meaning and emotion. Good printers are dreamers and risk takers who find ways to breathe life into the image so the viewer can interact with it and discover meaning. Printmaking is an art that blends concrete technical processes with subjective feelings. If a print is lacking in one of these areas, it will not be successful.

Printmaking techniques are not difficult to learn and can be mastered with practice, patience, and discipline. Finding a photo-

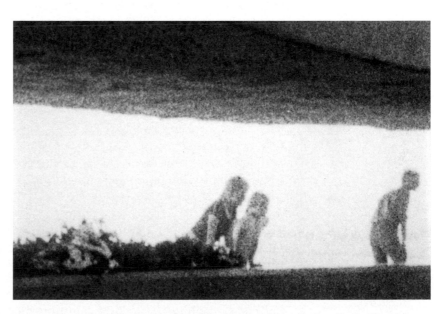

Figure 6.1 Friedman recorded this scene using a Leitz 21 mm Super Angulon lens, which delivers great depth of field, and then enlarged a small section of the 35 mm negative. Friedman states that "by radically isolating and enlarging a segment of the full frame photograph, I transformed a picture about a memorial sculpture created to honor those who were murdered at Majdanek concentration camp into a photograph about tourists who visit the site."

© James Friedman. *Tourists at Monument Designed by Sculptor Wiktor Tolkin that Includes Three Tons of Human Ashes from Majdanek's Crematoria, Majdanek Concentration Camp, near Lublin, Poland*, from the series *12 Nazi Concentration Camps*, 1983. Toned gelatin silver print. 20 × 24 inches.

graphic voice to express yourself is a much more complex matter. It means listening to yourself and then pursuing that direction by exposing film and making prints. The key is to devote the time needed to explore these inner processes. Ultimately one may ask if being an artist is an innate ability or one that can be learned, and wonder if following these suggestions will make a difference. The answer is maybe and maybe not, but how will you know unless you try? These pathways should help you organize and more thoughtfully present your ideas in visual form.

As you gain printing experience, you will acquire items of personal preference. There is no need to rush out and buy everything at once. Find out exactly what you need before making any purchases. Do not get carried away. More equipment will not necessarily make you a better printer or produce a more powerful image. If lack of specific equipment is preventing you from producing photographs, acquire what is necessary to make the image. The printmaker's job is to find a convincing way to give concrete form to the dream that is encapsulated in the negative.

PRINTING EQUIPMENT

The Enlarger

The enlarger is the fundamental instrument in most photographers' darkrooms. Considerable thought should be given to the following items when choosing an enlarger.

Size
The size of an enlarger refers to the maximum negative size it can handle. Enlargers are widely available in sizes from 35 mm (24 × 36 mm) up to 8 × 10 inches (20.3 × 25.4 cm). When purchasing an enlarger, choose a machine capable of handling the largest negative that you anticipate using. A 4 × 5 inch enlarger is generally a good investment because it is versatile and allows you room to work with all the widely used negative sizes. Even if you plan to work only with roll film, a larger format enlarger can ensure uniform light coverage of the negative. Some enlargers experience a falloff of light in the corners (vignetting) when used with their maximum negative size.

Illumination
Any size of enlarger can distribute light evenly across the negative in a number of different ways. The two major methods are known as the condenser and the diffusion systems.

In a *condenser system*, the illumination generally comes from one very bright tungsten bulb, which is often frosted to reduce contrast. In the better systems, the light is focused through plano-convex lenses, with the convex sides facing each other. The lenses focus the light into straight parallel lines known as a collimated beam. A condenser enlarger provides greater image sharpness and contrast than a diffusion enlarger. Many 35 mm photographers prefer this system because of its ability to retain image sharpness at high levels of magnification. Condenser enlargers generally form brighter images and thus provide the fastest exposure times.

The disadvantages of condenser systems include the fact that any defects in the negative, as well as grain and dust, are emphasized in the print. There also can be a loss in tonal separation in the highlight areas due to the Callier effect.

The *Callier effect* refers to the way the light is scattered by the silver grains that form the image. In a condenser system, the highlights of the negative, which have the greatest deposits of silver, scatter and lose the most light. The shadow areas, having the least amount of density, scatter the least amount of light. The net effect is that the upper highlight values can become blocked and detail is lost. The Callier effect also accentuates the differences between the shadow and highlight areas, delivering a print with greater contrast.

The degree to which this effect is revealed in the print varies widely due to differences in the design of the various enlargers. The Callier effect is not as noticeable in films with a thin (slow) emulsion. It is barely perceptible in chromogenic films, in which the final images are formed with colored dyes instead of silver.

To compensate for the Callier effect when printing with a condenser system, some photographers slightly reduce their development time. This produces more separation in the highlight areas. If the development time is reduced too much, there will

be a loss of separation in the lower shadow tones.

In a *diffusion system*, the illumination is diffused. The most popular diffused-light source is the cold light. It consists of a fluorescent grid or tube that is situated behind a diffusing screen. The cold light produces very smooth, uncollimated light, which is not affected much by the Callier effect. This enables the upper highlight areas to be printed without blocking up. Also, since the cold light does not produce much heat, there is no problem with negatives buckling. The cold light tends to minimize the effects of dust and other minor imperfections in the negative, thereby reducing the amount of spotting required in making the print.

Cold lights require their own transformers and are extremely sensitive to voltage fluctuations and temperature changes. A voltage stabilizer or a light-output stabilizer, which monitors the intensity of the tube and automatically adjusts it, is highly recommended to make printing more consistent. Certain solid-state digital timers cannot be used with cold lights because the surges of current produced by the tube can damage the timers. Diffusion systems that operate with tungsten bulbs help you avoid these difficulties, but they can produce enough heat to cause buckling with larger negatives.

Diffusion systems are generally slower than condenser systems, and require longer exposure times. Prints made with a diffusion enlarger also tend to appear less sharp. Diffusion models work best with larger negatives, which require less magnification, making sharpness less critical. Compared to a condenser, a diffusion enlarger will reduce overall contrast. A cold light tends to lower contrast in the shadow areas. This effect is not as noticeable with diffusion systems using incandescent bulbs.

Both condenser and diffusion systems offer advantages and disadvantages. Ideally, it is advantageous to have access to both types. When the opportunity presents itself, try out both systems and see if your aesthetic and technical considerations are more fulfilled by one system than the other.

Negative Carriers

The negative carrier is made to hold the negative flat and parallel to the enlarging lens. There are two basic types of carriers: glass

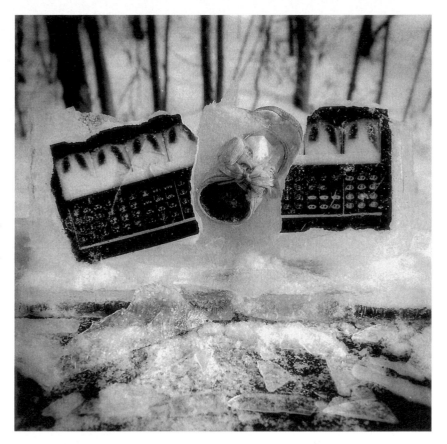

Figure 6.2 Nakagawa tells us that this series revolves around a time when, "I found out that my father was dying of cancer and that my wife was giving birth to our daughter. Photographing became a way for me to 'slow down' and question things that were happening to me as change brought a different rhythm to my life. I became fascinated with preserving and creating memories by constructing visual connections and relationships between my family members. Through this cycle of age, I began to recognize time as being circular, where the beginning and end can occur simultaneously." Nakagawa wanted to maintain a critical narrative of death and birth without being overtly emotional or nostalgic. He did this by using a Zone VI variable-contrast cold light enlarger head and a cold-tone paper (Ilford Multigrade IV FB, Glossy) with warm-tone developer (Agfa Neutol WA) and very weak selenium toning solution to create subtle tonality changes.

© James Nakagawa. *C.A.T. Scan and Baby Shoe, Bloomington, IN, Winter,* 1999, from the series *Kai*, 1998–1999. Toned gelatin silver print. 14 × 14 inches.

and glassless. A glassless carrier is most often used with negative sizes up to 4 × 5 inches. A glass carrier is usually recommended with negative sizes of 4 × 5 inches or larger to make sure that the film remains flat. Two advantages of glassless carriers are that you only have to worry about keeping the two sides of the negative (rather than the four additional surfaces of the two pieces of glass) from collecting dust and also that there are no Newton rings to be concerned with.

Table 6.1 Normal Enlarging Lenses Compatible with a Given Format Size

Format	Normal Focal Length	Wide-Angle Focal Length
35 mm	50 mm	40 mm
6 × 6 cm	75 mm to 80 mm	60 mm
6 × 7 cm	100 mm to 105 mm	80 mm
6 × 9 cm	100 mm to 105 mm	80 mm
4 × 5 inch	150 mm to 160 mm	135 mm
5 × 7 inch	210 mm (8½ inch)	Not recommended
8 × 10 inch	300 mm–360 mm (12–14 inch)	Not recommended

Newton Rings Newton rings are the iridescent concentric circles that occur when the film and glass are pressed together with an uneven amount of pressure. They are caused by the interference effect of light reflecting within the tiny space between the glass and the base side of the negative. They do not occur between the glass and the emulsion side of the film. Changing the amount of pressure between the glass and the negative should cause the Newton rings to disappear. Some photographers have reportedly solved this problem by gently rubbing the glass surface of the negative carrier with jeweler's rouge to roughen the glass. An unexposed sheet of Kodak Professional B/W Duplicating Film (available in 4 × 5 inch or 8 × 10 inch sheets) can be fixed, washed, cut to size, and placed between the glass and the negative to eliminate this problem.

Negative Curl Most negatives will curl slightly toward the emulsion side. This can cause the image to be slightly less than sharp. You can correct this by stopping the lens down to a smaller aperture to increase the depth of focus.

Negative Pop If the enlarger light is left on for a long time during composing and focusing, the negative can overheat and pop up, changing its position. If this happens, let the negative cool down and refocus.

Enlarging Lenses

Enlarging lenses need to be sharper than camera lenses to resolve the grain or dye pattern in the film during printing. A typical 35 mm camera lens may record 100 line pairs per millimeter (lp/mm) of information on the film, but a good enlarging lens is capable of resolving 300 lp/mm. This translates into better grain definition, delivering sharper

prints and clearer separation of tonal values. The higher resolving power of an enlarging lens also enables it to outperform most camera lenses when doing flat copy or macrophotography. Adapter rings are available to mount enlarging lenses on cameras for such purposes.

Field Flatness The characteristics that make a good enlarging lens are not the same as those that determine a good camera lens. Since the negative and paper are flat during the exposure of the print, a good enlarging lens needs to have a flat field of focus. The problem is that the field curvature of a lens changes with distance, meaning a lens can have a truly flat field at only one distance.

Most camera lenses can tolerate some field curvature, but enlarging lenses cannot. A camera lens typically has a flat field of focus at about thirty feet. The average enlarging lens has a flat field at a magnification of about 4×, with an acceptable flatness range from about 2× to 6×.

If the lens does not produce a flat field of focus, it will not be possible to get both the center and edges of the image sharp. Stopping down the lens to a small f-stop, thus increasing the depth of field, can help correct focusing problems caused by a lack of field flatness.

Focal Length It is important to have an enlarging lens of the proper focal length to match the format size of the negative. The general rule is to have the focal length of the lens about equal to the diagonal measurement of the negative in order to make a conventional looking print.

A wide-angle lens has a focal length 20 to 25 percent shorter than that of a normal lens. This means the wide-angle lens is capable of increasing the image size by about 30 percent at the same enlarger height as a normal lens. The biggest problem with wide-angle lenses is that they have more image falloff in the corners than an enlarging lens with a normal focal length. Table 6.1 lists the starting points for various types of enlarging lenses that are compatible with given negative formats to deliver normal pictorial results. Variation from these rules can produce other types of visual effects. For instance, using a 105 mm enlarging lens with

a 35 mm negative will compress the visual space.

All lenses make a somewhat brighter image in the center than they do at the edges. Just as with a camera lens, an enlarging lens generally provides optimum image sharpness if it is stopped down two to three f-stops from its widest aperture.

Using Longer than Normal Focal Length Lenses Some printers prefer a longer focal length enlarging lens than normal, like an 80 mm lens with a 35 mm negative, because it uses only the center of the lens's field of view. This means that resolution is at its peak, making for better definition at any given f-stop, and avoids the problem of illumination falling off at the edges. The disadvantage is the need for a greater distance from the lens to the easel, which requires the enlarger to be raised to a higher level. This increases the exposure time and can surpass the capacity of the enlarger's bellows to focus the image.

Focus Shift An enlarging lens should be color corrected and free from major aberrations. Poorly corrected lenses can create spherical aberrations, which lower image definition and produce focus shift. When a lens is at its maximum f-stop (wide open), the image is created by the center and edges of the lens. When the lens opening is stopped down to a small f-stop to make the print, only the center of the lens is used to form the image. If the lens is poorly corrected, using only this tiny central portion can cause the point of focus to shift, which results in a loss of image sharpness.

Dirt and Flare Make sure the enlarging lens is always clean and there is no light flare from leaks around the enlarger. Both these conditions will produce a loss of contrast in the print.

Inexpensive enlarging lenses usually have four elements. Lenses having fewer than four elements are not recommended. Better quality lenses normally have six or more elements. They are better corrected for color and may be labeled APO (apochromatic). They probably will deliver better definition in black-and-white printing as well.

Safelights

Most conventional black-and-white papers can be conveniently used under specific safelight conditions. Normal-graded papers are sensitive only to blue light and can be handled under a fairly bright yellow safelight. Variable-contrast papers are sensitive to a wider band of the spectrum and may require a different safelight filter. A light amber filter, such as Kodak's OC, is a good general choice when working with both graded and variable-contrast papers. Check the specific manufacturer's instructions before use.

For use with contact papers, Kodak recommends using its OA filter (greenish yellow). Panchromatic papers (sensitive to the full visible spectrum), such as Kodak Panalure, are designed to produce an accurate tonal translation of a color negative into a black-and-white print. They are sensitive to a much broader range of the spectrum and should be handled under a No. 13 safelight filter (amber) or in total darkness. Orthochro-

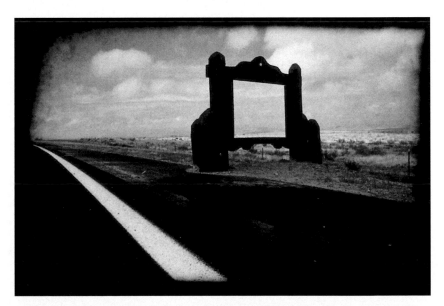

Figure 6.3 The choice of enlarging lens can greatly affect the look of the final print. The 35 mm negative for this image was made with an 18 mm Nikkor lens, but rather than use a standard 50 mm enlarging lens, Hirsch chose a 105 mm Componar lens. This combination purposefully plays with the viewers' sense of pictorial space by taking the distortion of a very wide-angle camera lens (100 degree view) and then condensing it with a slightly telephoto enlarging lens. This fabrication of a new pictorial space reminds us how much artifice there is in the creation of a photographic print.

© Robert Hirsch. *Untitled* (detail), from the series *The Architecture of Landscape*, 1999. Toned gelatin silver print. 20 × 16 inches. Courtesy of CEPA Gallery, Buffalo, NY.

Table 6.2 Safelight Filters and Their General Applications

Color	Kodak Safelight Filter	Application
Yellow	(OO)	Black-and-white contact and duplicating material
Greenish Yellow	(OA)	Black-and-white contact and duplicating material
Light Amber	(OC)	Contact and enlarging papers
Red	(No.1)	Blue-sensitive materials
Light Red	(No.1A)	Slow orthochromatic materials
Dark Red	(No.2)	Faster orthochromatic materials
Dark Green	(No.3)	Panchromatic materials
Brown	(No.6B)	Blue-sensitive X-ray films

matic (not sensitive to red) materials—for instance, litho films such as Kodak Commercial Film—need to be handled under a red safelight such as a Kodak No. IA, No. 1, or No. 2. These filters are safe for most papers except the panchromatic types.

Safelights come in a variety of styles and price ranges, from inexpensive models that screw into a light fixture to powerful ceiling-mounted sodium-vapor units. Some lamps offer the versatility to switch filters to match whatever paper is being used. Ruby lamps, with the filter built into the glass, are a very inexpensive alternative to safelights, although some workers claim that some of these bulbs are not safe and will fog the paper. It is best to test all safelights periodically with the specific materials being handled under them. In addition, the distance of the safelight from the paper, the brightness of the bulb, the age of the filter, and the number of safelights used are all factors in fogging.

If a safelight fogs the paper before it is exposed, this process is called hypersensitization. The most frequent cause of safelight fog is latensification, which occurs if the safelight fogs the paper after it has been exposed. Minimum amounts of safelight fog are noticeable as a loss of contrast in the upper highlight values. This causes the tones to become more compressed and lowers the overall contrast of the image. As the fog level increases, the print becomes denser (darker), most noticeably in the highlight areas. Table 6.2 provides a list of common safelight filters and their general applications.

Safelight Testing

The safelight's bulb size and distance from the print should permit safe handling of the material for about 5 minutes. You can perform several different tests to ensure selection of the proper safelight.

Quick Test Under operating safelight conditions, place an opaque object, such as a coin, on a piece of printing material. Leave it there for 5 minutes and then process the paper. If a white area is visible, safelight correction is required.

Pre-exposure Test Using the enlarger, pre-expose the paper to make a very faint gray tone. Pre-exposed paper is more sensitive to small amounts of light than unexposed paper and so pre-exposing the paper makes the test more accurate. After pre-exposing the paper, place an opaque object in the center of it and position the paper at the normal distance it will be from the safelight. Leave it there for 2 minutes. After processing, the outline of the object should not be visible. To find the maximum safelight time, repeat the test, adding 1 or 2 minutes of safelight exposure until the outline of the object becomes visible.

Real-Thing Test In total darkness, make an exposure that will produce a full tonal range print. After making the exposure, cover half the paper with an opaque piece of paper, turn on the safelight, and put the paper under the safelight, at its normal distance, for 2 minutes. Turn the safelight off and process the paper. After processing, visually compare the two halves. If a careful examination of the two, especially in the highlight areas, does not reveal any loss of contrast or increase in density, the safelight can be considered safe with that particular paper under those conditions.

General Safelight Guidelines

- Match the safelight designation with the type of paper being used.
- Minimum distance with a single direct safelight and normal graded paper is about 4 feet with a 15-watt bulb.

- A 25-watt bulb can be used in a single indirect safelight hung from the ceiling in an 8 × 10-foot darkroom.

- Avoid having a direct safelight too close to the enlarger or processing sink. Follow the manufacturer's guidelines as a starting point for correct distance placement.

- Check the condition of the filters periodically. They can deteriorate over time without any visible change in color. A safelight that shows any signs of deterioration or uneven density should be replaced.

- For added protection, prints can be processed facedown during most of the development time.

- Test safelights regularly and whenever you are using a new printing material.

Easels

In addition to providing a stable surface for composing and focusing the image, an easel must be able to hold the printing material flat and parallel to the negative. It also provides a stable surface for composing and focusing the image. Easels with independently adjustable blades are recommended because they allow you to change the paper size and the size of the print borders. Easels with a white focusing surface can reflect enough light back through certain single-weight papers to produce a change in the overall print values. This can be corrected by painting the easel yellow or by taping a thin sheet of opaque cardboard to it. This is not usually a problem with double-weight papers.

Focusing Devices

The image must be critically focused on your easel to ensure the maximum benefit of the camera and enlarging lenses. When making enlargements, optimum focus occurs when the grain of the negative is sharp over the entire image. You can achieve this through the use of a grain focuser or magnifier. These devices generally have a mirror that diverts part of the projected image to an eyepiece for viewing. Adjust the fine-focus control of the enlarger until the grain appears sharp in the eyepiece.

With large-format negatives and some fine-grain films such as Kodak Technical Pan Film, focusing on the grain can be difficult. In cases such as these, use a focusing device that simply magnifies a small part of the image in the eyepiece for viewing. These devices also are useful for checking the corner sharpness of the image. Many people use both types of focusing aids to ensure optimum focus.

Whenever you are using filters, such as those used with variable-contrast papers, you will obtain the best results if you place the filters between the light source and the negative. Filters used below the negative can affect the optical quality of the image and the focus. If you are using filters below the negative, recheck the focus with the filter in place.

The following guidelines will help you produce sharply focused enlargements:

1. Adjust the enlarger to get the proper print size.

2. Open the lens to its maximum aperture, to produce the brightest possible image.

3. Place a scrap sheet of paper, emulsion side down, the same type as you will use for the final print, in the easel as a focusing target.

4. Adjust the fine-focus control on the enlarger until the image is sharply focused.

5. Stop the lens down to a working aperture of between f-8 to f-16 to improve image sharpness.

6. Recheck for possible focus shift. Make any final adjustments after the working lens aperture is set.

7. Remove the scrap focusing paper, insert the printing paper, and make the exposure.

Timers

Accurate and repeatable results are required ingredients in the timing of all photographic procedures. Timers are available with mechanical or electronic operating gear, having both a visible display and audible signal to indicate when the timing operation is complete.

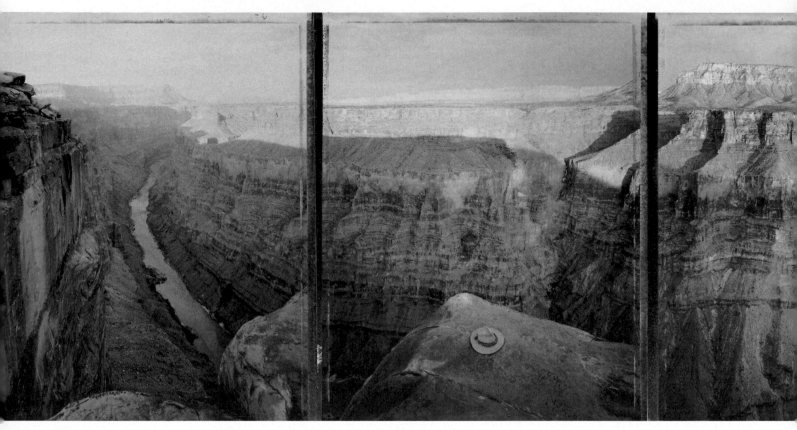

Figure 6.4 When making a series of images to be used in sequence, as in Klett's five-panel piece, it is usually important to have each print match as closely as possible for the sake of visual continuity. To obtain these results, especially when making large images, the printmaker must be consistent in all procedures such as focusing the image. All mechanical equipment, including safelights, must be checked to make sure it is in top working order to deliver accurate and repeatable results.

© Mark Klett. *Around Toroweap Point, Just Before and After Sundown, Beginning and Ending with Views Used by J.K. Hillers, Over 100 Years Ago, Grand Canyon*, 1986. Gelatin silver prints. 20 × 80 inches. Courtesy of PaceWildensteinMacGill Gallery, New York.

Electronic timers are extremely accurate, especially for short times. They can be set to give repeatable results in units as small as a fraction of a second, which can be useful for fine-tuning a print. Some can be set to run an entire processing program. The digital electronic timers are generally the most expensive and may not work with cold-light enlarging heads.

Mechanical timers are less expensive and are compatible with any standard photographic equipment. They are not as accurate as electronic timers at brief exposures and cannot be set to run a processing program.

Trays

Good quality photographic trays that are impervious to chemical contamination are available in heavy plastic or stainless steel. To facilitate agitation of the solutions, the trays should be slightly bigger than the print being processed. For example, an 8 × 10 inch print should be processed in an 11 × 14 inch tray.

Trays are available with flat or ribbed bottoms. Some workers prefer the ribbed bottom because they say it is easier to pick the print out of the tray. Others say the ribbed bottom can damage the print by scratching it against the ribs or causing the print to bend or fold more easily. Generally, having several of both types is useful. Try each type to determine personal preference.

When the printing session is complete, discard the developer and pour the stop bath into the developer tray. This will neutralize the residual alkaline developer solution. Thoroughly wash all trays with warm water.

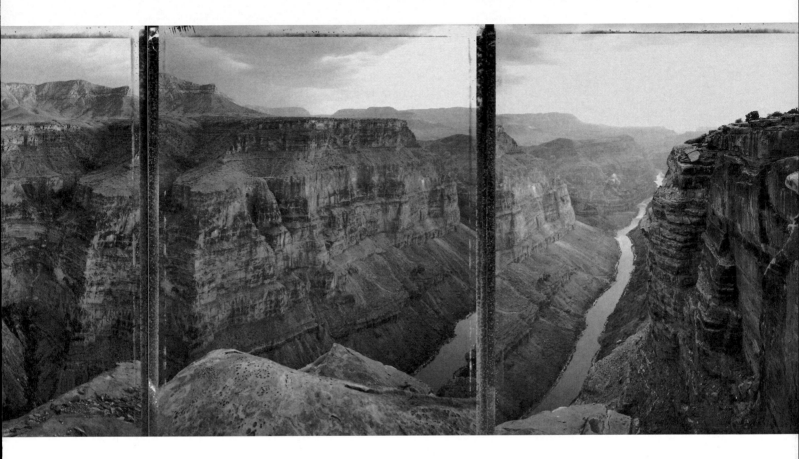

Many printers label or color coordinate their trays so that they always use the same tray for each solution to avoid chemical contamination. Commercial preparations compatible with environmental concerns are available to clean stubborn stains.

Enlarging Meters

Enlarging meters are designed for mass-production situations, but in the making of a fine print, the artist should be actively involved in appraising the tonal range of the print and not spending time programming a meter. The expressive print is a unique and highly subjective item and does not lend itself to a cool, mechanical process of analysis. If you want machine prints, take the film to your local one-hour processing shop.

Miscellaneous Equipment

Negative Cleaning Materials

A clean negative ensures maximum quality and reduces the headache of later spotting the print. Antistatic devices can help you achieve this goal. Antistatic brushes, such as the Staticmaster, do a good job but contain small amounts of radioactive polonium. If this is a concern, use an antistatic device such as the hand-held Zerostat gun. Just point the Zerostat at the film and squeeze the trigger, showering positive ions onto the film. When you release the trigger, the film is struck by a stream of negatively charged ions, which neutralize both the positive and neg-

ative charges. The Zerostat is more likely to be sold in record stores than in camera shops, as it works well on any plastic-based surface, such as a disk. It requires no batteries and does not use any radioactive materials. In conjunction with the Zerostat, you can use a good sable brush to clean the negative.

Canned air, another cleaning device, is not recommended, as it simply blows the dust around. Some products spit their propellant out of the can along with the air, which can stain the negative.

Dealing with Scratches

Products such as Edwal No-Scratch can be used with small-format negatives to hide scratches that do not go completely through the emulsion. Clean the negative before painting on No-Scratch. After printing the negative, remove the No-Scratch completely with film cleaner and lint-free towels such as Photo-Wipes, as No-Scratch leaves a sticky residue and this and other defect-hiding products will diffuse and soften the image.

Other Tools

Other important printing items are a reliable thermometer, burning and dodging tools (which can be homemade from an opaque board and thin, hard wire or a bicycle spoke), print tongs to avoid getting chemical solutions on your skin, thin surgical gloves for handling prints (especially during toning), and a collection of graduates and storage bottles.

A Notebook

Keep a notebook to record the details of how each print was made. Typical information should include negative identification; type and grade of paper; type, dilution, and temperature of developer; f-stop; exposure time; and burning and dodging instructions. This record can save you time if you have to reprint the negative and can refresh your memory when you are creating new prints.

STANDARD PRINTING MATERIALS

All black-and-white photographic printing materials consist of a base or support, generally paper, coated with a light-sensitive emulsion. The emulsion is made of silver halide crystals suspended in gelatin. Silver

chloride, silver bromide, and silver iodide are the most widely used silver halide salts in contemporary photographic emulsions. The individual characteristics of an emulsion, such as contrast, image tone, and speed, are determined by the type of silver salt or salts, how they are combined in coating the base, and any other ingredients added to the emulsion.

Silver chloride papers are generally very slow and are used for contact printing. They have excellent scale and tonal values and are easy to tone. Bromide emulsions are much faster, can be used for either enlarging or contact printing, and usually have a cool or neutral tone. Bromide and chloride are often combined in the making of warm-tone papers.

The speed of the emulsion is determined by its ANSI (American National Standards Institute) number and is comparable to the ISO rating system for films. These numbers are not of any particular use in the making of an expressive print, except as an indicator for comparing relative increases or decreases in exposure times when changing papers.

Modern papers come in a variety of surface textures and sheens, different weights, and various base tints. There are no industry standards in these areas. Each manufacturer creates its own set of guidelines, so the photographer must sort through the options and find what is appropriate for a particular situation.

Paper Types

Currently there are three basic commercially prepared paper types: conventional fiber-based papers, resin-coated (RC) papers, and papers for activation or stabilization processing.

Fiber-Based Papers

Fiber-based papers are coated with barium sulfate, a clay substance known more commonly as baryta, beneath the emulsion. This provides a smooth, clean, white background that covers the inherent texture of the paper and provides a reflective surface for the emulsion. Cool or warm coloring is often added to the baryta, since it covers the paper base and provides the white that you see in a print. Photographic papers are predominantly three

different emulsions: chloride, bromide, and chlorobromide. Most papers are the chlorobromide combination with a small amount of silver iodide. The proportion of silver chloride to silver bromide determines the speed and tone of the paper. Papers with a higher proportion of silver chloride are generally slower and produce warmer tones than predominantly silver bromide papers, which are faster and produce a colder image. Beware of papers that have "optical brighteners" added to increase the reflectance in the highlight areas of the print, as they can lose their effect over time.

Resin-Coated Papers

Resin-coated (RC) papers have a polyethylene coating on both sides of the paper base, making them water-resistant so that chemicals cannot soak into the paper fibers. This allows RC papers to be processed and washed very quickly, as all the chemicals are easier to remove.

RC papers can be marked with a pen or pencil, dry fast, have a minimum amount of curl, and hold up well in physically stressful situations that would destroy a conventional gelatin silver print. The problems with RC papers include the following:

- The polyethylene layer tends to deteriorate and can crack over time.

- They cannot be processed to archival standards.

- They often have a reduced range of visible tones with poor separation in the dark values, and are apt to lack a solid maximum black.

- The brighteners commonly used in RC papers have a tendency to migrate into the shadow areas during washing. This produces a veiling effect that reduces the overall tonal range.

- The high reflectivity of the RC coating can create viewing problems.

- The picture elements often appear to sit on the surface, giving the image a lack of visual depth.

Papers for the Activation and Stabilization Processes

Papers that have developing agents incorporated directly into the emulsion are designed

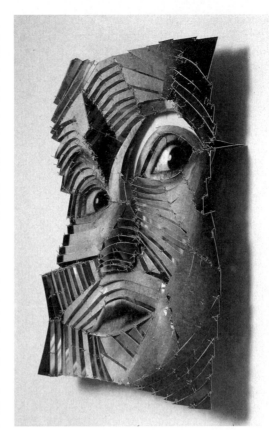

Figure 6.5 Selecting the proper paper to solve a specific problem is a critical component of printmaking. Sloan wanted to fuse photography with three-dimensional forms to stretch the traditional photograph beyond its flatness and to comment on the concept of the "decisive moment." Sloan fashioned this piece from two images made on RC paper for its strength. The photographs were mounted on aluminum and then cut into strips with tin snips. Holes were drilled in the edges and the pieces were reassembled using a secondary image for the vertical sections (to add depth). Galvanized steel wire was then threaded through the holes and twisted to hold the fragments together.

© Jennifer Sloan. *Fragmented Face*, 2000. Gelatin silver prints on aluminum. 24 × 20 × 4 inches.

for activation and stabilization machine processing (although they can be processed in a tray). When a print is needed immediately, this is the route to take, although the print quality will suffer. Both stabilization and activation processes are desirable for their convenience and immediacy. These papers are not intended for work requiring long-term keeping capabilities and cannot be processed to archival standards.

Stabilization Process

With the stabilization method, the processing time can be as short as 15 seconds for an 8 × 10 inch print. The print comes out of the machine damp, but air-dries within minutes at normal room temperature. This type of print will last for several days before beginning to deteriorate. Its life span can be increased by fixing and washing it, following regular print processing procedures.

Activation Process

The activation process, such as Kodak's Ektamatic Processors and companion Kodak Ektamatic SC paper, takes about 1 minute dry-to-dry time (the time the print enters the processor to the time it emerges) for an 8 × 10 inch print. This process is designed for deadline work, such as for a newspaper, where print stability is not important. The contrast of Ektamatic SC papers can be controlled with the use of Polycontrast filters. These papers can be conventionally processed in a tray and then fixed and washed to extend their life. If this is done, Kodak claims these prints will last as long as conventionally processed RC prints. Most activation papers like Ektamatic SC use fluorescent optical brighteners to produce a clearer white. Ektamatic SC papers produce a warm black tone with the processor and a neutral black tone with tray processing.

The Double-Density Effect

Why does a transparency (a slide) provide more detail and subtlety than a print of the identical scene? Transparencies are viewed by transmitted light—that is, the light passes through the transparency one time before being seen by our eyes. With a print, light passes through the clear gelatin emulsion and strikes the base support of the paper, resulting in a reflection rate of about 90 percent. Light that is not pure white (which is almost always the case) has to pass through the silver densities of the print twice, once when it strikes the paper and again when it is reflected back, and creates what is known as the double-density effect.

For example, imagine that the silver density in the emulsion of one part of a print allows 60 percent of the light to reach the base of the paper. Since only 90 percent of this light is reflected back from the base, only 54 percent of the light remains. Now this 54 percent has to pass through the same silver density again as it is reflected back, subtracting another 50 percent. Thus only 27 percent of the original light strikes the eye from this part of the print. The silver deposits in the print screen the light twice, creating the double-density effect. This results in a loss of detail, limiting the amount of separation between tones.

Paper Colors

Manufacturers make the base of their papers in a variety of colors. The color variations include brown-black, bluish black, and neutral black through a slightly warm to a very warm buff or ivory. There is no one standard for comparison. To get an idea of what the paper looks like, carefully examine and compare paper samples from each manufacturer. Most camera stores have these samples, or the company will send you a set upon request.

The image color will be affected by the choice of developer and can be further altered through toning. For instance, processing a warm-tone paper in a warm-tone developer can produce a print so warm it will have olive green values (which can be neutralized by toning).

Selection of paper color should be given serious thought, but it remains a highly subjective and personal matter. It should reflect the photographer's overall concerns and the mood he or she wants to achieve.

Paper Surface and Texture

Papers are available with a number of different surfaces. Smooth, glossy papers have the greatest reflectance range. They present the most brilliant images with the widest range of tonal separation and good detail in key highlight and shadow areas. Matte surfaces have a reduced reflection-density range, with the amount depending on the degree of texture. They produce a print with much less brilliance. The matte surface is a good choice when extensive retouching or hand-altering of the print is planned. Matte paper takes airbrush, regular brush, and

pencil retouching extremely well. Once again, there are no industry standards that permit direct comparison. Each manufacturer has its own system for designating the surface and texture characteristics.

Grades of Paper

Matching the density range of a negative to the exposure range of a paper is necessary for a print to reveal the complete tonal range of the negative. To accomplish this, photographic papers are made in various degrees of contrast. Papers are given a number, called a paper grade, to indicate their relative degree of contrast. The higher the number is, the harder or more contrasty the paper. There is no industry standard, as each company uses its own grading system. Table 6.3 lists some paper grades and their general contrast characteristics.

A normal negative, with a complete range of values, should produce a full range print on grade 2 or 3 paper. A normal negative can be printed on a lower grade of paper for a softer, less contrasty look or on a higher grade to achieve a harder, more contrasty appearance. If you want to make a long tonal range print from a contrasty negative, you should use a low-contrast paper. A high-contrast paper can be used to extend the tonal range of a low-contrast or flat negative. Soft, low-contrast papers are fast and have a long tonal scale. Hard, high-contrast papers are slower and have a shorter scale.

Even though a grade 2 paper is considered to be industry normal, there is really no standard for normal in printmaking. You should never feel locked into trying to print on only one grade of paper. Expressive printing means that each negative must be evaluated in terms of how the final print should read and feel, and the grade of paper should be selected accordingly. If you think a print

Table 6.3 Contrast Characteristics of Paper Grades

Paper Grade	General Contrast Characteristics
0	Very soft, extremely low contrast
1	Soft, low contrast
2	Normal, average contrast
3	Slightly above normal contrast
4	Hard, above normal contrast
5	Very hard, very contrasty

lacks contrast, make another print on a grade 3 or grade 4 paper and visually decide what works for you.

Variable-Contrast Papers

Variable-contrast papers have a blend of two emulsions. Usually the high-contrast emulsion is blue sensitive, and the low-contrast emulsion is orthochromatic, which is sensitive to blue and green. By exposing the paper through special variable-contrast filters or a variable-color light source, the different proportions of the two emulsions are exposed. Since variable-contrast papers are sensitive to a broader band of the spectrum than regular graded papers, you should read and follow the specific manufacturer's instructions for proper safelight conditions. Variable-contrast papers are designed to be exposed with tungsten or tungsten-halogen light bulbs. Their use with other sources, such as cold lights, may require experimentation.

Advantages
Only one box of variable-contrast paper is needed to produce a wide range of contrast. Filters are available in half-grade steps such as $1\frac{1}{2}$, $2\frac{1}{2}$, and $3\frac{1}{2}$. Also, various sections of the paper can be exposed with different filters to alter the contrast locally within the print. For instance, imagine a landscape having a dark, flatly lit foreground and a bright, contrasty sky. A higher than normal filter could be used to expose the shadow areas of the foreground and increase contrast. Then a lower than normal filter could be used to make a second exposure for the sky.

Disadvantages
Variable-contrast papers tend to print flatter than graded papers at any given level of contrast. They do not print as deep a cold-tone black as do graded papers, and the exposure time is longer with higher filter numbers. Also, using variable-contrast filters below the lens, as is most commonly done, can result in a loss of image contrast, cause distortion of the image, and reduce overall sharpness. It may be necessary to refocus the image after the filter is placed in front of the lens. This may be a problem, depending on

the intensity of the filter, as it might be difficult to see the image clearly enough to check the focus accurately. This problem can be eliminated by printing with a dichroic color head enlarger. When working with a color enlarger, most manufacturers provide magenta and yellow filtration that is equal to the filter numbers.

Variable-contrast papers can be compared to a zoom lens. A lens with a single fixed focal length should always deliver a sharper image than a zoom lens set at the same focal length. This does not mean you should not use a zoom lens, but it does mean that the lens has certain limitations. Likewise, variable-contrast papers can be used with great success in a wide variety of photographic applications. When the opportunity presents itself, try some of the variable-contrast papers and see if they meet your needs.

Mural and Postcard Paper

Photographers who want to make prints larger than 20 × 24 inches will probably have to obtain mural paper. Typically, mural paper is sold in rolls of various widths and lengths that start at about 40 inches wide and 100 feet long and come in F (smooth, glossy) and N (smooth, semi-matt) surfaces. Mural paper can be processed in homemade plastic troughs to save chemicals and space. One

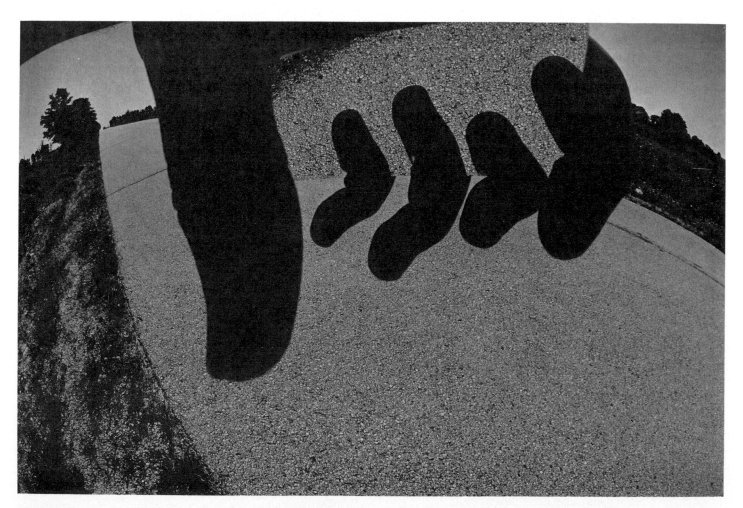

Figure 6.6 A 17 mm fish-eye lens and a mirror allowed Jachna to play with our traditional sense of perspective and space. A high-contrast print was achieved by exposing variable-contrast paper through a color enlarger with 40 points of magenta filtration. Many variable-paper manufacturers supply a guide that tells how the paper can be exposed by using the filters in a dichroic color enlarger.

© Joseph D. Jachna. *Door County, Wisconsin*, 1970. Gelatin silver print. 8 × 12 inches.

technique is to cut PVC pipe down the middle, cap the ends with a piece of Plexiglas, and seal them with fiberglass cement. Another way is to simply cap the ends of PVC pipe so that they become their own rotary processing tubes. Make certain the diameter of the PVC pipe is large enough to allow the chemicals to freely circulate around the paper in the tube to avoid processing marks. Mural paper can also be placed in a large, clean sink and the chemicals can be applied with sponges. A small amount of chemistry can be placed on the bottom of a clean sink. The sponge is constantly, yet gently, moved throughout the process while the paper is rotated to ensure even development. Different sponges should be used for each chemical to avoid possible contamination.

Photographers wishing to make their own official-looking postcards can use Ilford's 4 × 6-inch RC Post Card paper that comes in boxes of 100 and has the word "Postcard" on the nonemulsion side of the paper.

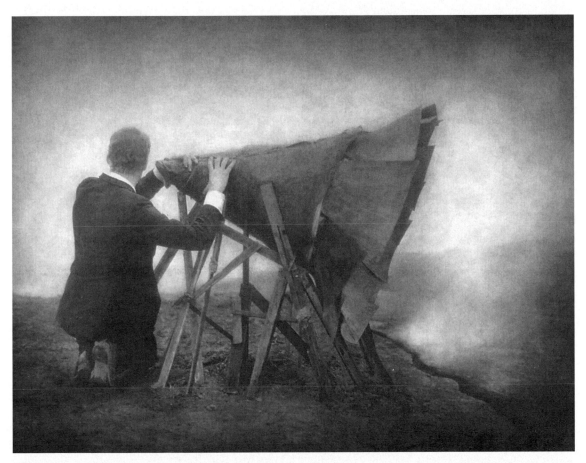

Figure 6.7 ParkeHarrison creates photographs that tell stories of loss, human struggle, and personal exploration within landscapes scarred by technology and overuse. ParkeHarrison says: "The scenes I depict display futile attempts to save or rejuvenate nature. I portray these attempts within my work by inventing machines and contraptions from junk and obsolete equipment. These contraptions are intended to help the character in the black suit I portray to jump-start a dying planet. I patch holes in the sky, create rain machines, chase storms to create electricity, communicate with the earth to learn its needs. Within these scenes, I create less refined, less scientific, more ritualistic, and poetic possibilities to work with nature rather than destroying it. I attempt to represent the archetype of the modern man and draw the viewer into the scene without dictating a message or the outcome of the myth presented." To produce large-scale prints, ParkeHarrison uses an enlarger mounted to a wheeled cart to project the image onto mural paper pinned to the wall. The paper is processed in troughs made from cutting PVC pipe long-ways and then capping the ends with a piece of Plexiglas sealed with fiberglass. The prints are manipulated with darkroom techniques, paints, and varnishes.

© Robert ParkeHarrison. *Listening to the Earth*, 1998. Gelatin silver print with mixed media. 34 × 45 inches. Courtesy of Bonni Benrubi Gallery, New York.

Figure 6.8 This work was part of a three-week mail art project that consisted of mailing photographic postcard collages from major cities in Europe to Buffalo, NY. Mead says that this card "representing Day 11 and my visit to the Victoria and Albert Museum in London, memorializes the conservation attempts on the famous Portland Vase through manipulation and alteration of two identical postcard images of the Wedgwood copy of the vase. The reconstructive efforts done on the vase are referenced through (1) the grid inscribed on the card, (2) the cutting and re-assembly of the images, (3) arrows making 'missing shards,' and (4) a small packet containing seventeen fragments that were actually left over after the reconstruction. Postal cancellation marks or other evidence of transatlantic mail passage served as chance additional to the collage."

© Jerry Mead. *Day #11-V&A Museum*, from the series *European Travellage*, 1995. Mixed media. 4 × 6 inches. Original in color.

Current Papers

More good photographic papers are being made today than in the past several years. Commonly used papers are currently made by Agfa, Arista, Bergger, Forte, Ilford, Kodak, Luminos, Mitsubishi, and Oriental. Every paper has its own distinct personality, and the makers often alter its characteristics over a period of time. The only surefire way to find out what these papers will or will not do for your work is to use them.

Print Finishing

Ferrotyping

If a high-gloss finish is desired, it is possible to dry a glossy paper on a special metal ferrotype plate. Ferrotype prints can produce a tremendous amount of glare. Using a glossy paper and not ferrotyping will deliver a smooth, semigloss finish with much less glare. The heat required during the ferrotype process may also darken print tonal values.

Air Drying

Generally, photographers making high-quality fine art–type prints prefer air drying because there is less dry-down effect than when heat is used. Typically, prints are squeezed on a piece of Plexiglas or heavy glass with beveled and sanded edges. They are then placed face down on a drying frame, which can be homemade or commercially purchased, that consists of a wooden or metal frame with new plastic screen material pulled tightly across it (window screen frames can also be used). Prints are allowed to dry naturally in a dust-free environment. The cleanliness of the screening material must be checked and maintained before each use. Prints may be weighted later under a heavy piece of glass to lessen the curling effect.

Prints are now ready to be spotted with a fine #0 sable brush and spotting colors like SpoTone or dyes like Dr. Martin's.

Waxing the Print

Gelatin silver prints can be treated with a wax medium such as Dorlands Wax Medium or Gamblin Cold Wax. Waxing can be done to protect the print surface, to create a surface similar to that of a painting, to build up a three-dimensional effect, or to make a three-dimensional object. Wax mediums contain mineral spirits along with several types of waxes and are very flammable. The wax is often heated to its melting point to make it easier to work with, but the flash point (the temperature at which the vapor of

a combustible liquid can be made to ignite) for wax mediums is between 107°F and 145°F. Do not expose the wax to direct flame. Melt the wax in a double-boiler pan. Wax medium may be thinned with turpentine or mineral spirits. Wax also comes "soft" and can be directly applied with either a buffing cloth or a small piece of cheesecloth to the surface of the photograph without thinning.

For protection, a small amount of wax the size of a dime will cover an 11 × 14 inch print. Afterwards the wax can be buffed to a sheen. Several coats of wax can be applied to simulate the surface of a painting, but you should allow several days or even a week between coats. A brush can be used to spread the wax and induce the brushstroke effects of a painting. A hair dryer can be used to keep the wax soft while spreading it on the print surface.

The wax can be applied even more thickly to achieve a tactile three-dimensional look. Prints can also be imbedded into blocks of paraffin wax to create a transparent three-dimensional presence. Wax mediums are generally available at professional art supply stores. If you cannot find wax locally try Siphon Art, P.O. Box 710, San Rafael, CA 94915, or Gamblin Artists Colors Co., P.O. Box 625, Portland, OR 97207.

SPECIAL PRINTING MATERIALS

Panchromatic Papers

Panchromatic means sensitive to the full range of the visible spectrum. Panchromatic papers are designed to produce an accurate black-and-white tonal rendition from a color negative. Regular printing paper is not panchromatic. It is sensitive mainly to the blue portion of the visible spectrum and distorts the tonal range of the original color negative (especially in the red part of the spectrum) when a black-and-white translation is created. Panchromatic papers, such as Kodak Panalure, should be handled under a color safelight filter, such as Kodak No. 13, or in total darkness.

Direct Positive Papers

Direct positive papers, such as Kodak Projection Positive Paper, are intended to

Figure 6.9 Adrian's idea of the photographic fragmentation of the human form evolved out of the aesthetic, historical, and theoretical tension between the belief in the body as an ideal form and as a series of fragmented parts. Adrian states that: "This shift from the body as unique and whole to the isolation of body parts and limbs, organs, and fluids, emphasizes the vulnerability of our bodies, revealing connections and divisions. I embed isolated body parts in blocks of wax, and combine them with a medium of classification and categorization to critique, resist, and reconstruct dominant representations of the human form. In a liquid state the wax is poured into an adjustable wooden box and the print is pressed into the top of the wax block as it cools, allowing a thin layer of wax to run over the image's surface and harden. Composed as geometric solids, it was the fleshy, tactile block of wax that gave the weight, impenetrability, and isolated presence that I sought for these exposed photographic fragments of the body."

© Kathleen Adrian. *Flesh Fragment* (Male head), from the installation *Fragmentations*, 1997–1999. Gelatin silver prints embedded into blocks of paraffin wax. 30 × 25 × 3 inches.

produce a positive rather than a negative image. This material can be exposed in a view camera and may be used to make direct positive enlargements from color trans-

parencies. Direct positive papers are used in the coin-operated portrait booths that deliver a strip of pictures while the subject waits.

Liquid Emulsions

Liquid emulsions give the photographer the freedom to go beyond two-dimensional paper-based printing. Liquid emulsions can be applied to almost any inanimate surface,

Figure 6.10 Hubbard, who had been investigating themes surrounding the human form, wanted to address the issue of AIDS by juxtaposing a classical odalisque pose against the contemporary threat. The original negative was made with Kodak High Speed Infrared black-and-white film, but was printed twice—once normally, and then flipped and printed again. The prints were produced by using a sponge brush to apply two coats of Liquid Light onto Stonehenge artists' paper. The second coat was applied while the first coat was still tacky. The paper was allowed to completely dry before printing. The paper was developed in straight Dektol to increase contrast. The resulting images were hand-colored with Marshall's Oils and Pencils, Prismacolor pencils, and charcoal. The title comes from a collection of Cole Porter songs released in 1990, *red hot and blue*, to benefit AIDS research and relief.

© Kitty Hubbard. *red, hot, and blue* (diptych), 1994. Hand-colored liquid emulsion on paper. 26 × 60 each. Collection of Kelly and Cleveland Adams, New York. Original in color.

including paper, canvas, china, glass, leather, metal, plastic, rock, and wood. Liquid emulsions allow the photographer to consider the possibilities of extending the photographic medium into the third dimension.

Liquid Light

Liquid Light is a commercially prepared direct silver nitrate emulsion. After it is applied to a surface, it is handled and processed in the same manner as the emulsion on normal photographic paper. Refrigerated, Liquid Light has a shelf life of up to two years. Here are some guidelines for using Liquid Light:

1. Place the bottle of solid emulsion in a pan of hot water until its contents become liquid (usually a couple of minutes). Open the bottle only under normal paper safelight conditions.

2. In the darkroom, under a paper safelight, pour some emulsion into a glass or plastic bowl. Do not use a metal bowl, as silver nitrate reacts with metal. Rapidly apply the emulsion with a soft, clean brush. Coat a piece of paper at the same time to serve as a test strip for determining the correct exposure. Mark the back of any paper that is coated because the emulsion can be hard to see once it dries.

3. Allow the coated material to dry in total darkness until it is at least tacky. After it is dry, it can be stored and handled like normal photographic paper. Best results are usually obtained if the coated material is used as soon as possible after drying.

4. The emulsion is slow and not very sensitive to light. When making an exposure, open the enlarging lens to about f-4 and make a series of about six exposures in 5-second increments on the test strip.

5. All processing solutions must remain between 60°F (16°C) and 68°F (20°C), as the emulsion will soften at temperatures above 70°F (21°C) and will release from the paper. Process following normal paper procedures, making sure not to let tongs touch the emulsion in the chemistry or wash baths. The emulsion is extremely delicate when wet. If the emul-

sion peels up at any time during processing, dispose of the print and start again. It may dry flat but in time will peel off of the paper.

6. Determine the correct time, make the exposure on the coated material, and process.

Liquid Light will produce a warm black image with soft contrast. The contrast can be controlled, to some degree, by using a normal paper developer such as Dektol or Selectol-Soft and varying the rate of dilution. A good starting point is 1 part developer to 10 parts Liquid Light.

Ag-Plus

Rockland also makes Ag-Plus, a liquid emulsion with a higher concentration of silver halide that has an ISO of 160, but otherwise is similar to the original Liquid Light. Its faster speed makes it the more practical choice when making larger prints, and it also requires thinner coatings of emulsion to produce an image.

Paper-based images can be colored with Rockland Print Tint or regular photographic toners. Rockland also makes a contact-speed emulsion designed to be used on fabric called Rockland Fabric Emulsion Sensitizer FA-1. The iron-silver emulsion gives an antique Vandyke iron-silver image with a full range of warm brown-black tones.

For more information on Liquid Light and other Rockland products, contact Rockland Colloid Corp., Box 376, Piermont, NY 10968.

Luminos Silverprint Emulsion

Luminos Silverprint Emulsion is another commercially prepared direct silver nitrate emulsion. The emulsion works well on both watercolor and printing paper and can be handled and processed like Liquid Light. The Silverprint Emulsion has an ISO speed of 160 and is rated as contrast 3. Diluting the emulsion 1:1 to 1:4 with hot water can alter the contrast. The more dilute the solution, the lighter the image. Additional coats of emulsion can be added to increase the contrast. Allow surface to almost dry between coats.

Figure 6.11 Photo linen is a manufactured cloth that has been treated with a photographic emulsion. It tends to have more contrast than emulsions that are applied to fabric by hand. DiVola used mural-size photo linen to produce an image that has the feel, look, and scope of a large-scale canvas painting.

© John DiVola. *Quarter Moon*, 1987. Photographic linen. 42 × 42 inches.

Table 6.4 Archival Processing for Silver-Based Fiber Papers at 68°F (20°C)

Step	Approximate Time
Developer	1½ to 3 minutes
Acid stop bath	1/2 minute
First fixing bath	3 minutes
Second fixing bath	3 minutes
Quick water rinse	As needed
First wash	5 to 10 minutes
Washing aid or hypo eliminator*	2 to 6 minutes
Hirsch's Express method: Perma-Wash and Rapid Selenium Toner**	1 to 10 minutes
Toning*	1 to 10 minutes
Final wash	60 minutes minimum
Air-dry	As needed

*Exact times are determined by the needs of the photographer through testing.
**The express method combines the washing and toning steps and may not be suitable for all papers.

Silverprint Emulsion is a very thin liquid when warmed. The thinner emulsion works its way into the fibers and bonds with the paper, unlike Liquid Light, which appears to sit on top of the paper. The emulsion is also much faster than Liquid Light. When making an exposure, open the enlarging lens to about f-8 and make a series of about six exposures in 5-second increments on the test strip. Once coated, Silverprint Emulsion has better keeping qualities than Liquid Light and can be kept up to a month before exposing and processing.

Luminos Photographic Linen

Luminos Photographic Linen is a commercially prepared cloth that has been treated with a photographic emulsion. It is available in a number of standard photographic paper sizes as well as in mural lengths (50 inch × 98 foot rolls) and is handled and processed like regular photographic paper. It tends to have a deeper black and more contrast than the Rockland emulsions.

For more information, contact Luminos Photographic Corp., 25 Wolffe Street, Yonkers, NY 10705.

PROCESSING PRINTS FOR PERMANENCE

"Eternal duration is promised no more to men's work than to men," said French writer Marcel Proust. The processing of prints to archival standards ensures that the work will have the opportunity to communicate with others in the future. A properly processed and stored black-and-white print should last at least hundreds of years. Table 6.4 summarizes the guidelines for achieving maximum life for black-and-white gelatin silver fiber papers.

It is relevant to remember that it may not be necessary to be a master craftsman to make thought-provoking work, but lack of skill in a specific medium can mean a loss of communicative ability. Deficiency of craft can be construed as intentional and part of the meaning, but it may also be interpreted as laziness and a basic misunderstanding of the power of the photographic image to affect and move the viewer.

ADDITIONAL INFORMATION

For a list of information sources, see Additional Information at the end of Chapter 3.

7 Black-and-White Paper Developers

Learning to become a good printer requires curiosity about all aspects of making an expressive print. The more information you have about developers, the more control you can exercise over the image. As your knowledge and competence increase, so do the visual possibilities.

PAPER VERSUS FILM DEVELOPERS

All silver-based developers, whether they are for paper or film, are quite similar in their chemical composition (see Chapter 5). The major difference between paper and film developers is that paper developers are generally more alkaline, which increases their energy. If a film developer is used to process a print, the image will appear gray with no maximum black (the deepest black the paper is capable of producing) and will lack contrast.

What a Developer Can Do

It is helpful to know what chemicals make up a typical paper developer and the functions they perform in printmaking. The choice of developer influences the tonal range, contrast, and image color of the print, but it cannot make up for a poorly exposed negative. The best and easiest way to get the type of print you want is to work from a properly exposed negative.

Developing-Out Papers

Developing-out silver-based papers (those requiring a chemical developer to bring out the image) have a thin emulsion that is designed to be chemically developed to completeness. Developing time varies depending on the type of developer, its dilution, the temperature, and the type of paper. All these factors will affect the outcome of the final print.

COMPONENTS OF BLACK-AND-WHITE SILVER PRINT DEVELOPERS

Major Developing Agents

Metol and Hydroquinone
Metol and hydroquinone are used in various combinations to form the majority of black-and-white print developers. Metol (Kodak Elon) produces a delicate, soft, neutral gray image with low contrast. With prolonged development, both contrast and density increase. Metol is energetic, has a long shelf life, and is commonly blended with hydroquinone to increase contrast.

Hydroquinone makes a high-contrast image with a brownish tint. It works best in the low and middle range of tonal values and is rarely used by itself because it requires lengthy development times. Combining hydroquinone with another developing

agent, such as Metol, activates it. Hydroquinone has a short life span and starts to become ineffective at temperatures below 60°F (15°C).

Metol-hydroquinone developers are convenient, economical, extremely versatile, and have a long life span. By varying the proportions of Metol and hydroquinone, the photographer can alter the color and contrast of the print.

Phenidone

Phenidone is the proprietary name of Ilford's developing agent that acts like Metol. Used alone, Phenidone produces a low-contrast image with a gray color. It is more expensive than Metol, but it also is more potent and can be used in much smaller amounts. Phenidone is recommended for people who are allergic to Metol. It acts as a superadditive agent (see Chapter 5) when combined with other developers such as hydroquinone. Phenidone has a long storage and tray life. It can often be exchanged for Metol in formulas by substituting 10 percent of the amount of Phenidone for the amount of Metol.

Amidol

This longtime favorite of classic printmakers such as Edward and Brett Weston is used to produce rich images with cold, blue-black tones. Amidol is often used at high dilutions such as 1:20 (1 part amidol to 20 parts water) with an extended development time of 10 minutes to produce soft images. This also can be effective when working with a very contrasty negative. Using amidol at reduced rates of dilution and at higher than normal temperatures can produce brilliant high-key prints. These have excellent highlight detail and retain subtlety without dulling the high tonal values.

Amidol is expensive and can stain the print, your skin, and clothes. Since amidol is poisonous, you must wear thin rubber gloves and/or use print tongs when working with it. Amidol is another alternative for those suffering from Metol poisoning.

Amidol must be mixed just before use, as it will keep only a couple of hours in solution. The addition of citric acid (60 grams per quart) as a buffer will help prolong amidol's useful life and will minimize the stain it produces.

Glycin

When used with bromide papers, glycin produces a straightforward black tone. With chloride or chlorobromide papers, it delivers soft brown or sepia tones. Glycin is often

Figure 7.1 Smith processed his 8 × 20 inch Super XX film in Pyro ABC. The resulting negative was contact printed on Azo paper, which was developed in amidol. This combination delivers a luxuriously detailed print that retains subtlety in both the high and low values and invites the viewer to linger over the image.

© Michael A. Smith. *New Orleans*, 1985. Gelatin silver print. 8 × 20 inches.

used with Metol and hydroquinone in developers such as Ansco 130, which favors the highlight areas of the print. With some papers, it produces a very slight stain in the upper highlight tonal range, often resulting in a soft glowing quality.

Reduction Potential

The strength of a developer's activity is known as its reduction potential (how rapidly the developer converts the silver halides to metallic silver). The relative reducing energy of a developer is measured against hydroquinone, which has been assigned an arbitrary reduction potential of 1. The reduction potentials of other commonly used developing agents are as follows: glycin, 1.6; Metol, 20; amidol, 30 to 40.

Other Paper Developer Ingredients

Accelerator
The energy and stability of a developer depend on the alkalinity (pH) of the solution. Most developers have an alkali added to serve as an accelerator. A greater concentration of alkali will produce a more energetic but short-lived solution.

The most commonly used accelerator is sodium carbonate, which is favored because its buffering action helps the developer maintain the correct pH level, thus prolonging its usefulness. Sometimes borax is used as the accelerator. On rare occasions, sodium hydroxide (caustic soda) is used for extremely active formulas or for high-contrast effects. It has a high pH and should be handled with full safety measures.

Certain developers, such as amidol, do not use an accelerator. In amidol, the reaction of the sodium sulfite with the water produces the needed pH for the developing action to take place.

Preservative
A preservative, usually sodium sulfite, absorbs the free oxygen molecules in the developer. This retards oxidation and extends the working life of the solution.

Restrainer
The restrainer slows down the reduction of the silver halides to metallic silver, slightly reducing the speed of the paper and increasing the development time. This is important in preventing fog caused by high-energy developers, extended development times, or out-of-date papers. A developer without a restrainer will reduce some of the unexposed silver halides to metallic silver, producing an overall fog. You can print through a light fog, but as the fog becomes denser, it also becomes visible in the finished print. The fog is most noticeable in the highlight areas. The upper range of tones will appear veiled and lacking in separation. The restrainer will keep the highlights clear and increase the apparent visual contrast of the print.

The most widely used restrainer is potassium bromide. If used in a high concentration, it will cause many papers to take on a greenish cast. Selenium toning (see Chapter 8) can neutralize this.

Benzotriazole is a popular organic restrainer that can be used to help clear fog and produce cleaner-looking highlights. It tends to produce colder tones than potassium bromide, shifting the image color to bluish black. Benzotriazole is available in powder form and as Edwal Orthazite (liquid).

Water
The key ingredient in any developer is water. Generally, if the water supply is safe for human consumption, it is safe for photographic purposes. The amount of chlorine added to many water supplies is too small to have any effect. The same applies to copper sulfate, which is often added to kill bacteria and vegetable growth. The most important consideration is to be sure that the water is close to neutral on the pH scale (7). If the water is more alkaline (having a pH greater than 7), it will cause the developer to be more active, thus reducing the total amount of time for development.

If the water contains a large number of impurities, boil it and let it stand until the precipitate settles. Then gently pour it, without disturbing the sediment, through prewashed cheesecloth or a paper filter. Distilled water may also be used.

If you suspect there is a problem with the water, do a comparison test by mixing two solutions of developer, one with tap water and the other with boiled or distilled water. Process and compare the results. Film is generally more susceptible to variations in

water quality than prints. The most common problems are foreign particles, which can damage the emulsion, and changes in the pH, which can affect the speed of the materials.

The amount of calcium, iron salts, and magnesium found in water determines its hardness. The greater the concentration of these minerals, the harder the water. Very hard water produces nonsoluble precipitates that collect on equipment and materials. The use of a water softener is not recommended because the softening process can remove too many of the minerals, especially calcium carbonate, and affect processing. Water softeners can drop the calcium content to below 20 parts per million (ppm). If the calcium carbonate level is too low, it can affect the activity and stability of the developer.

Many taps contain an aerating filter, a small screen screwed into the end of the faucet that adds oxygen to the water to improve its taste. This filter should be removed because added oxygen can increase the oxidation rate of many solutions, thus reducing their life span.

The perfect water supply for photographic purposes has a pH of about 7, contains 150 to 250 ppm of calcium carbonate, and is free of most particle matter.

OTHER PROCESSING FACTORS

Temperature

The rate of development depends on the reducing potential of the developing agent and its dilution, the characteristics of the emulsion, the amount of time in the developer, and the temperature of the solution. All developers work more quickly as their temperature rises. Just as with film development, 68°F (20°C) has been adopted as the standard processing temperature for most silver-based papers. All processing solutions, including the wash, should be kept as close to the temperature of the developer as possible.

Changes in the temperature affect not only the processing time but also the characteristics of the developing agents themselves. Metol performs consistently over a wide range of temperatures, but hydroquinone does not. It becomes extremely active above 75°F (24°C) and loses much of its effect below 55°F (13°C). For example, as the temperature drops below 68°F (20°C), a Metol-hydroquinone developer will produce a softer, less contrasty print than normal. As the temperature rises above 68°F, the print will become harder and contrastier. Changes in temperature also will change the image color of various papers from their normal appearance.

Time

Chloride papers are the fastest, having a developing time of about 1 minute. Bromide papers are the slowest, requiring times of 3 minutes or longer. Chlorobromide papers (widely used for enlarging) have the widest time latitude. Exposure and development times can be varied to produce different image colors. Chlorobromide papers have a normal developing range of $1\frac{1}{2}$ to 3 minutes. Generally, more exposure and less development will result in a warmer image tone than normal. Depending on the paper, less exposure and more development time will result in a colder image. A developing time that is too short will not allow the developer to permeate the emulsion evenly. This can result in flat, uneven, and muddy-looking prints. Too long a developing time can fog or stain the paper.

Agitation

To avoid uneven processing and streaking, prints should be agitated constantly by rocking the developer tray in different directions. First slide the paper, with a quick fluid motion, into the developer. Then lift up the front of the tray so that it is at a 10- to 30-degree angle and set it back down. Do the same thing on the right side of the tray. Repeat the procedure at the front of the tray and on the left side. Return again to the front and repeat this pattern of agitation until the development time is complete.

Prints should be kept under the developer during the entire processing time. Do not remove them from the developer for inspection, as exposure to the air can fog the developer-saturated emulsion.

Dry-Down Effect

Determining the correct exposure for an expressive print can be accomplished only through visual inspection. A number of factors need to be considered. Under safelight illumination, prints tend to appear darker than they do under white light. Prints always have a richer, more luminous look when they are glistening wet than they do after they have dried. All papers darken, losing some of their reflective power, as they dry. This dry-down effect can cause subtle shadow areas to become blocked. The highlight areas appear brighter in a wet print because the swelling of the emulsion causes the silver to spread apart slightly. This permits more light to be reflected back from the base of the paper. After the print is dry, the silver becomes more tightly grouped, so the density appears greater, reducing some of the brilliance of the highlight areas.

You can compensate for the dry-down effect by reducing the exposure time by 5 to 10 percent, depending on the paper. Some photographers dry a test print or strip with a hair dryer or in a microwave oven to obtain an accurate exposure. They can then compare the dried print with a wet one to get an idea of what changes will occur. This is important when working with an unfamiliar paper.

Edge Burning

Although edge burning is not a development technique per se, you should take it into consideration when deciding on the correct exposure. Many prints can benefit from additional exposure at the edges (5 to 10 percent of the total exposure is a good starting point). Making the edges darker can help keep the viewer's eye from wandering out of the corners of the print. This method is effective when there are bright highlights in a corner. Edge burning creates a definite separation between the print and its matte or mount board, keeping the two from visually blending together.

Method 1

The simplest method is to hold an opaque piece of cardboard that is larger than the print over the print, revealing the edge and about 25 percent of the image into the print. Then make an exposure equal to about 5 to 10 percent of the total print time. During the exposure, move the card away from the center of the print out to its edges. Each corner will receive two edge exposures, making them darker than the center portion of the entire edge. This can be visually effective, allowing the light to act as a visual proscenium arch that contains and frames the image.

Method 2

This technique permits all four edges to be burned in at the same time, thus giving all the edges and corners an equal increase in density. This is done by using an opaque board cut in the shape of a rectangle or oval in proportion to the image size and format. Center the board above the print so that it reveals the image area about 25 percent of the distance into the print. Set the timer for the desired amount of additional exposure, then using a smooth, steady motion, move the opaque board toward and away from the paper.

Figure 7.2 *The Shampoo Room* series documents the early 1990s New York nightclub scene where the worst sin was to be boring. In a world of ecstasy, VIP rooms, guest lists, drag queens, and alcohol, Klub Kids competed to see who was the most fabulous and fierce. Just as the subjects of this series of nightclub portraits used costume to draw attention to themselves, Valentino darkens the edges of his prints to keep the viewer's eye from wandering outside of the print and on his subjects.

© John Valentino. *Miss Channel, Limelight,* from the series *The Shampoo Room,* 1992. Gelatin silver print. 16 × 20 inches.

CONTROLLING CONTRAST DURING DEVELOPMENT

After you have selected the developer and grade of paper, you can alter the contrast of the final image in a variety of simple, straightforward ways.

Two-Solution Development

You can reduce contrast and bring out shadow detail by transferring the paper from the developer to a tray containing a 10 percent sodium carbonate solution or plain water and then transferring it back to the developer. You may repeat this process until you obtain the desired results. The following guidelines are a starting point for this procedure, but you will probably want to modify them as you go along.

1. Immerse the print in the developer for about 30 seconds.

2. Place the print in a 10 percent sodium carbonate solution without agitation for about 90 seconds. You can use plain water, but it will increase the chances of your getting a mottled effect, which can be very noticeable in textureless highlight areas such as a cloudless sky. The carbonate results in a more uniform density.

3. Return the print to the developer for an additional 30 seconds.

4. Place the print in the stop bath and continue to process normally.

Local Controls

In situations where it is not practical to burn or dodge, you can apply various solutions to change the print's tonal value. These operations can be carried out in a flat-bottom tray. Care must be taken to avoid getting the solution in areas where it is not wanted, as a dark or light halo effect might be created in the treated area. Use a brush or cotton swab to apply the solution. The type of paper being treated greatly affects the degree to which these controls can be applied without fogging or staining the print.

- *Glycerin* can be applied directly to the print to hold back (lighten) specific areas.

- *Hot water* can be used to increase the developer's activity in selected areas. Begin processing the print in a developer that is weaker than normal. After about 30 seconds, remove the print, place it on a flat surface, and brush very hot water on areas requiring more development. Give the print a number of brief applications, for about 10 to 15 seconds, and then return it to the developer. This process may be repeated.

- Straight, undiluted *stock developer* can be applied to specific areas for increased development and contrast. Begin by processing the print normally for 30 seconds. Remove the print from the developer, place it on a smooth, flat surface, wipe off all the developer with a squeegee or chamois cloth, and apply the stock developer, which has been heated to about 100°F (38°C). Let the print sit for 10 to 30 seconds, then return it to the regular developer. This process may be repeated as needed.

- *Alkali* may be applied to heighten the developer's effect. Prepare an accelerator such as sodium carbonate in a saturated solution, dissolving as much accelerator as possible in about 6 ounces of water. Follow the same application procedure as in the hot water method. This technique often produces the most noticeable visual effect.

- A small pocket *flashlight* with the bulb wrapped in opaque paper to form an aperture from which the light source can be controlled may be used to darken small portions of the print. This is accomplished by removing the print from the developer after about 30 to 45 seconds and completely wiping off the chemical with a squeegee or chamois cloth. The selected area is given extra exposure, and the print is returned to the developer tray for completion of the process.

- *Print flashing is* another effective way to reduce contrast and improve highlight detail. In traditional print flashing, the negative is removed from the enlarger and the paper is given a brief (1 second or less) exposure with white light. These short exposures can be difficult to control without an accurate digital timer.

- An alternative method that uses a longer flash time can be carried out with a mechanical timer. Before or after the print is exposed, hold a piece of tracing vellum such as Clearprint 1000H under the enlarging lens. Give the print a flash exposure of 10 to 20 percent of that required for the normal exposure. For instance, if the total exposure time were 15 seconds, the flash time would be 1½ to 3 seconds. There is no need to remove the negative from the enlarger, as the tracing vellum acts as a light mixer. The time will be determined by the effect desired and the light transmission qualities of the vellum.

- Finally, *altering the formula* of the developer will alter the contrast of the print. Adding more hydroquinone and/or potassium bromide to the formula can increase contrast. Increasing the amount of Metol (Elon) in the formula can decrease contrast. Blacks can be deepened through the addition of carbonate. The increase in Metol depends on the desired outcome, but a range of about 10 to 25 percent is suggested.

MATCHING DEVELOPER AND PAPER

Cold-Tone Papers

Fast, coarse-grain chlorobromide papers generally produce cold black through blue-black image color. The normal developer for these papers is a Metol-hydroquinone combination containing a large amount of accelerator (alkali) and a minimum of restrainer (bromide) to prevent fog. Complete development in a full-strength developer should deliver a print with rich, deep, luminous tones and full detail in key highlight and shadow areas. Shortened development times produce less than a maximum black, preventing details in the upper range of highlights from becoming fully visible. They permit mottling in clear areas, produce uneven effects with streaks, and give the image an overall greenish tone.

Warm-Tone Papers

Slower, fine-grain papers have a higher proportion of silver chloride than cold-tone papers. These papers work best when processed in Metol-hydroquinone developers that contain less accelerator (sodium carbonate) and more restrainer (potassium bromide) than those used with cold-tone papers. Increasing the exposure time and reducing the development time can create even warmer tones. This can be accomplished by diluting the developer with two to three parts of water and/or increasing the amount of potassium bromide. Less active developers such as glycin tend to produce warmer tones than the Metol-hydroquinone combinations. For maximum effect, use these methods with warm-toned papers, as they tend to have almost no effect on cold-tone papers.

DEVELOPER APPLICATIONS AND CHARACTERISTICS

Kodak Dektol

The most commonly used paper developer is Kodak Dektol, which is a Metol-hydroquinone formula. Dektol is a cold-tone developer that produces a neutral to blue-black image on cold-tone papers. It is available as a prepared powder or can be made from the D-72 formula, which is very similar. Dektol's standard dilution is 1:2 (1 part developer to 2 parts water) with a recommended developing range of 45 seconds to 3 minutes at 68°F (20°C). It can be used straight to increase contrast or diluted 1:3 or 1:4 to cut contrast and produce warmer tones on certain papers. If you do this, add a 10 percent solution of potassium bromide for each 32 ounces of working solution. Almost every manufacturer makes a developer that is very similar to Dektol. People who are allergic to Metol developers can use Phenidone-based prepared formulas such as Ilford Bromophen and Ilford ID-36.

Kodak D-72 Formula
This is a cold-tone paper developer.

Water (125°F or 52°C)	16 ounces (500 milliliters)
Metol (Elon)	45 grains (3 grams)
Sodium sulfite (desiccated)	1½ ounces (45 grams)
Hydroquinone	175 grains (12 grams)
Sodium carbonate (monohydrate)	2¾ ounces (80 grams)
Potassium bromide	30 grains (2 grams)
Cold water to make 32 ounces (1 liter)	

Processing procedures are the same as those for Dektol. For colder, blue-black tones, reduce the amount of bromide (start by reducing it by one-half).

Kodak Polymax T

Polymax T is a liquid developer designed to produce a neutral to cold-black image on cold-tone papers. It has a standard dilution of 1:9 (1 part developer to 9 parts water) with a useful range of processing times from 1 to 3 minutes at 68°F (20°C).

Ilford Bromophen

Bromophen is a Phenidone-hydroquinone–based cold-tone developer which is available in prepared powder form. It is normally diluted 1:3 (1 part developer to 3 parts water) and has a developing time of $1\frac{1}{2}$ to 2 minutes at 68°F (20°C).

Figure 7.3 The image, photographed directly from a television, was projected in an enlarger to about 30 × 40 inches. Nine 8 × 10 inch pieces of paper were exposed under specific areas of this projection. All the paper was processed in Sprint Quicksilver, which is known for its ability to develop image tones at a very steady rate. The final composite that takes us in and out of conventional photographic time was made by gridding together the various 8 × 10 inch sections.

© Karl Baden. *Strike*, 1985. Gelatin silver prints. 24 × 30 inches.

Ethol LPD

LPD is a Phenidone-hydroquinone developer available in both liquid and powder form. LPD can be used with both cold- and warm-tone papers. Varying the dilution of the stock solution can alter the tone of either warm- or cold-tone papers. LPD is designed to maintain uniform contrast even if the dilution of the stock solution is changed. For example, with a cold-tone paper it may be diluted 1:8 (1 part developer to 8 parts water) to produce a very light to warm silver tone, or 1:2 for a cold to blue-black tone. Dilutions of 1:6 and 1:4 deliver light silver and neutral silver tones, while a dilution of 1:1 or even full strength produces the coldest, most brilliant blacks. Ethol LPD has a standard development time of $1\frac{1}{2}$ to 3 minutes at 70°F (21°C). LPD offers great print capacity and may be replenished.

Sprint Quicksilver

Quicksilver is a pyrazolidone-hydroquinone developer that develops all image tones at a constant rate. This means that overall print density increases with development, and contrast remains fairly stable. It has a standard dilution of 1:9 (1 part developer to 9 parts water) with a useful range of 1 to 4 minutes at 65°F to 77°F (18°C to 25°C). At the standard dilution, it produces a neutral tone on cold-tone papers. It gives warm-tone papers a more neutral color than other developers and is not recommended for certain cold-tone chloride papers (contact papers) such as Azo. Quicksilver may be converted to other Sprint Systems developers such as Direct Positive B&W and color slide and print developers.

Kodak D-52/Selectol

D-52, also known as Selectol, is designed to produce a warm black to a brown-black image with normal contrast on warm-tone papers. D-52 is generally mixed 1:1 (1 part developer to 1 part water) and is developed for 2 minutes at 68°F (20°C). Increasing the exposure and reducing the development time to $1\frac{1}{2}$ minutes can produce a slightly warmer image color. Increasing the develop-

ment time and reducing the exposure can result in colder tones and a slight increase in contrast. The effectiveness of either technique depends on the paper being used. For warmer tones, increase the amount of bromide (start by doubling it).

Kodak D-52 Formula

Water (125°F or 52°C)	16 ounces (500 milliliters)
Metol (Elon)	22 grains (1.5 grams)
Sodium sulfite (desiccated)	3/4 ounce (21.2 grams)
Hydroquinone	90 grains (6 grams)
Sodium carbonate (monohydrate)	250 grains (17 grams)
Potassium bromide	22 grains (1.5 grams)
Cold water to make 32 ounces (1 liter)	

Kodak Ektonol

Ektonol is a warm-tone developer available in prepared powder form and designed for images that are going to be toned. Ektonol's standard dilution is 1:1 (1 part developer to 1 part water) with a recommended developing time of 1½ minutes at 68°F (20°C). It contains no carbonate, giving it a lower pH than most cold-tone developers. This makes it good for rapid-process papers that have a developing agent built into the emulsion. The lower activity of this developer does not trigger the developing agent in the paper, thus permitting some control over development (see Chapter 6).

Kodak Ektaflo, Type 2

Ektaflo, Type 2, is a liquid developer for warm-tone papers. At a dilution of 1:9 (1 part developer to 9 parts water), it has a development time of 1½ to 4 minutes. The warmest tones are produced by the lowest development times. An increase in time will produce colder tones.

Kodak Selectol-Soft

Selectol-Soft is a packaged powder proprietary formula similar to D-52, but it develops the print to a lower contrast and favors the development of highlight areas. Selectol-Soft is known as a surface developer. It penetrates the emulsion slowly, acting on the highlights first and then on the middle and lower tonal areas. It gets stronger as the development time increases. Selectol-Soft acts like a low-contrast, Metol-only developer such as Ansco 120 (see formula). It has a regular development time of 2 minutes at 68°F (20°C) and a standard dilution of 1:1 (1 part developer to 1 part water). Changes in the dilution and development time affect the image color on warm-tone papers. Extending the development time to 8 to 10 minutes deepens the blacks, creating a rich print with a fairly neutral tone. Selectol-Soft can be used in conjunction with a cold-tone developer such as Dektol for additional contrast control (see the next section on variable-contrast development). Its warm-tone characteristics are not noticeable on cold-tone papers, but it will develop a cold-tone grade to a lower level of contrast.

Ansco 120 Formula
This is a low-contrast Metol developer.

Water (125°F or 52°C)	24 ounces (750 milliliters)
Metol	1/4 ounce (12.3 grams)
Sodium sulfite (desiccated)	1 ounce (36 grams)
Sodium carbonate (monohydrate)	1 ounce (36 grams)
Potassium bromide	27 grains (1.8 grams)
Cold water to make 32 ounces (1 liter)	

Ansco 120 is usually diluted 1:2 (1 part developer to 2 parts water), but it may be used at full strength or at a higher dilution. Its normal developing time ranges from 1½ to 3 minutes at 68°F (20°C).

Variable-Contrast Development

Variable-contrast developers are useful for making small adjustments (less than a full paper grade) that permit precision adjustments of the tonal range of the print. Three separate approaches to working with variable-contrast developers are offered: (1) using a combination of the standard Kodak developers Dektol and Selectol-Soft, (2) working with a two-part developer like Edwal T.S.T., and (3) using the classic Dr. Roland Beers formula that must be mixed from scratch. (See "Other Paper Developer Formulas" at the end of this chapter.)

Dektol and Selectol-Soft

Stock solutions of Dektol and Selectol-Soft can be combined to provide almost as much contrast control as the Dr. Beers developer. They have the advantage of being mixable from widely available commercial formulas. Two methods have been successful in varying the contrast with Dektol and Selectol-Soft.

In the first method, you can add contrast to a long tonal range print and build up a good solid maximum black by adding 50 milliliters of straight stock Dektol per liter of Selectol-Soft stock solution (1½ ounces per quart). Increase the amount of Dektol in 50-milliliter increments until you achieve the desired contrast. The maximum that can be added is about 350 milliliters of Dektol per liter of Selectol-Soft stock solution (10 ounces per quart). Beyond this limit, the outcome resembles that achieved with Dektol alone. Do not add any additional water to this solution.

In the second method, begin print development in Selectol-Soft until good highlight separation is evident. Then transfer the print into Dektol to complete its development. Different times in each solution and different amounts of dilution permit a good deal of variation in contrast. As a starting point,

Figure 7.4 *Killing Time* brings together the architectural ruins of the Anasazi culture from the 1100s in New Mexico with the contemporary urbanscapes from Denver, Colorado; Montezuma, Colorado; and Carefree, Arizona. By combining negatives with visual accuracy into a quadruplet, Erf has created the impression of a single photograph bringing together never seen realities and truths from two cultures. Alignment of these images is critical to unify the composition and is made easier with the use of a large-format view camera, in this case a 1926, 11 × 14 inch Kodak Empire State View with a 12 inch Dagor lens. The ground glass allows the artist to align images exactly by juxtaposing the image on the ground glass with an actual photograph while in the field. Erf begins with a single picture and then proceeds to build his quadruplets one photograph at a time until complete. The use of two-step contact print development, using Selectol Soft 1:1 for 2½ minutes and then Dektol 1:2 for 2½ minutes on an Ilford multigrade fiber-based paper, gives Erf the ability to fine-tune and control contrast to make the four different prints match up.

© Greg Erf. *Killing Time*, 1997. Toned gelatin silver prints. 22 × 28 inches.

placing a print in Selectol-Soft for about 90 seconds and then in Dektol for 90 seconds will produce results that are about halfway between those of developing the print in either solution by itself. Prints not receiving full development will lack a rich maximum black.

Edwal T.S.T.

Edwal T.S.T. (Twelve-Sixteen-Twenty) is a liquid two-part developer capable of controlling both the contrast and tone of an image. T.S.T. is very convenient and versatile and can deliver distinct visible results on a wide range of papers. T.S.T. can be diluted from 1:7 (1 part developer to 7 parts water) up to 1:39 to achieve varying effects. At 1:7, T.S.T. produces the coldest tones and the deepest blacks. At 1:15, it produces a neutral black. Warm tones on warm-tone paper begin to occur at a 1:19 dilution. The softest warm tones occur at a dilution of 1:39. T.S.T. will not produce a brown-tone image on cold-tone paper.

For normal contrast and image tone, Edwal recommends using 1 ounce of solution B for every 8 ounces of solution A, regardless of the dilution used. Development times for normal contrast prints are 2 to 2½ minutes at 70°F (21°C).

Reducing the amount of solution B will proportionally increase the contrast. Solution B can be eliminated entirely for maximum effect. Reducing solution B also increases the developer's activity, and it may be necessary to reduce the standard development time or slightly reduce the paper's exposure time.

If you want maximum contrast, you can add Edwal Liquid Orthazite, a restrainer containing benzotriazole, to T.S.T. to prevent fog. Use 1/2 to 1 ounce of Orthazite per quart of T.S.T. at the 1:7 dilution to maintain clean, clear highlight detail.

You can decrease print contrast by increasing the amount of solution B up to double the normal amount. When you increase the amount of solution B, you can extend the development time up to 4 minutes.

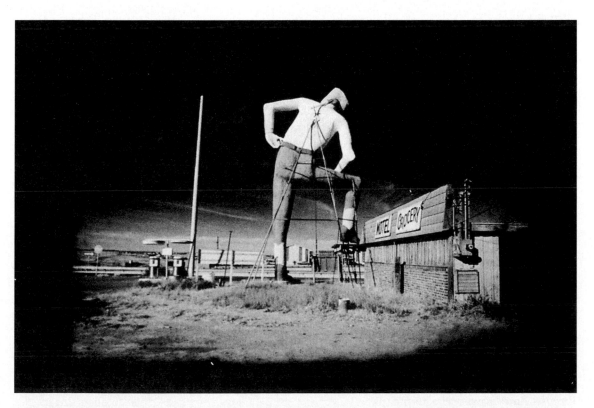

Figure 7.5 Part of printmaking involves working through the process to arrive at a desired cerebral and emotional response of the subject. For psychological effect, Hirsch wanted to produce the coldest tones and the deepest blacks while maintaining clear highlight detail. He did this by using Edwal T.S.T. developer at 1:7 with no solution B and 1 ounce of Orthazite.

© Robert Hirsch. *Untitled* (detail), from the series *The Architecture of Landscape*, 1999. Toned gelatin silver print. 20 × 16 inches.

Solarizing Developer

The Sabattier effect, commonly called solarization, is achieved by re-exposing the print (it may be done on film) to white light while it is being developed. The problem with this procedure is one of control. The print tends to get dark and muddy very rapidly. The following is a formula for a solarizing developer similar to Solarol, which maintains print contrast during this procedure.

Solarizing Developer (Stock solution)

Water (68°F 20°C)	24 ounces (750 milliliters)
Metol (Elon)	180 grains (12.0 grams)
Sodium sulfite (anhydrous)	1¼ ounces (37.5 grams)
Sodium carbonate (monohydrate)	615 grains (41.0 grams)
Sodium bromide	72 grains (4.8 grams)
Cold water to make	32 ounces (1 liter)

Solarol

Solarol is a prepared powder developer that has been specially formulated to maintain print contrast during this procedure. Following are some guidelines for working with Solarol:

1. Prepare a stock solution of Solarol and dilute it 1:1 (1 part developer to 1 part water) for use at 68°F (20°C).

2. Make a normal print on high-contrast paper to determine the correct exposure and development time. This information is vital because the ideal time for re-exposure is at about one-third the time needed for total development. High-contrast paper tends to deliver a more pronounced effect. Simple scenes emphasizing strong graphic form are usually good subjects for initial experiments.

3. Place a 40-watt light bulb with a shock-proof switch about 3 feet above the area where the developer tray with the print will be placed for re-exposure.

4. To achieve the Sabattier effect, expose a piece of paper at one-third less time than the normal test print in step 2. For example, if the exposure time for the test print was 12 seconds, the correct exposure for the Sabattier effect would be 8 seconds.

5. Develop the paper face up in Solarol for one-third the established developing time. For instance, if the developing time for the test print was 120 seconds, the ideal time for re-exposure would be at about 40 seconds. At this point, turn on the 40-watt bulb, without removing the paper from the developer, for 1 second.

6. Continue the developing process for the total established time.

7. After development is complete, finish processing the print following normal procedures.

The intensity of the Sabattier effect can be altered, from strong to gentle, by the following: (1) varying the distance of the white re-exposure light from the developer tray, (2) using different-strength light bulbs (10 to 200 watts), (3) increasing or decreasing the amount of re-exposure time, or (4) printing on different grades of paper. Practice, patience, and experimentation are needed to discover the full range of possibilities with the Sabattier effect.

Nonrecommended Developers

It is possible to achieve unusual effects by processing in nonrecommended developers. Normal silver-based paper can be processed in a litho developer, with the rest of the steps remaining the same, to produce different tonal and color effects than those produced with a normal paper developer. For example, Ilford's Multigrade RC or Luminos Classic Warmtone paper can be processed in Kodalith Super RT or developer to create a very soft, low-contrast image with a pinkish brown color. Depending on the paper, Kodalith Super RT has a useful development range of about 1½ to 4 minutes at 68°F (20°C). The print may appear dark after it comes out of the developer, but it tends to bleach out in the fixer. Image color can often be controlled through a combination of exposure and development time (long exposure with short development or short exposure with extended development). Print mottling can

result from this technique, but some people find that this enhances the look. Another example is the use of activator and stabilizer with regular photographic papers. Experimentation is in order.

Developers can also be applied in nontraditional ways such as with a spray bottle or a paintbrush. Developers can also be combined with other unintended ingredients to achieve uneven print densities, partial image development, unusual print colors, and brushlike visual effects.

Exhausted Developers

When a developer nears exhaustion, unusual color shifts can occur. When silver grains in paper first begin to develop, they have a yellowish color. As they develop further they turn reddish, then brown, and finally black. Exhausted developers are unable to fully reduce the silver halide in the emulsion, leaving a colored image. Overexposing the print and then underdeveloping it will produce similar results. Mixing equal amounts of exhausted developer (glycin-based developers work best) with fresh developer can also create shifts in print color.

Figure 7.6 To make this picture, Lebe made a photogram directly on the paper. This photogram was contact printed on high-contrast paper processed in Solarol. The image was then very slightly bleached with potassium ferricyanide, with specific areas being bleached with a brush or Q-Tip. Finally, the print was painted with liquid watercolors. To make application easier, Photo-Flo was added to the mixing water to help the watercolors penetrate the print surface.

© David Lebe. *Garden Series, #2*, 1979. Gelatin silver print with paint. 16 × 20 inches. Original in color.

OTHER PAPER DEVELOPER FORMULAS

The following formulas can be helpful in controlling the contrast and image tone of silver-based black-and-white photographic papers.

High-Contrast Developer

Agfa 108 Formula

Water (125°F or 52°C)	24 ounces (750 milliliters)
Metol	75 grains (5 grams)
Sodium sulfite (desiccated)	1½ ounce (40 grams)
Hydroquinone	88 grains (6 grams)
Potassium carbonate	1½ ounce (40 grams)
Potassium bromide	30 grains (2 grams)
Cold water to make 32 ounces (1 liter)	

This paper developer will produce higher than normal contrast on many cold-tone papers with a hard, cool blue-black tone. It is generally used at full strength with a development time of 1 to 2 minutes at 68°F (20°C).

Warm-Tone Developers

It is possible to produce tones through warm black, luminous brown, and sepia by varying the type of developer. The type of paper used determines the effects generated. Fast neutral-tone papers yield warm blacks and brown-blacks, and slower warm-tone papers produce brown-black through very warm brown in the same developer. Experimentation is required to find the combination that will produce the desired image tone.

Agfa 120 Formula
This is a warm-tone hydroquinone developer.

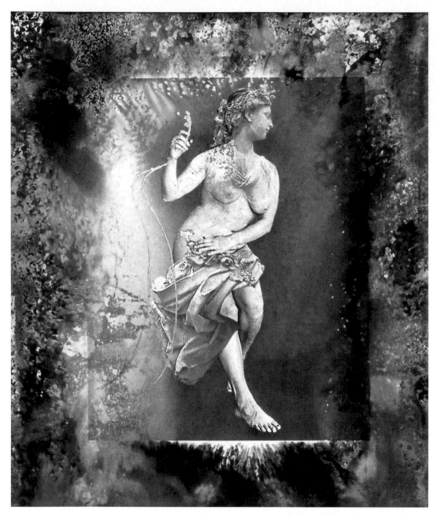

Figure 7.7 Fish's manipulated photographs question Western concepts of beauty by combining classical sculpture with nude figure studies. Her 6 × 7 cm negatives are scanned and reworked with Adobe PhotoShop® and outputted to 4 × 5 inch film by a service bureau. To achieve her unique tones Fish begins processing her print in Dektol (1:1), but during the development process she sprays the paper with nonrecommended developers: a mixture of Ilford Multigrade developer and Kodak activator and stabilizer. A starting mixture might consist of 30 percent developer, 40 percent activator, and 30 percent stabilizer. The resulting images provoke awareness of the shortcomings of our "unclassically" proportioned bodies and our less-than-ideal corporeal states. (See Color Plate 2.)

© Alida Fish. *Walking with Pygmalion, #8,* 1998. 20 × 16 inches. Toned gelatin silver print. Courtesy of Schmidt/Dean Gallery, Philadelphia, PA. Original in color.

Water (125°F or 52°C)	24 ounces (750 milliliters)
Sodium sulfite (desiccated)	2 ounces (60 grams)
Hydroquinone	350 grains (24 grams)
Potassium carbonate	2½ ounces (80 grams)
Water to make 32 ounces (1 liter)	

Standard starting procedure is to dilute the developer 1:1 (1 part developer to 1 part water) at 68°F (20°C) and process 1½ to 3 minutes. On a paper such as Agfa Brovira-Speed, this combination produces a warm black tone. Agfa 120 can deliver a variety of warm black to brown tones depending on the paper, dilution, and exposure time. For instance, a brown-black tone can be produced on Agfa Portriga Rapid by increasing the exposure time by up to about 50 percent, diluting the developer 1:5, and processing 4 to 5 minutes.

Agfa 123 Formula

This is a brown-tone hydroquinone developer.

Water (125°F or 52°C)	24 ounces (750 milliliters)
Sodium sulfite (desiccated)	2 ounces (60 grams)
Hydroquinone	350 grains (24 grams)
Potassium carbonate	2 ounces (60 grams)
Potassium bromide	365 grains (25 grams)
Cold water to make 32 ounces (1 liter)	

Agfa 123 is designed to produce brown-black through olive-brown tones on warm-tone portrait paper. For example, you can get a neutral to sepia brown on Agfa Portriga Rapid by doubling the normal exposure, using a dilution of 1:4 (1 part developer to 4 parts water), and processing for about 2 minutes. If you increase the exposure time to 2½ times normal, use a dilution of 1:1, and extend the processing time to 5 to 6 minutes, Portriga Rapid can produce a brown-black tone.

Amidol Formula

Water (125°F or 52°C)	20 ounces (800 milliliters)
Amidol	120 grains (10 grams)
Sodium sulfite (desiccated)	365 grains (30 grams)
Citric acid (crystal)	60 grains (5 grams)
Potassium bromide (10% solution)	3/4 ounce (30 milliliters)
Benzotriazole* (1% solution)	1/2 ounce (20 milliliters)
Cold water to make 32 ounces (1 liter)	

*Edwal Liquid Orthazite can also be used.

Amidol is designed to be used full strength and developed for 2 minutes at 68°F (20°C) to get blue-black tones. It may be diluted and have the developing time lengthened to obtain softer, high-key prints. Amidol must be mixed fresh before each use because it will keep for only a few hours in stock solution. Since amidol has no carbonate, it does not require exact mixing. Variations in the amount of amidol affect the developing time. Variations in the amount of sodium sulfite affect the keeping qualities of the solution. Amidol is not very sensitive to bromide, so the amount of potassium bromide may be adjusted to ensure clear highlights. Contact papers often need only about half as much bromide as enlarging papers.

Glycin Developers

Glycin is a versatile paper developer that produces a strong, deep black on bromide papers and brown to sepia tones on warm-tone chloride and chlorobromide papers.

Glycin Formula

Water (125°F or 52°C)	24 ounces (750 milliliters)
Sodium sulfite	$3\frac{1}{3}$ ounces (100 grams)
Trisodium phosphate (monohydrate)	$4\frac{1}{6}$ ounces (125 grams)
Glycin	375 grains (25 grams)
Potassium bromide	45 grains (3 grams)
Water to make 32 ounces (1 liter)	

With bromide papers the normal dilution is 1:4 (1 part developer to 4 parts water), and with chloride and chlorobromide papers the dilution is 1:3. Normal developing time is 2 to 3 minutes at 68°F (20°C). A wide range of tonal effects can be achieved by altering the exposure, dilution, and processing time.

Ansco 130 Formula

Ansco 130 is an all-purpose Metol-hydroquinone glycin developer that produces smooth, deep, well-separated black tones while retaining highlight detail and brilliance with a wide range of processing times.

Water (125°F or 52°C)	24 ounces (750 milliliters)
Metol	32 grains (2.2 grams)
Sodium sulfite (desiccated)	$1\frac{3}{4}$ grains (50 grams)
Hydroquinone	50 grains (11 grams)
Sodium carbonate (monohydrate)	$2\frac{1}{2}$ ounces (78 grams)
Potassium bromide	80 grains (5.5 grams)
Glycin	50 grains (11 grams)
Cold water to make 32 ounces (1 liter)	

It is normal for this developer to appear to be slightly colored. For normal results, dilute 1:1 (1 part developer to 1 part water) at 68°F (20°C). Cold-tone papers can be developed for 2 to 6 minutes, while warm-tone papers have a range of $1\frac{1}{2}$ to 3 minutes. Higher contrast can be achieved by using Ansco 130 straight. Increasing the dilution to 1:2 can create softer prints.

Ilford ID-78 Formula

ID-78 is a Phenidone-hydroquinone warm-tone developer.

Water (125°F or 52°C)	24 ounces (750 milliliters)
Sodium sulfite (desiccated)	$1\frac{3}{4}$ ounce (50 grams)
Hydroquinone	175 grains (12 grams)
Sodium carbonate (desiccated)	2 ounces (62 grams)
Phenidone	$7\frac{1}{2}$ grains (0.5 gram)
Potassium bromide	6 grains (0.4 gram)
Cold water to make 32 ounces (1 liter)	

Dilute 1:1 (1 part developer to 1 part water) at 68°F (20°C) and process for 1 minute. To extend the developing time, increase the dilution to 1:3 and process for 2 minutes.

Table 7.1 Dr. Beers Variable-Contrast Developer Dilutions

	Contrast							
	Low		Normal				High	
	Sol 1	Sol 2	Sol 3	Sol 4	Sol 5	Sol 6	Sol 7	Sol 8
Parts of A	8	7	6	5	4	3	2	1
Parts of B	0	1	2	3	4	5	14	15
Parts of water	8	8	8	8	8	8	0	0

Sol = solution.

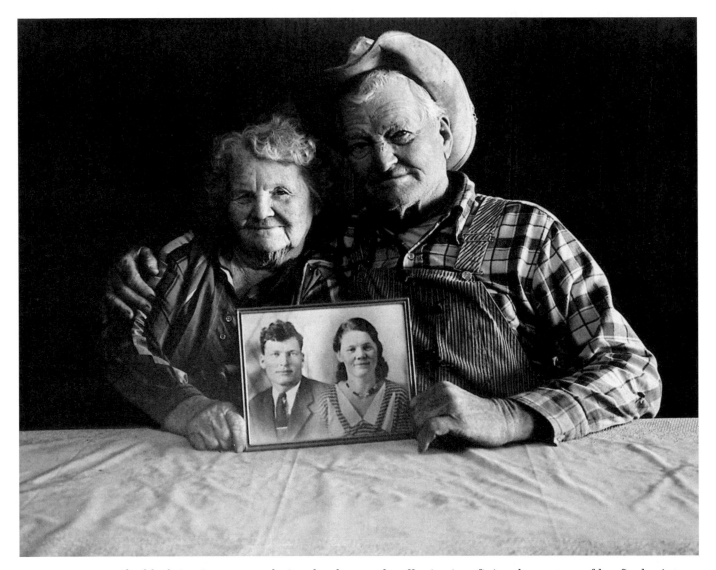

Figure 7.8 Van Cleef finds Dr. Beers two-solution developer to be effective in refining the contrast of her final print. To retain the subtle nuances of the texture of this image, Beers solution #3 (slightly lower contrast than normal) was used with grade 2 Agfa paper. The Metol developing agent in solution A acts on the high tonal values while the hydroquinone develops the middle and lower tonal values.

© June Van Cleef. *Retired Farmer and His Wife*, 1988. Gelatin silver print. 11 × 14 inches. Courtesy of The Afterimage Gallery, Dallas.

Catechol (Pyrocatechin) Formula

Pyrocatechin yields exceedingly rich brown tones on bromide papers.

Water (110°F or 43°C)	22 ounces (700 milliliters)
Catechol (Pyro-catechin)	60 grains (4 grams)
Potassium carbonate	1½ ounces (45 grams)
Potassium bromide	6 grains (0.4 grams)
Water to make 30 ounces (900 milliliters)	

Catechol (Pyrocatechin) works best at about 100°F (38°C) with exposure times greatly reduced from those used with normal cold-tone developers. After development, the print is cooled in a water bath and then processed following normal procedures.

Dr. Beers Variable-Contrast Formula

Dr. Beers is the standard against which variable-contrast developers are generally measured. Varying the proportions of the stock solutions A and B results in a progressive range of tonal contrasts.

Stock Solution A

Water (125°F or 52°C)	24 ounces (750 milliliters)
Metol	120 grains (8 grams)
Sodium sulfite (desiccated)	350 grains (23 grams)
Sodium carbonate (desiccated)*	300 grains (20 grams)
Potassium bromide	16 grains (1.1 grams)
Cold water to make 32 ounces (1 liter)	

Stock Solution B

Water (125°F or 52°C)	24 ounces (750 milliliters)
Hydroquinone	120 grains (8 grams)
Sodium sulfite (desiccated)	350 grains (23 grams)
Sodium carbonate (desiccated)*	400 grains (27 grams)
Potassium bromide	32 grains (2.2 grams)
Cold water to make 32 ounces (1 liter)	

*The original Dr. Beers used potassium carbonate. Sodium carbonate may be substituted, as it is less expensive and more widely available. It should not produce any observable differences.

Stock solutions A and B are mixed at the time of use in varying proportions to yield a progressive range of contrasts, as listed in Table 7.1. Dr. Beers has a developing range of 1½ to 5 minutes at 68°F (20°C). The low-number solutions can be diluted even further with water for extremely soft effects.

ADDITIONAL INFORMATION

Adams, Ansel. *The Print.* Boston: Little, Brown, 1995.

Anchell Stephen G. *The Darkroom Cookbook.* Second Ed. Boston: Focal Press, 2000.

Toning for Visual Effects 8

Toning plays a vital role in translating the photographer's visual intent into a concrete reality. Alterations in the color relationships of a print can dramatically change the aesthetic and emotional responses to the work.

PROCESSING CONTROLS

When working with black-and-white materials, the following four factors play a role in determining the final color of the photograph:

1. Paper type and grade
2. Developer type, dilution, and temperature and length of development
3. Processing and washing
4. Chemical toner type, dilution, and temperature and length of toning

The developer-paper combination plays a key role in determining the look of the print, regardless of which type of toner is selected. Similarly, toner that delivers the desired visual effect with one developer-paper combination can be ineffective or produce undesirable effects with another. Most manufacturers provide charts that list widely used and recommended paper-toner combinations. For example, if the printmaker wanted to achieve the maximum warm brown color from a toner, a paper such as Ilford Multigrade Fiber Base Warmtone developed in

Kodak D-52 might be recommended. Almost all papers respond to some degree to most toners. Generally, warm-tone silver chloride papers (contact papers) show a more pronounced toning effect than cold-tone silver bromide papers (enlarging papers).

Extended development times tend to limit the effect of a toner. A warm-tone developer, such as Kodak D-52 or Kodak Selectol-Soft, used in place of a cold-tone developer, such as Kodak Dektol, will produce even warmer images. Thorough washing is important to avoid print staining. Experience, testing, and careful observations are necessary for consistent and repeatable results. Keeping a written record of procedures can help you build a storehouse of toning knowledge. Experimentation is the only way to see what works best in your situation.

BASIC TYPES OF TONERS

Many toners are available in prepared liquid or powder form, and mixing from formulas may derive even more variations. Chemical toners can be divided into three major types: replacement, mordant dye, and straight dye.

Replacement Toners

The use of inorganic compounds (salts) to replace or partially replace the silver in a fully processed photograph makes for a wide

variety of image colors. In this process, the silver is chemically converted with toners such as gold, iron, selenium, sulfur, and other metallic compounds. Some of these toners act directly on the silver image, while others rely on bleaching the image and then redeveloping it in a toning solution. It is possible to achieve muted and subtle visual effects with replacement toners, which are also permanent and stable.

Mordant Dye Toners

A *mordant* is a compound that combines with a dye so the color cannot bleed or migrate within the dyed medium. In mordant dye toning, the image is converted to silver ferrocyanide through the use of a mordant such as potassium ferricyanide. A mordant acts as a catalyst, permitting the use of dyes that would not normally combine with silver. The dye is deposited in direct proportion to the density of the ferrocyanide (mordant) image. This process allows dye toners to be used to produce a wide variety of vivid colors. Image color can be further altered by immersing the photograph in a bath containing different colored dyes or by combining dyes. Some of the problems with mordant dye toners are:

1. They are not as stable as replacement toners.

2. They are more likely to fade upon prolonged exposure to UV light.

3. Some of their initial intensity is often lost during the washing process.

4. Traces of the toner are often left in the white base areas of the paper even after a complete wash.

Straight Dye Toners

With these toners, the silver is not converted and the dye affects all areas equally. These toners are widely available and very easy to use. Although they can produce vivid colors, the lack of difference in toner intensity between the highlight and shadow areas tends to create a flat color field effect. This can unify a composition, or it can create a sense of sameness that can be visually dull.

PROCESSING PRINTS TO BE TONED

The following procedures are recommended starting points for all toning procedures discussed in this chapter, unless otherwise noted. Table 8.1 summarizes the processing steps in toning for visual effects.

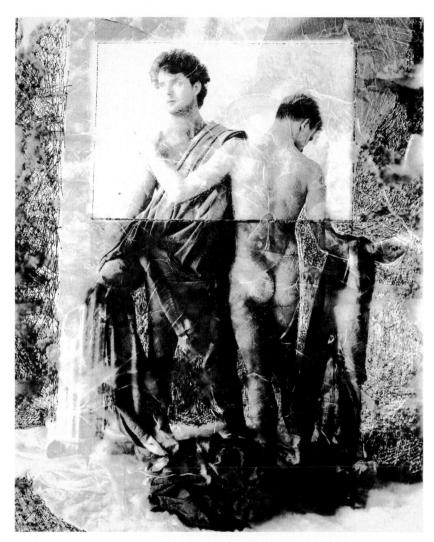

Figure 8.1 Toning permits the photographer to reenter the photograph and continue to make visual statements about the nature of the subject. The photographer's knowledge of materials and expressionistic drive can come together in this process. Byrd used an etching needle on his 6 × 7 cm negative (emulsion side for black lines and base side for white lines). The print was made by exposing the negative through wet tissue paper on the paper's surface for 50 percent longer than the normal time. Then the interior rectangle was masked, and the print was given additional exposure. The paper was processed in Ethol LPD (1:1) for 3 minutes. After the final wash, the print was immersed in copper toner for 10 minutes, redeveloped in LPD (1:9) for 20 seconds, treated with a silver toner for 5 minutes, washed in a hypo clearing bath, and reimmersed in the copper toner for 5 minutes.

© Jeffrey Byrd. *Life Is Splendid and Obscure and Long Enough*, 1989. Gelatin silver print. 20 × 16 inches. Original in color.

Table 8.1 Processing Steps in Toning for Visual Effects at 68°F (20°C)

Step	Summary	Time
1. Developer	Select a developer-paper combination to match the toner	1½ to 5 minutes
2. Stop bath	Use a regular 28% acetic acid stop bath.	1/2 minute
3. First fix	Use only fresh fix. Check to see if hardener is needed. Do not overfix.	3 to 5 minutes
4. Second fix	Same as step 3.	3 to 5 minutes
5. Rinse	Remove excess fix with water.	5 minutes minimum
6. First wash*	Begin the removal of chemicals.	2 to 5 minutes
7. Washing aid	Use Perma-Wash or Kodak Hypo Clearing Agent.	2 to 5 minutes
8. Second wash	Remove fixer residuals to prevent staining.	10 minutes
9. Toning	Use a minimum of three trays: Tray 1—water holding Tray 2—toner Tray 3—collection tray Tray 4—running water (print washer)	
10. Washing aid	Same as step 7.	2 to 3 minutes
11. Final wash*	Remove all chemicals from the paper.	60 minutes
12. Drying	Air-dry, face down, on plastic screens. Do not use heat.	As needed

*All washing times must be established for specific conditions. The times given should be adequate to prevent print staining in most applications.

Printing and Development

To a certain degree, almost all toners affect the contrast and/or density of a print, so it is a good idea to experiment before toning any final prints. Some toners lighten the final print and others darken it. Changes in exposure and/or development time may be needed to adjust for these effects. Many toners' instructions tell you whether to expect such changes. When first working with a toner, it is helpful to make extra prints, including duplicates of what is believed to be the proper exposure and prints having more and less exposure than normal. The making of additional prints also permits variation in toning times, thus increasing your selection of color effects.

Stop Bath

After development is complete, prints should be drained and then immersed in a 28 percent acid stop bath for 30 seconds with constant agitation at 68°F (20°C).

Fixer

Proper fixing, with fresh fix, is a must to ensure high-quality toning results. Either a single rapid fixing bath or a two-bath method can be used. Incomplete fixing will fail to remove residual stop bath and silver thiosulfate compounds, resulting in an overall yellow stain on prints toned with selenium or sulfide. These stains are most visible in the border and highlight areas of the print. Purplish circular stains are often due to improper agitation during fixing. Excessive fixing can bleach the highlight areas and produce an unexpected change in the color of the toned image.

Many papers tone more easily if the paper is fixed without any hardener. Some toners specifically require the use of fix without hardener. Check the directions *before* processing.

Prints toned with nonselenium brown toners can be treated with a hardener to increase surface durability. This is done right before the final wash. A hardening bath such as Kodak Liquid Hardener is diluted 1:3 (1 part hardener to 3 parts water), and the prints are immersed in it with constant agitation, for 2 to 5 minutes. The print is then given a final wash.

Washing before Toning

After proper fixing, rinse excess fixer off the print and begin the first wash of at least 5 minutes at 68°F (20°C). Photographs can be stored in a water holding bath until the printing session is complete. This allows the

remaining washing and toning steps to be carried out at the same time.

After the first wash, prints are immersed in a washing aid or hypo eliminator for recommended times, usually about 2 to 5 minutes. The print is then washed for a minimum of 10 minutes, after which it is ready to be toned.

Previously processed and dried prints can be toned, but first they must be allowed to soak in a water bath and become completely saturated. If you do not do this, the toner might be unevenly absorbed, resulting in a mottled finish.

Washing after Toning

After the print has been toned, it must be washed. The washing time will vary depending on the combination of paper, toner, and washing technique. Check the manufacturer's recommendations for suggested starting washing times. A general guideline is to rinse the print immediately after it comes out of the toner, immerse it in a washing aid, with constant agitation, for 2 to 3 minutes, and then give it a final wash of 1 hour.

The wash and washing aids can affect certain toner-paper combinations. For instance, mordant dye toners tend to lose intensity during the final wash. You can compensate for this loss by extending the toning time. When the print is immersed in a washing aid, sepia toners may be intensified or a shift in tonality may occur, while blue toners may lose intensity.

Drying

Toned prints should be allowed to air-dry, facedown, on plastic screens. Heat-drying can produce noticeable shifts in color.

GENERAL WORKING PROCEDURES FOR TONERS

Safety

Review and follow all safety rules outlined in Chapter 2 before beginning any toning operation. Always wear thin, disposable rubber gloves and work in a well-ventilated area. Some toners, such as Kodak Poly-Toner

and certain sepia toners, release sulfur dioxide (rotten-egg smell) and should be properly ventilated with an exhaust fan. Have no other photographic materials in the toning area. Certain toners can release hydrogen sulfide gas, which can fog unexposed film and paper and oxidize unprotected silver images on film and prints.

Equipment

When working with a single-bath toner, a minimum of three clean trays, slightly larger than the print, are required. The first tray is used to hold the prints waiting to be toned. The second contains the toner. The third contains a water bath to hold the prints after they have been toned. A fourth tray or print washer with a running water bath is desirable to rinse off excess toner. The action of the toner will continue as long as there is any toner remaining on the paper. Different tonal effects can be achieved by varying the dilution rates of the single-bath toners.

Reuse of Toners

Once toners have been diluted and used, they cannot be reliably stored or reused. An exception is hypo alum sepia toner, which actually improves with use and can be kept for years. Generally, the correct amount of toner solution for the number of prints being toned should be mixed for each toning session and discarded after it has been used.

Use of a Comparison Print

Keep a wet, untoned print next to the print being toned as a visual guide to the toner's action. This is the only accurate way to measure how much effect has taken place. A disposable work print can be placed on the backside of a flat-bottom tray and propped up next to the toning tray for easy viewing.

BROWN TONERS

Brown toners are the most widely used and diverse group of toners. They are generally considered to have a warm, intimate, and engaging effect. They are divided into three

major groups. Selenium toners such as Kodak Rapid Selenium Toner deliver purplish to reddish brown tones. Cool chocolate browns are created from single-solution, sulfur-reacting toners such as Kodak Hypo Alum Sepia Toner T-1A, Kodak Polysulfide Toner T-8, and Kodak Brown Toner. Very warm browns are produced by bleach and redevelopment sulfide toners such as Kodak Sulfide Sepia Toner T-7a. Any Kodak toner with a "T" in the name is a formula toner and must be prepared by you. Berg and Edwal also make brown toners.

Some toners are capable of producing a wide range of effects and cannot be put into a single category. These include Kodak Poly-Toner, which can yield a wide range of colors, and Kodak Gold Toner T-21, which produces a range of neutral brown tones on warm-tone papers.

Brown Tones on Warm-Tone Papers

Many warm-tone papers, such as Ilford Multigrade Fiber Base Warmtone and Luminos Charcoal R Warm-tone, lose contrast and density in polysulfide brown toners such as Kodak Brown Toner and Kodak Polysulfide Toner T-8. These toners also bleach the image slightly, producing a yellow-brown color that may not be visually acceptable. You can compensate for these effects by modifying the development time. Using Luminos Charcoal R Warm-tone paper as an example, process it in Kodak D-52 (1:1) for 2 minutes at 68°F (20°C). Use the same exposure time to make another print, but increase the development time to 3½ minutes. The extra development time increases both the contrast and the density, offsetting the bleaching effect of the toner. Warm-tone papers can deliver even richer browns when processed in a cold-tone developer such as Dektol (1:3) for 3½ minutes at 68°F (20°C).

Brown Tones on Neutral- and Cool-Tone Papers

Neutral- and cool-tone papers, such as Kodak Polycontrast, do not produce a yellow cast. You can maintain contrast and density by increasing the developing time by about 25 percent and leaving the exposure time the same.

Kodak Rapid Selenium Toner

Kodak Rapid Selenium Toner is a prepared single-solution toner that can be used to make purplish brown to reddish brown colors on neutral- and warm-tone papers. Rapid Selenium Toner converts the silver image into brown silver selenide and causes a slight increase in print density and contrast. The increased density is more noticeable in the highlight areas, while the increased contrast is more noticeable in the shadow areas. To compensate for these characteristics, a slight reduction (often less than 10 percent) in development time may be necessary.

The starting dilution rate for Rapid Selenium Toner is 1:3 (1 part toner to 3 parts water). The normal toning time range is 2 to 8 minutes. Diluting the toner 1:9, 1:20, or 1:30 slows the toning action, producing a variety of intermediate effects, and is easier to control. Very subtle effects and protective benefits against atmospheric gases can be achieved by diluting 1 ounce of Rapid Selenium Toner to a gallon of water and toning for 8 to 15 minutes. Allow for the fact that toning will continue for a brief time in the wash. A faint smell of sulfur dioxide may be noticeable when you are working with this toner. After toning is complete, treat the print with a washing aid and then wash for 1 hour.

Kodak Poly-Toner

Kodak Poly-Toner is a versatile, single-solution, commercially made toner. Poly-Toner changes the silver image into part selenide and part sulfide. It is capable of producing a variety of brown tones, from sepia on cold papers to warm browns on warm papers. Table 8.2 provides some common starting points for working with Kodak

Table 8.2 Toning with Kodak Poly-Toner at 70°F (21°C)

Dilution	Tone Produced	Time
1:4	Reddish brown	1 minute
1:24	Brown	3 minutes
1:50*	Warm brown	7 minutes

*A loss of density can occur at this dilution. Compensate by increasing the print's development time.

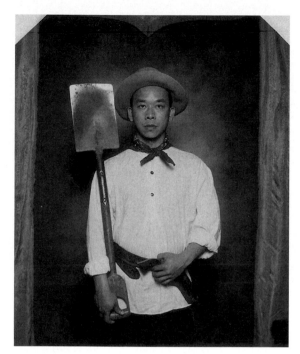

Figure 8.2 Pipo uses the nineteenth-century photographic syntax to reinterpret and simulate tintype portraits made in the American West. Using himself as an Asian model for all the characters, he takes on and gives new twists of meaning to gunslingers, musicians, miners, and gentlemen. "By consciously assuming culturally powerful icons, and not the assumed stereotypical representations of Asians as the submissive *other* (opium addicts, domestic servants) my goal is to humorously and ironically question and challenge the legitimacy and authority of the Western myth." Pipo uses Kodak Poly-Toner to warm the image to mimic the feel of an old photograph. The prints were future toned with a combination of coffee and chicory from the Café du Monde in New Orleans.

© Pipo Nguyen-Duy. *AnOther Western*, 1998. Toned gelatin silver print. 5 × 4 inches. Original in color.

Poly-Toner. Following toning, immerse the print in a washing aid and then wash for at least 1 hour.

Kodak Brown Toner

Kodak Brown Toner is a packaged single-solution toner that produces sepia tones on most papers. This is accompanied by a loss in contrast that can be offset by increasing the development time. Brown Toner changes the silver image into brown silver sulfide. This toner does contain potassium sulfide and should be used only in a well-ventilated area.

Kodak Brown Toner has a normal toning range of 15 to 20 minutes at 68°F (20°C) with agitation. When toning is finished, treat the print with a washing aid and then wash for at least 1 hour. Increasing the temperature will increase the toner's activity and reduce the toning time. Kodak Polysulfide Toner T-8, whose formula is provided later in this section, can produce results very similar to those produced by Kodak Brown Toner.

Kodak Sepia Toner

Kodak Sepia Toner is a prepared two-solution toner that can provide good sepia tones on cold-tone papers such as Kodak Polymax Fine Art and Ilford Multigrade IV FB, or yellow-brown tones on warm-tone papers. Varying the toning time to alter the color is ineffective with Kodak Sepia Toner and is not recommended. This toner changes the silver image into brown silver sulfide. It results in some loss of print density, which can be corrected by increasing the exposure time.

With Kodak Sepia Toner, the print is bleached in solution A for approximately 1 minute, until the blacks in the shadow areas disappear. A light brown image in the shadows, with the lighter tones becoming invisible, indicates that the bleaching is complete. If the print is not totally bleached before being put in the sulfide toner, irregular tones are likely to occur. After bleaching, the print is thoroughly rinsed for a minimum of 2 minutes in running water, then immersed in solution B for about 30 seconds, until the original density returns. Following the completion of the toning operation, the print is placed in a washing aid and then washed for a minimum of 1 hour. Kodak Sulfide Sepia Toner T-7a, whose formula is provided in this chapter, delivers similar results to those achieved with Kodak Sepia Toner.

Retoning Process
It is possible to retone prints in Kodak Sepia Toner to achieve a subtler, but nevertheless more striking, effect than can be produced from a fully toned sepia image. The gray

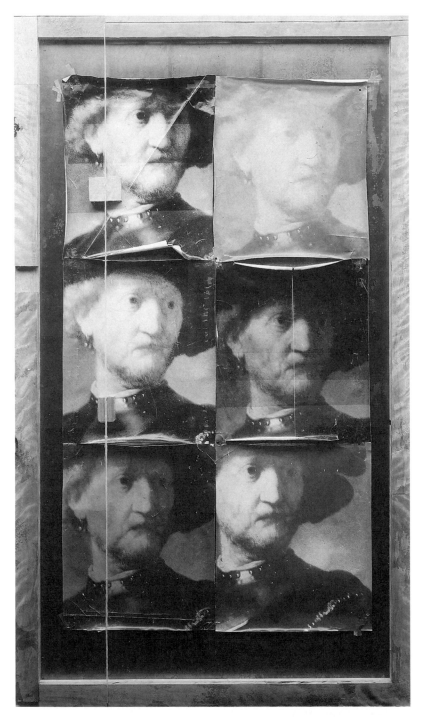

Figure 8.3 Reflecting on the idea of more than one, Doug and Mike Starn challenge many basic concepts of fine art photography. They are known for crumpled, scratched, torn, and taped-together images that have been thumbtacked to the wall. The Starns make large-scale photographs and installation pieces designed to hold the viewers' attention in big gallery spaces alongside painting and sculpture. *Rembrandt Heads* is six prints of the same negative, photographed at the Art Institute of Chicago, that were given six different exposure times. These prints were then copper-toned at different lengths of time, resulting in a variety of copper hues from salmon to deep copper.

© Doug and Mike Starn. *Rembrandt Heads*, 1989. Toned gelatin silver prints with Scotch tape. 88 × 51 inches. Original in color.

areas are the most affected with this method, turning slightly golden brown rather than reddish brown. The black portions of the print change little or not at all.

For this retoning process, make a number of prints that are slightly darker than normal (start with a range of 10 to 25 percent darker). Papers such as Ilford Multigrade Fiber Base Warmtone and Ilfobrom Gallery FB deliver good results. Begin experimentation with test prints, as it may be necessary to adjust the processing times depending on the type of paper and its contrast. To achieve the subtlest effects, begin with a dry print that has been fixed and completely washed. Use the regular Kodak Sepia Toner mixture at about 68°F (20°C) and follow these steps:

1. Place the print in solution A (bleach) for about 30 seconds.

2. Wash in running water for 2 minutes.

3. Place the print in solution B (toner) for approximately 1 minute.

4. Wash in running water for 2 minutes.

5. Rebleach the print in solution A for about 15 seconds.

6. Wash in running water for 2 minutes.

7. Retone in solution B for approximately 1 minute.

8. Wash for 1 minute.

9. (Optional) Place the photograph in a 1:13 solution of Kodak Liquid Hardener (1 part hardener to 13 parts water) for about 3 minutes with occasional agitation.

10. Give the image a final wash in running water for a minimum of 30 minutes.

Kodak Hypo Alum Sepia Toner T-1a

Kodak Hypo Alum Sepia Toner T-1a is designed to deliver sepia tones on warmtone papers. Hypo Alum Sepia Toner T-1a results in a loss of contrast and density, which can be offset by increasing the exposure time by up to 15 percent or increasing the development time by up to 50 percent. This toner is designed to be used at a high

temperature, 120°F (49°C), for 12 to 15 minutes. Toning at above 120°F for longer than 20 minutes may cause blisters or stains on the print. The toner may be used at room temperature, but toning will take several hours. The solution should be agitated occasionally during this process. After completion, it may be necessary to wipe the print with a soft sponge and warm water to remove any sediment. The print is then treated with a washing aid, followed by a final wash of at least 1 hour.

Kodak Hypo Alum Sepia Toner T-1a Formula

Prepare this formula carefully following these instructions:

Water (68°F or 20°C)	90 ounces (2,800 milliliters)
Sodium thiosulfate (pentahydrate)	16 ounces (80 grams)

Dissolve completely and then add the following solution:

Water (160°F or 70°C)	20 ounces (640 milliliters)
Potassium alum (fine granular)	4 ounces (120 grams)

Now add the following solution, including the precipitate, slowly to the hypo alum solution while stirring rapidly.

Water (68°F or 20°C)	2 ounces (64 milliliters)
Silver nitrate crystals*	60 grains (4 grams)
Sodium chloride	60 grains (4 grams)

*Dissolve the silver nitrate completely, then dissolve the sodium chloride. Immediately add the solution along with the milky-white precipitate to the hypo alum solution. The formation of any black precipitate should not impair the action of the toner if it is properly handled. Wear gloves because silver nitrate will stain anything it touches black.

After combining these two solutions, add water to make 1 gallon (3.8 liters). When you are ready to use the toner, heat it in a water bath to 120°F (49°C).

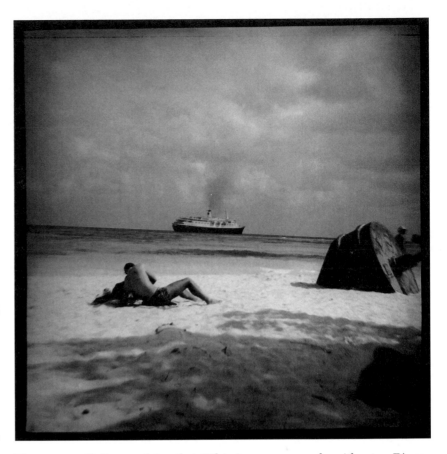

Figure 8.4 Bailey explains that "This image was made with a toy Diana camera that permits little control when taking a photograph. This necessitates a more spontaneous and intuitive approach to making photographs. Neither the result from the Diana, nor the subsequent toning processes employed, respond well to willful intent (the expectation that a certain predetermined look can be achieved upon command). This approach requires that one entrust oneself completely to the tools, to the materials, and to the processes themselves." Bailey later printed the image on Ilford, Warm Tone fiber paper in Zonal Pro HQ Warm Tone developer (10:1). To achieve the brownish-pink color, Bailey used a hypo alum sepia toner.

© Jonathan Bailey. *Playa del Carmen* (*Quintana Roo*) 1994. Toned gelatin silver print. 5½ × 5½ inches. Original in color.

Kodak Sulfide Sepia Toner T-7a

Kodak Sulfide Sepia Toner T-7a is a two-solution bleach and redevelopment toner. It is capable of delivering warm brown tones on many types of paper, including cold-tone papers. Its results and general characteristics are similar to those achieved with the packaged Kodak Sepia Toner.

The print to be toned is placed in solution A (bleach) until only a faint yellowish brown image remains. This takes 5 to 8 minutes. The print is then rinsed completely in running water for a minimum of 2 minutes. Next it is immersed in solution B (toner)

until the original details return, about 1 minute. After this procedure, the print is given a thorough rinse and treated in a hardening bath for 2 to 5 minutes. The hardening bath can be prepared by mixing 1 part prepared Kodak Liquid Hardener with 13 parts water, or using 2 parts Kodak Hardener F-5a stock and 16 parts water (see formula). The hardening bath should not affect the color or tonality of the print. After toning (and hardening), place the print in a washing aid and then wash for a minimum of 1 hour.

Kodak Sulfide Sepia Toner T-7a Formula

Stock Bleaching Solution A

Water (68°F or 20°C)	32 ounces (1 liter)
Potassium ferricyanide (anhydrous)	2½ ounces (75 grams)
Potassium bromide (anhydrous)	2½ ounces (75 grams)
Potassium oxalate	6½ ounces (195 grams)
28% acetic acid*	1¼ ounces (40 grams)
Water to make 64 ounces (2 liters)	

*To make 28 percent acetic acid from glacial acetic acid, combine 3 parts glacial acetic acid with 8 parts water.

Stock Toning Solution B

Sodium sulfide (*not* sulfite; anhydrous)	1½ ounces (45 grams)
Water (68°F or 20°C)	16 ounces (500 milliliters)

Prepare the bleaching solution as follows:

Stock Solution A	16 ounces (500 milliliters)
Water	16 ounces (500 milliliters)

Prepare the toner as follows:

Stock Solution B	4 ounces (125 milliliters)
Water to make 32 ounces (1 liter)	

Mix the solutions directly before use and dispose of them after each session.

Kodak Hardener F-5a Formula

Water (125°F or 50°C)	20 ounces (600 milliliters)
Sodium sulfite (anhydrous)	2½ ounces (75 grams)
28% acetic acid*	7½ ounces (235 milliliters)
Boric acid crystals**	1¼ ounces (37.5 grams)
Potassium alum (fine granular, dodecahydrate)	2½ ounces (75 grams)
Cold water to make 32 ounces (1 liter)	

*To make 28 percent acetic acid from glacial acetic acid, combine 3 parts glacial acetic acid with 8 parts water.

**Crystalline boric acid is suggested because it is difficult to dissolve boric acid in powder form.

The standard dilution for Kodak Hardener F-5a is 1:13 (1 part hardener to 13 parts water). Process for 2 to 5 minutes at 68°F (20°C).

Kodak Polysulfide Toner T-8

Kodak Polysulfide Toner T-8 is a single-solution toner delivering slightly darker brown tones than Kodak Sulfide Sepia Toner T-7a on warm-tone papers. Unlike Kodak Hypo Alum Toner T-1a, it has the advantage of not having to be heated. This toner is not recommended for use with cold-tone papers.

Kodak Polysulfide Toner T-8 Formula

Water	96 ounces (750 milliliters)
Sulfurated potash	1 ounce (7.5 grams)
Sodium carbonate (monohydrated)	145 grains (2.5 grams)
Water to make 32 ounces (1 liter)	

Prints are immersed in Polysulfide Toner T-8 for 15 to 20 minutes, with agitation, at 68°F (20°C). Raising the temperature increases T-8's activity and reduces the toning time to as low as 3 to 4 minutes at 100°F (38°C). After toning, the print is rinsed in running water for at least 2 minutes and can then be treated in a hardening bath, as mentioned in the Kodak Sulfide Sepia Toner T-7a section, for 2 to 5 minutes. If sediment forms on the print during the toning process, it should be removed with a soft sponge and warm water before the final wash. When these operations are complete, treat the print in a washing aid and give it a final wash of at least 1 hour.

Kodak Gold Toner T-21

Kodak Gold Toner T-21, also known as Nelson Gold Toner, is a single-solution toner that yields an excellent range of brown tones on most warm-tone papers but has little effect on most cold-tone papers. T-21 is unique in the fact that it tones the highlight and shadow areas at the same rate. This allows the toning action to be stopped any time the desired effect has been achieved without having to worry whether the highlight and shadow areas have received equal effects. It also makes possible a variety of even-toned effects that can be created by simply changing the time in the toning bath. T-21 has a normal toning time range of 5 to 20 minutes. This toner requires careful preparation to achieve the expected results.

Kodak Gold Toner T-21 Formula

Stock Solution A

Water (125°F or 50°C)	1 gallon (4 liters)
Sodium thiosulfate (pentahydrate)	2 pounds (960 grams)
Ammonium persulfate	4 ounces (120 grams)

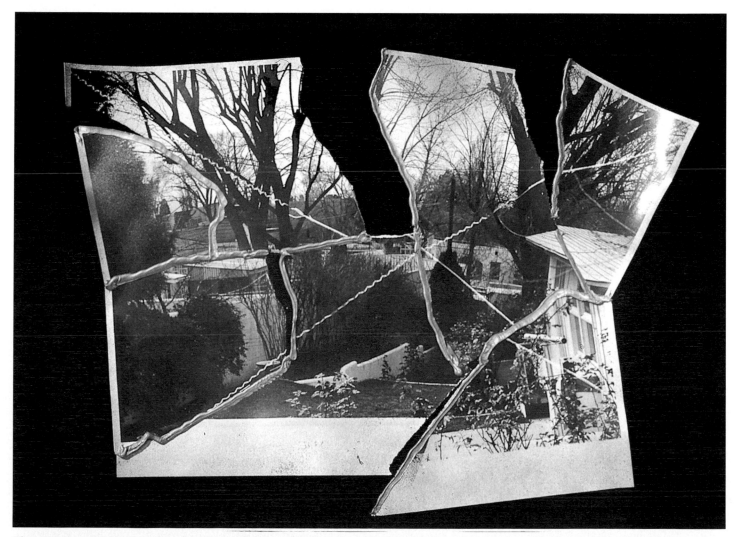

Figure 8.5 Barrow wondered how much he could alter the photographic image and yet retain its specific qualities. In putting together this work, he used gold toner at an elevated temperature of 135°F (57°C) to create extreme blue-blacks on a cold-tone paper. The print was torn apart and then reconstructed with staples and silicon caulking. Various areas of the image were fogged with spray lacquer paint.

© Thomas Barrow. *Yard Descent*, 1982. Gelatin silver print with caulk and paint. 17 × 21 inches. Courtesy of Andrew Smith Gallery, Santa Fe. Original in color.

The sodium thiosulfate must be totally dissolved before adding the ammonium persulfate. Vigorously stir the solution when adding the ammonium persulfate. The solution should turn milky. If it does not, increase the temperature until it does.

Cool the solution to about 80°F (27°C), then add the following solution, including the precipitate, slowly, stirring constantly. If predictable results are desired, the first bath must be cool when these two solutions are combined.

Cold water	2 ounces (4 milliliters)
Silver nitrate crystals*	75 grains (5 grams)
Sodium chloride	75 grains (5 grams)

*The silver nitrate crystals must be completely dissolved before adding the sodium chloride. Wear gloves as the silver nitrate will stain anything it comes in contact with black.

Stock Solution B

Water (68°F or 20°C)	8 ounces (250 milliliters)
Gold chloride	15 grains (1 gram)

Slowly combine 125 milliliters of stock solution B with all of stock solution A, stirring rapidly. Allow the bath to stand until it is cold and a sediment has formed at the bottom. Pour off only the clear liquid for use, leaving the sediment behind.

Pour this clear solution into a tray and heat it with a water bath to 110°F (43°C). During toning, maintain a temperature of 100°F to 110°F (38°C to 43°C). When toning is complete, treat the print in a washing aid and give it a final wash of at least 1 hour.

This bath may be revived by adding stock solution B. The quantity needed depends on the number of prints toned, the intensity of the tone desired, and the time of toning. For instance, when toning to a warm brown, add 4 milliliters of stock solution B after about fifty 8 × 10 inch prints or the equivalent have been toned.

Kodak Gold Protective Solution GP-1

For years Kodak Gold Protective Solution GP-1 was the standard treatment to protect a silver-based photograph from atmospheric gases. Recent scientific evidence indicates that selenium toning can be more effective and a great deal less costly for protective measures. GP-1 is an extremely stable toner that is capable of yielding very pleasing brown tones. The high cost of gold has limited its widespread use. Gold toner protects all fiber-based papers and creates at least a slight visual effect in almost all cold-tone papers.

For protective toning, the print is immersed in the gold toner for about 10 minutes, with agitation, at 68°F (20°C), or until a barely perceptible change in image tone (a slight blue-black) occurs. The toning time can be increased up to 20 minutes for visual effect. Following the toning operation, treat the print with a washing aid and give it a final wash of at least 1 hour.

Kodak Gold Protective Solution GP-1 Formula

Water 68°F (20°C)	24 ounces (750 milliliters)
Gold chloride (1% stock solution)	2½ drams (10 milliliters)
Sodium thiocyanate	145 grains (10 grams)
Water to make 32 ounces (1 liter)	

Mixing 1 gram of gold chloride in 100 milliliters of distilled water can make a 1 percent stock solution of gold chloride. Add the stock solution of gold chloride to the amount of water indicated (24 ounces). Mix the sodium thiocyanate separately in 4 ounces (125 milliliters) of water. While stirring rapidly, slowly add the thiocyanate solution to the gold chloride solution. GP-1 deteriorates quickly and should be mixed right before use. It has a capacity of about thirty 8 × 10 inch prints per gallon. Work in a well-ventilated area and wear protective gloves when mixing this formula.

BLUE TONERS

Kodak Blue Toner T-26

Kodak Blue Toner T-26 delivers solid, deep blue tones on warm-tone papers and soft blue-black tones on neutral-tone papers. It has no effect on cold-tone papers. T-26 increases the contrast and density of the print slightly. This can be corrected by reducing the normal exposure time (a 10 percent reduction is a good starting place).

This toner deteriorates rapidly and should be mixed immediately before use. Toning starts in the highlight areas and then slowly moves into the shadows. Careful observation is necessary to avoid getting a partially toned print with blue highlights and untoned shadow areas. Berg, Edwal, and Photographers' Formulary also make blue toners.

The range of toning times is 8 to 45 minutes at 68°F (20°C). Increasing the temperature of the bath to 100°F to 105°F (38°C to 40°C) speeds up the toning action, thus decreasing the toning times to 2 to 15 minutes. Since toning is slow, only occasional agitation is needed to avoid streaking. For consistent results with a number of prints, slide them rapidly into the toner one after the other. T-26 exhausts itself very quickly. It has a capacity of only five to fifteen 8 × 10-inch prints or the equivalent per quart. When toning is finished, immerse the print in a washing aid and follow with a final wash of at least 1 hour.

Kodak Blue Toner T-26 Formula

Part A Solution

Water 68°F (20°C)	31 milliliters
Gold chloride*	0.4 grams

Part B Solution

Powder thiourea (thiocarbamide)	1 gram
Tartaric acid	1 gram
Sodium sulfate (anhydrous)	15 grams

*A 1 percent gold chloride solution can be used (available from chemical supply sources). Use 40 milliliters of this solution as part A and add 937 milliliters of water to make a total of 977 milliliters of solution.

Dissolve the gold chloride in the water to make part A. Add part A to 946 milliliters (1 quart) of water at 125°F (52°C). Stirring, add part B. Continue to stir until all the chemicals are totally dissolved.

RED TONERS

Red toners can be intense and spectacular, but they require more work than brown or blue toners to achieve good results. Generally, the best and most varied results require toning the print in two separate toners. For example, a print is first toned in Kodak Sepia Toner or Kodak Brown Toner and thoroughly washed. Then it is immersed in Kodak Blue Toner T-26 for 15 to 30 minutes at 90°F (32°C) with occasional agitation. Cold-tone papers produce solid reds, while warm-tone papers yield orange-red hues.

Start with a print having more density and contrast than normal, as there is a loss of these qualities, especially in the shadow areas, with most papers. Red tones can be produced in a single bath of Red Toner GT-15 (see formula). Regardless of which method you use, treat the completed toned print with a washing aid and give it a final wash of at least 1 hour. Berg and Edwal also make red and copper toners, which may be mixed to produce intermediate hues and intensities.

Red Toner GT-15 Formula

Stock Solution A

Potassium citrate	1½ ounces (100 grams)
Water 68°F (20°C) to make 16 ounces (500 milliliters)	

Stock Solution B

Copper sulfate	115 grains (7.5 grams)
Water to make 8 ounces (250 milliliters)	

Stock Solution C

Potassium ferricyanide	100 grains (6.5 grams)
Water to make 8 ounces (250 milliliters)	

Mix stock solution B into stock solution A. While stirring, slowly add stock solution C. Red Toner GT-15 bleaches the print. Compensate by extending the printing time well beyond normal, up to 50 percent.

GREEN TONERS

Green tones are possible with a toner such as Green Toner GT-16. This toner is most effective on warm-tone papers. It bleaches the image, so more exposure time than normal (10 to 25 percent) is necessary. Berg, Edwal, and Photographers' Formulary make green toners.

Green Toner GT-16 Formula

Stock Solution A

Oxalic acid	120 grains (7.8 grams)
Ferric chloride	16 grains (1 gram)
Ferric oxalate	16 grains (1 gram)
Water 68°F (20°C) to make 10 ounces (285 milliliters)	

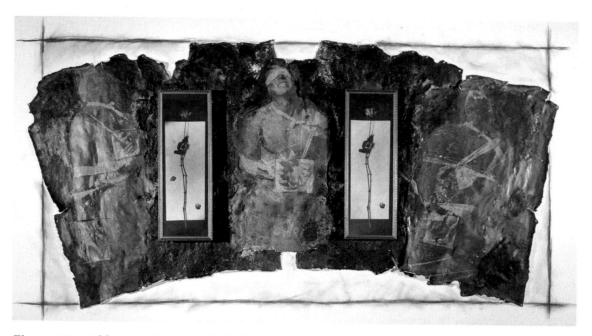

Figure 8.6 Addressing issues of the body, including sexual preference and AIDS, Byrd began this piece with medium-format studio shots that were printed on Kodak Poly Fiber matte surface paper. To add texture, Byrd scratched the negatives by putting them under his shoe and spinning on them. The prints were made about 30 percent too dark and toned for about 20 minutes in copper toner. The dry prints were torn and glued together and painted with a mixture of glue, sand, and tar. The photographs of the roses were done on 4 × 5 inch fiber paper, stand off the larger image about 3 to 4 inches, and are in gold frames. When installed, a charcoal frame is directly drawn onto the gallery wall around the entire piece. (See Color Plate 3.)

© Jeffrey Byrd. *Listening for Falling Debris*, 1991. Toned gelatin silver prints with mixed media. 75 × 137 × 3 inches. Original in color.

Stock Solution B
Potassium ferricyanide 32 grains (2 grams)
Water to make 10 ounces (285 milliliters)

*Stock Solution C**
Hydrochloric acid 1 ounce (28.4 milliliters)
Vanadium chloride 32 grains (2 grams)
Water to make 10 ounces (285 milliliters)

*First add the acid to the water. Then heat the solution to just below the boiling point and add the vanadium chloride.

Mix stock solution B into stock solution A. Stirring vigorously, add stock solution C.

Tone in the mixed solution until the print appears deep blue. Then remove and wash until the tone changes to green. After the green tone appears, continue to wash for an additional 10 minutes. Treat the print with a washing aid and give it a final wash of at least 1 hour.

If a yellowish stain appears, you can remove it by placing the print in the following solution:

Ammonium thiocyanate 25 ounces (1.6 grams)
Water 68°F (20°C) to make 10 ounces (285 milliliters)

This operation should be carried out before treating the print with a washing aid and giving the final wash.

TONING VARIATIONS

Selective Toning

It is possible to tone only selected areas of a print by brushing on a mask that prevents the toner from affecting the covered area.

Begin with a frisket material such as Fotomask made by Luminos Photo Corp., Grumbacher Miskit, Incredible White Mask liquid frisket, or rubber cement and thinner plus different-size brushes. Fotomask is handy because it is a bright red liquid plastic, making it easy to see where it has been applied. Rubber cement, thinned 1:1

(1 part rubber cement to 1 part rubber cement thinner), may also be used. Another option is clear self-adhesive frisket, such as Photo/Frisket Film made by Badger Airbrush.

Working Technique

Working on a dry print, brush the frisket or rubber cement onto the areas not to be toned. When using rubber cement, apply several thin coats, allowing one to dry before applying the next. This ensures complete coverage and reduces the likelihood of the toner's seeping into areas that are not fully protected.

To avoid leakage into protected areas, some printmakers place the dry print directly in the toner without any presoak. If you do this, you must constantly agitate the print to avoid streaks. Because of the mask, the print may buckle and curl due to uneven wetting, but this should not harm the print. If this method does not work, presoak the print for 3 to 5 minutes.

After toning is complete, follow the normal post-toning procedures. Remove the frisket *after* the print has been washed for about 30 minutes. You can remove Fotomask by picking it up with sticky masking tape or by rubbing your fingers across the covered area after the print has gone through about half of its final wash. After you remove the mask, wash the print for a minimum of 1 hour to get rid of any residue from the mask.

Multitoned Prints

Different toners can be selectively applied to various areas of the photograph. If you are doing this, you must repeat the entire process each time, with the exception of the extra wash, which is given after all the toning is done. If you do not wish to combine toners, be certain to protect the previously toned areas with frisket.

Areas of a print can be selectively toned while it is still wet. Exact control and evenness of toning are extremely difficult to achieve, but interesting and unexpected possibilities exist with this technique.

To wet-tone a well-washed print, place it on a clean, flat surface and squeegee the back and then the front so it is completely free of water. Then apply the toner with a brush or cotton swab. You can add a couple of drops of a wetting agent such as Kodak Photo-Flo to the toner to prevent it from beading up on the print surface. For more intensity, rinse the print with water, squeegee, and apply a second coat of toner. Apply only one color toner at a time. You can repeat this process as many times as you wish to obtain the desired results.

Toning with Colored Dyes

Prints can be toned with almost any substance. Natural organic dyes made from beets, coffee, grapes, or tea are possibilities. Commercial dyes such as RIT™ are more commonly used. These are inexpensive, come in a wide range of colors, and are available at most supermarkets.

RIT™ dyes come in powder form and are prepared by mixing the dye with a gallon of water at 125°F (52°C). Mix the dye thoroughly, as undissolved crystals will stain the print.

Dye Technique

1. Presoak the print in water for about 2 minutes.

2. Immerse the print, emulsion side down, in a tray of prepared dye at 100°F (38°C).

3. There is no standard dyeing time. The dye begins to work after about 1 minute, depending on the type of paper used and the color desired. Agitate the print constantly. You can view it anytime, as the dye will continue to work until the print is removed from the solution.

4. When the desired color is achieved, remove the print and wash it for 15 to 60 minutes, or until all the excess dye is removed.

5. Air-dry the print, face down, on a plastic screen.

Selective Dyeing

Dyes, like toners, can be used to make multicolored compositions. First apply the frisket to any areas you do not want dyed. After the first areas have been dyed, washed, and dried, remove the frisket or rubber cement from the next area that you want to dye. You can protect the previously dyed area with frisket or rubber cement. Then place the print in another tray containing a different color dye. You may repeat this process as many times as desired.

Mixing Colors

A mixed-colored effect can be achieved by treating the print with different dyes without using any masking materials.

Bleaching Dyed Prints

You can use plain household bleach or Farmer's Reducer, applied with a number 0 or smaller brush, to remove small areas of dye from the image. Bleaching can provide accents in highlight areas or be used to create white areas within the composition.

Split-Toning

Split-toning can visually expand the sense of space within a photograph by intensifying the differences between the cool white highlight areas and the warm brown shadow areas. This can create an unexpected and subtle sense of spatial ambiguity. Some photographers claim that split-toning can unify objects within a composition and give it added depth. Others do not care for it, saying it fractures the continuity of the photograph by making it seem disjointed and out of kilter. The only way to evaluate the effect of split-toning is to apply the technique to an image and decide whether it creates the desired visual effect. Chlorobromide papers like Ilford Warmtone, Agfa Portriga, and Luminos have two different sizes of silver particles in the emulsion which tone at different rates, making them more useful for split-toning.

Paper and Developer Selection

As in all toning operations, the choice of paper and developer plays a key role in determining the visual outcome. Silver chloride contact papers, such as Kodak Azo, deliver a noticeable split-toning effect. The use of a warm-tone developer, such as Kodak D-52, with such papers yields an even more vivid effect. Chlorobromide enlarging papers tend not to work as well, and bromide papers show almost no effect. If your negatives are not big enough to contact print, you can enlarge them (see Chapter 3). Photograms (cameraless images made by placing objects directly on the paper) also can be split-toned (see Chapter 11).

A more pronounced split-toning effect seems to take place with the developer temperature slightly above normal. A temperature of 77°F (25°C) with Azo paper in Kodak D-52 is a suggested starting point. Keep the temperature constant, as variations of even 1 degree can alter the results.

Processing Procedures

Adjust the exposure time so that Azo paper can be developed in Kodak D-52 for 1 minute at 77°F (25°C) with constant agitation. Developing for more than 1½ minutes tends to reduce the split-toning effect. Developing for less than 45 seconds can produce an image with streaks or without the proper density. After development is complete, continue to process following normal print processing procedures, up through the first wash. Then you are ready to tone.

Split-Toning Formula

A split-toning solution can be prepared by mixing the following formula:

Water (68°F or 20°C)	750 milliliters
Rapid Selenium Toner	70 milliliters
Perma-Wash	30 milliliters
Kodak Balanced Alkali (sodium metaborate)	20 grams
Water to make 1 liter	

Immerse the prints in the toner bath and agitate by continuously interleafing the prints (taking the bottom one and moving it to the top). Observe the prints carefully. Keep an untoned print available for visual reference. First the blacks will intensify. Next the print will exhibit an overall dullness. Finally the shadow areas will start to warm up, and the split between the highlights and shadows will begin to become evident. This should happen within about 4 to 5 minutes.

Continue toning until you like the color and effect. At this point, put the print in a water bath. If the print tones too long, the split will lose its intensity and eventually disappear, taking on a uniform brown color. When split-toning is complete, treat the print with a washing aid for 2 minutes, then wash for at least 1 hour. Air-dry the print, face down, on a plastic screen.

GP-1 Split Toning Process

Jonathan Bailey has developed the following formula.

Step 1: Tone prints in a working solution of Kodak Rapid Selenium toner (1:10–1:15)

until the tones in the print split. Treat the print with a washing aid for 2 minutes, then wash for at least 1 hour.

Step 2: Place selenium toned prints in GP-1 stock solution. With constant agitation, tone prints by inspection until the desired result is reached (usually 3 to 10 minutes). The gold tone will strengthen blues in the highlights and will add a dark green to the shadow areas. Hand wash for 15 minutes. Let prints sit in a water bath and change water every 15 minutes. Air-dry the print, face down, on a plastic screen.

GP-1 Stock Solution

Part A
Gold chloride 1 gram
Distilled water to make 100 ml

Part B
Sodium thiocyanate 100 grams
Distilled water to make 1,250 ml

For a working solution, mix 10 ml Part A to 500 ml water. Add 125 ml Part B, and then water to make 1,000 ml. Stock solutions will keep for months in brown glass containers. Use working solution immediately after mixing and discard after use. Working solution tones about twelve 8 × 10 inch prints.

Toning Black-and-White Films

It is possible to tone black-and-white films for color effects. Kodak T-20 is a versatile, single-solution dye toner that can be used to produce many different color effects. Be certain to mix and use this formula only in a well-ventilated area.

Kodak T-20 Dye Toner Formula

Dye*	3 to 6 grains (0.2 to 0.4 grams)
Wood alcohol or acetone	3¼ ounces (100 milliliters)
Potassium ferri-cyanide	15 grains (1 gram)
Glacial acetic acid	1¼ drams (5 milliliters)
Water (68°F or 20°C) to make 32 ounces (1 liter)	

*The amount of dye needed depends on the type of dye being used, as follows:

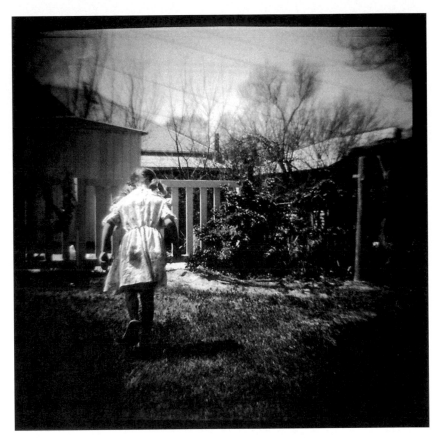

Figure 8.7 Angel tells us that "These photographs elicit memories and thoughts rather than the specific reality of the observed world. I use a plastic Diana camera that eliminates the detail often found in traditional photography. Through the distortion provided by this camera, I engage the viewers in a dialogue between their own experiences or associations and the photograph itself. After selective bleaching the print was split-toned in sepia toner. The print was removed from the toner bath A before the entire image was affected, quickly rinsed, and put into toner bath B immediately. Thus the highlights are warm and the shadows cool."

© Catherine Angel. *Going Home*, from the series *Enchanted Landscapes*, 1994. Toned gelatin silver prints. 16 × 20 inches. Courtesy of Photo-Eye Gallery, Santa Fe. Original in color.

Nabor Yellow 6G	3 grains (0.2 grams)
Auramine 0 (yellow)	6 grains (0.4 grams)
Methyl violet	1¼ grains (0.1 grams)
Methylene blue BB	3 grains (0.2 grams)
Rhodamine B (red)	6 grains (0.4 grams)
Nabor Orange G	3 grains (0.2 grams)
Nabor Brilliant Pink	3 grains (0.2 grams)
Nabor Blue 2G	3 grains (0.2 grams)
Bismark Brown	3 grains (0.2 grams)
Victoria Green	6 grains (0.4 grams)
Fuchsin (red)	3 grains (0.2 grams)

Average toning time is 3 to 9 minutes at 68°F (20°C). The tone will vary depending on the film and length of toning time. Beyond about 9 minutes, there is a danger that the image will begin to bleach out. One should experiment on unwanted or duped

film before attempting to tone a finished piece. After toning is complete, wash the film until the highlights are clear, and then continue to give the film a final wash of about 15 minutes. These dyes are not considered archival and will fade over time.

ADDITIONAL INFORMATION

Books

Donofrio, Diane (Ed.). *Photo-Lab Index, Lifetime Edition.* Keene Valley, NY: Morgan and Morgan, 2001.

Hicks, Roger, and Frances Schultz. *The Black and White Handbook: The Ultimate Guide to Monochrome Techniques.* New York: Sterling Publishing, 1997.

Stone, Jim. *Darkroom Dynamics: A Guide to Creative Darkroom Techniques.* Boston, MA: Focal Press, 1985.

Toning KODAK Black-and-White Materials. Kodak Publication No. G-23.

Other Sources

Berg Color-Tone, Inc., P.O. Box 16, East Amherst, NY 14051

Edwal Scientific Products, 12120 South Peoria Street, Chicago, IL 60643

Luminos Photo Corp., P.O. Box 158, Yonkers, NY 10705

Photographers' Formulary, P.O. Box 950, Condon, MT 59826 (bulk chemicals and prepared versions of many formulas that are no longer commercially manufactured)

9 Special Cameras and Equipment

WHAT IS A CAMERA?

A traditional camera, from a room-size camera obscura to the latest hand-held automatic, is essentially a light-tight box. A hole (aperture) is made at one end to admit light, and some light-sensitive material (usually film) is placed inside the box opposite the hole. The camera's purpose is to enable the light to form an image on the film. This can be accomplished in a variety of ways, but most modern cameras have the same basic components. These include the following:

- A viewing system that allows accurate composition of the image.

- A lens, instead of a hole, that focuses the rays of light to form a sharp image at the back of the camera. This image is upside down and backward. The lens also determines the field of view and influences the depth of field in the scene.

- An adjustable diaphragm, usually an overlapping circle of metal leaves that creates an adjustable hole called an aperture. The aperture controls the intensity of the light that passes through the lens. When it is widened (opened), it permits more light to pass through the lens. When it is closed (stopped down), it reduces the amount of light passing through the lens.

- A shutter mechanism that prevents light from reaching the film until the shutter is released. The shutter opens for a measured amount of time, allowing the light to strike the film. When the time has elapsed, the shutter closes, preventing any additional light from reaching the film.

- A focusing control that changes the lens-to-film distance, thus allowing a sharp image of the subject to be formed at various distances.

- Light-sensitive material, traditionally film, that records the image created by the light. Most cameras use roll film, cassettes, or individual sheets. Electronic cameras record images magnetically on disks or in memory chips.

- A holder for the light-sensitive material. This is a system or device designed to maintain the correct position of the film in relationship to the lens.

- A film-advance mechanism, in roll and cassette cameras, that advances the film after an exposure is made to the next available unexposed portion of the roll or cassette. Sheet film is loaded into film holders that are put in the back of the camera. Electronic imaging cameras automatically go to the next free space on the disk.

- A light meter, usually built into the body of the camera, measures the intensity of the light.

The Role of the Camera

The camera remains the primary tool that most photographers use to define and shape

an image. The selection of camera and lens can determine image characteristics such as sharpness, tonal range, field of view, and graininess of the final print. Because of this, it is often possible to identify the type of camera used in the creation of a particular image. Consequently, the type of camera chosen should support the photographer's way of seeing and working, since it plays an integral role in determining the final outcome of the image. To limit the choices of cameras is to reduce the possibilities of what one can express about the nature of a subject and photography itself.

Throughout the history of photography, the changing needs of the photographer, as well as the expanding applications of the medium, have led to the development of many specialized camera designs. Cameras are the result of centuries of evolutionary change. This can be seen in designs from the past, such as Etienne-Jules Marley's photographic gun (capable of capturing a sequence of images on a single round photographic plate), to those of the present, as in today's spy camera hidden inside a working digital watch.

The camera's design is a basic part of the photographer's visual language. It is up to the individual photographer to understand and apply a camera's capabilities, to learn its strengths and limitations, and to know when to use different cameras to achieve the desired results.

We assume that the reader has a fundamental knowledge of the basic cameras currently in widespread use, including the single lens reflex (SLR), the range finder, the twin lens reflex, and the view camera (see Chapter 13 for the digital camera). If you are not familiar with how these cameras operate, a review is in order before continuing with this chapter. The remaining sections of this chapter introduce some cameras and techniques that photographers have used to explore nontraditional photographic visions.

Additional Information

Adams, Ansel. *The Camera*. Boston: Little, Brown, 1983.

TOY CAMERAS: THE DIANA AND THE HOLGA

Are you feeling alienated by the latest high-tech camera equipment? If the answer is yes, try a Holga and escape into the simplicity of a totally plastic toy camera. Beginning in the early 1960s, the Diana (120 film size camera) was made by the Great Wall Plastic Factory of Kowloon, Hong Kong. It was also marketed under other names such as Arrow and Banner. They were often given as prizes at carnivals or as free promotions. The Diana is no longer made, and the main sources for these cameras are secondhand stores, yard sales, flea markets, camera shows, and online auctions.

Camera Models

A number of different Diana models were produced. The original has only a single shutter speed (the shutter speed varies tremendously from camera to camera, from about 1/30 to 1/200 second). Some models have a B (bulb) setting for time exposures. The Diana F features a built-in flash, but the synchronization often does not work properly. The shutter on all these cameras can be fired as many times as wanted, so it is easy to make multiple exposures (often unintentionally). All these models have three aperture settings: sunny (f-16), cloudy (f-6.3), and dull (f-4.5). The cameras also have adjustable zone focusing areas, which can be set at 4 to 6 feet, 6 to 12 feet, and 12 feet to infinity. The Diana uses 120 roll film and makes 16 exposures of about 2 × 2 inches per roll.

Diana cameras have become collectors' items, making them harder to find and more expensive. A clone model called the Holga is currently being manufactured which uses 120 film and produces 6 × 4.5 cm, and 6 × 6 cm negatives. It has a 60 mm, f-8 plastic lens and focuses from 3 feet to infinity. The Holga's shutter speed is about 1/100 second and has two f-stops: f-8 (normal) and f-11 (sunny). No two Holga cameras are the same; some have slow shutters, others have peculiar lens distortions, and almost all have light leaks.

True Diana fans say, "It just ain't the same." While the optics of the two cameras are not

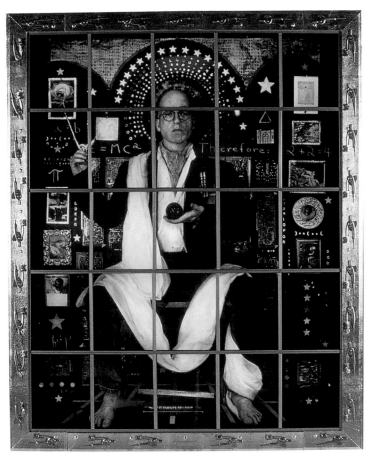

Plate 1 © Kathleen Campbell. *Rational Being*, from the series *Modern Theology or a Universe of Our Own Creation,* 1996. Color Duratrans and mixed media. Light box installation. 4 × 5 feet.

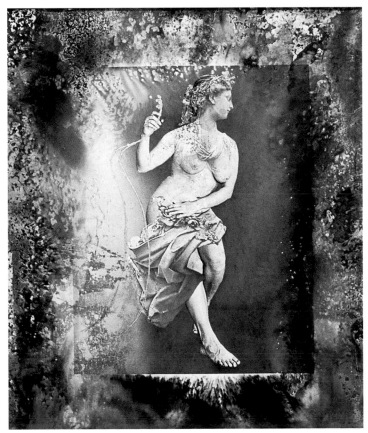

Plate 2 © Alida Fish. *Walking with Pygmalion*, #8, 1998. 20 × 16 inches. Toned gelatin silver print. Courtesy of Schmidt/Dean Gallery, Philadelphia, PA.

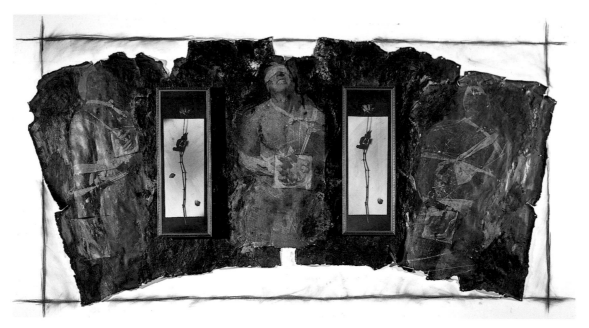

Plate 3 © Jeffrey Byrd. *Listening for Falling Debris*, 1991. Toned gelatin silver prints with mixed media. 75 × 137 × 3 inches.

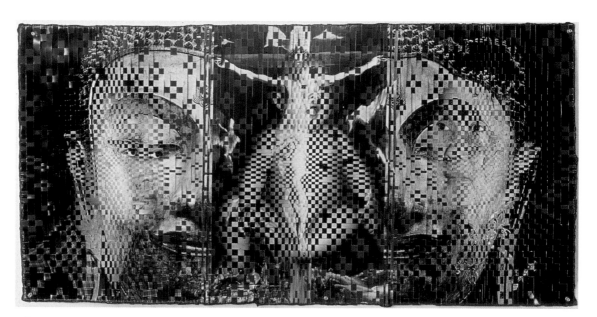

Plate 4 © Dinh Q. Lê. *From Zero to First Generation*, 1997. Woven chromogenic color prints and linen tape. 29¼ × 57½ inches. Courtesy of CEPA Gallery, Buffalo, NY.

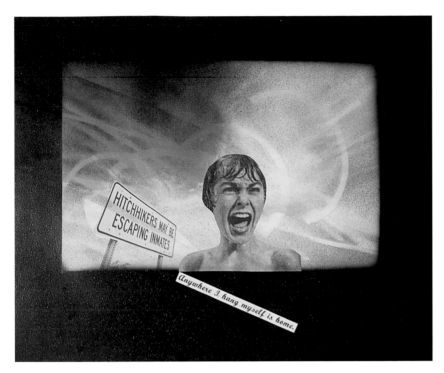

Plate 5 © Robert Hirsch. *Anywhere I Hang Myself Is Home,* 1992. Toned gelatin silver print with mixed media. 16 × 20 inches. Courtesy of CEPA Gallery, Buffalo, NY.

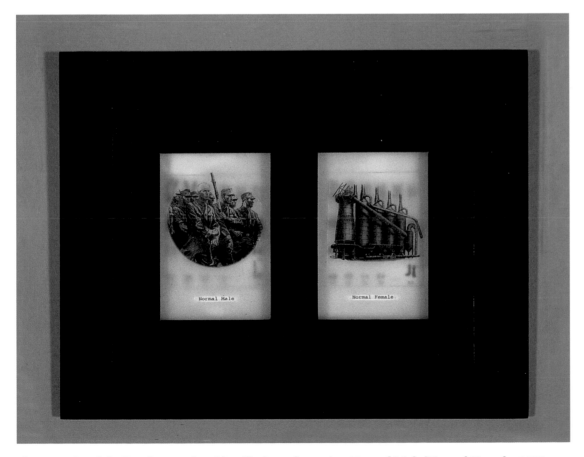

Plate 6 © Adele Henderson. *#55* (detail), from the series *Normal Male/Normal Female*, 1998. Print on paper, Plexiglas, wax, white shellac, wood frame, and one or more of the following: engraved and inked lines, litho ink transfers, hand painting in oil, asphaltum, or Lazertran transfer. $7^{1}/_{2} \times 9^{1}/_{2}$ inches.

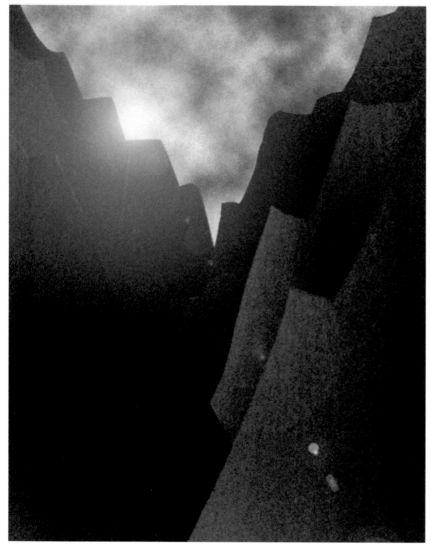

Plate 7 © Tyrone Georgiou. *Sunrise Paper Mountain*, 2000. Variable-sized digital file.

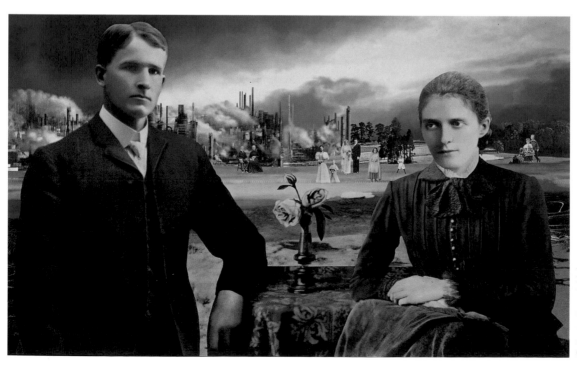

Plate 8 © Martina A. Lopez. *Revolutions in Time 1*, 1994. Dye destruction print. 30 × 50 inches. Courtesy of Schneider Gallery, Chicago, IL.

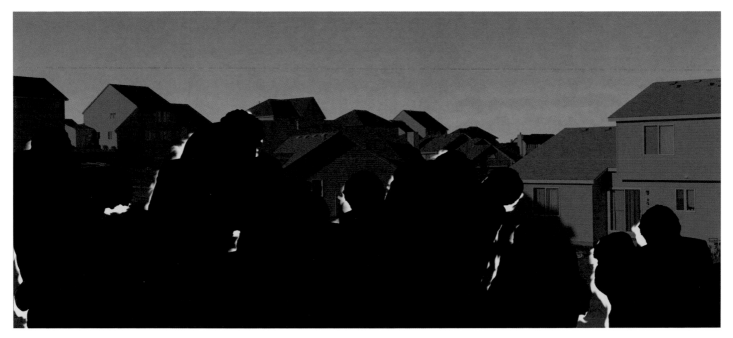

Plate 9 © Gary Hallman. *Karoshi Corona*, 1996. Pigmented inkjet on rag paper. 48 × 24 inches.

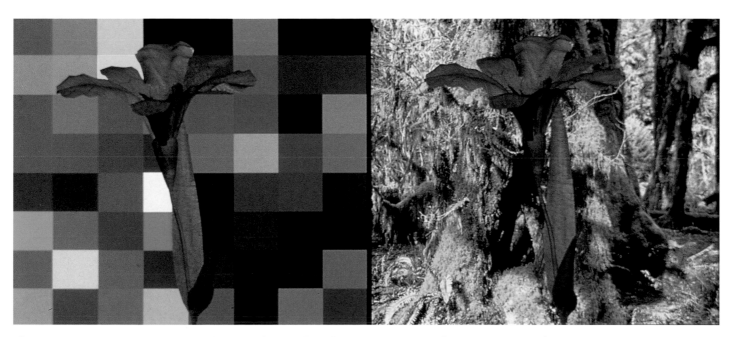

Plate 10 © MANUAL (Suzanne Bloom and Ed Hill). *Olympia*, 1999. Iris inkjet print. 17 × 35¼ inches. Courtesy of the Moody Gallery, Houston, TX.

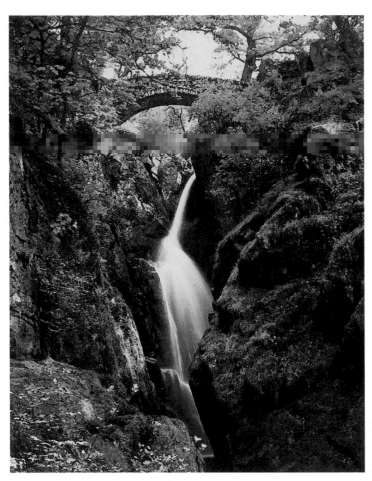

Plate 11 © John Pfahl. *Airey Force, Lake District, England,* 1995/1997. Iris inkjet print. 16½ × 13 inches. Courtesy of Nina Freudenheim Gallery, Buffalo, NY.

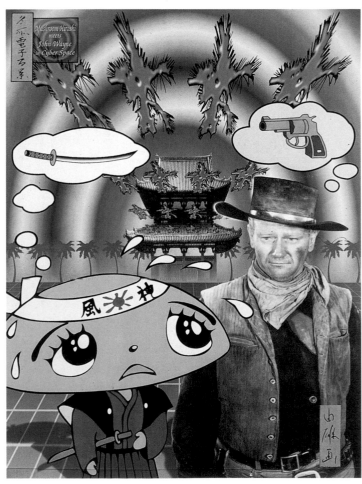

Plate 12 © Yoshio Itagaki. *Mushroom Hiroshi Meets John Wayne in Cyberspace,* 1996. Digital file. 40 × 30 inches.

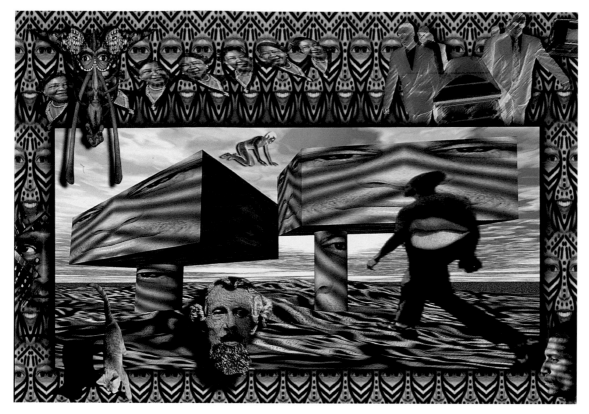

Plate 13 © Stephen Marc. *Untitled*, from the series *Soul Searching*, 1997. Dye destruction print. Variable-sized digital file.

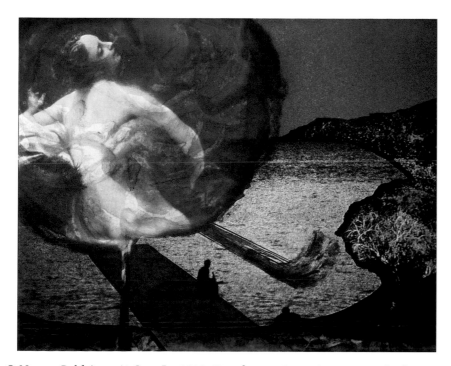

Plate 14 © Nancy Goldring. *At Sea, Io*, 1996. Dye destruction print. 30 × 40 inches.

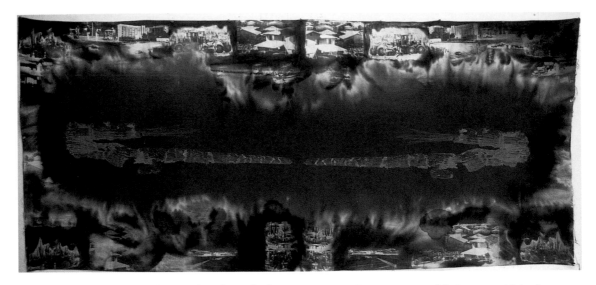

Plate 15 © Robert Renfrow. *The Shroud of Tucson,* 1999. Cyanotype on fabric. 43 × 96 inches.

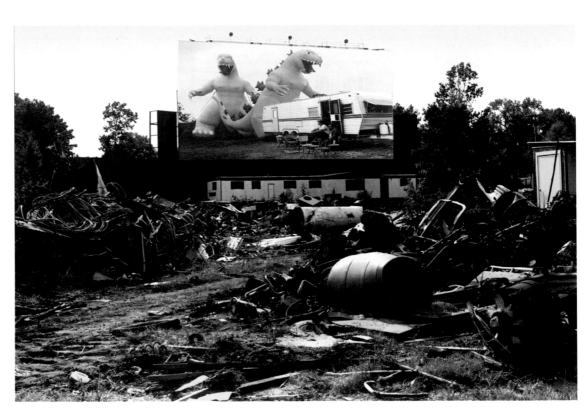

Plate 16 © Osamu James Nakagawa. *Godzilla and White Trailer Home,* 1996. Chromogenic color print. 26½ × 40 inches.

exactly alike, the Holga is so inexpensive (usually under $20) that you can purchase additional cameras and feel free to alter the plastic lens with sandpaper or paint on the lens to create soft focus or colored effects.

You can permanently convert the Holga's shutter speed to bulb by removing the shutter spring and gluing the shutter to the open position. The shutter arm that used to trigger the shutter will now open to let light in as long as the shutter release is depressed and will close when released. The shutter arm will let some light in, so it's necessary to put the lens cap on between exposures to prevent fogging.

The Holga has a hot shoe for flash but it is unusual in that it causes two flashes, one when you press the shutter and one when you release. The exposure is made with the first flash; the second flash serves no particular purpose except to wear down the batteries more quickly.

Characteristics

Light Leaks
Almost all the Dianas and Holgas have light leaks. Many photographers wrap black tape around the camera body, after the film is loaded, to prevent stray light exposure of the film. The red transparent frame-counter window and the inside seams of the camera also can be taped. Some people paint the camera's interior flat black. The area where the lens is attached to the camera has been known to leak light, requiring additional taping.

You can take multiple images on one frame or overlap images by partially winding to the next frame. The film-advance mechanism does not always completely tighten the exposed film, resulting in a light fog when the film is removed from the camera. Many Diana users combat this by unloading the film in a darkroom or changing bag and then placing the film in an opaque container or wrapping it in aluminum foil. Others just go with the flow and take whatever surprises the camera may provide.

The Lens
The plastic lens creates a soft-focus image. The lens tends to be sharpest in the middle, with the focus falling off rather rapidly toward the edges. The lens is not color corrected, so unusual color effects and shifts are normal.

The Viewfinder
The Diana's and the Holga's viewfinders are not corrected for parallax, so what you see in the viewfinder is not exactly the same as what the lens sees. This produces an image with a somewhat haphazard look because you have to figure out the composition by intuition and guesswork. Often what you see is higher than what the lens sees; raising the camera slightly can compensate for this.

Film Selection
Black-and-white or color films may be used. Negative films having an ISO of 400 are often shot to compensate for the limited range of camera adjustments. These fast films provide a greater tolerance for exposures that are less than perfect (a likely situation with the cameras). The faster films tend to emphasize grain and texture, adding to the lack of traditional image clarity for which Diana and Holga photographs are known. Use only brand-name 120 roll film. Some of the off-brands use heavier spools and paper that tend to bind in the camera or break the advance mechanism.

Why Choose a Plastic Camera?

The Diana and the newer Holga question photographic axioms such as "a photograph must be sharp," "a photograph must have maximum detail," and "a photograph must possess a complete range of tones to be considered good." Plastic cameras challenge the photographer to see beyond the equipment and into the image.

The cameras also are easy to use. There is no need to use a light meter or to calculate shutter speeds and f-stops. Finally, the Diana and the Holga summon up the Dadaist traditions of chance, surprise, and a willingness to see what can happen. This lack of control can free you from worrying about doing the "right" thing and always being "correct." Since both cameras are toys, they allow you to look at and react to the

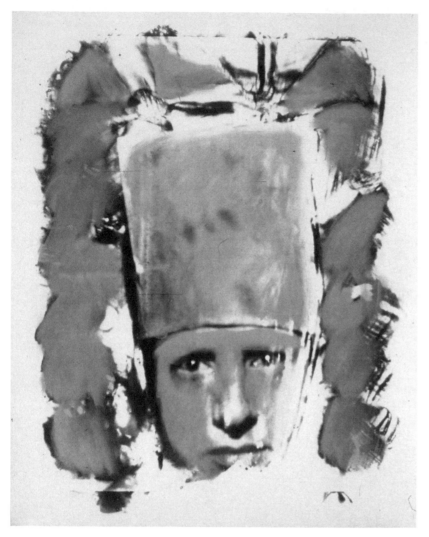

Figure 9.1 In an effort to dispense with the standard, hard-edged, rectangular photographic image, Wessner used a Diana camera to combine theater, drawing, painting, and photography. The prints were developed by painting nondiluted Dektol onto the paper with handmade brushes, feathers, reed pens, and rags. The effect disengaged the head of the figure from the background, causing it to float and break up the traditional sense of pictorial space. In the final step, the image was painted with metallic powders.

© Robyn Wessner. *Star Hats*, 1987. Gelatin silver print with metallic powders. 31 × 25 inches. Original in color.

world with the simplicity and playfulness of a child.

THE PINHOLE CAMERA

Would you like a new camera but do not think you can afford one? For a couple of dollars and a few hours of your time, you can build a simple pinhole camera. Pinhole cameras are commonly made from sheet-film boxes, oatmeal boxes, and coffee cans.

Building cameras allows you to participate in an aspect of picture making from which you are normally excluded. Many photographers enjoy the feeling of creating the camera that in turn forms their photographic vision. The pinhole camera removes you from the expensive high-tech environment of fully automatic or digital cameras and returns you to the basic function of vision.

An image formed by a pinhole instead of a lens has the benefit of universal depth of field. This means that everything from the foreground to the background appears to have the same degree of sharpness. A uniformly soft, impressionistic image is characteristic of pinhole photographs.

Building a Pinhole Camera

You can make a pinhole camera out of any structurally sound light-tight container (avoid shoeboxes). A 4 × 5 inch film box (100-sheet size) makes a good first pinhole camera with a wide angle of view, because the closer the light-sensitive material is to the pinhole, the wider the field of view and the shorter the exposure.

Get a thin (0.002) piece of brass or aluminum about 2 inches square from an automotive or hardware store. Also obtain a sharp, unused sewing needle (see Table 9.1). A number 13 needle is ideal for a 4 × 5 inch film box (the smaller the pinhole, the sharper the image and the longer the exposure time). Since the distance between the front and back of the box is short, a larger needle hole could result in exposure times that are too short.

Hold the needle between your thumb and index finger and gently drill a hole in one

Table 9.1 Diameter of Some Common Sewing Needles

Needle Number	Hole Diameter
4	.036 inches
5	.031 inches
6	.029 inches
7	.036 inches
8	.023 inches
9	.020 inches
10	.018 inches
12	.016 inches
13	.013 inches

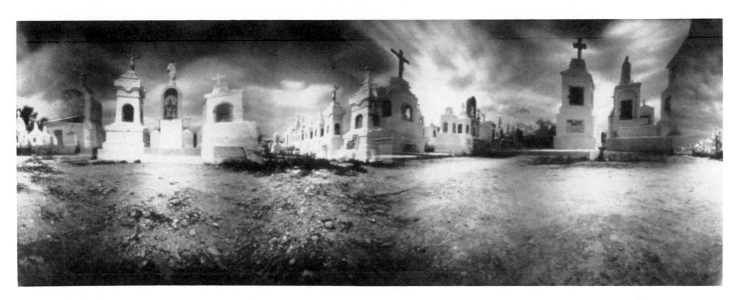

Figure 9.2 Building a pinhole camera allows you to create a machine that reflects your own personal vision. Renner constructed a six-pinhole panorama camera. Outdated aerial Plus-X film was exposed, processed in Dektol, and contact printed on grade 5 paper. The image presents a ghostly combination of space, time, and movement, which could not have been achieved with a commercially made camera.

© Eric Renner. *Ticul/Graves*, 1969. Gelatin silver print. 10 × 29 inches.

side of the metal. Then turn the metal over and drill the other side. Do not stab a hole into the metal. Use very fine sandpaper to remove any burrs around the hole. Repeat this procedure until the opening is the same size as the diameter of the needle. By drilling, sanding, and slowly expanding the hole, you should end up with an almost perfectly round aperture without any burrs. The more perfectly round and burr-free the pinhole, the sharper the image will be.

After completing the drilling operation, find the center of the front of the camera box. At this center point, cut a square opening equal to half the diameter of the metal pinhole material (1 inch square). Save this cutout for use as a shutter. Center the pinhole metal inside the box and secure it with black tape.

Darken the cutout on all sides with a black marker. If necessary, put black tape around the sides so it fits snugly back into the camera front, over the pinhole. Let a piece of tape stick out to act as a tab-type handle. This handle will allow the cutout to form a trapdoor-style shutter that can be removed and replaced to control the exposure time.

Exposing Paper

Begin by exposing black-and-white photographic enlarging paper outside in daylight. Single-weight fiber paper without any printing on the back works best. This paper is readily available, inexpensive, easy to process, and you can see exactly what is happening under the safelight. Typical daylight exposures with a film-box camera can run from 1 to 15 seconds, depending on the time of day, the season, the size of the pinhole, and the focal length (the distance from the pinhole to the paper).

Determining the Exposure

To determine the f-stop of your pinhole camera, simply measure the distance from the pinhole to the film plane and divide by the diameter of the pinhole. The formula for calculating the f-stop is: $f = v/d$ where f equals aperture, v equals distance from pinhole to film or paper, and d equals pinhole diameter. For example, a .018 inch pinhole at a distance of 6 inches from the paper (focal length), produces an f-stop of 333.

Processing

After making the exposure, process the paper using normal black-and-white methods. If the paper negative is too dark, give it less exposure time. If it is too light, give it more exposure time. Trial and error should establish a paper negative with proper density within three exposures. When you get a good negative, dry it and then contact print it (emulsion to emulsion) with a piece of unexposed paper. Light will penetrate the paper negative. Process and then evaluate the paper positive. Make exposure adjustments and reprint until you are satisfied.

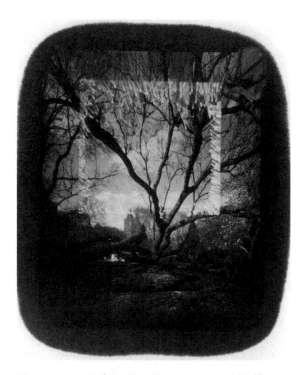

Figure 9.3 In his *Two Canyons* series Bullis explores two locations: the Columbia Gorge near Vantage, Washington, and the concrete and steel canyons of New York City. Based on past experience, Bullis composes intuitively because his pinhole camera does not have a viewfinder. Using a camera-mounted matte box and consulting with notes and sketches, Bullis uses a light pencil to add light drawings to the latent image before development.

© Larry Bullis. *Ingar in a Tree, Central Park*, from the series *Two Canyons*, 1991. Cyanotype. 6 × 5 inches.

Exposing Other Materials

After you have mastered the camera and the black-and-white enlarging paper, you are ready to expose any type of photographic material in the pinhole camera. Materials may include film (black-and-white or color), regular RA-4 color paper, Ilfochrome (which gives a direct positive), and even Polaroid materials such as SX-70.

Converting a 35 mm Camera to a Pinhole Camera

You can convert a 35 mm camera to a pinhole camera by covering a UV filter with opaque paper in the center of which you have made a good pinhole. Attach the pinhole filter to the camera's lens, and it becomes a pinhole camera. You also can convert an old snapshot-type or disposable camera to a pinhole camera by removing its lens and replacing it with a pinhole aperture.

Why Make Your Own Camera?

A small group of photographers build their own cameras or modify existing models. Here are some of the reasons why they do this:

- For the aesthetic pleasure and craftsmanship of creating their own photographic instrument
- To build a camera to carry out a specific function for which there is no commercial equivalent
- For financial reasons, as it is often possible to make equipment for a great deal less than it would cost to buy it commercially

Additional Information

Books
Hirsch, Robert. *Exploring Color Photography*. Third Ed. NY: McGraw-Hill, 1997.
Renner, Eric. *Pinhole Photography: Rediscovering a Historic Technique*. Second Ed. Boston, MA: Focal Press. 1999.
Shull, Jim. *The Hole Thing: A Manual of Pinhole Photography*. Dobbs Ferry, NY: Morgan and Morgan, 1974.

DISPOSABLE CAMERAS

A recent contribution to our throwaway culture is the disposable camera. It was conceived as a way to sell film and prints to people who do not own a camera, are caught without one at a special moment they wish to capture, or just have the urge to shoot some snapshots. Typically these cameras have a cardboard or plastic body containing a fixed-focus plastic lens with simplified internal workings.

These disposables offer photographers an inexpensive way to expand their image-capturing abilities. Two unusual models use 35 mm film. The first is the Kodak MAX Waterproof, which is encased in plastic and is waterproof to a depth of 12 feet. This makes it an ideal camera for use during inclement conditions. It features a fixed-focus, single-element 35 mm plastic lens with one exposure setting of f-11 at 1/110 second. The camera comes loaded with 27 exposures of 800-speed film and has oversize controls for ease of use while underwater. A camera like this enables the photographer to take pictures without the fear of damaging expensive equipment.

The second 35 mm disposable is the Kodak Max Panoramic Camera, which is a pseudo panorama-type camera producing an image almost three times longer than it is wide. It contains a fixed-focus 25 mm f-12 lens with a shutter speed of 1/100 second. It records a 78-degree horizontal view on a 13.33 × 36.4 mm band across the middle of a normal 35 mm frame and has a curved film plane to ensure edge-to-edge sharpness. It is designed to make dramatic 4 × 11 inch prints.

You do not have to dispose of a disposable camera after a single use. Many disposables can be carefully opened, reloaded with whatever type of 35 mm film is desired, resealed, and reused. The plastic lens tends to produce a rather soft image similar to that produced with the Diana or Holga camera. As long as relatively fine-grain film is used and small prints are produced, the image quality should be acceptable. This soft effect can be exaggerated by making big enlargements. Using higher speed films is a way to achieve a heightened grain effect. It is also possible to remove the plastic

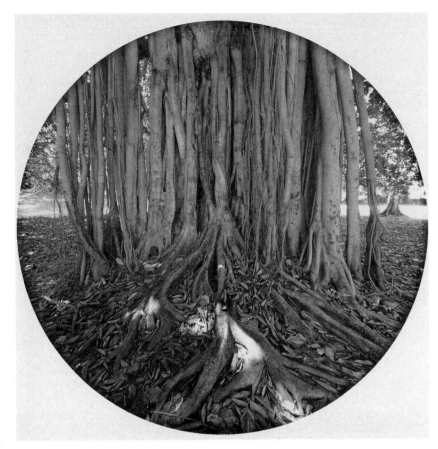

Figure 9.4 The camera used to make this circular image was hand-carved out of a solid piece of mahogany. It uses 5 × 7 inch film, features a spring-loaded ground-glass back, and has a peephole viewfinder so that hand-held shots can be made. In blending traditional craftsmanship with electronic technology, Wang used Phil Davis's computer programs (*Beyond the Zone System*) to establish film speed, exposure, and development time. Wang has made other cameras as a way of escaping from the restrictions of the manufacturer's predetermined formats.

© Sam Wang. *Banyan Tree*, 1988. Gelatin silver print. 14 inch circular image on 16 × 20 inch paper.

lens and replace it with a pinhole aperture, thus creating a store-bought pinhole camera.

EXPANDING THE ANGLE OF VIEW

Many photographers find that the normal lens that comes with their camera limits their vision. These imagemakers want their work to reveal a larger sense of visual space. Dealing with larger expanses of space poses a number of problems. Aesthetically, there never seems to be enough visual information in this type of photographic image, prohibiting the image from successfully conveying the sense of physical space at the site where the photograph was made.

Technically, due to distortion problems with cameras and lenses, it is problematic to achieve a realistic rendition of sweeping expanses of space. Traditionally, there are two approaches to solving this problem: the use of ultrawide-angle lenses, and the use of special-purpose panoramic cameras. Some contemporary imagemakers have abandoned both these methods in search of a new aesthetic answer. They have come up with alternatives such as combining many individual images to create a single nontraditional representation of the scene. See the section on panoramic mosaics later in this chapter and Chapter 11 for discussions of some of these methods.

Rectilinear Wide-Angle Lenses

The first method most photographers think of when they want to portray an expanded sense of space is the ultrawide-angle lens.

Figure 9.5 Crane wanted to change the reality of a microcosmic world. She did this by making images using Polaroid Positive/Negative film in a 2½ pound, 4 × 5 inch handmade wooden camera with a 65 mm Schneider Super Angulon lens. Crane hand-held the camera and used a wide aperture opening with a moderately fast shutter speed. Crane says she primarily exposed the front of her subject "by moving in very close to it. I used the extreme wide-angle lens to exaggerate and enlarge the subject so that it would dominated the image area while the space behind it became miniaturized."

© Barbara Crane. *Fleshy Fungi # 6*, 1989–1990. Toned gelatin silver print. 8 × 10 inches and 16 × 20 inches.

The newer and more expensive lenses are rectilinear, meaning that they are designed to reproduce straight lines without bending or distorting them. An example of such a lens is the 14 mm Nikkor f-2.8 that produces a 114-degree sweep, giving a broad sense of open visual space. The amount of distortion is minimal, providing the subject has been vertically aligned with the camera back on a leveled tripod. The slightest tilt will cause straight parallel vertical lines to converge. Circular spaces and rounded objects tend to reveal more distortion than those with straight horizontal planes. Many of these lenses have built-in filters, thus encouraging the photographer to interact with and further interpret the scene.

The cosine law dictates that there is always some light falloff with a rectilinear lens. This loss of illumination is noticeable in the corners of the frame (vignetting), making the center of the image appear brighter. The amount of falloff depends on the quality of the lens.

Wide-angle lenses have more depth of field at any given aperture than their normal or telephoto cousins. This can be used to advantage when a photographer wants to maintain image sharpness from the foreground through the background. Wide-angle lenses also allow imagemakers to get very close to a subject and manipulate the depth of field to control what parts of the image will remain in focus.

Full-Frame Fish-Eyes

A typical full-frame fish-eye (FFF) provides 180-degree diagonal coverage and about 150-degree coverage across the 36 mm side of 35 mm film. Unlike a rectilinear lens, a high-quality FFF should not produce any vignetting. However, these lenses do suffer from heavy barrel distortion. The center portion of the lens (about 5 to 10 degrees) usually has the least distortion, which becomes more pronounced toward the edges of the frame. Because of this, strong vertical lines on both sides of the frame will bend toward each other. Visually, this can result in a sense of closed space, which defeats one of the main reasons for using a FFF. If bending lines are not acceptable, you should not consider using these lenses. Some photographers

like this barrel distortion and incorporate it in their imagery. When evenness of illumination is of prime importance, the FFF is preferable to a wide-angle rectilinear lens.

PANORAMIC CAMERAS

Why will an ultrawide-angle lens on a 35 mm camera not produce a panoramic photograph? Regardless of how short (wide) the focal length of the lens happens to be, the aspect ratio remains unchanged. The aspect ratio is the height-to-width relationship of any film format. The 24 × 36 mm format of a 35 mm image has an aspect ratio of 1.5:1, making it 50 percent wider than it is high. A panoramic camera achieves its effect by altering the aspect ratio, making its horizontal plane two to five times wider than its vertical plane, thus increasing the sense of space.

Types of Panoramic Cameras

Panoramic cameras can be divided into three basic designs:

1. A swing-lens camera having a curved film plane.

2. A roll film camera (not an SLR) capable of recording a horizontal slice of an image. This is done by using a longer-than-normal focal length lens designed to be used on a larger format (view) camera.

3. A 360-degree camera whose entire body rotates while the film is pulled past a stationary slit that acts as the shutter. These cameras are actually "any angle" cameras. The amount of visual coverage is determined by setting the camera to rotate for a prescribed number of degrees. Many can be reprogrammed to go past a complete 360-degree circle until they run out of film to expose.

Swing-Lens Cameras

The 35 mm Widelux, whose 26 mm fixed-focus lens provides a 24 × 56 mm frame, produces a 140-degree view and is the best-known and most widely used of the swing-lens cameras. It gives a wide field of view and offers good image size, and the image

can be printed on a 2¼ inch enlarger. The Widelux image is made by a lens that swings left to right and has a curved film plane to compensate for the angle of the swinging lens. The camera does not have a conventional shutter but a focal-plane drum-slit mechanism to make and record the exposure. The Widelux 1500 works on the same principles but uses 120 roll film to give a 150-degree view on a 50 × 122 mm frame. A 4 × 5 inch enlarger is needed to make prints larger than contact size.

The Russian-made Horizon 202 is a relatively inexpensive swing-lens camera that produces a 120-degree horizontal and 45-degree vertical view. It has a built-in bubble spirit level that is visible from the top of the camera and can also be seen in the viewfinder for use in hand-held shots. When the camera is level, the camera produces an image with a straight horizon. When the image is taken with the camera tilted up or down, the horizon looks bent. The Horizon 202 comes with a 28 mm f-2.8 lens and an aperture range from f-2.8 to f-16. It has a shutter with two speed ranges; the first is 1/2, 1/4, and 1/8 of a second and the other is 1/60, 1/125, and 1/250 of a second. These exposure times are achieved by varying the slit width of the shutter from 6 mm to 1.5 mm in combination with the rotation speed of the lens.

The Round-Shot 35 is a swing-lens camera manufactured by SEITZ Phototechnik in Switzerland. Because it comes with a fixed f-2.8 35 mm lens it produces a more "normal" perspective because the 35 mm lens does not accentuate the foreground area of the frame as much as a Widelux 26 mm lens. The Round-Shot has reflex viewing, so the photographer can preview the scene to see what the lens will take in at any given angle setting. It is run by a hand-held control unit and features a push-button microprocessor panel that includes a liquid crystal display (LCD) that shows the preselected angle of view and a frame counter. The camera operates in 90-degree increments, allowing for up to eight shots equaling 720-degree views on 35 mm film.

The swing-lens cameras all possess similar characteristics. They have limited shutter speeds, as the speed indicated applies only to the vertical section of the film being exposed by the focal plane slit at any given

moment. The overall length of time it takes to make the exposure is longer than the indicated shutter speed. The actual exposure time is how long it takes the swinging lens to make its full sweep. For this reason, the sharpest results are obtained when the camera is on a tripod. Hand-held swing-lens cameras are sharp only at high shutter speeds. These cameras must be held on the top and bottom, not on the front and back, or your fingers might be included in the picture. Holding these cameras by hand can require some practice to produce a decent image. Most of these cameras work best on a precisely leveled tripod, as camera tilt results in either concave or convex horizons.

Since the lens is closer to the center of the subject than to either of its ends, the "cigar effect," which visually expands the center portion of the image, comes into play. It is most noticeable with straight parallel lines. Objects moving in the same direction as the lens rotation may be stretched, and those moving against the lens rotation may be compressed. By learning how this effect works, you can either use it to your advantage or compensate for it. A conventional flash generally cannot be used with this type of camera.

Roll Cameras

Roll cameras equipped with a view camera–type lens produce a more limited panoramic effect but do not have the exaggerated perspective of an ultrawide-angle lens on a normal camera. This design alters the aspect ratio by providing an elongated frame. Examples of these cameras include the Fuji GX 617, a 6 × 17 cm format which has four interchangeable lenses: a 90 mm f-5.6, a 105 mm f-8, a 180 mm f-6.7, and a 300 mm f-8 lens. The GX 617 camera can use either 120 or 220 roll film. The Linhof Technorama 617 S III is a 6 × 17 cm format camera that has interchangeable 72 mm, 90 mm, or 180 mm lenses providing views of 115, 110 and 72 degrees, respectively; and the Linhof Technorama 612 PC is a 6 × 16 cm format which has interchangeable lenses, an 8 mm rise that gives the effect of a shift lens, and takes 120 or 220 roll film.

Hasselblad XPan

One of the most versatile roll film cameras is the Hasselblad XPan Dual Format Panoramic camera with interchangeable lenses. Introduced in 1999, the XPan is capable of making 24 × 65 or 24 × 36 format sizes on the same roll of film. The 24 × 65

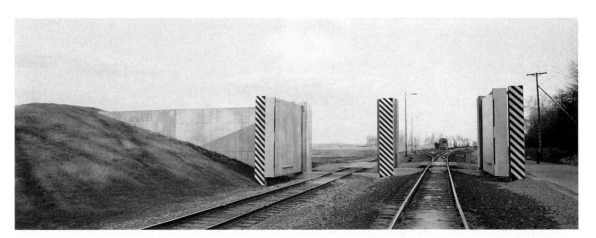

Figure 9.6 The XPan is a flat film camera that reduces panoramic distortion found in curved film lens-type cameras. This produces a more natural binocular view of the world, allowing the photographer to see photographically at the same angle of view, perspective, and coverage as we do with our eyes. A 35 mm camera capable of taking standard format or panoramic shots, the XPan is a rangefinder camera with standard SLR-type features such as autoexposure and motor film advance. One of the unique features of the XPan is its ability to switch between standard 35 mm (24 × 36 mm) and panoramic format (24 × 65 mm) without wasting film. When you turn the format knob, the film rewinds or forwards to prevent images from overlapping or to avoid having large gaps in between frames.

© Keith Johnson. *St. Genevieve*, 1999. Toned gelatin silver print. 7 × 18 inches.

format has an aspect ratio of 1:2.7, but since the film lies flat, distortion is minimal. There are three medium-format lenses available that give superior coverage without reduced corner sharpness, even at larger lens apertures. These lenses are: a 90 mm (with angle of view of 23 or 39 degrees and the approximate equivalent of a 50 mm lens on a 35 mm camera when in panoramic mode), a 45 mm (with angle of view of 44 or 71 degrees, with the approximate equivalent of a 25 mm lens on a 35 mm camera when in panoramic mode), and a 30 mm lens (with angle of view of 62 or 94 degrees with an approximate equivalent of a 17 mm lens on a 35 mm camera when in panoramic mode).

The camera offers shutter speeds of 2.5 minutes to 1/1000 of a second and the synch speed is 1/125 of a second, allowing use of normal electronic flash. Bare bulb flash or extremely wide-angle diffused flashes are recommended. The XPan utilizes DX coding, aperture priority, TTL automatic metering, and auto-bracketing. It also has a self-timer and continuous-mode shooting. The film loads are 21 exposures on 36-exposure 35 mm film and 13 exposures on 24 exposure lengths. Focusing is done through a range finder that is lens and format coupled and provides parallax correction.

360-Degree Camera

The 360-degree cameras include the Globuscope, which has a 25 mm lens capable of producing a complete circular image of 157 mm on 35 mm film; the Alpa Roto 60/70, which uses either 120, 220, or 70 mm film, has a 75 mm lens to deliver 360-degree views, and has a provision for a repeating flash; and the Hulcherama 120S, which uses 120 or 220 film with a 35 mm lens to create views up to and beyond 360 degrees. The Hulcherama 120S can use Mamiya, Hasselblad, or Pentax lenses, and has an up and down lens shift and through the lens viewing.

Panoramic Effects without a Panoramic Camera

It is possible to simulate the look of a panoramic camera image with a normal single-frame camera by capturing a series of overlapping views. This is called the panoramic mosaic working technique.

With a 35 mm camera, you would use a lens having a focal length of 35 mm to 55 mm. Lenses with wider or narrower focal length tend to create more distortion when you attempt to put the images together. To make the matching of the single frames easier, begin by photographing an outside scene that is evenly illuminated by daylight. Load the camera with a slow film (ISO 25 to 100) for maximum detail. Kodak T-MAX 100 is a good film to start with. Place the camera on a precisely leveled tripod with a panoramic head calibrated to show 360 degrees. Use a mid-range to small lens opening (f-8 or smaller) to ensure that you get enough depth of field. Using a cable release or self-timer, make a series of exposures covering the entire scene. Overlap each successive frame by about 25 to 33 percent.

After printing is complete, overlap the prints. For the most naturalistic look, carefully match the prints' tonality. (Extra care must be taken during the printing of the images to make sure the tonality is constant.) Trim and butt them together where the seam is least obvious. For the most accurate perspective, trim and butt together only at the center 10- to 15-degree portion of each image. Prints may be attached to a board using dry-mount tissue or an archival white glue such as Jade No. 403 distributed by Talas. If you plan to dry-mount the print, be sure to tack the dry-mount tissue to the back of the print before trimming.

Instead of butting the images exactly together, you can mount them separately with space in between. This style of presentation is known as a floating panorama.

Many cameras now come equipped with a so-called panorama mode, which is a film mask that alters the aspect ratio.

Additional Information

Talas, 568 Broadway, New York, NY 10012.

SEQUENCE CAMERAS

Hulcher Sequence Cameras

Specially designed sequence cameras such as the Hulcher 35 mm Model 112 and the

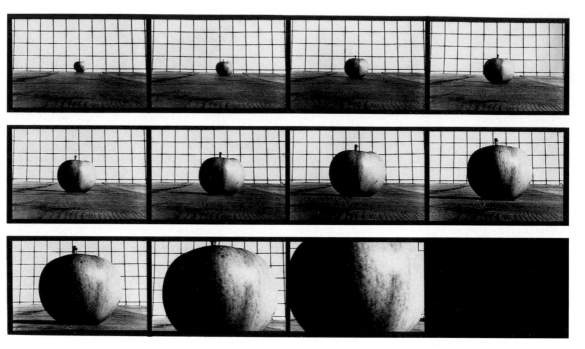

Figure 9.7 The artists photographed with a 16 mm Bolex movie camera. Then they edited, sequenced, enlarged, and stripped the negatives for the final series of images that was contact printed. Hollis Frampton [1936–1984] and Marion Faller satire the images of Eadweard Muybridge, whose exhaustive study of *Animals in Motion* (1899) and *The Human Figure in Motion* (1901) included over 20,000 photographs of men, women, children, and animals in common and sometimes unusual types of movement. Faller and Frampton employed the visual devices of Muybridge's nineteenth-century study, including the scientific grid, while creating humorous scenarios like *Mature Radishes Bathing* and *Zucchini Squash Encountering a Sawhorse*.

© Marion Faller and Hollis Frampton. *782. Apple Advancing [var. "Northern Spy"]* from the series *Sixteen Studies from VEGETABLE LOCOMOTION*, 1975. Gelatin silver print. 11 × 14 inches.

Hulcher 70 (70 mm) Model 123 can expose a prescribed number of frames during a specified period of time. You can load these cameras with magazines holding 100 to 400 feet of film, and they can make exposures as rapidly as 65 frames per second (fps). The limited hand-production of the Hulcher cameras makes them very expensive. Detailed information is available from the Charles A. Hulcher Company, 909 G Street, Hampton, VA 23661.

Power Winders and Motor Drives

Many 35 mm cameras today come with a built-in power winder that can make exposures at the rate of 2 to 6 fps. Most 35 mm SLRs have optional motor drives that are capable of exposing film at the same rate. Either type is usually more than adequate for most sequential uses. Some professional cameras have special film backs that increase the number of exposures (up to 250) that you can make without reloading.

Single-Image Sequences/16 mm Movie Cameras

Even without a sequence camera, power winder, or motor drive, you can achieve a sense of sequential time by stringing together a series of individual images into a single composition. If grainy enlargements are not a problem, you might consider using a 16 mm movie camera to make sequential images. The video camera revolution has caused the prices of 16 mm equipment to drop drastically, making them a more affordable option. Black-and-white 16 mm negative film, such as Eastman Double-X (ISO 200 tungsten or 250 daylight) and 4-X (ISO 400 tungsten or 500 daylight), is available in 100-foot rolls. These films must be processed by a commercial lab with 16 mm capability.

Using a movie camera is ideal because it is designed to make a sequence of single-image exposures (typical speeds are 8, 16, 24, 32, and 64 fps).

Obsolete and Toy Cameras

Over the years, various manufacturers have produced cameras capable of making sequential exposures. Examples include the Graph-Check, which has eight separate lenses that are fired sequentially in a controlled time span of 1/10 to 4 seconds onto 4 × 5 inch film. The Yashica Samurai, with automatic focusing and a 25 mm–75 mm zoom lens, can expose a roll of 35 mm film continuously, like a movie camera, or one frame at a time as quickly as you can press the shutter-release button. Such cameras can now be located via online auctions and used camera sources. A good source of used equipment is the monthly publication *Shutterbug*, 5211 S. Washington Avenue, Titusville, FL 32780.

Another possibility is the plastic point-and-shoot sequence cameras that are marketed and distributed under various names like Action Catcher. These cameras feature four single-element lenses that make four separate exposures about 1/8 second apart on a single frame of 35 mm film. Currently a model can be ordered from Porter's Photography, P.O. Box 628, Cedar Falls, IA 50613-9986 for under $15.

Electronic Imaging

Still and video digital cameras and electronic editing offer imagemakers numerous sequential potentials. These topics are covered in Chapters 12 and 13.

SPECIAL-USE CAMERAS

Scale Model Camera

There are all sorts of cameras designed to accomplish particular tasks. One such camera is the Photech Scale Model Camera, which was built to meet the needs of architects, designers, engineers, and others who work with tabletop models. It allows them to

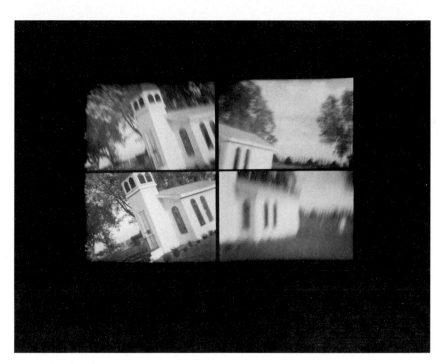

Figure 9.8 A toy sequence camera provides a simple and inexpensive technique of creating unusual spatial juxtapositions, exaggerating proportions, altering scale, and disrupting space and time. By purposely moving the camera while it was making its exposures, Hirsch plays off of the Renaissance system of one-point perspective by fragmenting the subject and redefining it from various viewpoints. Each frame offers new information, implying that meaning is a continuous process of visual change that is relative to the viewer's mental and physical position, thereby making doubt a major subject of the image. This four-frame compression also allows the audience to comprehend, in a single view, the multiplicity of a subject.

© Robert Hirsch. *Dream Land Chapel*, 1989. Toned gelatin silver print. 16 × 20 inches.

see how the model will look at full size. The Scale Model Camera is small and lightweight, and it has an inverted periscope snorkel design that enables the photographer to position it within the model rather than outside it. This greatly increases the number of vantage points from which images of the interior of the model can be made, while maintaining the correct perspective.

The camera comes equipped with an f-90 lens, giving it an almost infinite depth of field from about 2½ inches to infinity. It has an optical viewfinder that allows you to preview the image without distortion. Exposures are made on Polaroid 3¼ × 4¼ inch film by using a remote-control device. This ensures sharp pictures by eliminating camera shake, one of the biggest problems in scale model photography.

For more information about the Photech Scale Model Camera, contact Charrette

Corporation, 31 Olympia Avenue, Woburn, MA 01888.

Half-Frame Cameras

A common special-use camera is the 35 mm half-frame model, which exposes one-half of a standard 35 mm frame, doubling the number of exposures that can be made on a roll of film. Originally designed to be compact cameras, Olympus made 19 "Pen" models and four "F" series reflex models from 1959 to 1983, virtually creating the half-frame market. The name Pen derives from the concept that a camera could be carried and used as easily as a writing instrument. Photographers have intentionally used half-frame cameras to create diptychs. They deliberately expose the film knowing that they will print the subjects of the two half-frames as a single image to form a visual juxtaposition.

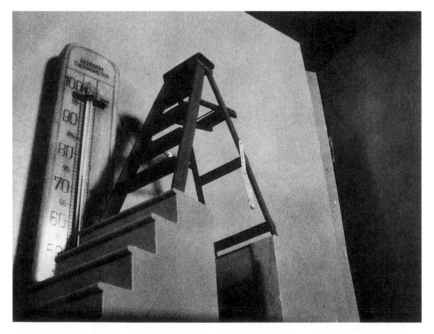

Figure 9.9 Miniature tableaux allow DeFilipps Brush to use juxtaposition and extreme discrepancies of scale to explore visual conditioning. The counter-reality evokes the themes of anticipation, expectation, and recognition, which imply, but do not include, human presence. The Photech Scale Model Camera is an ideal tool, since it can be maneuvered within a constructed space. The alternative would be to use a camera to look into the space from above, which would not be suitable for the artist's purposes.

© Gloria DeFilipps Brush. *Untitled* (#*2155*), 1986. Gelatin silver print with colored pencils. 19½ × 27½ inches on 24 × 30 inch paper. Courtesy of MC Gallery, Minneapolis. Original in color.

110 Format and APS Cameras

In the past, serious photographers have used other amateur style cameras such as the Pentax Auto 110 (1979–1983), a bantam SLR that used 110 film cartridges and featured interchangeable lenses. The tiny negative was an excellent way to produce exaggerated grain and soft focus effects. Today similar results can be achieved with high-speed film and the Advanced Photo System (APS), which was introduced in 1996. The APS cameras use a film cartridge about a third smaller than a conventional 35 mm cassette.

Additional Information

A good reference to learn about such cameras is *McKeown's Price Guide to Antique & Classic Cameras*. The latest edition lists and describes over 10,000 cameras, lenses, and accessories. It also provides technical and historical information as well as current market values (they also have a Website).

STEREOSCOPIC PHOTOGRAPHY

The fusing of photography with Sir Charles Wheatstone's discovery of the stereoscopic effect—the illusion of the third dimension on a flat field of view—set off two waves of stereo mania in Europe (1854 to 1880) and the United States (1890 to 1920). Stereo cards became immensely popular because of the illusion of depth, space, and solidity that they were able to produce. The stereo phenomenon, like television and computers of today, found its way into millions of homes, bringing entertainment, education, and propaganda in a manner deemed aesthetically pleasing by the public at large. It is still occasionally used commercially for special promotions, as in the *Sports Illustrated* Winter 2000 swimsuit issue, which featured a 3D section and viewing glasses.

Producing the Stereo Effect Photographically

The three-dimensional effect is created by taking separate photographs of a subject

from two different viewpoints. These viewpoints are 2½ inches apart, which is the average distance between the pupils of the human eyes. The easiest way to do this is with a stereo camera. The typical stereo camera has two lenses, 2½ inches apart, and an interlocking double shutter that simultaneously exposes the two images side by side on the film. A print from each image is properly mounted on a standard 3½ × 7½ inch stereo card. The right image is on the right side of the card, and the left image is on the left side, with 2½ inches between the centers of the images. The card is then placed in a stereo viewer, whose main purpose is to present the right image only to the right eye and the left image only to the left eye. The brain combines the two images, creating the visual sensation of the third dimension.

Stereo Cameras

The last big boom in stereo followed World War II and lasted until the late 1950s. Many cameras, viewers, and projectors were made during this time, and they constitute the majority of stereo equipment still used today. The most common cameras were manufactured by Kodak, Revere, Sawyer, Stereo Realist, and Wollensak. The Nimslo, which uses the lenticular screen (described in the next section), was manufactured in the 1980s. The Argus Stereo Camera is the only stereo camera currently being made. The Argus stereo 3-D camera kit has twin 28 mm fixed-focus lenses and uses 35 mm film. The kit comes with its own viewer, which holds 4 × 6 inch prints. The Polaroid passport cameras, which make two exposures at the same time on a single piece of Polaroid film, also can be used to make stereo portraits.

Lenticular Screen Cameras

Some stereo cameras produce three-dimensional effects by interlacing the images through the use of a lenticular screen. The lenticular screen is made up of a transparent pattern of tiny lens elements called lenticules. The lenticules recreate an image on the emulsion as a series of lines or points from which a completed image is formed. When

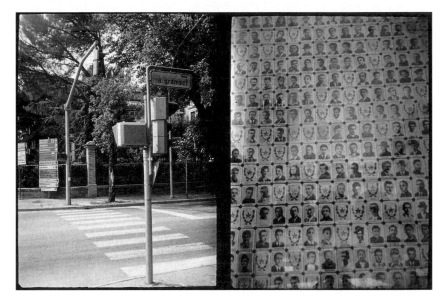

Figure 9.10 Photographer and video and installation artist Steve Harp uses a Canon Demi half-frame camera, which records 72 (rather than 36) images on a roll of 35 mm film, to produce diptych images about travel, place, and history. The camera makes vertical rather than horizontal images, allowing two adjacent frames to be put together in the negative carrier and printed as one image. Using his camera quickly as a sketchbook, Harp produces a series of diptychs in which juxtapositions are created and where each individual image is seen or considered in terms of the other.

© Steve Harp. *Diptych—Forli*, 1998. Gelatin silver print. 16 × 20 inches.

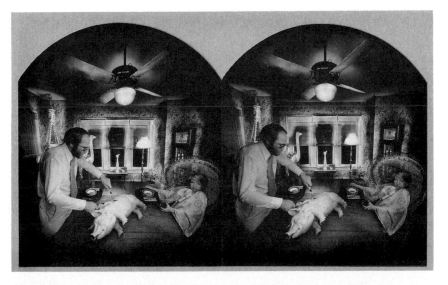

Figure 9.11 Meares built a stereo camera designed to use Polaroid Positive/Negative material. This permits instant evaluation and subsequent modification of the in-process image. The resultant three-dimensional photographs, when viewed with a stereoscope, allow the viewer to enter the spatial world of Meares's archetypically derived dream images.

© Lorran Meares. *Thanksgiving with the Findell's*, 1978. Gelatin silver prints (stereo pair). 3½ × 7 inches.

viewed, the lenticules allow only the right eye to see the right lens image and the left eye to see the left lens image. This permits the human brain to blend the images, thus producing a three-dimensional effect. Stereo cameras such as the Nimslo, Nishika, and Trilogy use the lenticular system. Special processing of the prints is required to produce the stereo effect. The lenticular screen is used to make stereo postcards, posters, and magazine illustrations.

Stereo with a 35 mm Camera

The simplest way to experiment with stereo photography is with a 35 mm camera. Just make two exposures of a static (nonmoving) scene. After you make the first exposure, shift the camera to the left $2\frac{1}{2}$ inches and make the second exposure. This can be accomplished by making the first exposure with the camera up to the right eye and the second exposure with the camera up to the left eye. Binocular stereo attachments that consist of mirrors and prisms, which split a 35 mm frame into a narrow vertical pair, are marketed for 35 mm cameras.

Make prints no larger than $3\frac{1}{2} \times 3\frac{1}{2}$ inches of the right and left images, making certain that the density of both is the same. Mark the back of the right image with an "R" and the back of the left with an "L" to avoid confusing the two.

Draw a light pencil line down the center of a $3\frac{1}{2} \times 7$ inch, 2 ply matte board (the stereo card). Attach the right image to the right of this line and the left image to the left of the line. For viewing, put the card on a flat, evenly illuminated surface. Cut a piece of matte board to about $3\frac{1}{2} \times 5$ inches and place the $3\frac{1}{2}$-inch side on the centerline between the two images. Look down the 5-inch side. The board will act as a divider, keeping the right eye focused on the right image and the left eye focused on the left image. Inexpensive twin plastic lenses are available for easier viewing.

Additional Information

Books

Burder, David, and Pat Whitehouse. *Photographing in 3-D*. Distributed by Reel 3-D, Enterprises, Inc., P.O. Box 2368, Culver City, CA 90231.

Starkman, David, and Susan Pinsky. *Reel 3-D Enterprises' Guide to the Nimslo 3-D Camera*. Distributed by Reel 3-D, Enterprises, Inc., P.O. Box 2368, Culver City, CA 90231.

Tomosy, Thomas. *Restoring the Great Collectible Cameras: (1945–1970)*. Distributed by Amherst Media, 155 Rano St., Buffalo, NY 14207.

Waack, Fritz G. *Stereo Photography: An Introduction to Stereo Photo Technology and Practical Suggestions for Stereo Pho-*

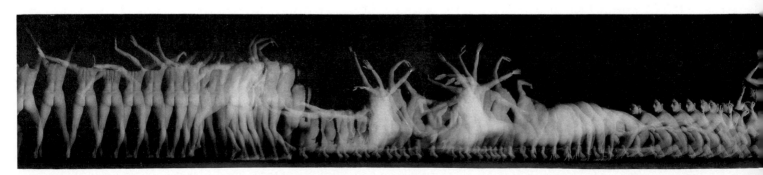

Figure 9.12 To overcome some of the limitations of using a strobe to stop action, Davidhazy has done extensive work with moving-film stroboscopy. These methods enable him to analyze motion in detail over an extended period of time while producing motion-analysis images suitable for publication.

© Andrew Davidhazy, Rochester Institute of Technology. *Stroboscopic Nude Study #2*, 1987. 35 mm transparency film. $1 \times 9\frac{1}{4}$ inches. Original in color.

tography. Distributed by Reel 3-D, Enterprises, Inc., P.O. Box 2368, Culver City, CA 90231.

Other Sources

Berezin Stereo Photography Products, 21686 Abedul, Mission Viejo, CA 92691.

National Stereoscopic Association, P.O. Box 14801, Columbus, OH 43214.

Reel 3-D, P.O. Box 2368, Culver City, CA 90231 (new stereo equipment).

Stereo Photography Unlimited, 1005 Barkwood Court, Safety Harbor, FL 34695 (used stereo equipment).

STROBOSCOPIC PHOTOGRAPHY

Photographs of moving subjects made by the use of repeated flashes or a pulsing light source are known as stroboscopic photographs. Ernst Mach achieved the first successful stroboscopic images, of bullets in flight, at the end of the nineteenth century. In the early 1930s, Dr. Harold Edgerton of the Massachusetts Institute of Technology (MIT) developed the modern electronic flash, ushering in the modern era of stroboscopy.

Stroboscopic Effects

There are two ways that stroboscopic effects are generally used to make photographic images. The first method of stationary film stroboscopy takes place in a darkened room, where the shutter of the camera is opened for a very brief time. During this time, the successive flashes of light from a stroboscope stop and capture a subject in motion. The result shows the subject at different points during its course of travel on a single piece of film. Dr. Edgerton's widely known images are examples of this process. The limitations of this method include the number of exposures that can be made on a single piece of film before the event becomes chaotic, and the actual length of time (determined by the speed of the subject's motion) that is available to record the path of the subject's travel.

The second method, moving film stroboscopy, permits a clear and detailed visual record of a subject's motion to be made over a longer period of time. This method is discussed in the following section.

Moving Film Stroboscopy

The following items are needed to carry out moving film stroboscopy:

1. A 35 mm camera with a T (time) or B (bulb) setting that permits the film to be rewound with the shutter open. Some cameras automatically close the shutter when the film is rewound.

2. A strobe that can be operated at a fractional power setting, such as 1/32 or 1/64, and can be fired in quick succession. Flash

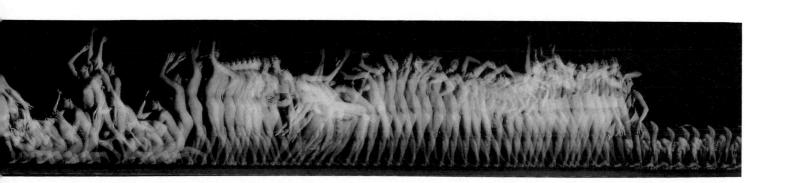

units with a stroboscope mode designed for use with motor drives are ideal because of their rapid recycling time.

For those who want to purchase a true stroboscope, Edmund Scientific, 101 East Glouchester Pike, Barrington, NJ 08007-1380, and Radio Shack stores sell the least expensive stroboscopes. The physics department at a local school or college also might be able to lend you a stroboscope.

3. Thirty-six exposures of black-and-white or color film.

Find a shooting area with a dark background (black is best) and enough room for the subject to carry out its intended path of motion. It must be possible to darken this area so that the stroboscope becomes the sole light source. Set up the stroboscope so it illuminates only the subject and not the background.

Load the camera with your film of choice and advance the film until the next to last frame appears on the film counter. To avoid exposing any of the film, it is best to do this in a darkroom or changing bag with the lens cap on, the aperture closed, and the shutter set to the highest speed. Make certain that the shutter is completely wound before going on to the next step. If the last wind leaves the shutter half-cocked, push in the rewind button and finish the cycle without forcing the camera's mechanism.

Place the camera on a tripod. Set the camera's aperture to what it would be for a normal single-flash exposure based on the subject-to-flash distance or a flash meter. Focus on the subject. Push the rewind release button to enable the film-advance sprockets to turn freely without tearing the film perforations. Set the shutter at the T or B setting. If you use B, lock the shutter in its open position with a locking cable release. Turn off or block out any light except the stroboscope or flash.

Turn on the strobe and have the subject begin its motion. Observe it a few times to get a good idea of its path of travel. When you are ready to make the exposure, open the shutter with the T or B setting and start winding the film at a steady and even pace as the subject performs, illuminated only by the strobe. If you are using a camera strobe,

an assistant can hold and fire it off-camera. The key factor in determining the outcome is the speed at which the film is wound past the open shutter, based on the length of film in the camera. There are three basic factors to consider in deciding how quickly to wind the film:

1. The speed at which the subject travels

2. The frequency of the strobe illumination

3. The amount of separation desired between images

Additional Information

Collins, Douglas, and Joyce Bedi. *Seeing the Unseen: Dr. Harold E. Edgerton & the Wonders of Strobe Alley.* Cambridge, MA: MIT Press, 1994.

Davidhazy, Andrew. "Moving Film Stroboscopy." *Kodak Newsletter for Photo Educators*, Volume 21, No. 1(1988): pp. 1–3.

Edgerton, Harold. *Electronic Flash/Strobe.* Third Ed. Cambridge, MA: MIT Press, 1986.

UNDERWATER EQUIPMENT AND PROTECTION

Until recently, if you wanted to make pictures in or around water, you had only two options: get a Nikonos 35 mm underwater camera or find a cumbersome watertight housing for the equipment. Today there are numerous options available.

The Underwater Standard: Nikonos

Since the 1960s, the Nikonos has been the underwater camera by which all others are measured. The present model, Nikonos V, has interchangeable lenses, is submersible to a depth of 160 feet, can be operated manually or by automatic aperture priority, comes with through-the-lens (TTL) flash metering, and has a film speed range of ISO 25 to 1,600. It is the most professional and expensive of all the current underwater cameras. For more information, contact Nikon, Inc., 623 Stewart Avenue, Garden City, NY 11536.

Motormarine I and II

Sea & Sea of Japan offers underwater SLR housing and camera systems featuring the Motormarine I and II cameras. These cameras can be submerged to 150 feet and offer a wide array of professional features, including interchangeable lenses, electronic flashes, and other accessories, many of which are compatible with the Nikonos. Sea & Sea products are distributed by GMI Photographic, Inc., P.O. Drawer U, Farmingdale, NY 11735.

Weatherproof versus Waterproof

The development of the weatherproof/waterproof lens shutter, or compact camera, has provided a number of alternatives to the Nikonos. These cameras are essentially automatic point-and-shoot machines to which weather/water protection has been added. They are designed for people with an active lifestyle who do not want to risk ruining their expensive camera gear in a canoe or on a ski slope. Many different models of waterproof and weatherproof cameras are available. There is even a disposable waterproof camera. It is important to distinguish between a completely submersible camera (waterproof) and one that only resists water, dirt, dust, and sand but cannot be submersed (weatherproof). The manufacturer will usually state how many feet one can submerge a waterproof camera.

All the current models are lens shutter cameras and not SLRs. They have Galilean finders that provide only an approximation of the exact image size. They are more limited than a Nikonos in terms of submersible depth, ISO range, and exposure control. In exchange for these limitations, the photographer gets a less expensive, lightweight, and durable camera capable of delivering good image quality in average lighting conditions.

Submersible Sags

Another recent development is the mechanically sealed, heavy-duty plastic bag, which enables photographers to keep their equipment dry and still operate the camera controls. High-quality bags such as Pioneer's EWA-Marine-housing have optical glass lenses for distortion-free images and built-in gloves for easy operation. They also are large enough to handle flash units and motor drives and are tested to a depth of 100 feet. These bags can be adapted to fit almost any camera, from a compact to a 6×7 cm unit. Bags are also available for video camcorders and movie cameras. For further information, contact Pioneer Marketing and Research, 216 Haddon Avenue, Suite 522, Westmont, NJ 08108.

For the general transporting of equipment in wet conditions, such as on a raft trip, try a product such as the Bagton. It is made out of yellow polyester that is resistant to UV light and is waterproof, tear-resistant, and supposedly unsinkable. Bagtons come in different sizes, with a capacity ranging from 1 to 42 gallons. For more information, contact Ne, Inc., P.O. Box 1587, Cambridge, MA 02238-1587.

Hard Cases

To protect equipment when you are traveling or when doing fieldwork, you might consider purchasing a rugged, lightweight, shock-resistant, watertight case made of noncorrosive, light-reflecting material. Pelican equipment cases (Pelican Products, 2255 Jefferson Street, Torrance, CA 90501) are the least expensive. They are made from high-impact ABS structural resin and have an O-ring seal that is watertight to 10 feet. Satter's Tundra cases (Satter's, 4100 Dahlia Street, Denver, CO 80207) are structurally similar to those made by Pelican, but they are waterproof to a depth of 30 feet and cost a little more. The most expensive cases are made by Rimowa (H.P. Marketing, 16 Chapin Road, Pinebrook, NJ 07058) and are waterproof to 67 feet.

Hard Case Alternative

An inexpensive alternative to buying a hard case is using a large portable ice chest, such as those made by Coleman or Igloo. If watertight security is not important, an ice chest packed with foam offers excellent protection for photographic gear.

What to Do if Equipment Gets Wet

Should a piece of photographic equipment get wet, quick action is necessary to save it from ruin. If salt water is the culprit, flush the item with fresh water. Then open the equipment up as much as possible and completely dry it with a hair dryer set on low. A drying oven also can be effective and is easy to construct. Place the wet equipment in a plastic bag with a zip-type closure. Place the nozzle of a hairdryer inside the bag and zip the bag closed. Secure any open spaces with tape. Then make a small hole at the opposite end of the bag so the air and moisture can escape. Turn the hair dryer on low and let it run until the gear is totally dry. When the equipment is dry, take it to a camera repair shop as soon as possible.

10 An Introduction to Some Widely Used Alternative Processes

Thus far this book has primarily dealt with applications of traditional silver-based photography. There are numerous alternative processes that can be used to create a photographic image. Most of the processes discussed in this chapter are now considered to be commercially obsolete. Once regarded as technical breakthroughs, they have been discarded in favor of new processes that are more convenient, faster, and cheaper to use. Some of these processes come from other visual mediums, like drawing, painting, and printmaking. Other methods, such as the use of a copy machine, derive from commercial communications. These processes are often combined, blurring the boundary between the various visual arts media (see Chapter 11). Some can deliver a longer tonal scale while others produce synthetic colors. If French writer Marcel Proust was correct when he said that art is a "translation" of life, then learning about these processes can be a recipe for change that may expand the horizon of possibilities and make you a better photographer by permitting another way of expressing your ideas about life.

The common factor among these diverse alternative processes is that they do not produce an image that looks like a traditional gelatin silver photograph. The straight print is what most people expect to see when they look at a photograph. It is the cherished frozen instant, removed from the flow of linear time that has been preserved for contemplation and examination. The task of this

type of photograph has often been to record and document the visible world. Since the 1960s, many photographers have questioned the virtues of the straight photograph, particularly its spare range of working materials and the prescribed area in which the photographer is supposed to operate. The alternative processes allow the imagemaker to explore and extend the relationship between the photographer, the event being photographed, the interpretation of subject, and the process of photography. In these alternative processes, the camera image becomes a point of departure for transforming the entire relationship. The resulting photographs challenge traditional "factory made" ideas about the camera image, and as facts become less important, beauty and imagination can step forward in importance. The nature and scope of photography have been redefined by an alternative aesthetic that says a good photograph is not necessarily based on objectivity and scientific rationale. It dramatically demonstrates that there are multiple intelligences—ways of seeing—that can come into play when making photo-based images.

This chapter provides an introduction to some processes that have been widely used in recent years. It offers a technical starting point based on formulas and methods that have been proven successful. In most cases alternative printers have to mix their own sensitizer and processing chemicals from stock chemical compounds and coat their own paper. Most of the processes discussed

are contact printing processes, not enlargement ones, and thus a negative equal to the final image size is required. (See Chapter 3 for one way of making enlarged negatives and for information on making negatives directly from slides.)

The discussion here is confined to coating paper stock with various emulsions, although it is possible to use these emulsions on almost any porous material, including ceramics and fabric. For more information on coating other materials, see Additional Information at the end of the chapter. Be certain to follow all the safety rules outlined in Chapter 2. Regardless of which process you use, it is advisable to read the chapter in its entirety before experimenting with any of the processes, as specific methods from one technique often can be applied to another.

ABOUT PAPER

The most important and often overlooked part of an alternative image is the paper on which it is printed. Being able to select the paper that best supports the image is an advantage of the alternative processes. The color and texture of the paper an image is printed on play a major role in determining what the final photograph looks like and how a viewer will respond to it. In gelatin silver, gum, and carbon prints the photochemistry is contained within a binder layer on top of the paper so that the image actually floats on the uppermost portion of the paper. In alternative processes iron salts are absorbed into the surface fibers of paper where they come into contact with various chemical substances, so the image is in fact part of the paper.

Paper is made from cellulose fibers derived from different plant sources, primarily cotton and wood pulp. Papers made from the wood of coniferous trees are known as sulfite pulp paper. In these papers wood chips are cooked in calcium bisulfate or sodium sulfite, and bleached, producing long, strong fibers. The highest quality of these papers is known as alpha cellulose papers. Papers made from this process are generally not suitable for alternative printing. Cotton rags or rag papers come from the part of the cotton plant that is used for textile

manufacture. Rag content describes the amount of cotton fiber relative to the total amount of material used in the pulp. These papers are the most suitable for the processes described in this chapter. Many papers designed for drawing, etching, and watercolor may have bleaches, buffers, clay fillers, dyes, optical brightening agents, sizing agents, and wet-strength resins incorporated into the fibers, which can affect the appearance of the print.

Wet Strength and Acid Content

Two primary concerns in choosing a paper for alternative photographic processes are wet strength and acid content. Generally papers that are suitable for etching, lithography, or watercolor have sufficient wet strength to withstand the coating, processing, and washing of prints. Acid-free paper is a must for most art applications. To produce their papers, archival manufacturers sometimes neutralize the acids in paper by adding an alkaline substance like calcium carbonate or magnesium carbonate into the pulp. Calcium carbonate reacts with iron-based sensitizer solutions used in many alternative processes, changing their pH, and producing unpredictable results. Therefore a nonbuffered acid-free paper is recommended.

Cold and Hot Press Paper

Cold pressed paper has a surface with slight texture that is produced by pressing the finished sheet between cold cylinders. Cold press papers tend to absorb more liquid than hot pressed papers, which have a smooth surface that is produced by pressing a finished sheet through hot cylinders. Hot press papers are generally more suitable for alternative processes.

Sizing

Sizing is the process by which gelatin rosin, starch, or another synthetic substance is added to paper to provide resistance to the absorption of moisture and to fill in the gaps between paper fibers. Sizing added to the

pulp during manufacture is known as internal sizing. After the sheet is formed, it may be either surface sized (painted or brushed on the surface), or tub sized (immersed in a bath).

Experimentation is essential, because a paper that works well with the cyanotype process might not be chemically compatible with a platinum/palladium sensitizer. Be aware that papers with the same name, but made by different mills, may have undergone different chemical preparation during manufacture and therefore deliver dissimilar results.

CYANOTYPE PROCESS

Cyanotype, Greek for "dark blue impression," is one of the easiest and least expensive ways of gaining hands-on experience with an alternative nonsilver process. Sir John Herschel invented the method in 1842 and used it as a proto-photocopy machine for making duplicates of his intricate notes.

The first aesthetic application of the cyanotype is credited to Anna Atkins, who worked with it in the 1840s and 1850s to illustrate her book *Photographs of British Algae: Cyanotype Impressions*. The heyday of the process was in the 1880s, when architects and shipbuilders used precoated cyanotype paper to make fast, inexpensive copies of line drawings.

The major disadvantage of the process, which kept it from becoming more widely adopted, is its bright blue color. In *Naturalistic Photography for Students of Art* (1889), Peter Henry Emerson said, "No one but a vandal would print a landscape in red or cyanotype." Yet the process remained popular for a time with professional and amateur photographers as an inexpensive and speedy method for proofing negatives.

The chief attractions of the cyanotype are as follows:

1. The process is simple and inexpensive.

2. It may be used on a variety of surfaces and materials.

3. Its relatively long printing times enable the printmaker to observe the image during the printing process.

4. The final image can last a long time (be archival), depending on the base material.

5. The intense blue color can be altered with additional processing steps.

How the Process Works

Herschel discovered that when light acts on certain ferric (iron) salts, they are reduced to a ferrous state. Many of these processes, including cyanotype, kallitype, Vandyke, platinum, and palladium, are sometimes referred to as iron-salt-sensitive processes or ferric processes, since they are all based on the reduction of iron.

In the cyanotype process, the light catalyzes the reduction of ferric ammonium citrate to a ferrous salt. The ferrous salt then acts as a reducer on the potassium ferric cyanide. This produces a precipitate of insoluble blue pigment, ferrous ferricyanide, which is also known as Prussian blue. The areas that are not exposed to light remain in a ferric state. During development, washing removes these unreduced salts, leaving behind the insoluble ferrous ferrocyanide. During drying, the ferrous ferrocyanide oxidizes to the distinctive deep blue.

It is possible to obtain different colors by changing the metallic salt applied to the ferrous image. Basically this is what happens in kallitype and platinum printing. It is also possible to alter the final blue image through a toning process.

Safety

In addition to the general safety guidelines provided in Chapter 2, be aware of these specific concerns when working with cyanotypes:

1. Potassium ferricyanide should not be heated above 300°F (147°C) or allowed to come in contact with any concentrated acid, as poisonous hydrogen cyanide gas can be produced.

2. Unused emulsion should be disposed of by absorbing it in kitty litter placed inside a plastic bag. This bag should be sealed and placed in a covered trash container outdoors.

Printing

Cyanotype emulsion has a long exposure scale. Negatives with a complete range of tonality work well, as do contrasty negatives. A full range of tones can be produced on a smooth paper from a negative that would normally require a Grade 0 paper in normal silver-based printing.

The cyanotype emulsion can be applied to any absorbent surface, including almost any paper, even colored stock (except those that have an alkaline buffer), fabric, bisque ware, and leather. The emulsion can be applied to other photographs or combined with other processes like Vandyke and with techniques such as hand-coloring and toning.

Choosing a Paper

A high-quality, well-sized rag paper such as Arches Cover and Arches Platine, works well as a starting point. Beautiful prints also can be made on unsized papers, such as Rives BFK. Any changes in the color of coated paper (when stored in the dark) from yellow to green or blue is a sign of paper/chemistry incompatibility.

After you have mastered the technique, consider applying the emulsion to fabric or even chamois leather. The tighter the weave of the fabric, the deeper the blue tends to be.

Commercially made cyanotype paper is available at specialty art supply stores. It is also sold as sun paper in museum and science stores. The quality of these materials varies widely and should be tested before buying in quantity.

Making the Sensitizer

The cyanotype emulsion is made by preparing the sensitizer from two stock solutions which are combined in equal parts at the time of use.

Cyanotype Formula

Stock Solution A

Water (68°F or 20°C)	250 milliliters
Ferric ammonium citrate (green)*	50 grams

*The green variety provides an emulsion that is about twice as light-sensitive as the brown.

Stock Solution B

Water (68°F or 20°C)	250 milliliters
Potassium ferricyanide	35 grams

Mix the solutions separately. Store them in tightly closed opaque containers. The separate solutions have a shelf life of up to six weeks.

When you are ready to use them, combine equal amounts of stock solution A and stock solution B. Once combined, they have a useful life of about one day. The peak sensitivity of coated paper occurs within the first two hours after the emulsion has been applied. Coated paper may be stored and used, with reduced light sensitivity, for a period of about two weeks.

Modern Cyanotype: The Mike Ware Process

Photographer and chemist Michael Ware has developed an "improved" cyanotype formula. Ware has replaced ferric ammonium citrate with ferric ammonium oxalate to make a formula that is more light-sensitive, more readily penetrates paper fibers, and is less prone to mold than the traditional process. The results are cyanotype images that do not bleed, require shorter exposures, and have a dark (almost black) maximum density.

The preparation of this sensitizer solution calls for a little more experience in chemical manipulation than is required to make a traditional cyanotype sensitizer. This work should be carried out under tungsten light, not fluorescent or daylight. A hotplate will be found convenient for heating the solutions.

Michael Ware has provided the following instructions:

Sensitizer chemicals needed:

Ammonium iron (III) oxalate	30 grams
Potassium ferricyanide	10 grams
Ammonium dichromate	0.1 grams
Distilled water	100 cc

Analytical Reagent (AR) Grade (99%) chemicals are preferred.

1. Heat 20 cc of distilled water to about 160°F (70°C) in a small Pyrex glass beaker, and completely dissolve 10 grams

of potassium ferricyanide in it, with stirring; keep the solution hot.

2. Heat 30 cc of distilled water in a second beaker to about 120°F (50°C), and dissolve in it 30 grams of ammonium iron (III) oxalate. Add 0.1 gram of solid ammonium dichromate and dissolve it. (If you cannot weigh out this small amount, then add 0.5 cc of 20 percent ammonium dichromate solution, previously prepared by dissolving 2 grams of the solid in distilled water and adding water up to a final volume of 10 cc.) Mix thoroughly.

3. Now add the hot potassium ferricyanide solution to the ammonium iron (III) oxalate solution, stir well, and set the mixture aside in a dark place to cool and crystallize, until it just reaches room temperature. For this quantity of solution, the cooling will take an hour or two.

4. Separate the liquid from the green crystals by decanting (carefully pouring the liquid off the mass of solid) and filtering (a Whatman grade 1 filter paper is adequate). The green crystals (potassium iron (III) oxalate) should be disposed of safely because they are poisonous. The volume of filtrate extracted should be about 60 cc.

5. Make up the filtered solution with distilled water to a final volume of 100 cc. Mix well. (This sensitizer can be made more dilute, e.g., by making up to 200 cc; it will be faster to print, but will yield a less intense blue.)

6. Store the sensitizer solution in a well-stoppered, clearly labeled brown bottle. Kept in the dark, at room temperature, its shelf life should be at least a year.

Safety alert: If ingested, this sensitizer solution is much more toxic than traditional cyanotype sensitizer and immediate medical attention must be sought.

Applying the Emulsion

The emulsion from either formula can be applied under subdued tungsten light or in a darkened room. Avoid fluorescent lights because most of them produce UV light, which can affect the cyanotype emulsion, as well as all the other nonsilver processes discussed in this chapter. UV light raises the base fog level of the coated emulsion, reducing its overall sensitivity. This can reduce the contrast range and degrade the highlight and shadow details.

Spread newspapers on all working surfaces to protect them from cyanotype stains. After making the sensitizer, coat the paper with it. Two ounces of working solution will coat about eight 8 × 10 inch prints.

There are two basic ways to coat paper. The first coating method is called floating. Put the emulsion in a tray and float the paper on the solution for 2 to 5 minutes. Occasionally tap the backside of the paper gently to dispel any air bubbles, taking care not to get any of the sensitizer on the nonemulsion side.

The second method involves using a polyfoam brush (the same type used to paint the trim on your house). Tape or pin the paper to a smooth, nonporous surface. Dip the brush into the emulsion, squeeze out the excess, and brush evenly across the paper. The emulsion should be kept wet and not be overworked or reapplied during this process, or it will lose sensitivity.

Dry the paper in total darkness (a hair dryer, set on low, can be used to speed drying). The coated paper should appear yellow-green when it is dry.

Exposure

Cyanotypes are exposed by contact printing with a UV light source such as the sun, full spectrum or plant growth fluorescent lamps, a sunlamp, a carbon arc, or a mercury vapor lamp. In a darkened room, put the negative on top of the sensitized paper (emulsion to emulsion) in a contact frame or under Plexiglas or glass (glass absorbs UV light, making exposure times somewhat longer). A contact-printing frame with a tensioned split back is a major convenience in all nonsilver printing as it permits inspection without the risk of misaligning the paper and the negative.

Consistent sunlight is the best source of exposure. Sunlight exposure time may run from 5 to 20 minutes depending on the location, the time of day, the cloud conditions, and the season. Exposure times with sun-

Figure 10.1 Using a Victorian visual vocabulary, Dugdale's cyanotypes are rich in metaphor, nostalgia, and melancholy. Even after cataracts and a series of strokes left him with only 30 percent of his sight, Dugdale has continued to make images with an 11 × 14 inch Kodak view camera built in 1910. Often taking inspiration from a diverse group of photographers including William Henry Fox Talbot, Thomas Eakins, and George Platt Lynes, Dugdale uses intuition and memory to compose his images while relying on a magnifying glass and assistants to focus his camera.

©John Dugdale. *Christ Our Liberator*, 1999. Cyanotype. 11 × 14 inches. Courtesy of Wessel + O'Connor Gallery, NY, NY. Original in color.

lamps start at about 15 minutes. Keep the lamp about 24 inches from the print frame. If the frame gets too warm, a small fan can be used to dispel the heat. Wear appropriate eye protection when working with any sunlamp. The correct exposure time can be determined through inspection or by making a test strip. As the paper is exposed, it turns from yellow-green, to green, to dark green, to blue-green, and finally to blue-gray, at which time exposure should be complete.

It is necessary to overprint, as the highlight areas will lighten when the print is washed. Print until the highlights are considerably darker than desired. At this point, the shadow areas will begin to reverse. Check exposure by opening one side of the print frame back and carefully lifting the paper away from the negative, without disturbing the registration. If you are using glass, tape the paper and negative together on the support board on three sides, leaving the fourth free for inspection.

Processing

Process the print in subdued tungsten light by washing it in a tray of running water for 10 to 15 minutes at 68°F (20°C). Wash until the highlight areas are clear of stain (no yellow color should remain). Allow the print to dry in a darkened room. Washing in alkaline water (pH 8 or higher) will bleach the image. This can be corrected by increasing the exposure time.

Cyanotypes can fade slightly after processing, but they will return to their original color if left in the dark to reoxidize. The final look of a cyanotype cannot be determined until it has had a chance to completely dry and oxidize.

Oxidation Solution

To see the final tone immediately, place the print in an oxidation solution directly after washing.

Cyanotype Oxidation Solution Formula

Water (68°F or 20°C)	200 milliliters
Hydrogen peroxide (regular 3% solution)	20 milliliters

Quickly and evenly immerse the print in the oxidation solution for a couple of seconds. Remove, rinse, and dry it.

Toning

The color of a cyanotype can be altered to a certain extent through the use of chemical

toners. Formulas that require the direct uses of ammonia or ferrous sulfate are not recommended because the colors obtained from them easily fade. It is possible to produce only local changes in color by brushing the toner on selected areas of the print. You can make more than one color change on a print.

Red-Brown Tones

Solution A
Water (68°F or 20°C) 180 milliliters
Tannic acid 6 grams

Solution B
Water (68°F or 20°C) 180 milliliters
Sodium carbonate 6 grams

In a tray, immerse the print in solution A for 5 minutes. Then immerse the print in a separate tray of solution B for 5 minutes. Follow with a 10-minute wash in running water at 68°F (20°C).

Lilac to Purple-Brown Tones

Tannic acid 70 grams
Water (68°F or 20°C) 1 liter
Pyrogallic acid 1 gram

Mix the tannic acid and water. Heat the solution to 120°F (49°C) and add the pyrogallic acid. Rapidly and evenly immerse the print in the solution, or splotching may result. Allow the image to tone until it takes on a lilac color. Wash in running water at 68°F (20°C) for 15 minutes.

Deeper tones can be produced by putting the print in a solution of 15 grams of caustic potash and 1 liter of water. After toning in this solution, wash for 15 minutes.

Violet-Black Tones

Solution A
Water (68°F or 20°C) 1 liter
Sodium carbonate (washing 50 grams
 soda)

Immerse the print in this solution until it turns yellow, then wash for 2 minutes.

Solution B
Gallic acid 8 grams
Pyrogallic acid 0.5 grams
Water (68°F or 20°C) 1 liter

Take the yellow print from solution A and place it in solution B until the desired color appears. Follow with a 10-minute wash in running water. The gallic acid produces the violet tones. Increasing the pyrogallic acid results in a blacker tone.

KALLITYPE AND VANDYKE BROWNPRINT PROCESSES

Kallitype Characteristics

Dr. W.W.J. Nichol invented the kallitype in 1899. The process is based on Sir John Herschel's iron-silver reduction process called the chrysotype (the modern process is provided at the end of this section). This process is similar to platinum printing, except the kallitype image is made up of metallic silver instead of platinum.

The kallitype is a simple process consisting of silver nitrate and ferric salt. When the kallitype emulsion is exposed to light, some of the ferric salt is reduced to a ferrous state. The newly created ferrous salt reduces the silver nitrate to metallic silver. This metallic silver is not as stable as metallic platinum. Careful processing that removes all the ferric salt and nonimage silver greatly increases print stability.

The kallitype process was never commercially popular because it was introduced at the same time as gaslight papers, which were contact-printing, developing-out papers with a silver chloride emulsion that could be exposed by artificial light. Even more important, the kallitype had an initial reputation for impermanence. When Nichol first unveiled his process, he recommended the use of ammonia for a fix, which proved to be ineffective. When fixed in sodium thiosulfate (hypo), a kallitype can be as permanent as any other silver-based process.

The kallitype offers an excellent introduction to the more complex platinum printing. It is not as versatile as platinum, but it is a much less expensive way of achieving a platinum-like print quality. As in the platinum print, the kallitype works well with a continuous long-tone negative. There are several formulas and variations of the kallitype process. The easiest one is known as Vandyke or Brownprint. After mastering it, you will be prepared to move on to the more complex general kallitype process.

Vandyke Brownprint Characteristics

The Vandyke Brownprint technique is named after the characteristic rich brown tones found in the paintings of seventeenth-century Flemish master Anthony Van Dyck (or Vandyke). A Vandyke image produced from a long-tonal-range negative will have complete detail, from full shadows to full highlights. Shorter-tone negatives produce less-deep shadows. The color can range from medium brown to dark black-brown. Image contrast can be slightly controlled during development with the addition of potassium dichromate to the developer water. The emulsion has a shelf life of a couple of months and improves with age. Ideally, the emulsion should be prepared and allowed to age two to three days before it is used.

Most acid-free rag papers, such as Arches Platine, Arches Cover, and Strathmore 500, offer good starting points. Rives BFK will work, but it should be sized first for consistent results (see the section on gum bichromate later in this chapter). As with cyanotypes, the emulsion may be applied in subdued tungsten light by brushing or floating. No metal should come in contact with the silver nitrate, as it will cause a chemical reaction, so polyfoam brushes with all-wooden handles are suggested for coating. After the paper is coated, it should be dried in a darkened room. Paper may be heat- or fan-dried and should be printed on immediately, as the coated emulsion loses its sensitivity rapidly, producing flatter, grayer images. Be sure the coating is yellow before making any exposures. If it looks brown, it is no good.

The Vandyke process works well on many fabrics because it contains no colloidal body such as gelatin or gum arabic. The emulsion soaks into the fabric, leaving it unaltered (it does not stiffen up). Natural fibers, such as close-weave cotton, produce the deepest brown tones. Do not use permanent-press materials as they repel the emulsion.

When combining a Vandyke with a cyanotype image it is necessary to print the cyanotype first, to prevent the Vandyke from bleaching.

Vandyke Formula

Stock Solution A

Ferric ammonium citrate	90 grams
Distilled water (68°F or 20°C)	250 milliliters

Stock Solution B

Tartaric acid	15 grams
Distilled water (68°F or 20°C)	250 milliliters

Stock Solution C

Silver nitrate*	30 grams
Distilled water (68°F or 20°C)	1 liter

*Wear gloves when handling silver nitrate because it will stain black anything it touches.

Mix each stock solution separately. With constant stirring, combine stock solutions A and B, then slowly add stock solution C. Store in a tightly closed opaque container in a cool, dry location. Allow to ripen (age) two to three days before using. Shake the emulsion before each use, including between brush dips, to ensure even distribution of the silver nitrate. Tightly sealed and refrigerated solutions can last for years. Do not let the ferric ammonium citrate be heated above 300°F (147°C) or come in contact with any concentrated acid, as poisonous hydrogen cyanide gas can be produced.

Exposure

A Vandyke Brownprint is contact printed, using a print frame or heavy piece of glass and a smooth support board, under sunlight or an artificial UV light source until highlight detail becomes visible. Summer sunlight exposures can be as brief as 30 seconds but winter exposures can take an hour or more. The color of the emulsion will change from yellow to a dark reddish brown during normal exposure. The exposure time for the Vandyke emulsion is about half that for cyanotypes. A typical trial exposure in full summer sun might be about 2 minutes. A comparable exposure with photofloods at about 24 inches from the print frame could be about 15 minutes. Underexposed (thin) negatives can be exposed until the emulsion turns a tan-brown color. Overexposed (dense) negatives should be exposed until the emulsion turns silvery brown.

Development

The Vandyke is developed in a darkened room in running water at 68°F (20°C) for a couple of minutes, or until the water runs clear. The negative basically determines the contrast, but it may be increased slightly by adding a 10 percent dichromate solution to the developer water. After the print has washed for 1 minute, transfer it to a tray con-

taining 16 ounces (475 ml) of water and about 10 drops of the dichromate solution. Increasing the number of drops of dichromate solution produces more contrast. After the desired level of contrast is reached, transfer the print back into a tray of running water. This process may be repeated.

Fix

To achieve the true Vandyke brown and ensure permanency, the image must be fixed in a 5 percent bath of plain thiosulfate for 5 minutes at 68°F (20°C). This fixing bath is prepared by dissolving 25 grams of sodium thiosulfate in 500 milliliters of water. Since it is a weak solution, it should be monitored with a hypo check and replaced often.

When the image enters the fix, it will darken and turn brown, and the highlights should become brighter. Fix, with agitation, for 5 minutes. If the image is allowed to remain in the fix longer than 5 minutes, it can begin to bleach. Extending the time in the fix can correct for overexposed prints.

Washing and Drying

Wash the image in running water at 68°F (20°C) for 5 minutes. Then place it in a hypo clearing bath for 2 to 3 minutes and give it a final wash of 30 minutes to ensure permanence. The image can be air- or heat-dried. Heat drying will darken the brown tone.

A Basic Kallitype Process

The basic kallitype process is similar to the Vandyke, but it is more complex. The basic kallitype formula uses a mixture of ferric oxalate, oxalic acid, and silver nitrate as the sensitizer. When this emulsion is exposed to light, the ferric oxalate is changed to a ferrous state, which reduces the silver nitrate to metallic silver. During development, the ferrous oxalate is dissolved, leaving behind the metallic silver that forms the image. The advantages of kallitype over the Vandyke are that it offers better control over contrast and tone.

Kallitype Formula

Distilled water (100°F or 38°C)	16 ounces (473 milliliters)
Ferric oxalate	2¾ ounces (78 grams)

Oxalic acid*	80 grains (5.2 grams)
Silver nitrate*	1 ounce (31 grams)

*Wear gloves when handling both oxalic acid and silver nitrate as they are poisonous and will stain anything they come in contact with.

Dissolve the ferric oxalate and oxalic acid in the water. Constantly stirring, add the silver nitrate. Pour the solution into an opaque bottle with a tightly sealed lid and allow it to ripen for at least three days before use.

After the emulsion has ripened, warm the container in a water bath at 100°F (38°C) to redissolve the crystalline silver oxalate precipitate. Apply the emulsion in a darkened room to paper or cloth at 100°F by floating or coating with a polyfoam brush. The emulsion can be heat-dried. Printing should be carried out immediately because the sensitized coating will begin to deteriorate within a day.

Development

The image color is determined by the selection of developer. Contrast can be controlled through the use of a 10 percent potassium dichromate solution in any of the developers (see Development in the Vandyke section). With a normal contrast negative, add 2 drops of the 10 percent potassium dichromate solution to the developer. If the negative is flat (lacks contrast), add 6 to 10 or more drops to the developer. There is no need to add any dichromate with contrasty negatives. Prints are processed for 5 to 10 minutes in any of the developer formulas. Best results are usually obtained when the developer is warm.

Kallitype Black-Tone Developer Formula

Distilled water (100°F or 38°C)	500 milliliters
Borax	48 grams
Sodium potassium tartrate (Rochelle salt)	36 grams

Kallitype Brown-Tone Developer Formula

Distilled water (100°F or 38°C)	500 milliliters
Borax	24 grams
Sodium potassium tartrate	48 grams

Kallitype Sepia-Tone Developer Formula

Distilled water (100°F or 38°C)	500 milliliters
Sodium potassium tartrate	24 grams

Kallitype Clearing Solution Formula

After development is complete, rinse the print in running water and clear it for 5 minutes using the clearing solution.

Water (68°F or 20°C)	1 liter
Potassium oxalate	120 grams

Kallitype Fix Formula

After the clearing bath, fix the print for 5 minutes in the fix solution. Be sure to check and replace this solution often.

Water (68°F or 20°C)	1 liter
Sodium thiosulfate	50 grams
Household ammonia (plain)	12 milliliters

Washing and Drying

Wash the print for several minutes, then treat it with a hypo clearing bath for 3 minutes.

Figure 10.2 A year after William Henry Fox Talbot announced his invention of silver-based photography, Sir John Herschel developed a method for making photographic images in gold. Herschel's chrysotype formula, named after the Greek word for gold, had difficulties with contrast control and image fogging. (The modern formula eliminates those problems.) Depending on the size of the microscopic particles of gold, the type of paper, and developer, chrysotypes can range in color from blacks and pinks, to blues, purple, violet, green, and in some cases a golden color.

© Robert Schramm. *Full Moon*, 1999. Chrysotype print. 8 × 8 inches. Original in color.

Give a final wash of 30 minutes to ensure permanence. Air-dry the print.

Combining Processes

The cyanotype and the kallitype processes contain chemicals that will attack one another when combined on the same surface. Unusual visual effects are possible, but do not expect the resulting image to be permanent. Changes can take place within a week. If you wish to preserve the effect, it is necessary to rephotograph the work on color film.

Chrysotype Process

Robert W. Schramm and Liam Lawless developed the following chrysotype process that can be carried out in room temperature of 68°F (20°C).

1. Sensitizer:
 8 drops of 10 percent gold chloride solution (made with distilled water)
 12 drops of distilled water
 20 drops of 18 percent ferric ammonium citrate solution
 Note: After the sensitizer is mixed you have about 20 minutes to coat the paper before the gold starts precipitating out. The look of the images is similar to the cyanotype except they are more of a flat slate blue with a slight reddish cast, which can give them a light purple appearance.

2. Developer:
 Potassium oxalate solution. Use 1/2 teaspoon in a pint of water.
 Develop for 1 to 2 minutes.

3. Clear:
 10 percent sodium sulfite solution.
 Clear for 1 minute.

4. Wash for 30 to 60 minutes, depending on the paper.

PLATINUM AND PALLADIUM PROCESSES

William Willis patented the platinum printing process in 1873 and began to market it in 1879 under the name Platinotype. Photographers such as P.H. Emerson and Fred-

erick H. Evans used the paper. It also became extremely popular with the Pictorialists, the Linked Ring Society, and the Photo-Secessionists.

Platinum is a contact-printing process in which the image is first partially printed out (becomes visible) in UV light. After exposure, the full image is chemically developed out to completion. Like all printing-out processes (P.O.P.), it allows subtle highlight details to be retained without the deep shadow areas becoming buried. This is due to its self-masking ability. When a print is made using this process, the shadow areas are the first to appear on the paper, darkening the top layer of the print emulsion, which then acts as a mask. This mask holds back some of the light so the shadows do not get as dark as they would in a silver-based print that is developed out. Consequently, light is permitted to pass through the denser highlight areas of the negative without the shadows going black and losing detail. Thus a soft print with a long tonal scale and luminous shadow detail can be produced.

All sensitizing and developing can be done under subdued tungsten light. Varying the proportions of the sensitizer solutions controls contrast. Platinum produces an image color from silvery gray to rosy brown. The print has a matte surface, so there is no reflected glare. Platinum is more stable than silver, so images can be as permanent as the paper on which they are printed.

The major disadvantage of platinum is its extremely high cost. For this reason, platinum papers have not been widely available since 1937. At present, the Palladio Company is making a platinum-palladium paper in two contrast grades (see Additional Information at the end of this chapter). Palladium, which is somewhat less expensive, can be substituted for platinum and will deliver similar results, although it does not provide as much color variation. Palladium produces brown-tone prints. Platinum and palladium are often mixed in equal parts to produce a warmer tone than can be achieved with platinum alone.

Platinum Printing

Platinum is not light-sensitive enough to permit enlarging, so a large or enlarged negative is needed for contact printing. Due to the slowness of the material, burning and dodging are not generally done during printing but are carried out when the enlarged negative is made (see Chapter 3).

The platinum process is similar to other ferric, iron-sensitive processes such as the kallitype, except that platinum salts are used in place of silver salts. The paper is sensitized with ferric oxalate and potassium chloroplatinite. When exposed to UV light, the ferric salts are reduced to the ferrous state in proportion to the density of the negative. When the print is developed in a potassium oxalate developer, the newly formed ferrous salts are dissolved, and they, in turn, reduce the platinum to the metallic state. The image is then cleared in a bath of dilute hydrochloric acid, which eliminates the remaining ferric salts, leaving behind an image composed only of platinum.

Negatives

Platinum delivers a classic straight-line response, meaning that the print will reveal the full range of tonal values, from dark shadows to very subtle highlights, that have been recorded on the negative. For this reason, negatives possessing a long and full density range with good separation and shadow detail make excellent candidates for printing. Platinum is one of the few emulsions capable of successfully rendering such a wide contrast range. Generally, a contrasty and dense negative that will print well on a Grade 0 silver-based enlarging paper is a good starting place.

If the negatives being made are only for platinum printing, some printmakers increase the amount of exposure given to the film by as much as quartering the standard ISO rating. For instance, a 400 speed film would be exposed at ISO 100. T-MAX films are an exception. Try T-MAX 100 at ISO 75 and T-MAX 400 at ISO 200. In addition, some people increase the developing time by 30 to 50 percent. D-23 is a favorite developer for negatives that will be used to print on platinum (see Chapter 4 for the formula). Thin negatives look dull, flat, and lack detail. On the other hand, printing negatives made on high-contrast film (litho film) is not common because their lack of tonal range does not take full advantage of the subtleties of the platinum process. Obviously, experi-

mentation is in order. If the negatives being made are for both platinum/palladium and silver printing, expose T-MAX 400 at ISO 200 or T-MAX 100 at ISO 50 and process in D-23.

Paper

Fine-textured, 100 percent rag papers, like Crane's Kid Finish #64, is an excellent starting point. Papers with too much texture cause the fine details of platinum to be lost. Rives BFK and similar papers are very absorbent and soak up copious amounts of expensive emulsion. Such papers can be sized to reduce their rate of absorption (see the section on gum bichromate later in this chapter). A paper's chemical makeup can have a noticeable effect on the color and tonal range of the print. Paper manufacturers are continually making changes in their operations. Test a variety of papers in order to determine the desired results.

Chemicals

The price of platinum and palladium salts varies greatly, so check a number of sources before ordering. Sometimes ferric oxalate can be hard to find. It is deliquescent (dissolves by absorbing moisture from the air) and should be stored in a tightly sealed opaque bottle. If prints appear to be fogged, test the ferric oxalate by dissolving some in water and adding a 5 percent solution of potassium ferricyanide. If this mixture turns blue, the ferric oxalate has become ferrous. Discard it, as it will deliver poor results.

Platinum Emulsion Formula

The emulsion is made up of three separate stock solutions, each stored in an opaque glass bottle with a medicine dropper. Do not interchange the droppers. Label the bottles and store them in a dark place. The platinum solution lasts indefinitely. The oxalates will keep for a couple of weeks or up to a few months if refrigerated. When the oxalate solution goes bad, the print highlights become uneven and start to fog. Follow all safety procedures as outlined in Chapter 2 when handling these chemicals.

Stock Solution 1

Distilled water (120°F or 49°C)	55 milliliters
Oxalic acid	1 gram
Ferric oxalate	15 grams

Stock Solution 2

Distilled water (120°F or 49°C)	55 milliliters
Oxalic acid	1 gram
Ferric oxalate	15 grams
Potassium chlorate	0.3 grams

Stock Solution 3

| Distilled water (100°F or 38°C) | 50 milliliters |
| Potassium chloroplatinite* | 10 grams |

*Do not use chloroplatinate. If some of the platinum should precipitate out of the solution during storage, warm it in a water bath, prior to use, to redissolve the platinum.

All the solutions should be prepared 1 to 2 days beforehand and allowed to ripen. When you are ready to use the solutions, combine them to produce the desired contrast level (see the next section) in a clean glass bottle. Tighten the top and mix by shaking.

Contrast Control

The contrast of the image is controlled by varying the proportions of solution 1 and solution 2. Following is a list of emulsion mixtures for contrast control with a normal negative.

Very Soft Prints

Solution 1	22 drops
Solution 2	0 drops
Solution 3	24 drops

Soft Prints

Solution 1	18 drops
Solution 2	4 drops
Solution 3	24 drops

Average-Contrast Prints

Solution 1	14 drops
Solution 2	8 drops
Solution 3	24 drops

Above-Average-Contrast Prints

Solution 1	10 drops
Solution 2	12 drops
Solution 3	24 drops

High-Contrast Prints

Solution 1	0 drops
Solution 2	22 drops
Solution 3	24 drops

Raising Contrast In addition to increasing the amount of solution 2 in the emulsion,

you can raise the contrast of a print by doing one or more of the following:

1. Use a hard, smooth-surface (hot pressed) paper.
2. Give the paper a second coat of emulsion after the first has dried.
3. Add 5 to 25 drops of a 10 percent solution of potassium dichromate to the developer.
4. Lower the temperature of the developer.
5. After the first exposure is processed and dried, recoat the paper and expose it again with the same negative.

Lowering Contrast Print contrast may be lowered in the following ways:

1. Use a soft, rough-surface (cold pressed) paper.
2. Reduce overall exposure time and process in a warm to hot developer.
3. Add a few drops of clearing bath to the developer.

Applying the Emulsion

The emulsion can be applied under subdued tungsten light. Practice coating on scrap paper. Use water to which a few drops of food coloring has been added to make it easier to see what is happening. Tape or pin the paper to a smooth, flat surface. Use a brush with no metal parts (about 2 inches wide) that has a thin row of bristles so a minimum amount of emulsion is used. If the brush has any metal, do not let the emulsion come in contact with it, as this will cause a chemical reaction that will contaminate the emulsion. Metal parts may be painted with rubber cement for protection.

Dip the brush into distilled water and squeeze it out. Doing this will reduce the amount of emulsion used. Using a clean dropper, put a line of emulsion along the top of the paper. With long, rapid, parallel strokes, brush the emulsion up and down and back and forth until the surface is dry. Coat an area larger than the negative so that the excess can be trimmed off to make test strips. Spread the emulsion as evenly as possible. Avoid puddles that may soak into the paper and produce uneven print density.

Wash the brush immediately after use, as exposure to light will cause ferrous salts to form in any remaining emulsion. If the brush is not properly washed, these salts can contaminate future prints during the coating process. Paper can also be coated by using a 3/8 inch or 1/2 inch diameter glass or acrylic rod instead of a brush. Rods coat paper evenly and use less solution than other coating methods and can be purchased or made.

Making Your Own Glass Coating Rods Obtain solid glass rod stock or Pyrex glass rod and tubing from a supplier like Fisher Scientific (see Additional Information at the end of the chapter) or from a glassblower supplier. The rod should be slightly longer than the width of the paper to be coated. With a three-cornered file, score the rod where you want to cut it. Grasp the rod in both hands with your thumbs on the side of the rod opposite the score and snap the rod like a stick. The rod will break neatly at the score. The ends of the rod can be rounded using a plumber's propane torch by holding one end of the rod in the flame and rotating the rod slowly. The flame will glow yellow and the end of the rod will begin to melt. Withdraw the rod from the flame and let it cool (do not put the rod in water to cool, as it will shatter). Repeat the procedure on the other end.

Coating Paper with a Rod Using a clean dropper, put a line of emulsion along the top of the paper. Place the rod in the emulsion and pull the rod and emulsion across the paper. When you have reached the other side of the paper, lift the rod up and down slightly to redistribute the emulsion and then drag the emulsion back to your original starting point. Repeat this procedure five or six times until the paper is evenly coated. Remove any excess emulsion with a paper towel.

Drying the Paper Once the paper is coated, hang the paper with plastic clips or clothespins with no metal in a darkened room, or use a hair dryer on low heat to speed drying. Platinum emulsion is hygroscopic, and will absorb moisture from the air. If too much moisture is absorbed into the paper, the highlight areas can produce degraded and grainy results. Heating the paper as it dries

helps reduce the likelihood of this occurring. When dry, the unexposed paper should be a pale yellow color.

Do not handle the emulsion surface, as it is easily contaminated before printing is completed. Sensitize only the paper needed for immediate use. Expose and process as soon as possible.

Printing

The emulsion is exposed by contact printing with UV light. Combine the negative and paper (emulsion to emulsion) in a printing frame or under glass with a smooth, firm support. A typical sunlight exposure can run 1 to 5 minutes depending on the season, the time of day, and cloud cover. Many workers prefer a UV exposure unit with a fluorescent, pulsed xenon, or quartz light source. They produce more constant exposures that can be easily repeated (see Additional Information at the end of this chapter). A home sunlamp also may be used. At a distance of about 24 inches from the printing frame, exposure times may run 15 to 30 minutes with a sunlamp. Since the platinum emulsion is expensive, making test strips that show key highlight and shadow areas is recommended.

The image will print out to a limited extent, appearing to be a lavender-gray against a yellowish ground. Correct exposure will have detail in the highlight areas, but this will be faint and is difficult to use as an accurate guide (another reason to make test strips). The correct exposure cannot be determined until the print has been processed and at least surface dried.

Exposure time also depends on the amount of potassium chlorate (solution 2) in the emulsion. An increase in potassium chlorate cuts the printing speed and results in higher contrast. An emulsion for very soft prints, having no solution 2, may need 25 percent less exposure than normal. An emulsion for high-contrast prints, having the maximum amount of solution 2, may need up to 75 percent more exposure than usual.

Platinum Developer Formula

Due to the hygroscopic nature of platinum emulsion, the print should be processed immediately after exposure. Development can be carried out under subdued tungsten light in a saturated solution of potassium oxalate.

Water (120°F or 49°C)	48 ounces (1,420 milliliters)
Potassium oxalate	1 pound (454 grams)

Store the developer in an opaque bottle and use at 68°F (20°C). Do not discard the developer. It will last a long time without any replenishment and can actually improve with age as the platinum residuals build up. When a precipitate forms, decant the solution (gently pour off the solution without disturbing the sediment) into another container.

The developer acts very rapidly, so you must immerse the print, face up, with a quick, continuous motion. Hesitation may produce development lines or streaks that can sometimes be removed by rubbing the print while it is in the developer. Development time is 1 to 2 minutes, with gentle agitation. Development is automatic, meaning that the chemical reaction will continue until it is complete and then it will stop. Consequently, increasing the development time beyond about 2 minutes will not affect the final image.

The color of a platinum print becomes warmer as the temperature of the developer rises. A warmer temperature also increases the printing speed of the paper, so less exposure is required. Make sure the developer temperature remains constant between the test strip and the final print to ensure consistent results. Warm developer reduces the overall print contrast. You can compensate for this to a certain degree by increasing the amount of solution 2 in the emulsion.

Platinum Clearing Bath Formula

After development, in normal room light, clear the print in three successive baths of dilute (1:60) hydrochloric acid (1 part hydrochloric acid to 60 parts water). This bath removes any remaining ferric salts by changing them into soluble ferric chloride. If this is not done, the print will remain light-sensitive and continue to darken. Some workers have found that citric acid, phosphoric acid, or Bostick & Sullivan's EDTA Clearing Agent (tetra-acetic acid tetra-sodium) work well and are safer to use than hydrochloric acid.

Hydrochloric Acid Clearing Solution

Water (68°F or 20°C) 420 milliliters
Hydrochloric acid (37%) 7 milliliters

Always add acid to water. This solution may be reused and lasts indefinitely.

EDTA Clearing Solution

Water (68°F or 20°C) 420 milliliters
EDTA 15 grams

Clear the print for 5 minutes in three separate trays of the clearing bath with occasional agitation. After a few prints have been cleared, dump the first bath, refill it with fresh solution, and move it to the end of the clearing trays so it becomes the third bath. Move the second bath up to the first position and the third to the second. This ensures the complete removal of the iron salts from the print. The third bath should remain clear after the print has gone through. If it is not clear, give the print a fourth bath in fresh clearing solution.

Washing and Drying

After clearing, wash the print for 30 minutes in running water at 68°F (20°C). Handle the print with care, as it is very delicate at this stage. Prints may be air-dried or dried with low heat from a hair dryer.

Spotting

Dried prints may be spotted with black India ink diluted with water. This often matches the neutral to warm black tones of a platinum print. Burnt umber and lampblack

Figure 10.3 Modica spent ten years photographing the lives of a family with 14 children living in an isolated rural town in New York using an 8 × 10 inch view camera and one lens. Modica chose platinum printing for its extended and subtle tonal range and because the image is located in the paper itself, as opposed to sitting on top of the paper as in a gelatin silver print.

© Andrea Modica. *Treadwell, New York*, from the book *Treadwell*. Platinum/Palladium print. 8 × 10 inches. Original in color.

watercolors work well when mixed to the proper shade.

Combination Printing

Platinum can be combined with palladium, gum, or cyanotype. When cyanotype is used with platinum, the cyanotype should be printed last, as the potassium oxalate developer will bleach the cyanotype image.

Palladium Printing

When comparing palladium with platinum, remember that they act very much alike. Even experts can have difficulty seeing the difference between a platinum and a palladium print. Palladium is less expensive than platinum and produces a permanent brown-tone print that is warmer than the image achieved with platinum. The working procedures are the same as those used with platinum, except for the following:

- Palladium salts are not as sensitive as platinum salts to potassium chlorate, which controls the contrast. This can be corrected by doubling the amount of potassium chlorate in solution 2.

- Palladium is more soluble in hydrochloric acid, so the clearing bath can be diluted 1:200 (1 part hydrochloric acid to 200 parts water). The contrast of palladium cannot be increased by adding potassium dichromate to the developer because the image will bleach out during the clearing baths.

- Solution 3 of the emulsion sensitizer must be modified as described in the following formula.

Modified Palladium Emulsion Solution 3 Formula

Distilled water (100°F or 38°C)	2 ounces (60 milliliters)
Sodium chloro-palladite	169 grains (9 grams)

If sodium chloropalladite is unavailable, use the following formula.

Modified Palladium Emulsion Solution 3A Formula

Distilled water (100°F or 38°C)	1½ ounces (40 milliliters)
Palladium chloride	77 grains (5 grams)
Sodium chloride	54 grains (3.5 grams)

GUM BICHROMATE PROCESS

The gum bichromate process operates on the principle that colloids (gelatinous substances) become insoluble when they are mixed with certain light-sensitive chemicals and exposed to UV light. This effect is called hardening or tanning. The most frequently used colloids in photography are albumen, gelatin, and gum arabic. In the gum bichromate process, the support material is coated with a gum arabic that contains a pigment (watercolor or tempera) and with a light-sensitive chemical (ammonium or potassium dichromate) to produce a nonrealistic color image from a contact-size negative. Gum arabic, a water-soluble colloid, is hardened by exposure to UV light and thus made insoluble in direct proportion to the density of the negative. The areas that are not hardened remain water soluble and are washed away with the unneeded pigment during development. The hardened areas are left intact and bond the pigment to the support. A great deal of control over the final image can be exercised through the following: choice of paper, pigment, localized development, recoating the paper with the same color or a different color, or using the same or different negatives for additional exposures.

John Pouncy patented the first workable gum process in the late 1850s. The process was used by the Pictorialists from the 1890s to about 1920, often under the name Photo-Aquatint. Gum printing experienced a major revival in the late 1960s. Among the reasons for making gum prints are the following:

- It is inexpensive because it uses no metal salts.

- It permits extensive manipulation of the image.

- It is versatile, so it can be combined with other processes.

- It is permanent.

The disadvantages of gum printing stem from its versatility. It is a more difficult process to control than the nonsilver processes discussed earlier in this chapter. Multiple coats of emulsion and exposure are necessary to build up a deep, rich image. The support material (paper) must be sized, or the registration of the different exposures will not line up, thus producing blurry images. Any subtle or fine detail will be lost in the process. Gum also does not deliver a realistic color image balance.

This section offers a starting point for making gum prints on paper. There are countless formulas for gum printing, and the process can be used with almost any type of support material. Keep a record of your working methods and make adjustments. Feel free to modify the suggested working methods whenever necessary.

Paper

Start with a high-quality watercolor or etching paper that has a slight texture and the ability to withstand repeated soaking and drying. Some widely available papers include Arches Watercolor, Rives BFK, and Strathmore 500 Series (two- or three-ply). All paper should be presoaked and sized. Some papers, such as Strathmore 500, can be purchased presized. For exacting work, even these papers may have to be presoaked and resized.

Presoaking
Presoak by placing the paper in hot water (100°F or 38°C) for 15 minutes and then hanging it up to dry. Without the presoak, the paper will shrink after the first time it is processed, thus making accurate registration of the next exposure impossible.

Sizing
After the presoak, size the paper. There are two widely used methods of sizing. The quickest and easiest way is to use spray starch. Pin or tape the paper to a clean, smooth support board. At a distance of about 12 inches, start spraying the starch at the bottom of the paper in horizontal sweeps and work upward to the top of the paper. Do not overspray, as too much starch will prevent the emulsion from sticking to the paper. Use a soft, clean, damp sponge to wipe off any excess starch and to ensure an even coat. Apply a thin coat of starch between exposures to prevent the colors from bleeding into each other.

The gelatin method of sizing is more effective but also more time-consuming. Dissolve 28 grams of unflavored gelatin in 1 liter of cold water. Allow it to swell (sit) for about 10 minutes and then slowly heat the solution to 100°F (38°C) until it is completely dissolved. Pour the solution into a tray and soak each sheet of paper for 2 minutes. Lightly squeegee off the excess solution and hang the paper up to dry (low heat may be used).

Many workers give the paper a second coat of sizing after the first one has dried. The gelatin sizing must be hardened or else it will wash away during processing. In a well-ventilated area, harden the surface by floating the paper in a bath of 25 milliliters of 37 percent formaldehyde and 500 milliliters of water for 2 minutes and then drying it. A 1 percent glyoxal solution can also be used to harden gelatin sizing. In a well-ventilated area, add 25 ml of glyoxal 40 percent solution to 900 ml of water. Add water to bring the level up to 1 liter. Float the sized paper in the 1 percent glyoxal solution for 5 to 10 minutes and then dry.

Emulsion

The emulsion is made of pigment, gum, sensitizer, and distilled water. Varying the amounts of these ingredients will result in noticeable changes in image characteristics. For this reason, experimentation is a must. A specific combination might deliver results that are pleasing to one imagemaker but unsatisfactory to another.

Pigments

The easiest way to add color to the emulsion is with good-quality tube-type watercolors such as Winsor-Newton and Grumbacher. Many workers find that the opaque gouache-style watercolors perform well. Tempera colors also may be used. The following is presented as a basic palette, which comes close to resembling the primary subtractive colors in color photography:

- Alizarin crimson (close to magenta)
- Monastral or thalo blue. Prussian blue is not recommended because it is chemically incompatible with cadmiums and vermilions.
- Cadmium yellow (pale). Hansa yellow is a less expensive synthetic that can be substituted for cadmium.

In addition to these three primary colors, there are earth colors such as burnt sienna (brownish brick red); raw sienna (yellower than burnt sienna); burnt umber (dark red-brown); and raw umber (yellowish brown). These colors, in conjunction with lampblack, are useful in making a wide variety of tones.

Note that the chrome colors, such as chrome yellow, can be chemically incompatible with the sensitizer and with other organic pigments. Emerald green, which is poisonous, should not be mixed with other colors, as it is not chemically compatible.

Gum Solution

The gum solution may be prepared from a formula, but it is advisable to purchase it in small premixed amounts. This bypasses the difficult process of dissolving the gum and prevents the handling of mercury chloride, which is a toxic chemical used to stop the growth of bacteria. Lithographer's gum (14°Baumé) solution is available from graphic arts or printing suppliers. Be sure it comes with a preservative, such as 1 percent formaldehyde, as it does not keep well. To ensure its freshness, some practitioners buy it in small quantities and replace it often.

Sensitizer

The recommended sensitizer is ammonium dichromate (bichromate is the same thing) because it is more sensitive to light than potassium dichromate, thus making faster exposure times.

Ammonium Dichromate Sensitizer Formula

Distilled water (80°F or 27°C)	100 milliliters
Ammonium dichromate*	30 grams

*Wear gloves, as this may cause skin irritation.

Store sensitizer in an opaque bottle. If precipitate forms during storage, reheat and dissolve the solution.

Preparing the Emulsion

The amount of pigment should be varied depending on the desired effect and the type of paper being used. The following is provided as a general guideline, but experimentation is in order.

Gum Dichromate Emulsion Formula

Gum arabic solution	40 milliliters
Pigment (tube-type watercolors)	*
Ammonium dichromate sensitizer	40 milliliters

*Pigment amounts vary greatly depending on the desired effect. The following is only a starting point:

Alizarin crimson	3 grams
Monastral or thalo blue**	2 grams
Cadmium yellow	3 grams
Burnt sienna	3 grams
Burnt umber	3 grams

**Pure blues are difficult to achieve because the orange dichromate tends to shift the color balance to green.

Put the gum arabic and pigment in a clean baby food jar, secure the lid, and shake rapidly until the solution is completely mixed. Then add the dichromate and shake until the solution is uniform. Generally, the gum and dichromate are mixed in equal proportions, while the amount of pigment is varied. It is advisable to use the emulsion quickly, within one day or working session, as it does not keep well.

The Effects of Varying the Emulsion Ingredients

Varying the proportions of the gum, pigment, and sensitizer results in the following changes:

- *Increasing the gum* permits more pigment to be retained without staining. If there is too much gum, the emulsion will be too thick to be easily applied and may flake off during development.

- *Decreasing the gum* causes the emulsion to set up more slowly and also may cause staining.

- *Increasing the pigment* causes the emulsion to set up more rapidly and deepens the color in the shadow areas. This often requires forced development and may produce stains in the highlights. Too much pigment may cause the image to crumble off the paper during development.

- *Decreasing the pigment* allows the highlight areas to develop more readily but produces very low contrast, as there will be little shadow density.

- *Increasing the sensitizer* delivers less contrast, as it thins the emulsion; thus less pigment is deposited on the support surface.

- *Decreasing the sensitizer* results in a lack of light sensitivity, with only the shadow areas printing out.

Coating the Paper

The emulsion is not very sensitive to light while it is wet, so coating can be carried out under subdued tungsten light. The paper should be pinned or taped to a smooth, flat board. Generally, the lightest color is applied first, as it may not print well over the darker colors. Some workers like to print a dark color first to make registration easier when additional coats are applied.

Pour the emulsion in a small nonporous bowl or jar. Dip a spreading brush at least two inches wide (polyfoam brushes work fine) into the emulsion. Squeeze out the excess on the side of the bowl. Coat the paper with long, smooth, horizontal strokes and then with vertical ones. Have enough emulsion on the brush to make one complete stroke without having to redip. The strokes should overlap slightly. Perform this operation as rapidly as possible (10 to 15 seconds for an 8 × 10 inch). Do not let the emulsion puddle or flood the paper.

Immediately take a dry blending brush and, holding it vertically to the paper, paint in long, gentle strokes, using only the tip of the brush to smooth out the emulsion. This step also should be done as quickly as possible. The coating must be even and thin, or the gum may flake off the print later.

Stop blending as soon as the emulsion becomes stiff or tacky. Many of the small brush strokes will smooth out as the paper dries.

Hang the paper to dry in a darkened room. A fan or hair dryer, set on low heat, can be used to speed drying. The paper should be exposed as soon as it is dry, as it will not keep for more than about a day. If it is sealed in a plastic bag and refrigerated, however, the paper can keep for up to two weeks. Try to avoid working in humid conditions, as the bichromate solution absorbs moisture from the air, making it less sensitive.

Exposure

Combine the negative and paper (emulsion to emulsion) in a contact-printing frame or under a clean piece of glass with a smooth support board. Expose this sandwich to UV light. Typical sunlight exposures can be 5 to 10 minutes. With photofloods, at a distance of 18 to 24 inches from the printing frame, exposures may be 20 to 60 minutes. Sunlamp exposures can range from 10 to 40 minutes. Different pigments require different exposures. Use a fan to lengthen the life of the light source and keep the negative and print from getting too hot. Excessive heat may produce a pigment stain in the print.

Development

Immediately after exposure, the print should be developed in subdued tungsten light. Slide the print, emulsion side down, into a tray of water at 70°F to 80°F (21°C to 27°C). Allow it to float without agitation. Change the water after about 5 minutes, when it has become cloudy. Transfer the print to a tray of fresh water or remove the print and change the water in the tray, then return the print to the tray. For the full range of tones, development should be complete in about 30 minutes. You can tell it is complete when the highlight areas are clear. If development seems to be going too slowly due to overexposure or the use of too much pigment, raise the temperature of the water to 100°F (38°C). If a print is underexposed, you can use additional layers of exposure to build up the image density. Overexposure or too

Figure 10.4 To make visible the power and magic of this special place, Taylor first made a cyanotype exposure on Arches 140-pound watercolor paper. He then did a second exposure with gum bichromate to add color, richness, and texture. The image was finished with layers of mixed media, such as acrylic, chalk pastel, watercolor, and colored pencil. The edges of the paper were hand-torn to enhance the primitive feel of the print.

© Brian Taylor. *The Great Pyramids*, 1985. Cyanotype, gum bichromate, and mixed-media print. 16 × 20 inches. Original in color.

Multiple Printing

After a single exposure, most gum images look flat and weak, lacking color saturation and a sense of visual depth. Multiple printing adds contrast to the shadow areas, can extend the overall tonal range, and can give the image an appearance of greater depth. In basic multiple printing, the dried image is recoated and re-exposed with the same negative in register. This can be repeated numerous times. Gum printing can be successfully combined with cyanotypes for heightened color and contrast or with posterization negatives.

Registration

A simple way to register the print is to mark all four corners of the negative on the paper with a soft lead pencil. Variations in multiple printing include printing negatives with different densities, using color-separation negatives, and using entirely different negatives, printing out of registration, and changing the pigment.

For more accurate registration, tape a piece of heavy paper along one edge of the negative. Sandwich the negative and paper (emulsion to emulsion) together. Use a standard hole punch to make a hole in two of the corner edges of the paper and the base sheet. Attach registration buttons, available at a graphic arts store, to the support board. Fit the negative and base sheet into the registration buttons. This will perfectly register the negative and paper each time it is recoated.

much heat can harden the emulsion, making it impossible to wash off. The emulsion of an extremely underexposed image might float off the paper during development. If the emulsion flakes off, it was applied too thickly.

Forced Development

A soft brush and/or a directed stream of water (from a hose, graduate, or atomizer) can be used to manipulate the image. These forced development methods diminish subtle print detail but permit the use of more pigment in the emulsion, increasing the contrast and density of the image. The amount of pressure applied by the brush or stream of water determines the abrasive effect. The print may be removed from the tray of water, placed on a piece of Plexiglas for manipulation, and then returned to the tray to finish the development process. When development is complete, hang the print to dry.

Clearing

After all the printing operations are finished, a yellow or orange stain may be visible. This may be cleared in a 5 percent solution of potassium metabisulfite or sodium bisulfite. Immerse the print in the clearing bath for 2 to 5 minutes, wash it for 15 minutes, and dry it.

ELECTROSTATIC PROCESSES: COPY MACHINES

Copy machines provide the imagemaker with another opportunity to experiment

with technological advances originally designed for business use. They enable the photographer to combine electronic, manual, and mechanical processes in the creation of new images.

Black-and-White Copiers

Black-and-white copy machines are very accessible and less expensive to use than their color counterparts. They provide a good starting point for conducting experiments with copiers. You can apply many of the things you learn on these machines to work on a color copier. The quality of image reproduction varies widely depending on the type of system used. Generally, continuous-tone images lose a great amount of detail when copied. Some systems provide a special screen, which can be used to improve the copy delivered from a full-tone image. Graphic images tend to work well with most machines.

All the black-and-white copiers allow the imagemaker to alter the density of the print. Some accept a variety of paper stocks, including different colors. Most machines make enlargements and reductions at fixed percentages of the original. Others permit you to make more than one copy on the same piece of paper; thus multiple exposure combinations are possible.

The black-and-white copiers rely on a number of different systems to form a completed copy print. Older systems that required a special chemically treated paper to create an image offer the least in terms of image permanence. The systems using an electrostatically charged toner that can form an image on any type of paper, including acid-free rag paper, provide the most stable copy print.

Color Copiers

Color copiers are widely available and artists are using them to explore their more complex imaging functions. Color copiers use the subtractive colors (magenta, yellow, and cyan). Each color is separated from the original through an internal filtering unit. The image is then reproduced with toners (pigments) made up of thermoplastic powders that are electronically fused onto the paper, making a permanent image. Copiers that use toners do not require a specially treated paper and therefore can be fused onto a variety of artist's papers.

The original color copiers worked like a simple camera, using a lens to take a picture of the document to be copied. It produced a very flat and limited field of focus that extended only about one-quarter to one-half inch above the copier glass. Current color copiers are digital (see next section). Color copiers provide many printmaking options, including the following:

- Rapid and consistent duplication and production
- Ready conversion of three-dimensional objects into flat printouts
- Manipulation of colors and contrast (many can produce a monochrome copy)
- Image enlargements and reductions
- Printing on many different supports, such as archival artist's paper, acetate, and silicon transfer sheets (which can be ironed onto paper or fabric)

An added virtue is that the pigments used to form the image are stable and provide a long print life. The rapid feedback of this process enables instant correction and further interaction of the printmaker with the materials and processes. Prints made on artist's paper can be hand-colored with pencils, dyes, inks, or watercolors. Individual prints can be connected with one another to form a larger mosaic of images.

Digital Color Copiers
Digital color copiers have a scanner (see Chapter 13) that reads the image to be copied and converts it into digital signals that are then sent to a raster image processor or RIP. The RIP converts color files into printing instructions that are transmitted to a laser printer capable of delivering color copies of up to 64 gradations per color. Like the original optical copier, digital color copiers use the subtractive color system, but in addition to magenta, yellow, and cyan, these copiers also use black. The black enables these machines to reproduce colors more accurately and to provide a greater sense of depth.

Figure 10.5 Artist and high school art teacher Pat Bacon began using a photocopier to produce images to compensate for a less than ideal school group darkroom. Bacon prints each of the students' images as a high-contrast 8 × 10 inch photograph. Then each photograph was copied, finished, and pieced together as a quilt would be. Finishing involved coating the surface of the paper with a layer of Golden's Polymer Medium and allowing it to thoroughly dry. This top layer becomes a transparent workable surface that is flexible, durable, and easy to repair. Between layers of polymer medium and Golden's UV varnish Bacon applies paint, stains, and dyes. This method allows the work to be very portable between school, studio, and unorthodox installation sites. Bacon says, "The piece is a testament to my frustrations as an educator with the lack of educational response to social change."

© Pat Bacon. *Students and Desks* (detail), 1991. Electrostatic print with mixed media. 50 × 48 inches; overall size 50 × 192 inches. Original in color.

Digital color copiers have features that can be used with an image editing unit. While digital copiers typically do not offer noticeably higher quality than optical copiers, they do offer a greater range of features including:

- Programmable color balance memory
- Sharpness control to accentuate or soften detail
- Enlargement or reduction feature that permits a subject to be stretched or squeezed to fit a specific space
- Slanting control to set the horizontal and vertical copying ratios separately and position the original at a variety of angles
- Multipage enlarger that divides the image into multiple sections that can be printed in sequence and assembled into a single piece
- Color conversion mode that lets you change the color of an original or a specified portion of the original
- An image composition key that lets you combine original color materials with black-and-white text
- An area designation that lets you frame, blank out, or segment the image
- Shifting modes that allow the image to be reduced and moved to any position on the page
- The ability to make a color copy from a negative as well as a slide
- The ability to connect the copier to a computer network

ADDITIONAL INFORMATION

Books

Barnier, John Ed. *Coming into Focus: A Step-by-Step Guide to Alternative Photographic Printing Processes*. San Francisco, CA: Chronicle Publishing Company, 2000.

Blacklow, Laura. *New Dimensions in Photo Imaging*. Second Ed. Boston, MA: Focal Press, 1995.

Crawford, William. *The Keepers of Light: A History and Working Guide to Early Photographic Processes*. Dobbs Ferry, NY: Morgan and Morgan, 1980.

Farber, Richard. *Historic Photographic Processes: A Guide to Creating Handmade Photographic Images.* NY: Allworth Press, 1998.

Hirsch, Robert. *Exploring Color Photography.* Third Ed. New York: McGraw-Hill, 1997.

Nettles, Bea. *Breaking the Rules: A Photo Media Cookbook.* Third Ed. Urbana, IL: Prairie Book Arts Center, 1992.

Reeve, Catharine, and Marilyn Sward. *The New Photography: A Guide to New Images, Processes, and Display Techniques for Photographers.* Cambridge, MA: Da Capo Press 1987.

Scopick, David. *The Gum Bichromate Book: Non-Silver Methods for Photographic Printmaking.* Second Ed. Boston, MA: Focal Press 1991.

Ware, Mike. *Cyanotype: The History, Science, and Art of Photographic Printing in Prussian Blue.* London: Science Museum and the National Museum of Photography, Film, and Television, 1999.

Periodicals

The World Journal of Post-Factory Photography, Judy Seigel, editor, 61 Morton Street, New York, NY 10014.

Other Sources

Bostick & Sullivan, P.O. Box 2155, Van Nuys, CA 91404 (catalog of materials for platinum printing).

Chicago Albumen Works, Front Street, Housatonic, MA 01236 (a line of products including a gelatin chloride printing-out paper).

Fisher Scientific, 2000 Park Lane, Pittsburgh, PA 15230.

The Palladio Company, P.O. Box 28, Cambridge, MA (precoated platinum-palladium papers and UV exposure units).

Photographers' Formulary, P.O. Box 950, Condon, MT 59826-0950.

Altering Photographic Concepts: Expansion of the Lexicon 11

HAND-ALTERED WORK

The hand altering of photographic images began soon after the daguerreotype process was made public in 1839 to compensate for the latter's inability to record color. By the beginning of the twentieth century hand-altered work was popular with the foremost Pictorialists such as Edward Steichen, Frank Eugene, and Gertrude Käsebier whose images often resembled drawings, lithographs, and paintings. They used it to show that photography was more than an automatic mechanical process and could be controlled and manipulated with the same expressive intent as traditional art forms. Today hand-altered processes are not done for compensation or imitation but to expand the boundaries of the photographic medium. Hand alteration enables photographers to bring into existence concepts, dreams, and feelings that cannot be achieved through standard photographic methods, thereby providing a bridge that can meaningfully unite ideas, materials, practice, and vision.

To grasp the ever-changing cultural dialogue, a photographer has to be ready to seize time's wonders. Generally this does not come easy. Being an artist entails making a long-term commitment to aesthetic and technical training in what French writer and theoretician Roland Barthes dubbed "the kitchen of meaning," where one willingly toils to realize a bountiful visual roux. Hand-altered work allows photographers to prolong their interaction with the process, thereby redefining the temporal architecture of the image. This shift in time enables the moment of exposure to act as a beginning rather than as an ending of imagemaking. These flexible hand techniques can expand the consciousness of a photographer and give rise to an extended sense of reality that can articulate both an objective exterior and a subjective interior view of a subject. Hand-altered work can demonstrate how photography is an elastic process of discovery and invention and not just a fixed body of technical data that is frozen at the moment of exposure. Hand-altered work may commingle at the juncture of what is real and what might be real, reminding us that the invisible and the intangible are as important as what we see in concrete reality. Such processes encourage an artistic and intellectual rethinking of the action between a matter-based and a mind-based interpretation of a subject.

Hitting Resistance

Hand alteration is a way to expand the photographic lexicon and is not meant to replace or threaten traditional modes of working. When hand-altering work, take the freedom to push and pull the ideas and materials until resistance is felt. Push on the walls of familiarity, but learn to stop before resistance turns into chaos. When one hits

resistance to new ideas and methods, it indicates you are entering unchartcd waters. There are no guides, instructions, or maps to offer direction. You are on your own. This enables you to know how far you can stretch the medium and yourself. Maintain a record of your experiments so the results can be duplicated and your knowledge shared. Keep in mind what Picasso said: "The eyes of an artist are open to a superior reality."

Since there are fewer standards in hand-altered work than in conventional methods, how does one find satisfaction? Your mind will quit circling and say yes to what has been created. During the act of making there may even be a dynamic haptic interchange between the artist and the materials, which physically culminates at completion. This is when you know it is time to cease working. Your own character is now intertwined with the piece. As the photograph is transformed, so are the photographer and potential viewers.

Doing the Opposite

Much of this book has been dcvotcd to providing known pathways for the expressive photographic imagemaker. As soon as you have gained control over the medium and tools and are able to express what you desire, it is time to avoid getting bogged down by too many rules. Pretend to have a spiritual Doppelgänger, an apparitional double or counterpart, who does the opposite of what you normally do. Too much knowledge can be as inhibiting as too little. Doing the opposite keeps one from being too complacent and judgmental. Reaching into the unknown is one way to grasp new possibilities. Keep a notebook of new ideas for future reference.

Try not to become smug with what you already know. Education is a continuous process of waking up and focusing your attention on the subject at hand. It means giving in to possibilities and allowing yourself the opportunity to see what may not have been apparent or visible when you began the process.

The Insecurity of the New

When something new is created, it brings with it a sense of insecurity. This is because

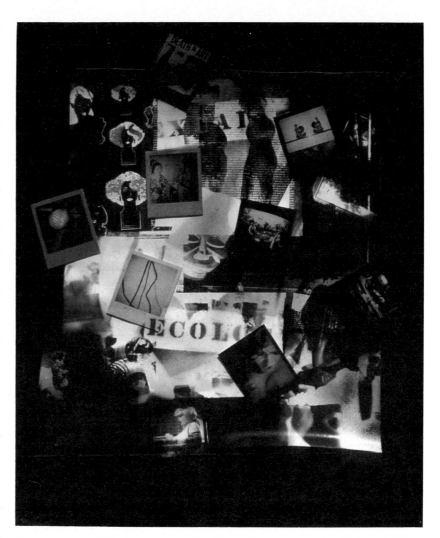

Figure 11.1 This is an example of how Barrow uses the Polaroid SX-70 for note taking when working on an idea that does not conform to conventional working practice. The visual notes, including images made off a video monitor, are scattered across the photogram in an attempt to discover meaning that is simultaneously clearer and more ambiguous. When a satisfactory composition is achieved, the SX-70 prints are stapled in place. Color and text are added with spray lacquer paints.

© Thomas Barrow. *Sexual Ecology*, 1986. Gelatin silver print with stapled Polaroid SX-70 prints and spray lacquer paints. 26 × 25 inches. Courtesy of Andrew Smith Gallery, Santa Fe. Original in color.

the new is not identifiable with our daily familiar world. Such insecurity occurs when you are able to leave the beaten path and not yield to the comfort of habit, imitation, or trend. The new often produces much resentment because it entails throwing over a previous set of working conventions. Having blind faith in the ways of the past can lead to mediocrity. The new forces one to confront the past, discard its illusions, make corrections, and move forward in different directions.

Not all new images and working methods will take you to the final destination you seek. Often the act of doing something for the first time helps to uncover what will ultimately bring new structure to a vision. Stay focused on the process of image making itself, that vital interplay between alternative configurations and passions, rather than fixating on a particular form of closure. Each outcome can then be both a transitory hypothesis and a declaration of the will to know. One of the beauties of art is that it can relinquish a closed system in which there is only one right way to do something in favor of an open approach that allows multiple correct answers to a question. Hand-altering work animates the imagemaker to feel free to transform the ingredients of imagination and physical existence into a collection of previously unseen appearances and structures. In "The Legend of the Sleepers," Danilo Kis sums up this idea: "Oh, who can divide dreams from reality, day from night, night from dawn, memory from illusion."

This chapter covers some key aspects of hand-altered work by dividing it into the following working methods: cameraless images, camera-based photographs, darkroom-generated pictures, and postdarkroom work.

Additional Information

Barrett, Terry. *Criticizing Photographs: An Introduction to Understanding Images.* Third Ed. Mountain View, CA: Mayfield Publishing, 1999.

Grundberg, Andy. *Crisis of the Real, Writings on Photograph, 1974–1989.* New York: Aperture Foundation, 1999.

Hughes, Robert. *The Shock of the New.* Second Ed. New York: McGraw Hill, 1991.

PHOTOGRAMS

A photogram is a cameraless, lensless image made by placing two- or three-dimensional objects directly on top of light-sensitive material and then exposing it. Conceptually, the photogram is entirely different from traditional camera images based on outer reality in which the photographer starts with everything and eliminates or subtracts any-thing that is not wanted in the frame (a process of subtractive composition). When making a photogram, the imagemaker begins with nothing except a blank piece of paper, like a painter approaching an empty canvas, and adds the necessary ingredients to make the final piece (a process of additive composition).

The photogram plays with a viewer's expectations of what a photograph is supposed to look like. Although it appears on the surface to be a photograph, there is a sense of ambiguity and mystery, as the viewer attempts to understand the reality of the image.

The light source used to make the exposure is often angled or moving rather than perpendicular to and stationary with the light-sensitive material. When the image is developed, no exposure effects will be visible where an opaque object was completely covering the light-sensitive emulsion. What is created is a silhouette of the object when translucent or transparent objects are placed on the emulsion. Partial shadowing occurs under opaque objects that are not in complete contact with the emulsion creating a wide assortment of tones. Any area left uncovered will get the maximum exposure and hence be black without any discernible detail.

The early pioneers in search of a practical photographic process were Johann Schulze in 1727, Thomas Wedgwood and Humphry Davy in 1799, and William Henry Fox Talbot from 1834 through the mid-1840s. All of them worked with cameraless images, establishing it as the earliest means of making light-sensitive pictures. The technique did not see much application until Christian Schad, a Dadaist painter, revived it in 1918 to create abstract images that he called Schadographs. Within a short time, Man Ray countered with his Rayographs. In Berlin during the 1920s, László Moholy-Nagy followed suit with what we now refer to as photograms. The contributions of these three imagemakers helped to perfect and reestablish the photogram in the twentieth century.

What to Print On

Photograms can be made on any type of light-sensitive material. Black-and-white

paper is a good place to begin experimentation. One can then move on to color paper and other materials such as cloth. Black-and-white paper is convenient and familiar, and it can be handled under normal safelight conditions. This makes it easier to arrange the objects in the composition.

Careful consideration must be given to the choice of objects used in making a photogram. The selection of materials is limitless. Go beyond the hackneyed approach of taking some coins and keys out of your pocket or purse. Consider using natural objects such as feathers, flowers, grass, leaves, plants, rocks, and sand. Try putting raw eggs or oil in a ziplock bag to make fluid compositions. Objects such as glass and stencils offer additional avenues to pursue. If you do not find what you need, make it yourself. Start simply, and as you master the working technique, increase the complexity of the arrangements. Ink applied on a thin piece of glass or acetate and then overlaid on the paper and exposed can widen your field of ideas. Also try combining natural, human-made, homemade, opaque, translucent, and transparent objects with ink to form a composition.

Exposure Methods

Although the easiest way to make an exposure is by using the enlarger or room light as a source, it also offers the least in terms of visual variety in the final print. To increase the range of visual effects, use another source of exposure, such as an electronic flash or a small desk light with a flexible neck. Using a fractional power setting on the flash or very low-wattage bulbs (15 watts) will produce longer exposure times and thus provide more opportunity for manipulation. Fluorescent tubes will deliver a more diffused and softer image than a reflector bulb or flash. Using a light source at different angles to the paper will produce a wide range of results. Varying the intensity of the light or the distance of the light from the paper during exposure will help to create a wider range of tonality in the final print.

Another method is to use a penlight. Wrap opaque paper around the penlight to act as a crude aperture-control device, thus enabling you to have more precise control over the intensity and direction of the light. The penlight can be used like a drawing instrument to emphasize specific areas of exposure. It also may be attached to a string and swung above and around the paper to produce unusual exposure effects.

Rather than making a single exposure from one source, try a series of brief exposures that combine different angles and light sources. Also try moving as well as stationary exposures.

For repeatable results, without ruining the arrangement of objects, place a piece of glass on spacers above the printing surface. The glass should be slightly bigger than the paper being printed. Blocks of wood or 2¼ inch film take-up reels can be used for spacers. Arrange the objects on the glass rather than directly on the paper. Define the exact printing area beneath the glass by using tape or a china marker to indicate where the corners of the paper should be positioned. After the objects are composed on the glass, turn off the white light and slide the photographic paper under the glass, lining it up with the corner marks. Before making the exposure, remove the spacers and carefully lower the glass on top of the paper. Be careful not to disturb any of the arranged items. Now expose the paper. If the exposure is made with the glass still up on spacers, the final image will be softer and less sharp.

Basic Steps to Produce a Photogram

You can begin to create a photogram under white light conditions:

1. Put a piece of glass or clear Plexiglas, a little larger than the paper being printed on, up on spacers.

2. Define the exact printing area under the glass by making marks with tape or a grease marker to indicate where the corners of the paper should be placed.

3. Use your collection of source materials to create a composition on the glass itself.

Now continue the process under safelight conditions:

4. Place the light-sensitive material under the glass, lining it up with the previously marked corner positions.

5. Carefully lower the glass or Plexiglas from the spacers.

6. Expose the paper. A working exposure range can be determined by making a test strip. Place a piece of unexposed paper under the glass. Hold or place the light source at the distance it will be used to make the exposure. Make a series of three- to five-second exposures, just as you would when making a regular print. Process the paper and select the desired time and density combination.

7. Process following normal procedures.

Figure 11.2 To produce her photograms Young folds pieces of photographic paper before development and uses a small flashlight to expose them. Her process reveals the undulations of the paper and becomes a representation of nothing more than the process of making the image. Young explains the motivation for her image this way: "If photography is a representation of something, what happens if you literally take away the object? Can I still maintain a trace of the world? To what extent can you make a photograph out of nothing that actually exists?"

© Cynthia Young. *Untitled*, 1997. Gelatin silver print. 42 × 42 inches.

Photogram Combinations

The color of the completed image can be changed through toning (see Chapter 8). After the print has dried, additional alterations are possible by drawing or painting on the image. Photograms can be produced on color negative and positive materials. They also can be combined with other photographic methods. For instance, try combining a camera-made image with a cameraless one. Try rephotographing the photogram and combining it with another cameraless image. Magazine pictures also can be combined with other cameraless materials. Remember, magazines are a print-through technique, and both sides of the page will be visible.

Experimentation with the choice of objects, sources of exposure, different types of light-sensitive materials, and postdarkroom techniques is necessary to discover the possibilities photograms have to offer.

Additional Information

Neususs, Floris M., Thomas Barrow, and Charles Hagen (Eds.). *Experimental Vision: The Evolution of the Photogram Since 1919.* Boulder, CO: Roberts Rinehart Publishers, 1994.

CLICHÉ-VERRE

Cliché-verre, drawing on glass, is another cameraless method used to produce a photographic image. Three English artists and engravers, John and William Havell and J.T. Wilmore, invented the technique. They displayed prints from their process in March 1839, making it one of the earliest supplemental methods to be derived from the invention of photography. In the original process, an opaque varnish was applied to a piece of glass and allowed to dry. Then a needle was used to etch an image through the varnish. The etched piece of glass was used as a negative and contact printed onto light-sensitive paper to make a repeatable image.

In the early 1850s, Adalbert Cuvelier modified the process by etching on glass collodion plates that were intentionally fogged by

light. Cuvelier introduced his method to artist Jean-Baptiste Corot, who used it as a means of producing fast and inexpensive editions of monochrome prints. Corot's success with cliché-verre caused many other artists of the French Barbizon School to follow suit. Thus the 1850s marked this process's high point in popularity.

There was only sporadic interest in cliché-verre during the first six decades of the twentieth century. Man Ray, László Moholy-Nagy, Francis Bruggiere, Henry Holmes Smith, and Frederick Sommer carried out experiments. In the United States, the process experienced a small revival during the late 1960s. Since then only a few imagemakers have used it, making it ripe for new exploration.

Making a Cliché-Verre

Obtain a piece of clean, clear glass that is a little larger than the size of the final print. 8 × 10 inches is a good minimum size; anything smaller makes it difficult to see what is being etched on the glass. Have the edges ground smooth to avoid glass cuts. Paint the glass with an opaque paint or varnish. Matte black spray paint also can be used. After the paint has dried, use a stylus (a sharp, pointed instrument such as an X-Acto knife, a heavy needle, a razor blade, or even a piece of rock or bone) to etch through the painted coating to the clear glass.

When the etching is finished, bring the glass into the darkroom. Under safelight conditions, lay it on top of a piece of unexposed black-and-white photographic paper. Make a print following normal working methods. As in photograms, try using different sources of light at a variety of angles to alter the look of the final image. The thickness of the glass will influence the clarity and sharpness of the final print. Thinner glass gives a sharper image. Generally, glass provides the smoothest and most concise line quality of any of the support materials.

Alternative Method 1: Color

Traditionally, cliché-verre was a black-and-white technique, but color paper may be used. By dialing in various color filter packs, one can produce a wide variety of color effects. Try multiple exposures using different filter packs and varying the type of light used for making the exposures.

Alternative Method 2: Paint Substitutes

Other media besides paint and varnish can be used to opaque the glass. One method is to "smoke" the glass by holding it over the chimney of a lighted kerosene lamp. Frederick Sommer used a smoked-glass technique very effectively in the 1960s. Henry Holmes Smith poured Karo corn syrup on glass, then photographed it and made dye-transfer color prints from the camera images. Opaque and translucent inks can be applied instead of paint, and printer's inks may be rolled onto the support surface.

Alternative Method 3: Glass Substitutes

Sheet film that has been exposed to white light and developed to its maximum density can be used in place of the opaque glass support. Film has the advantage of not being breakable and can also be put in the enlarger, so cliché-verre prints can be produced in various sizes. Generally, etching sheet film will produce a rougher and more ragged line quality than that achieved from a piece of etched painted glass. Acetate also can be used in place of glass or film. It can be purchased already opaque, or it may be painted or inked.

Combining Methods

Here are some additional combinations to consider:

- Scratch directly into the emulsion of a camera-made negative and then make a print.
- Combine the cliché-verre with a camera-made negative.
- Use ink and scratching with a camera-made image.

Figure 11.3 Using one of the alternative cliché-verre methods, Feldstein substituted sheet film in place of a glass support. He developed 4 × 5 inch film in Dektol under white light until it was completely black. Then he made the image by scratching, etching, cutting, tearing, and sanding the film. When the work on the film was complete, he put it into an enlarger to make a large-scale print.

© Peter Feldstein. *#11–88*, 1988. Gelatin silver print. 30 × 40 inches.

- Do not opaque the glass or acetate completely. Etch only the opaque portion and use the remaining clear area to incorporate a camera image or photogram.

- Collect images from newspapers and magazines. Under safelight conditions, position them directly on top of the light-sensitive material, cover it with glass, and make an exposure. Remember, they will be reversed, and both sides of the image will print. Try opaquing and etching part of the glass in concert with this method.

- Use a liquid emulsion such as Luminos Silverprint Emulsion or Liquid Light to produce a cliché-verre on other porous materials such as fabric or clay.

Additional Information

Glassman, Elizabeth, and Marilyn F. Symmes. *Cliché-verre: Hand-Drawn, Light-Painted, A Survey of the Medium from 1839 to the Present.* Detroit: Detroit Institute of Arts, 1980.

EXTENDED CAMERA EXPOSURES

When the majority of people begin to undertake photography, they have the "1/125 second mentality." They believe the photographer's job is to capture the subject by freezing it and removing it from the flow of time. By simply extending the amount of time the camera's shutter is open, however, an entirely new range of images can come into existence. This additional time also can provide an opportunity for the photographer to increase the interaction with the subject and in turn engage viewers for longer periods.

Equipment

You need a camera with a B (bulb) or T (time) setting to make extended time exposures. With the B setting, you hold the shutter in the open position for the entire exposure. With the T setting, you press the shutter release once to open the shutter and then press it again at the end of the exposure to close it. The camera is usually attached to a sturdy tripod. The shutter can be fired by means of a cable release with a locking set screw, which permits hands-off exposures. This reduces the chances of blurred images due to camera movement and vibrations. A sensitive hand-held exposure meter can be useful because some built-in camera meters do not read available darkness with accuracy.

For maximum steadiness, use a sturdy tripod and do not raise the center column any more than is necessary. A heavy weight can be hung from the center column as a ballast. Sandbagging the legs of the tripod also makes it less prone to movement. Close the shutter if the camera is shaken and resume the exposure after the disturbance has passed.

Acting as a Shutter

Hold a piece of black matte cardboard close to the front of the lens. When you are ready to end the exposure, place the cardboard in front of the lens and then close the shutter (using a cable release) to help reduce recording any camera jiggle on the

film. This is important when using a single lens reflex (SLR) camera body whose mirror flips back down at the end of the exposure. This technique also can be used to permit changes in aperture and focus during the exposure. If the camera should be jarred during any of these procedures, allow it to settle down before removing the cardboard from in front of the lens and continuing the exposure.

Adjusting the Aperture

Varying the length of exposure time drastically affects the final outcome of the image. Opening the lens to a wide aperture diminishes the depth of field and delivers the shortest exposure time. Closing down the lens to a small aperture increases the depth of field and gives longer exposures. Closing down the lens also allows for changes in focus and aperture. The extended exposure time permits you to work with additional sources of light, such as a strobe or flashlight, during the course of a single exposure.

Where to Start

Begin with a negative film having an ISO of about 100. Stop the lens down three f-stops from its maximum aperture. Bracket all the exposures (one f-stop under and up to three f-stops over in full f-stop increments). Keep a written record to compare with the results so more accurate exposures can be obtained with less bracketing in the future. Bracketing can always be useful, as the different lengths of time affect how the scene is recorded. Bracketing also is helpful in learning how to compensate for probable reciprocity failure, which is likely to accompany long exposures.

Reciprocity failure occurs with very brief or very long exposures. Each film has its own reciprocity failure characteristics, losing effective speed at different exposure levels and at different rates. A typical negative film of ISO 100 might need one-third f-stop more exposure if the indicated exposure is 1 second, one-half f-stop more time at 10 seconds, and one full f-stop at 100 seconds. This correction can be made by using either the lens aperture or shutter speed control. With color film, reciprocity failure also produces a shift in the color balance. For exact times and filter corrections of specific films, consult the manufacturer's reciprocity failure guide.

Most of the latest cameras rely on battery power to operate their shutters. Shooting a 36-exposure roll with minute-long times can drain a battery's power (button cells are more susceptible than AA alkalines or 6-volt lithium cells). Some of these electronic cameras offer a mechanical B setting. If you are not sure whether your camera has this feature, set the shutter to B, remove the batteries, depress the shutter release, and see if

Figure 11.4 By taking advantage of camera vision, it is possible for the photographer to record a subject in a way not visible to the human eye. To make this extended time exposure (about 10 minutes at f-11), Kenna mounted his 35 mm camera, equipped with a 17 mm lens, on a tripod. The long exposure introduces a sense of passing time and directional movement not found in a conventional photograph. The print was toned with sepia and selenium to add to the mood of mystery and create visual contrast.

© Michael Kenna. *Painswick Graveyard, Gloucestershire, England,* 1987. Gelatin silver print. 6 × 9 inches.

the shutter opens. If the camera does not have a mechanical B setting, take a fresh set of backup batteries, just in case the ones in the camera fail during the session.

Using Neutral Density Filters

When we contemplate long exposures, we tend to think of low-light situations, such as early evening, night, or inclement weather. One way to extend the amount of exposure time in any situation is to use a neutral density (ND) filter. An ND filter blocks equal amounts of all the visible wavelengths of white light. Such filters are available in various strengths, which will reduce the amount of light reaching the film by one, two, or four f-stops. ND filters may be used in tandem (one attached to the other) to reduce the intensity of the light even further.

Flash/Flashlight Techniques

A flash can be used to illuminate parts of a scene. Large areas can be "painted" with multiple flash exposures. With the camera on a tripod and the lens open, a person dressed in dark clothes can walk within the scene and fire the flash to illuminate specific items or to light a large space. A flash also can be combined with other techniques. For instance, one can focus on one area of a scene and illuminate it with a flash, then shift the focus to another area in the composition and use the flash to light it. Colored gels can be used to alter the color relationships within a scene.

A flashlight also may be used to illuminate the subject. Start with a subject in a darkened room. Put the camera on a tripod and set the aperture to f-8 or f-11. Use the B or T setting to open the shutter. Begin painting the subject with the flashlight, using a broad, sweeping motion. Do not point the light into the camera's lens. When you are done painting, close the shutter.

As you gain experience, you will be ready to tackle more complicated situations, such as working outside at night. When doing this, wear dark, nonreflective clothes so you may walk around within the scene without being recorded on film. Since it is

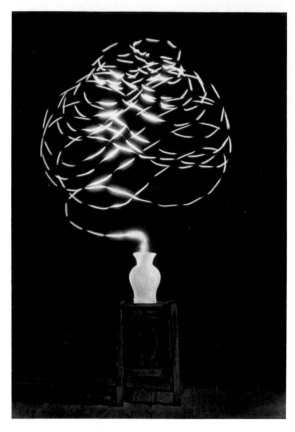

Figure 11.5 To make this light drawing. Lebe worked in a darkened room (the ambient light was below the film's sensitivity threshold) and wore dark clothing. The camera, mounted on a tripod, was set to B and left open as Lebe walked around using a small flashlight to make the exposure. When this was done, the subject was exposed with a quartz photolight. The resulting print was painted with watercolors. This series was made after the artist lost several people to the AIDS epidemic. What the photographer first thought were frivolous pictures came to express his experience of AIDS and death. The light became a life-affirming spirit, while the vase represented the body or a funeral urn.

© David Lebe. *Scribble, #19*, 1987. Gelatin silver print with watercolor. 20 × 16 inches. Original in color.

impossible to know exactly what the final effect will be, make a series of exposures varying the intensity of the light and the type of hand gestures used in applying it. Some gestures may be smooth and continuous; others may be short and choppy. Try dancing around, running, hopping, jumping, or waving with the light. You can have fun experimenting.

POSTCAMERA TECHNIQUES: IN SEARCH OF LOST TIME

The traditional photographic concepts of motion, space, and time can be altered in the darkroom as well as in the camera and can have the effect of building additional spans of time (experiences) back into a photograph. The methods discussed allow for alternative potentialities to be amplified, embellished, and expounded. Some techniques allow the imagemaker to mobilize and secure connections between formal artifice and disorder. Others permit the weaving of a simultaneous web of complex associations, a rich tangle of cross-stitching that can reveal an alternative temporality of a subject and demonstrate that the past, present, and future are a product synthesized by the memories of photographers and viewers. All these approaches can yield new insights into a subject and make the overall visual account richer and more thought provoking.

Painting the Print with Light

You can re-expose the light-sensitive printing material with a controlled source of light after the initial print is exposed or while it is developing. This can be achieved with a small penlight. Wrap a piece of opaque paper around the penlight so it extends a few inches beyond the body of the light source.

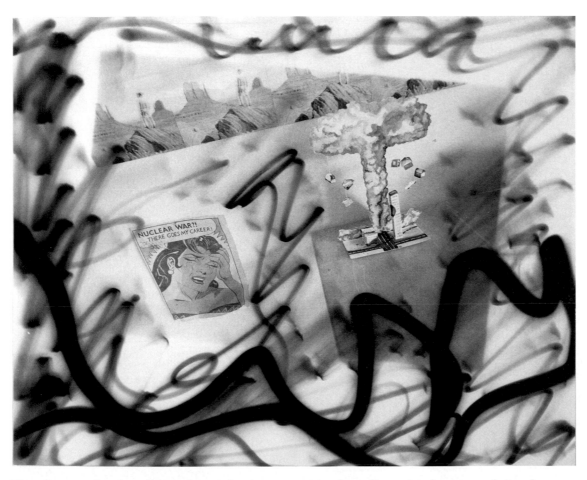

Figure 11.6 Starting with an image that incorporated a three-dimensional paper sculpture by artist Edward Collier, a Wonder Woman comic, and a 3-D postcard of Monument Valley, AZ, Hirsch relied on post-camera darkroom methods to complete his theme. He expressionistically painted the photograph with light to add a strong sense of haptic emotion and volatility. This was done to convey the absurdity and fear of growing up in a Cold War era when the U.S. and Russian foreign policy was one of mutually assured atomic destruction.

© Robert Hirsch. *Nuclear War?! . . . There Goes My Career!*, 1983. Toned gelatin silver print. 16 × 20 inches.

Secure it to the penlight body with tape. This paper blinder will act as an aperture to control the amount of light. Pinch the open end of the paper together to control the intensity and shape of the light source. Fiber optics also can be attached to the end of the penlight for tighter control over the light.

Working Procedure

Correctly expose the image on black-and-white paper. Place a red filter beneath the enlarging lens. Since black-and-white paper is not sensitive to red light, the red filter enables you to turn on the enlarger and see the projected image without affecting the paper. Open the lens to its maximum aperture. Turn on the enlarger and project through the red filter. This allows you to see where to draw with the penlight. Begin drawing with the light. You can cover specific areas of the print with opaque materials to prevent re-exposure.

It is also possible to draw with the light as the image begins to appear in the developer. This can produce a grayer line quality or a partial Sabattier effect.

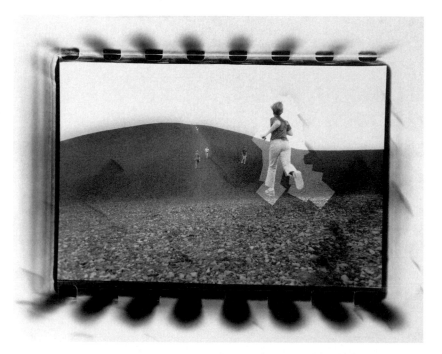

Figure 11.7 By moving the enlarger's fine focus knob during exposure, Hirsch was able to amplify the main figure's sense of movement. Masking the central figure and subtly painting the area around him with light further enhanced this illusion. The overall effect disturbs traditional notions about landscape photography, dismantles the concepts of the "decisive moment," ignores conventional print values while expanding the image out of the normal boundaries of the photographic frame.

© Robert Hirsch. *Running on the Craters of the Moon*, 1985. Toned gelatin silver print. 16 × 20 inches. Collection of Dr. Philip Perryman.

Moving the Fine Focus

If you move the fine-focus control on the enlarger during the exposure, the image will expand and/or contract. Start by giving the print two-thirds of its correct exposure. Then begin to move the fine-focus control and give the print the remaining one-third of its time. For example, if the normal exposure time is 12 seconds, give the print its first exposure of 8 seconds and the remaining 4 seconds while moving the fine focus. It may be necessary to stop down the lens and increase the overall exposure so there is more time available to manipulate the fine-focus control.

The final outcome is determined by the following:

- The ratio of the normal exposure to the moving exposure
- The speed at which the fine focus is moved
- How long the moving exposure is left at any one point
- Whether the fine focus is used to expand or contract the image
- When the moving exposure is made (Different effects will be produced depending on whether the fine focus is moved before, in the middle of, or at the end of the normal exposure.)

MULTIPLE-EXPOSURE METHODS

Multiple exposures can be carried out in the camera or in the darkroom.

Multiple Exposures in the Camera

To make more than a single exposure in the camera on one piece of film, begin with a controlled situation having a dark background. One must use a camera that has a double-exposure capability (see the camera's manual for specific instructions on how to carry out this procedure). Use one source of illumination to light the subject. Put the camera on a tripod, focus, and then figure the exposure for each frame based on the total number of exposures planned for that frame. Generally, the individual exposures are determined by dividing the overall exposure time by the total number of exposures. For instance, if the overall exposure for the scene is f-8 at 1/60 second, the time for two expo-

sures on one frame would be f-8 at 1/125 second each. This tends to work well if the illuminated subject(s) overlap. If there is no overlap and a dark background is used, the correct exposure would be f-8 at 1/60 second for each exposure. Be prepared to do some testing. To speed up the testing process, try using Polaroid materials.

Variations

You can change the amount of time given to the separate exposures within each frame by altering the f-stop or shutter speed. This can produce images of varying intensities and degrees of motion within the composition. Changing the f-stop will introduce differences in the amount of depth of field from one exposure to the next. Altering the shutter speed can produce both blurred and sharp images in a single frame. Moving objects around within the composition can create a ghostly half-presence in the picture. Altering the position of the camera can help you avoid building up the image on one place on the film. Start simply, bracket your exposures, and work your way into more complex situations.

Using a Masking Filter

A masking filter, which exposes only half the frame at a time, can be used to make a single image from two separate halves. You can buy this filter or make it by cutting a semicircular piece of opaque material to fit into a series-type filter holder designed for the size of the lens being used.

The following is a basic guide for using a masking filter with an SLR camera.

1. Place the masking filter on the camera lens. Compose and normally expose half the frame.

2. Wind the shutter without advancing the film.

3. Rotate the masking filter so the first half of the image that was exposed is not masked off.

4. With the second half of the frame now in view, compose and expose the second half normally.

5. After this second exposure, advance the film to the next frame.

Generally, allow each image to cross the centerline of the frame (mask) and come about one-third of the way into the blocked

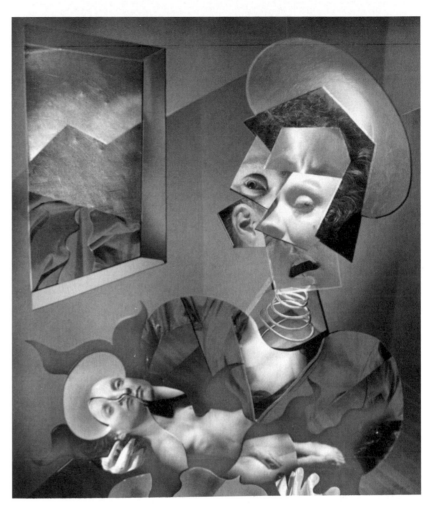

Figure 11.8 Northrup's in-camera multiple exposures were made with a homemade mask placed in front of the lens. The homemade mask consists of a matte board cut into shapes and put up in front of the camera on a glass frame. Pieces are taken out one at a time, viewable areas are exposed, and each piece is put back in registration. Moving objects between exposures creates a cubistic sense of time and space.

© Michael Northrup. *Mad Donna*, 1995. Chromogenic color print. 20 × 24 inches. Original in color.

area. This can help make the blend line less noticeable. The major problem with this technique is that it is often easy to see the line where the two images meet. Extra care in dodging and burning when making the print can make this less noticeable.

An intriguing variation is to make a mask that has a number of doors, each of which can be opened for individual exposure. These doors may be of different shapes and sizes. The composition can be rearranged and relighted for each exposure.

Multiple Exposure in the Darkroom

There are a variety of ways to accomplish multiple exposure in the darkroom. The

simplest method of altering the perception of time and space within a composition involves exposing a single negative more than once on a piece of light-sensitive material. There are many variations on this procedure.

1. Enlarge or reduce the image each time a new exposure is made. Allow the exposures to overlap and intermingle to form new images within the image.

2. Use different exposure times to create variety in image density.

3. Move the fine-focus control during some of the exposures.

4. Print only selected portions of the negative.

5. Combine this with other techniques such as cliché-verre or photograms.

6. Sandwich the negative with other negatives or with transparent materials.

7. Combine the negative with a positive (transparency) image.

8. Print from more than one negative.

Combination Printing

Combination printing is when two or more negatives are printed on a single piece of light-sensitive material to make the final image. Combination printing is not a contemporary innovation, but was originally devised to be used with the collodion wet-plate process in the mid-1850s to overcome the slowness of the film's emulsion and its inability to record certain parts of the spectrum. The technique was popularized in England by Oscar Rejlander and Henry Peach Robinson, and peaked by the 1880s. As technical improvements such as panchromatic emulsions and flexible roll film became available, combination printing was no longer necessary, and its practice rapidly declined. The process experienced a major rebirth in the 1960s with the images and teaching of Jerry Uelsmann. He used this precomputer technique in a surrealistic manner to juxtapose objects for which there was no correlation in the ordinary world.

Before the widespread use of digital imagemaking, combination printing was a way to make a composite of images by photographic means. Although the computer's ability to amalgamate images is unparalleled, not all imagemakers are abandoning combination printing. In an online exhibition of his work, Uelsmann addressed why he still creates certain images in the darkroom. "While I am interested in these computer options, I still have a basic love of the darkroom and the alchemy it embraces. In terms of the creative process, I find that the overwhelming number of options offered by the computer creates a decision-making quagmire."

Combination printing can be carried out by switching negatives in a single enlarger or by moving the light-sensitive material from one enlarger and easel to another, each having been set up to project a different image. If more than one enlarger is available, most people find the second method easier to use.

Multi-Enlarger Combination Printing

A simple combination print can be made by blending two images, each of which is set up for projection in a different enlarger and easel. This can be accomplished by following these guidelines.

1. Look through your contact sheets and find two images to combine. In the beginning, it is helpful to select images that have a clear horizontal or vertical dividing line. This will simplify the blending process.

2. Place each image in a different enlarger.

3. Size and focus the images. Allow them to overlap slightly.

4. Put a piece of plain white paper in the first easel. Use a marker to indicate the placement of the major objects and where the blending line will be.

5. Move this paper to the second easel and line up the second image and blending line with the indicated marks.

6. Make a test strip to determine the correct exposure for each enlarger.

7. Place the light-sensitive material in the first enlarger and make the exposure, using an opaque board to block the exposure around the blending line. Keep the board moving and allow some of the exposure to cross the blending line so there is no visible joining line.

8. Transfer the light-sensitive material to the second easel. Expose the second negative, using the opaque board in the same manner as in step 7 to block the first exposure.

9. Expect to carry out this procedure a number of times until you master moving the board to get a seamless blend. Patience and craftsmanship are necessary to successfully create this illusion. "Fantasy abandoned by reason produces impossible monsters; united with her, she is the mother of the arts and the origin of their marvels" (Goya).

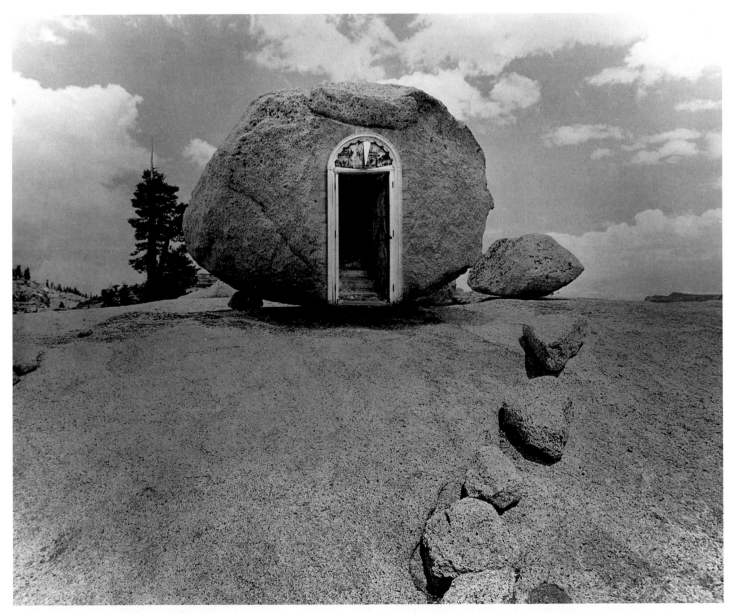

Figure 11.9 Uelsmann is the contemporary master of the multi-enlarger method of combination printing. Before entering the darkroom, he ponders his contact sheets, which make up his visual diary of things seen and experienced with the camera. This helps him to seek out fresh and innovative juxtapositions that expand the possibilities of the initial subject matter. He attempts to synthesize and reconstruct images to challenge the inherent believability of the photograph. All the information is there, yet the mystery remains. Uelsmann says that his greatest joy comes from amazing himself.

© Jerry N. Uelsmann. *Untitled*, 1986. Gelatin silver print. 16 × 20 inches.

Opaque Printing Masks

Printing masks can be used to block exposure to different areas of the light-sensitive material. The masks must be carefully cut to avoid making an outline around each area where the exposure was blocked.

A multiple opaque mask can be used with a single negative. In this case, a mask is made the same size as the final print. The mask is cut into various shapes corresponding to those in the image. One section of the mask is removed, and an exposure is made. This section is then replaced, and another is removed and exposed. The process is continued until all the sections have received exposure. The amount of exposure can be varied from section to section to create different density effects. Numbering the sections can help you keep track of what you have done.

Additional Information

Uelsmann, Jerry N., with essay by John Ames. *Uelsmann: Process and Perception.* Gainesville, FL: University of Florida Press, 1985.

FABRICATION: MAKING THINGS HAPPEN FOR THE CAMERA

The original impetus for photography was to fulfill the desire for a practical and automatic method of capturing images from the natural and visible world. Throughout photography's first 160 years, the majority of pictures were primarily of people, places, and things. Many current imagemakers want to expand the photographic lexicon to comment on internal realities.

One of the means photographers have used to express their inner concerns is *fabrication* (see front cover). In the photographic sense, fabrication is the creation of a new reality, one that cannot be naturally found in the visible world. To accomplish this goal, the photographer constructs, devises, or invents an assemblage of materials. The techniques and methods used often explore and question the nature of photography, photographic time, and how it is

used. Such work propels the photographer and the viewer to become more aware of the artificiality of photographic reality by posing questions such as: What makes up reality? What is a photograph? Why is appearance constantly taken for truth? Where and how does a photograph obtain its meaning? Do our representations correspond to reality? Could the world be different from the way we represent it?

In *Connections to the World: The Basic Concepts of Philosophy*, Arthur Danto states, "Philosophy is the effort to understand the relationships between subjects, representations and reality." The techniques photographers use to probe these questions and relationships include the following:

- Constructing environments to reflect ambitions, dreams, fantasies, and social commentaries

- Combining images and text by using typesetting, press type, rubber stamps, and handwritten messages that appear on or around the photograph

- Creating three-dimensional photographic images by means such as painting emulsions on a variety of surfaces, cutting up images and hanging them from objects, sewing and stuffing cloth that has been treated with a photo-sensitive emulsion, or making freestanding floor screens based on classic Oriental models

Sequences

Another aspect of fabrication involves departing from the traditional use of only a single image to convey a message. Cinematic seeing presents a series of images in which each frame modifies the sense of photographic time and space of the frame before and after it. This interaction between frames delivers additional information, thus enabling the audience to witness a different point of view or a new episode that can enhance their understanding of the subject. This technique can be accomplished directly in the camera using previsualization methods or created from prints using postdark-

room procedures. Some methods that have been used to explore cinematic imagemaking follow.

- The sequence is a group of images designed to function as a group rather than individually. Typically, sequences tell stories (although they do not have to be empirically narrative in nature), present numerous points of view, and provide information over an extended visual time period. Sequences can be made in the camera or put together using prints. They are often presented in a book format to encourage intimate viewing whereby meaning is built up page by page. A classic example of this strategy is Robert Frank's *The Americans* (1959).

- The grid, an evenly spaced grating framework of crossing parallel lines (like a tick-tack-toe board), has been used both at the moment of exposure and during printmaking to enclose and analyze an image. The grid breaks down an image into separate units while still containing it as a unified form.

- A modified form of the grid involves using a specially constructed easel that has individually hinged doors that may be opened and closed. This permits a single image to be broken down into separate quadrants, each of which can receive different exposure times. The overall effect in a single image can be fractured by light to create separate units within the whole.

- The contact sheet sequence combines aspects of the in-camera sequence and the grid. A scene is visualized in its entirety, but photographed as individual segments. When these separate frames are laid out and contact printed, they create a single unified picture.

- Using joiners, the practice of photographing a scene in individual parts and then fitting these together to form one image, was a method that painter David Hockney perfected during the 1980s. The images may be printed at the same size (as Hockney did) or cut into different sizes or shapes and arranged and attached in place.

Additional Information

Hoy, Anne H. *Fabrications: Staged, Altered and Appropriated Photographs.* New York: Abbeville Press, 1987.

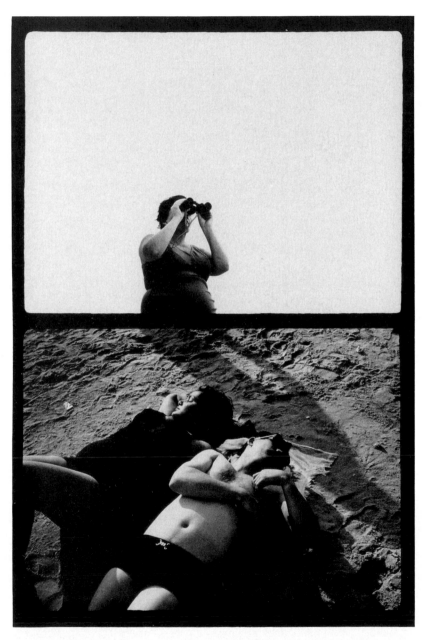

Figure 11.10 Metzker, not satisfied with the single image aesthetic, has experimented with multiple-image constructions. Here the stacked images use the interrelationship of the frames for content interpretation and visual contrast.

© Ray K. Metzker. *Untitled*, 1969. Gelatin silver print. 8 × 10 inches. Courtesy of Laurence Miller Gallery, New York.

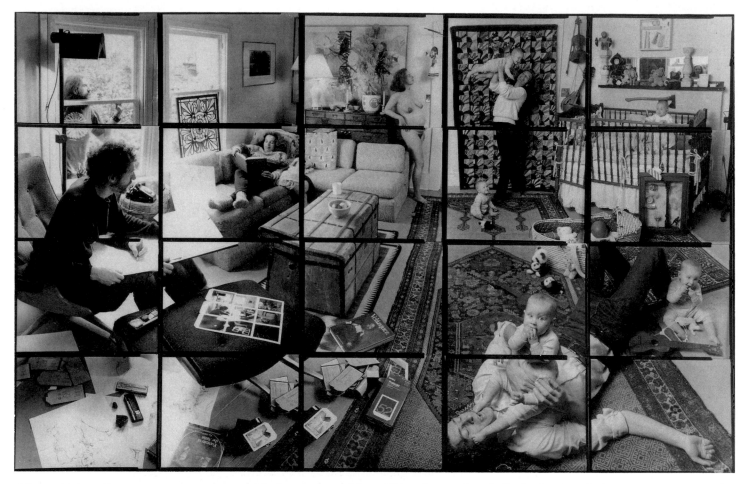

Figure 11.11 In an attempt to overcome his frustration with traditional portraiture's limited point of view, Levy constructed a photographic grid consisting of 20 individual images. Made with a 4 × 5 inch camera for precision of detail, these images scan the architecture and sense of time in the subject's living and working environment. They are printed together to form the illusion of glancing through a window at a snapshot of an event that may consist of fragmented views made months apart. The images explore and challenge our perceptive process by testing the limits of discontinuity in space and time that our brains will accept in reading an image. The self-reflective elements attest to the collaborative relationship between the photographer and the subject. The final print was made on variable-contrast paper so that each negative could be masked to give the correct contrast and exposure.

© Stu Levy. *Artist's Proof and Consequences or What It's Really Like*, 1988. Gelatin silver print. 16 × 25 inches.

COMPOSITE VARIATIONS

The Collage

A photographic collage is produced when cut and torn pieces from one or more photographs are combined on a common support. A photographic collage may include images from magazines and newspapers; a combination of colored paper, wallpaper, or fabric; natural materials such as sand, grass, flowers, and leaves; and three-dimensional objects. No attempt is made to deny that the image is an assemblage created from a variety of source materials. It is not rephotographed and is itself the final product.

The Montage

A montage follows the same basic rules as those used in making a collage. The major difference is that the final collection of materials is rephotographed. The making of this new negative allows the end product to be transformed back into a photographic print, from which additional copies may be produced. Sometimes the imagemaker

attempts to hide the source of the various images and materials in an effort to present a new, seamless photographic, as opposed to digital, rendition that will make people ask, "How can that be?" Great fun, innovation, and provocation are possible by juxtaposing people, places, and things that would otherwise not be seen together.

Making a Collage or Montage

You will need the following materials to assemble a collage or montage.

- A large collection of source images and materials
- A support print, board, or other material for a base. This background material may be a piece of matte board or a photograph. Generally, photographs having open, uncluttered areas offer a good starting point. The support should be large enough to allow plenty of room within which you can maneuver; 16 × 20 inches is usually a good size to begin with.
- Sharp scissors
- A sharp X-Acto knife (a number 11 blade is good)
- Adhesive glue or dry-mount tissue (if permanence is a concern, use an archival glue)
- Spotting colors and a fine sable brush (number 0)
- Fine-tip felt pens in various shades of gray and black
- A tacking iron and dry-mount press (if dry mounting is planned)

Following is a basic working guide for constructing a collage or montage.

1. Spread out all the source materials you are considering using. Do not be stingy.

2. Try a variety of arrangements and juxtapositions on the background support.

3. After you have made a preliminary selection, trim the source materials down to their approximate final size. If you are using dry mounting, tack the dry-mount tissue to the back of each selection so it will adhere properly after final trimming.

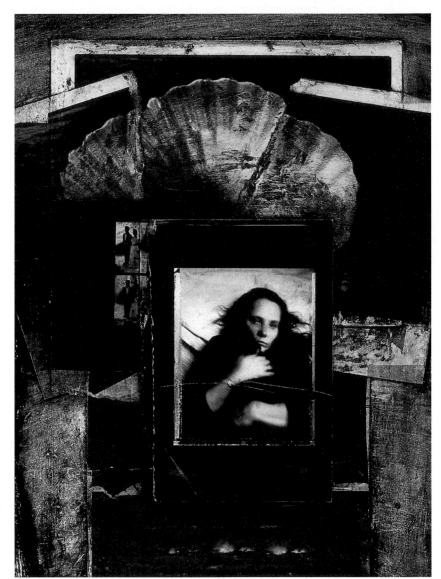

Figure 11.12 Angel uses collage to explore her experience as a cancer survivor and the process of healing both physically and emotionally. Angel tears photographs and collages them on 8-ply museum board using acrylic gel medium as an adhesive. "The tactile process of actually piecing together photographs is metaphorical as they represent the piecing together and layering of the experiences that comprise my life and how cancer defined it."

© Catherine Angel. *Lamentations*, 1995. Gelatin silver print with mixed media. 24 × 20 inches. Courtesy of Photo-Eye Gallery, Santa Fe. Original in color.

4. Trim materials to their final size. For the smoothest finish, use sharp scissors to make long, continuous, beveled cuts. Use the X-Acto knife only when cuts cannot be made with scissors. Cutting with a blade tends to produce a more jagged edge.

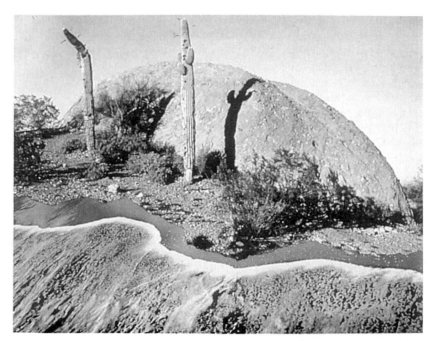

Figure 11.13 The use of photomontage enables Taylor to express his thoughts, which do not exist to be photographed, in a concrete manner. The finished pieces are purely photographic. Color changes are achieved with selectively applied sepia toner, and drawn lines are added by scratching on the negative. There is no attempt to make a seamless montage. The edges of the prints are torn to allow the viewer to discover and explore the process used to produce the new reality.

© Brian Taylor. *When California Goes*, 1985. Gelatin silver prints. 11 × 14 inches. Original in color.

5. Using the appropriate gray or black felt-tip pens, color the edges of the trimmed materials so they match each other and the support board. An edge that is too dark will be just as noticeable as one that is white.

6. Attach the trimmed, shaded pieces to the background support with glue or dry-mount tissue.

7. Add shadows with diluted spotting colors if desired.

Copying

If you are making a montage, the assembled work can be copied outside in clear, direct sunlight. Place the work on a clean, flat surface. The sunlight should be striking it at a 30- to 45-degree angle. Photograph the work with a 35 mm camera, ideally equipped with a macro lens to provide maximum flatness of field and sharpness. If you do not have access to a macro lens, you can use a 50 mm lens instead. It will easily fill the frame of a 16 × 20 inch piece; even an 11 × 14 inch work should fill the frame. Stop the lens down to f-8 or f-11 to ensure good depth of field. For maximum detail and minimum grain, use a slow, fine-grain film such as

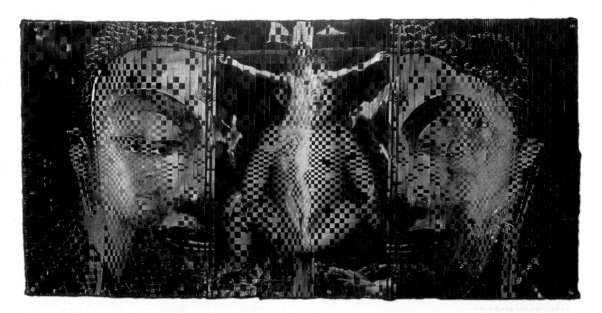

Figure 11.14 Lê's photo weavings came out of an early fascination with Western art. As a refugee from Vietnam and not being able to speak English, Lê spent a lot of his childhood in the library looking at art books. Lê combines the iconography of Eastern and Western cultures in a paper weaving style based on that of his aunt's grassmat weavings. Depending on the content of the image being constructed, Lê adjusts his weaving process to highlight certain aspects of the subject while keeping others hidden. (See Color Plate 4.)

© Dinh Q. Lê. *From Zero to First Generation*, 1997. Woven chromogenic color prints and linen tape. 29¼ × 57½ inches. Courtesy of CEPA Gallery, Buffalo, NY. Original in color.

Kodak Technical Pan Film for black-and-white or Fujicolor Superia Reala for color. Determine the proper exposure by reading an 18 percent gray card in front of the work. Do not meter directly from the work, or you may get a faulty reading.

The work may also be copied indoors. Tack or tape the piece to a wall. Set up two lights at 45-degree angles to the work. Using a gray card, measure the light falling on the work from each lamp, making sure each is casting even illumination across the piece. Then place the gray card in front of the work and take a meter reading off it with both lights on. For the sharpest results, use a large-format camera to copy the work. Collages also may be copied on a black-and-white or color electronic copy machine.

Additional Information

Golding, Stephen. *Photomontage: A Step-by-Step Guide to Building Pictures*. Rockport, MA: Rockport Publishers, 1997.

Photo-Based Installations

Photo-based installations can comprise arrangements of images, objects, sound, and text that are designed to function as a single work. Installations provide viewers with the experience of being in and surrounded by the work, and often feature video and sound components to produce a more intense sensory realization. Precedents for installations can be found in the Pop Art era of the late 1950s and 1960s, such as Allan Kaprow's "sets" for "Happenings" or Red Groom's theatrical environments such as *Ruckus Manhattan*. Most installations are unsalable and generally are exhibited and dismantled, leaving only photographic documentation of their existence.

PROCESSING MANIPULATION: RETICULATION

Reticulation is the wrinkling of the film emulsion into a weblike pattern or texture. Normally this is viewed as a processing mistake caused by differences in the temperature of the film's developing solutions. Until the 1950s, reticulation was not an unusual occurrence. Contemporary films very rarely suffer from this problem because of improvements in emulsion making, such as the use of improved hardeners. It can, however, be purposely induced for visual effect. Reticulation can literally dissolve the camera-based reality and replace it with a manipulated reality in which line, shape, and space are distorted and rearranged on the film's surface.

Reticulation can be accomplished through two basic methods. One way is to create extreme differences in temperature between the processing steps during film development. The other method is to induce it chemically after the film has been developed.

In the first method the film is developed at an elevated temperature (90°F or 32°C), then put in a very cold stop bath followed by a warm fixer. After this, the film is frozen before it is given a final hot wash. Even with these extremes, the hardener built into many modern films makes reticulation difficult if not impossible to accomplish.

Figure 11.15 Apicella-Hitchcock and McClave do collaborative installations to have control over the context and environment of their work. In an installation viewers must navigate through and around objects in space. In doing so the images and objects making up the installation interact with each other in unexpected ways, creating the possibility for the viewer to see things anew.

© Stephen Apicella-Hitchcock and Brian McClave. *Steps Towards an Understanding of a Severed Human Head*, 1999. Gelatin silver prints (assorted sizes), evidence bags, tags, forms, vitrines, 2 sets of clothing, books, two video monitors, time lapse surveillance camera, deconstructed Polaroid camera, clock, receipts and assorted ephemera. Dimensions variable. Original in color.

With the second method, the film is reticulated by chemical means, which gives the advantage of working with normally processed film (even film that is a couple of years old can work). It also enables direct observation and interaction with the process, allowing you to stop the reticulation when you see fit. This chemical method works with most black-and-white films.

Simple Chemical Reticulation

Sodium carbonate can be used to produce simple random reticulation. No two films seem to react to it in the same way. Even negatives on the same strip of film can respond differently, making this process highly unpredictable. Kodak's TRI-X is one film that works well with this technique. Using a medium- or large-format negative allows you to readily observe the process.

As mentioned earlier, previously processed film may be used, which can be useful for testing. The older the film is, the harder its emulsion surface tends to be, thus increasing the time it takes for reticulation to take place and also limiting its effects. Best results are achieved with freshly processed film.

The following guidelines are provided for chemical reticulation.

1. Start with a completely processed and dried negative.

2. Prepare the reticulation solution by combining 30 grams of sodium carbonate with 500 milliliters of water at 140°F to 150°F (60°C to 65°C). This solution has a useful temperature range of 105°F to 160°F (40°C to 71°C). As the temperature goes down, the action of the solution becomes slower. If the temperature gets too high, it will ruin the film's plastic base. You can maintain the temperature with the use of a hot plate.

3. Place the film directly in the hot solution, which is held in a clear glass jar or a small tray. For easy handling, attach a paper clip through a sprocket hole to individual frames of 35 mm film before placing them in a clean baby food jar filled with solution. Take care not to let the film come in contact with the walls of the jar, or uneven reticulation will result. Some workers prefer the tray process. Tape the film, emulsion side up, to a slightly larger piece of thin Plexiglas or glass and place in a tray. This technique makes observation and manipulation easier, and it provides a solid horizontal support. This method permits extending the time in the solution, which increases the effect and allows other visual distortion such as veiling effects to take place. Veiling is caused by the physical breakdown of the emulsion as it begins to dissolve and fold up. Be careful not to leave the film in the solution too long, or the emulsion will completely slide off its base. One can push the loose emulsion around with a brush or a very thin stream of water to create other effects.

4. When the film is placed in the solution, the protective gelatin layer will dissolve and rise to the surface. Allow the film to remain in the solution for 5 to 20 minutes, with occasional agitation. Reticulation may begin within 45 seconds. The first stages will produce a fine-textured pattern. As time passes, the pattern should become larger and more exaggerated. The process may not take as long with 35 mm film as with a 6 × 7 cm format. This is because the pattern will be more evident when the 35 mm film is enlarged to the same size as the 6 × 7 cm film. If the process is allowed to go too far, the pattern will become more important than the original subject.

5. When the desired result is obtained, remove the film from the solution. A pair of tweezers can be helpful when dealing with unattached pieces of film. Wash it in cool running water for 10 minutes, then hang it up to dry.

Water Reticulation

Some films that have not been fixed with an acid hardener can be reticulated in water. Put the freshly processed film, fixed only with a nonhardening fixer, in plain water at 150°F (65°C) and allow it to sit until the water cools to room temperature. This method will produce a much finer, softer pattern than that induced with sodium carbonate.

Masking

Specific areas of a negative can be masked with Luminos Fotomask or rubber cement to prevent reticulation (see Chapter 8). Use a fine brush to apply the mask directly on the emulsion (dull) side of the film and let it dry. Then immerse the film in the reticulating solution. There may be some slight reticulation around the edges of the mask, depending on the length of time the film is in the solution. After the film has been washed and dried, the mask can be removed with masking tape or with your finger. Film may be masked, partially reticulated, washed and dried, remasked, and further reticulated to create a variety of patterns within a single image.

HAND-COLORING

Hand-coloring lets the imagemaker voyage beyond the technical limitations of the photographic process to change the reality of a scene. Synthetic color can be applied to alter the mood, eliminate the unnecessary, and add space and time that were not present at the moment of exposure. This technique can help bridge the gap between the inner/subjective and outer/objective realities by enabling imagemakers to control the color of the external world with their imaginations.

Materials for Adding Color

A wide array of materials and processes can be used to apply color to a photograph. Some widely used coloring materials include acrylic paint, colored pencils, dyes (both fabric and food), enamel paint, marking pens, Marshall's Photo-Oil Colors, oil paint, photographic retouching colors, photographic toners (see Chapter 8), and watercolors.

Solvent-Based Materials
These materials can be divided into four basic groups: lacquer based, oil based, water based, and miscellaneous.

- *Lacquer-based paint* is usually sprayed from a can or airbrush (see the section on airbrushing later in this chapter).

- *Oil-based materials* are among the most common and easy-to-use coloring agents. Quality artist oil paints can be applied to almost any photographic surface. Before painting, a fine coat of turpentine is generally applied to the print surface with a cotton ball. Marshall Photo-Oils and Pencils are available in complete kits with directions for their application. Oil-based materials produce soft, subtle colors. Blending large areas of color is easy with oils. Since oils are slow drying, you can fix mistakes with cotton and turpentine.

- *Water-based materials*, such as acrylic paint, certain concentrated dye toners such as Edwal photographic retouching colors, and watercolors, are considered additive coloring agents. They can be applied straight or mixed to form new colors on a palette. Overall coloring agents are considered to be toners and are covered in Chapter 8. Nonacrylic water-based coloring agents like watercolors affect the print surface in the same manner as conventional spotting. The color penetrates the surface and becomes a permanent part of the image. Mistakes cannot be erased as with oils but must be painted over. Consequently, more care, skill, and forethought are required.

- You can create both intense and subtle color effects with water-based materials, depending on how much water is used to dilute the coloring agent. Since these materials do not sit on the print surface, as do oil-based materials, colors tend to appear brighter, clearer, and more intense. When covering large areas, water-based materials must be applied rapidly and smoothly if you do not want brush strokes to be evident in the final image. Dipping a brush in diluted Photo-Flo or lightly wetting the areas to be colored with a clean cotton ball and fresh water can reduce the likelihood of streaking.

- *Acrylics* are somewhat different from other water-based materials. Acrylics reside on the surface of the print and so tend to appear brighter and more opaque. If these qualities are not problematic, it can be easier to work with acrylics than with watercolors because they are slower to dry. Thus, they can be removed while still wet using cotton and water.

- *Miscellaneous materials* refers to unconventional materials, such as beets, coffee, or tea, which may be used to add color.

Combining Coloring Agents

Coloring agents can be combined, as long as you keep in mind the old adage about oil and water not mixing. Remember that lacquer and oil do not adhere well to water-based materials and that water-based agents do not adhere well to lacquer and oil-based materials.

Permanence

The permanence of all additive coloring agents depends on the following factors:

- The keeping properties of the specific coloring agents

- The type and condition of the surface being painted

- The levels of exposure to UV light

- Maintenance of proper display and storage conditions, including moderate temperatures and medium to low relative humidity

General Guidelines for Hand-Coloring

The following guidelines provide a starting point for applying additive colors to a photographic print.

1. Begin with a dry, processed, well-washed print. Most workers prefer a matte surface, but a glossy surface also can be used.

2. Gather together all the needed materials, including the coloring agents and applicators. Colors can be applied with various sizes of good-quality brushes, Q-Tips, cotton balls, lintless cloth such as Photo-Wipes, or small sponges. A mixing palette, water or another solvent, and white paper on which you can test mixed colors are required. In addition, your work area should have an adjustable, high-quality light source.

3. Read all the manufacturer's instructions and follow all safety procedures as outlined in Chapter 2.

4. Start practicing the technique with throw-away prints.

5. The final results depend on a combination of application, print surface, type of coloring agent, temperature, and humidity.

As you become more familiar with the materials and procedures, begin to deviate from the given modes of application. Try hand-coloring on fabric and nonsilver emulsions or combining the procedure with toning and masking. Hand-coloring is a highly individualistic process, so be adventurous and experiment. Do not be afraid to make mistakes. The ability to make meaningful photographs often comes through an intellectual and/or spiritual instinct that mastery of technique and hours of practice have liberated.

AIRBRUSHING

The airbrush, invented in 1882, is a small spray gun capable of delivering a precise combination of fluid (ink, dye, or paint) and air to a specific surface location. It is a versatile tool for those interested in photographic retouching of a completed image.

Types of Airbrushes

There are three general types of airbrushes: dual-action internal mix, single-action internal mix, and single-action external mix. *Dual action* refers to the way the airbrush is triggered (push the trigger down for air and back for color). This procedure permits the operator to change the line width and alter the value of opaqueness of the fluid without having to stop and make adjustments. For all-around versatility, a dual-action airbrush is a good choice.

When the trigger is depressed on a single-action airbrush, a preset amount of fluid is sprayed. The only way to control the amount sprayed is by turning the needle adjustment screw when the airbrush is not in use. If uniformity of fluid application is critical, a single-action brush is a wise choice.

Internal mix means that the air and fluid are blended inside the head assembly. Internal mixing produces a very smooth and thor-

oughly atomized fine-dot spray offering the precision and detail usually required for smaller works such as photographs.

External mix means that the air and fluid are mixed outside the airbrush head or fluid assembly. It produces a coarser, larger-dot spray than does internal mixing. External mix brushes are generally used for spraying larger areas.

Head Assemblies

Airbrushes also can have different head assemblies (for internal mix) or fluid assemblies (for external mix) which can be changed depending on the type of line quality desired and the viscosity (thickness) of the fluid being sprayed. There are three basic head types: fine, medium, and heavy. Internal-mix assemblies always provide finer line quality than external fluid assemblies, even when they are equipped with a similar-size head.

A fine head, which has the smallest opening, is used for extra-fine detail work. An internal mix can deliver line quality from the thickness of a pencil line to about 1 inch. An external mix is capable of making a line only as small as about 1/8 inch wide. It is intended to be used with fluids having a low viscosity, such as dyes, inks, gouaches, very thin acrylics, and watercolors.

A medium head is intended for detail work and can produce a line from 1/16 inch for the internal mix or 1/4 inch for the external mix to 1½ inches for both. A medium head will spray about twice the amount of fluid as the fine. It can handle more viscous materials, such as thinned acrylics, hobby-type enamels, and lacquers.

A heavy head has the biggest opening, delivering a spray line of 1/8 inch for the internal, 1/2 inch for the external, and 2 inches for both. Heavy heads spray about four times the amount of fluid as fine heads. They are designed for fluids having a high viscosity, such as acrylics, ceramic glazes, oil paints, and automotive paints.

Fluid Containers

Many airbrushes come equipped with a small cup, 1/16 to 1/8 ounce, for holding the

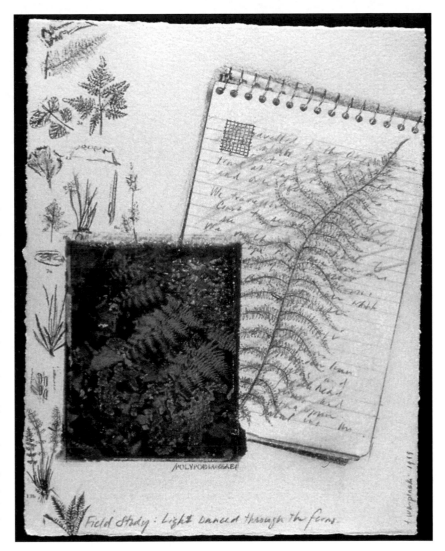

Figure 11.16 An artist and environmentalist, Warpinski's images reflect her reverence for the Western landscape and concerns that she has about the intimate connections to the land that much of contemporary landscape photography often neglects. Warpinski's mixed media collages are based on her field notebooks of the West, weaving together images of the land with references to geology, biology, botany, geography, anthropology, gender, history, and literature. This series, *Field Notebooks*, contains hand-manipulated black-and-white photographs that are combined with frottage (photocopier solvent transfers), rubber stamp relief prints, cellophane tape lifts, and drawing with graphite, colored pencils, and erasers.

© Terry Warpinski. *Light Danced Through the Ferns*, 1999. Mixed media collage. 16 × 20 inches. Original in color.

paint. These are too small for larger jobs, so specially designed jars with capacities of 3/4 ounce to 2 ounces can be attached to the airbrush. These extend the spraying range without the user's having to stop to remix the paint or refill the cup.

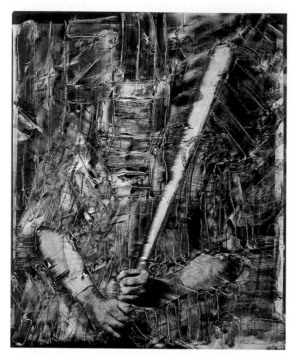

Figure 11.17 Farber uses photography to manipulate information from the real world in such a way that it makes the viewer question what is being seen. Layering is used to create visual ambiguity, tension, and enigmatic surfaces. In this work, the image of Babe Ruth was appropriated and rephotographed on 20 × 24 inch Polaroid material. The print was selectively masked and painted with a mixture of Rhoplex, gel, and acrylic paints. The masks were then removed, and these areas also were painted.

© Dennis Farber. *Baseball Abstract*, 1988. Polaroid with acrylic paint. 20 × 24 inches. Original in color.

Selecting the Right Equipment

Select an airbrush based on its intended application. A dual-action, internal-mix, fine-line unit with optional bottle containers is appropriate for most photographic uses. This combination provides the precision and versatility required for most operations involving the airbrushing of photographs.

Air Supply Sources and Accessories

The airbrush requires a steady, clean, and reliable source of dry, pressurized air. This can be obtained from canned air (propellant), such as Badger Propel, Paasche's air propellant, or from a compressor. Canned air, available at art supply stores, is convenient and initially less expensive, but it can run out unexpectedly at inopportune times. If airbrushing is going to be more than an occasional activity, consider investing in a compressor. Air compressors are available from airbrush manufacturers or at discount hardware and homecenter stores. Get one with a regulator that permits adjustment of the air pressure in pounds per square inch (psi). A regulator offering a pressure range of 10 to 100 psi is excellent for airbrushing photographs. The regulator also allows additional control over the intensity of the spray and the pattern it produces.

The airbrush must have a flexible hose running from the source of air to the brush. A lightweight vinyl hose can be used with a canned propellant, but a heavy-duty braided hose should be used with a compressor. A ten-foot hose is recommended, as it provides greater flexibility of movement while spraying.

A filter/extractor can be attached to the compressor to remove moisture and impurities from the air delivered to the brush. This is especially useful in humid climates.

Your Work Area

A drafting table with an adjustable-angle top provides an effective work surface. The table and the entire work area, including walls and floor, need to be protected from the airbrush spray fallout. Newspapers or drop cloths will do the job.

Prints can be pinned or taped at the corners to the work surface. They also may be attached with double-sided tape on the backside of the print.

Safety

Airbrushing should take place in a well-ventilated area. A work area with an exhaust fan is ideal. Since the spray is extremely fine, you should wear a double-cartridge respirator for protection. Bearded operators may not be completely protected because most respirators do not provide a tight fit over facial hair. Thin fabric masks do not offer adequate protection. Do not eat, drink, or smoke while airbrushing. Avoid putting your fingers in

your mouth while working, and wash your hands and fingernails thoroughly when you are done. Follow all other safety guidelines provided in Chapter 2.

Basic Airbrush Operation

Most airbrushes have the same basic operating procedures, but read the instruction book that comes with the airbrush for details.

1. Attach the air hose to the air supply (compressor or canned propellant), then connect the air hose to the airbrush.

2. If the air supply is regulated, set it to a beginning operating pressure of 30 psi. The normal working range is 15 to 50 psi.

3. Put the medium (such as paint) into the airbrush jar. The medium needs to be *thin*, about as thick as you would use if you were applying it with a brush. Screw on the jar top with the airbrush adapter and attach the entire unit to the brush.

4. If you are using a compressor, turn it on. Hold the airbrush perpendicular to the work surface. Press the trigger while easing it slightly backward to spray the desired amount of medium. For close-up work, reduce the amount of air pressure. Increasing the air pressure or the distance between the brush and the work will provide a wider spray pattern.

5. For best results, use a constant, steady motion. Start the motion before pressing the trigger. Then press the trigger, keeping the motion steady. Release the trigger when done, continuing to follow through with the motion. Uneven airbrush motion, known as arching, will result in an uneven application of the medium.

6. The most common problem beginners have is runs and sags, which result from holding the airbrush too close to the work surface, holding the brush still or moving it too slowly, or forgetting to release the trigger at the end of the stroke.

Mixing the Medium

A number of premixed, ready-to-use opaque airbrush colors are available from companies such as Badger and Paasche. These are con-

venient and easy to use but expensive. Mixing your own medium offers the greatest versatility and is more cost-effective. A good sable brush, number 4 to 7, to mix the medium is desirable. Inexpensive brushes can lose their bristles and clog the airbrush. Most media must be thinned, or they will clog the airbrush. Mixing can be done in the spraying jar. The medium's consistency should tint the brush but not color it solidly. The medium should stick to the sides of the jar but should not thickly color its sides.

Here is a beginning guide to thinning various media:

- 1 part water to 1 part watercolor
- 1 part water to 1 part nonclogging ink
- 7 parts water to 1 part acrylic
- 1 part enamel thinner to 1 part enamel

Note that acrylics dry very rapidly, so spraying needs to be almost continuous, or clogging will result. If you have to stop for a short time, dip the head assembly in a jar of clean water to prevent clogging.

As soon as you have finished with one color, spray clean water or solvent, depending on the medium used, through the airbrush until all the color is out.

Practice

Before attempting to airbrush any completed work, practice operating the brush. Most airbrushes come with instructions containing basic exercises to get you acquainted with how the brush works. If the airbrush does not have these exercises, go to the library and get a book on basic airbrush technique. These exercises can be carried out on scrap paper or board. Once you have mastered these techniques, move on to practicing on unwanted prints. When you have built up your confidence, try your hand at a good print.

Masking

Masks made of paper, board, acetate, or commercial frisket material can be used to control the exact placement of the sprayed medium. Masks may be cut to any shape or pattern. Handmade masks are held in

place with tape or a weight so the atomized medium does not get under the masked areas. Whenever you are using a mask, spray over the edge of it, not under it, to avoid underspray. Positive and reverse stencils can be used to repeat designs or letters.

Cleanup and Maintenance

When you have completed the work, clean the airbrush and paint jar thoroughly with water or solvent. The majority of airbrush problems are caused by failure to clean all the equipment properly. Follow the instruction guide for specific details on how to clean and maintain your airbrush.

Canned Spray Paint

A rough idea of what you can do with an airbrush can be learned by experimenting

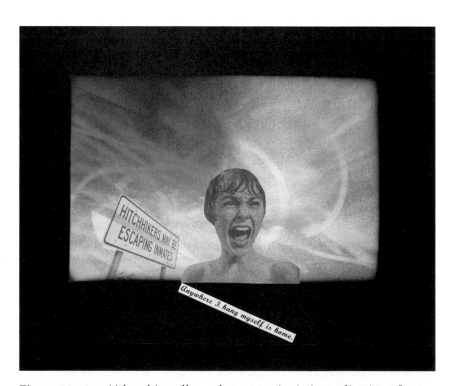

Figure 11.18 Airbrushing allows the expressionistic application of synthetic colors to evoke mood and to eliminate unwanted detail in order to direct the viewer's attention to specific areas of the composition. Postmodern strategies of irony and satire prevail as artifice for commentary on American dilemmas that include alienation, popular myths, sexual identity, and social fictions. Unadorned text is provided to furnish clues for additional meaning. (See Color Plate 5.)

© Robert Hirsch. *Anywhere I Hang Myself Is Home*, 1992. Toned gelatin silver print with mixed media. 16 × 20 inches. Original in color. Courtesy of CEPA Gallery, Buffalo, NY.

with different-colored canned spray paints. Follow all the general airbrush working and safety procedures. Canned spray paint provides a much wider field of spray and is not suggested for fine detail work. Canned spray paint and an airbrush can be combined. Just follow the guidelines provided in this section for combining media.

Since airbrushing is a postdarkroom activity, it can be used with any photographic printmaking method. To master airbrushing you must be willing to perform the task repeatedly. Opportunity abounds with the airbrush. See what you can do.

Additional Information

Following are some of the major airbrush manufacturers:

Badger Air-Brush Company, 9128 West Belmont Avenue, Franklin Park, IL 60131 (equipment, paint, supplies, educational books, and videos).
Paasche Airbrush Company, 7440 West Lawrence Avenue, Harwood Heights, IL 60656 (equipment, paint, supplies, and books).

TRANSFERS AND STENCILS

A wide variety of transfer processes permit an image to be transferred to another receiving surface. Transfers offer a fast, inexpensive, and fun way to work with your images or those from other sources like magazines. Transfers will be reversed (like a mirror image), so all lettering will be backwards. There will also be a shift in color. One can transfer more than one image to a single receiving surface, creating a collage of images. Most methods are experimental and can be done without the use of a printing press.

Stencils can be used in place of images and the material used to form the new image is only limited by one's imagination. Stencils can be cut by hand using an X-Acto knife and a sharp blade, or commercially by a sign-making or graphic arts company. Paint, ink, or other materials can be applied to a variety of surfaces through the stencil's openings.

Transfer Materials

Materials needed for transfers vary, but there are some that are useful for all processes. These include:

1. A burnishing tool. "Bone folders" are ideal; however, any blunt-edged tool such as a butter knife, a clay burnishing tool, a metal or wooden spoon, or a soft lead pencil can work.

2. A receiving surface. Ideally a smooth, absorbent material such as printmaking paper; however, cloth and other materials can be used if they have a fine, tight weave. Textured surfaces may also work but deliver less detail.

3. Large cotton balls and/or soft brush.

4. Appropriate solvent. Because solvents vary in their ability to dissolve inks one needs to experiment, starting with water, the least toxic solvent available. If this proves unsatisfactory use mineral spirits (paint thinner). If this does not work, move up to acetone, or "Goof-Off," available in hardware stores. These solvents evaporate rapidly. Transparent gels used for diluting oil-based silkscreen ink are generally very effective. Gels penetrate the paper, readily loosen the print image, and evaporate more slowly than liquid solvents. Silkscreen bases are available at art stores and commercial print supply companies. All these solvents contain volatile ingredients and can pose potential health hazards. Read the warning labels with each product. Work only in a well-ventilated area and follow all general safety rules (see Chapter 2).

Magazine Transfers (Petroleum Ink Bases)

Images from freshly printed, clay-coated, slick magazines work best. Test with water and if pigment dissolves, use water to make the transfer (see section on inkjet transfers).

Lay receiving material face up on a hard, smooth surface. Position the image to be transferred face down and use masking tape to secure one edge only, so that the paper can be folded back to expose its image without shifting its position. Generously apply the

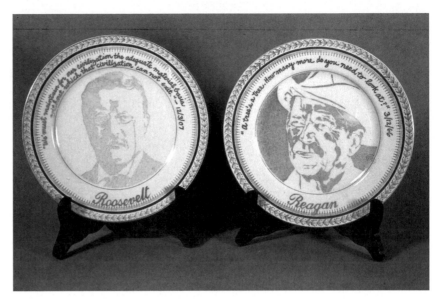

Figure 11.19 Abeles informs us that "The *Presidential Commemorative Smog Plates* are portraits of U.S. Presidents from McKinley to Bush (senior) created from particulate matter (smog) in the polluted air. The stencil images are cut from transparent or opaque materials, and placed over dinner plates that were placed on a rooftop for varying lengths of time (from four to forty days), depending on the extent of their violation or apathy toward the distressed environment. Upon removal of the stencil, the Presidents' visages in smog are revealed, accompanied by their historical quotes about the environment and business. The darker the image, the worse their environmental record." The Roosevelt quote reads "We must maintain for our civilization the adequate material basis without which that civilization can not exist." 12-3-07. The Reagan quote says "A tree's a tree. How many more do you need to look at?" 3/12/66. Abeles created the process for the first Smog Collector in 1987.

© Kim Abeles. *Theodore Roosevelt and Ronald Reagan*, from the series *Presidential Commemorative Smog Plates*, 1992. Smog on porcelain with gold enamel. 10 inch diameter. Courtesy of Art Resources Transfer, New York. Original in color.

solvent chosen with a cotton ball or brush to the face of the image. Quickly lay the coated magazine image back in contact with the receiving surface, and apply hard and even pressure with a burnishing tool to transfer the dissolved ink.

Each tool will yield a different result. Try a combination of tools for a variety of effects. Periodically check the results by lifting one corner of the magazine image up and inspecting the receiving base. When the magazine image dries and will not transfer any more ink, add more solvent to the image. Repeat this process until the image has been transferred. Be patient. This procedure can take up to 15 minutes. If you have access to a printing press it can be used instead of the hand burnishing.

Newspaper Transfers (Petroleum Ink Base)

Newspapers transfer unpredictably, which is their charm if one wants a distorted image. If you want something more predictable, copy (Xerox) or scan and laser-print the newspaper image (see next section).

Lay receiving material face up on a hard, smooth surface. Trim (if desired) and position the image to be transferred face down. Tape in place if desired, or simply hold in place while working. Lightly saturate a cotton ball with solvent, then blot the cotton ball on paper towels until damp (if it's wet it will cause the ink to run). With hand pressure, apply the damp cotton ball to the back of the newspaper in circular motions until the paper becomes transparent. You can check the progress of your transfer by lifting a corner and peeking. Replenish solvent as needed. If too much of the newsprint comes off on the cotton ball, try using a thin slip sheet between the cotton ball and the newspaper.

Black-and-White Copier, Laser-Printed, and Inkjet Transfers

A black-and-white image (made with a dry-toner copier or digital laser-printer) can be transferred onto another surface using a strong solvent. The method is identical to the newspaper transfer, previously mentioned, except that you will not need a slip sheet. A citrus-oil solvent may work on freshly printed images.

The advantage of the digital laser-print is that the image can be "flipped" prior to output and transfer, resulting in correct left-to-right orientation.

Inkjet prints can be transferred using plain water.

Color Copier or Laser-Printed Transfers

Color copiers used to have inks that readily transferred with solvents. This is now currently a rarity, but you may still find an old machine that will allow you to do this. One can experiment as the industry is always changing. Failing direct transfers, decal papers or Lazertran paper is an alternative.

Water or Vegetable-Based Color Print Transfers

Common small- and large-format digital printers use inks or dyes that can be transferred using plain water, water-based transparent silkscreen gels, or even acrylic gels. The most archival results begin with pigment-based prints. Patience and experimentation will be required. Density of ink, variations between printer hardware, inkjet paper, and receiving paper will result in dramatically differing results.

Many people have success using a printing press to transfer the image because it can quickly apply a large amount of even and intense pressure. The procedure relies on devising a way to evenly dampen the inkjet print and/or receiving paper. Generally, printing paper (made for hand lithography or intaglio) is soaked for 20–30 minutes, then blotted between two large clean towels (and a rolling pin) until damp, not soaking wet. It is then quickly placed on the printing press, the color inkjet print is laid face-down on the damp paper, covered with a clean thin sheet of flexible plastic (such as Lexan or polycarbonate), and quickly run through the press. The transfer is then checked, and if the image needs more dampening to release, this can be applied by using a spray bottle, a dampened sponge, or damp blotting paper. The variables are many, and experimentation will be required.

Decal Papers

Most copiers and digital printers have manufacturer-recommended clear "decal" or transfer papers for use with their machines—be sure the decal paper is compatible or it could ruin the machine. These are often "ironed" on with heat, and therefore application is limited. The results can be quite detailed; however, the clear plastic of the decal remains on the surface, even in areas where there is no image.

Lazertran Transfer Products

Lazertran Limited makes transfer papers for color copiers and laser printers. After outputting the digital file or color copy onto Lazertran paper, the image is trimmed and soaked briefly in water. This releases the image from its backing paper, and it can be applied onto paper, canvas, ceramics, tiles, glass, metal, plaster, plastic, or wood. Unlike

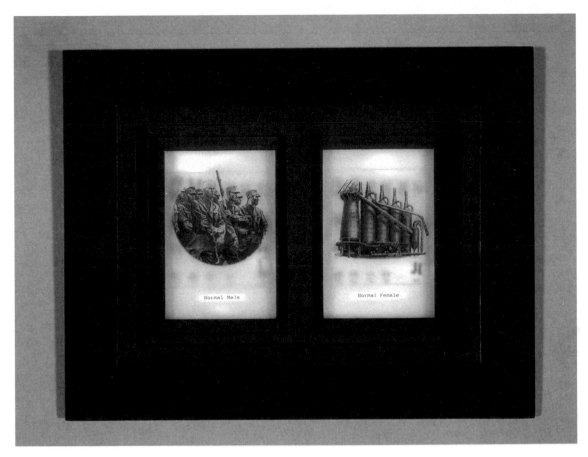

Figure 11.20 In this ongoing series, Henderson playfully pairs different images against a background of male and female chromosomes to engage viewers in speculation about the nature of gender. The grid-like presentation of between 60 and 100 works recalls the authority of a natural history museum, while it explores and layers the role of science and culture in shaping self-knowledge of the body and visualization of its intricacies. (See Color Plate 6.)

© Adele Henderson. *#55* (detail), from the series *Normal Male/Normal Female*, 1998. Print on paper, Plexiglas, wax, white shellac, wood frame and one or more of the following: engraved and inked lines, litho ink transfers, hand painting in oil, asphaltum, or Lazertran transfer. $7\frac{1}{2} \times 9\frac{1}{2}$ inches. Original in color.

decals that are ironed on, Lazertran's makers claim that it can be fused to bond permanently with a number of surfaces. They also make an iron-on transfer for silk and other sheer fabrics. Lazertran "Etch" is a different product made for transferring digital or photo images onto metal intaglio plates that are subsequently etched in acid and printed. For details contact: Lazertran Limited, 650 8th Avenue, New Hyde Park, NY 11040.

Transparent Contact Paper Transfers

Clay-coated magazine pictures can be transferred by using transparent contact paper with an adhesive backing. This is the type of contact paper often used inside kitchen cabinets. It is *not* photographic contact-printing paper.

Select a clay-coated magazine picture. Remove the backing from the transparent contact paper and stick it onto the front of the magazine image. Burnish the clear contact paper well with a blunt edged tool. This will remove all bubbles and transfer the ink onto the adhesive layer of the contact paper.

Soak the adhered image and clear contact paper in hot water until the paper backing of the image dissolves enough to be removed with a small sponge or your finger. When this step is complete, only the ink transfer will remain on the contact paper. Hang

the image up to dry. To protect the dry image and make it easier to handle, place a new piece of clear contact paper on the non-laminated side of the dried image and burnish it.

Aside from making a final piece with contact paper, you can use contact paper transfers for the following:

- Print them on light-sensitive material to get a negative image.

- Contact print them on a piece of film to make a negative from which prints can be made.

- Put them in a slide mount and project them.

- Use them in a copy machine that can make prints from slides.

Flexible Transfers

A clay-coated casein paper image may be transferred to an acrylic medium to deliver a flexible transparent transfer.

Select an image that has been printed on a clay-coated paper. Using a soft, wide brush, coat the front side of the printed image with acrylic gloss painting medium. Apply the acrylic medium quickly, in only one direction, and allow it to dry. Then apply it again in another direction and allow it to dry. Continue repeating this process until you have at least eight layers of medium.

Soak the coated image in hot water until the magazine picture dissolves and can be peeled off, leaving only the printer's ink in the acrylic medium. Hang the image up to dry. The acrylic medium will be white when it is wet, but it should become transparent after it dries.

The acrylic medium is flexible and can be shaped and stretched for many applications in which a regular transfer would not work. Warm the medium with a hair dryer before attempting to re-form it, or it may break. Re-application of the acrylic may be needed if it begins to tear or get too thin. Place it face down on a piece of glass and begin working it from the edges to form a new shape. The flexible transfer can be stretched around three-dimensional objects or be stitched, stuffed, and attached to other support bases.

Polaroid Image Transfers

Images formed on Polaroid instant print film can be transferred to another receiving surface, such as artist paper, 4 × 5 or 8 × 10 inch sheets of black-and-white or color film. These surfaces work well and provide an image large enough for viewing. To transfer an image from a piece of Polaroid print film to paper or another surface, follow these steps:

1. Normally expose a sheet of 4 × 5 inch Polaroid film.

2. Before pulling the print through the rollers, soak the receiving sheet in water (100°F/38°C) for about 1 minute. Remove the receiving sheet and use a hard roller or squeegee to eliminate the excess water. Quickly proceed to step 3.

3. As soon as the film is pulled through the processing rollers, cut off the ends of the film packet with a pair of scissors. This prevents the receiving paper from getting brown stains that result from excess Polaroid developer.

4. Separate the positive and the negative images. This step should be done between 10 and 15 seconds after step 3. Before 10 seconds the print may become fogged by light, and after 15 seconds the dyes begin to migrate to the receiving sheet.

5. Immediately apply the negative image (face down) on the new receiving support material. Using a brayer, roll the negative, with medium pressure, 4 to 6 times in the same direction. The quality and look of a transfer depends on the porosity of the receiving material. The negative image may be transferred to artists' paper, a photographic print, another Polaroid print, or even back to the positive from which it was originally removed.

6. Keep the negative warm and allow it to stay in place for two minutes before removing it from the receiving base. Separate the negative and support base before they dry, or you risk the likelihood of tearing the support base when you remove the negative.

Additional Information

Grey, Christopher, and Gwen Lute. *Photographer's Guide to Polaroid Transfer*. Amherst, NY: Amherst Media, 1999.

Thormod Carr, Kathleen. *Polaroid Transfers: A Complete Visual Guide to Creating Image and Emulsion Transfers*. New York: Amphoto Books, 1997.

Polaroid Emulsion Transfer

Emulsion transfer is a process for removing and transferring the top image layer of Polaroid ER films (Types 108, 669, 59, 559, 809) or Polacolor 64 Tungsten, onto another support surface. European imagemakers began experimenting with the process during the 1980s, but it did not gain entrance into American photographic practice until the 1990s. Basically, an exposed sheet of Polaroid ER film is submerged in hot water until the emulsion can be separated from its paper support and then transferred onto another surface such as ceramics, fabric, glass, metal, and wood. Three-dimensional surfaces also can be used. The process removes the image from its normal context and destroys the traditional frame, while adding a sense of movement and elements of the third dimension into the image. The following steps are provided as a portal to this nontraditional process.

The Emulsion Transfer Process

Emulsion transfers can be made onto any clean, smooth surface, including glass or sheet metal. Fabric support should be stretched and mounted because folds in the material can produce cracking when the emulsion dries. The emulsion can be transferred in sections by tearing it with your nails or cutting it while it is soaking. The print can also be cut into pieces before its first submersion. All steps may be carried out under normal room light.

1. Expose and process Polaroid Type 669, 59, 559, or 809 film and let it dry for 8 to 24 hours or force-dry with a hair dryer. Besides using a camera, exposures can be made onto positive transparency film and projected onto Polaroid ER. This can be done with the Polaprinter, the Vivitar

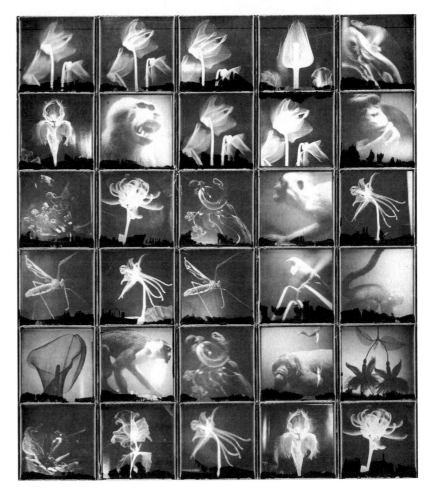

Figure 11.21 Transfer printing is an easy, fast, and fun method of working with found images. Hock made this piece from SX-70 images peeled apart during development. The backing was then adhered to a paper support. In this series, appropriated scientific images of primates and insects are juxtaposed. Visual contrast is created by combining cool- and warm-colored images within the composition.

© Rick McKee Hock. *Codex (Natural History) #17*, 1986. Altered Polaroid SX-70 images on paper. 20 × 22 inches. Courtesy of the Hallmark Collection, Inc. Original in color.

slide printer, the Daylab II, a colorhead enlarger, or a copystand.

2. Cover the backside of the print with plastic contact paper or with a coat of spray paint and allow to dry. This will prevent the back coat of the print from dissolving during the submerging process. Trim the white borders of the print if you do not want them to transfer.

3. Fill one tray, larger than the print, with 160°F (71°C) water. Fill a second tray with cold water. Place a sheet of acetate or Mylar on the bottom of the cold water tray.

If transferring onto watercolor paper, use a foam brush to moisten (but do not soak) the paper with room temperature water. Put the paper on a clean, smooth piece of glass and squeegee it onto the surface, taking care to remove all bubbles and wrinkles.

4. Submerge the print face up in the tray of hot water for 4 minutes with agitation. The water should be allowed to cool. Using tongs, remove the print from the hot water and place it in the tray of cold water.

5. While the print is under the cold water, lightly massage the emulsion with a pushing motion from the edges of the print toward the center. Slowly and carefully lift the emulsion and peel it away from its paper support base. Keep the emulsion that is being released from its support under the water. Now reverse the image (so it will not appear backwards when transferred) by bringing the emulsion back over itself (like turning down a bed sheet). Leave the emulsion floating in the water and dispose of the paper support. Hard water can make the emulsion difficult to remove. If this is a problem, try using bottled spring water.

6. Take hold of two corners of the floating emulsion with your fingers and clamp it on the bottom of the tray. Holding the emulsion, lift the acetate in and out of the water several times to stretch the image and remove the wrinkles. Repeat this on all four sides, always holding the top two corners. After it is stretched, you can dunk the image to purposely let the water curl and fold it. When you are satisfied with the image, remove it from the water and place it on your transfer surface, making sure the acetate or carrying material is on top.

7. Using your fingers to manipulate the image, carefully remove the acetate.

8. Smooth and straighten the image until it looks the way you want it to look. At this point the emulsion can also be resubmerged in and out of cold water to perform additional manipulations. When your manipulations are complete, roll the image with a soft rubber brayer from the middle outward. Begin using only the weight of the roller and gradually increase the pressure after all the air bubbles and excess water have been removed. Generally the operation is considered complete when all the folds appear to be pressed down. However, other rubbing tools and techniques may be used to achieve different effects.

9. Hang to dry. Transfer may be flattened in a warm dry-mount press. For added stability, protect from UV exposure.

Additional Sources of Information

Technical Assistance and Books

Polaroid provides toll-free telephone technical assistance at 800-225-1618, Monday through Friday, 8 A.M. to 8 P.M. (Eastern Time). Polaroid also offers *Polaroid 35 mm Instant Slide System: A User's Manual* by Lester Lefkowitz, which provides in-depth technical information; *Instant Projects* by Robert Baker and Barbara London, which contains a wealth of ideas and information on using their instant materials; and *Step By Step* (covering emulsion and image transfer and SX-70/Time-Zero manipulation). Write Polaroid Corporation, 575 Technology Square, Cambridge, MA 02139.

Equipment

Four Designs, 9444 Irondale Ave., Chatsworth, CA 91311, and Graphic Center, P.O. Box 818, Ventura, CA 93002, are sources for used SX-70s and customized film backs. Four Designs Company will convert old Polaroid 110A/B roll film cameras to use the new pack films. NPC Corporation, 1238 Chestnut St., Newton Falls, MA 02164, makes an SX-70 back for the Mamiya RB-67.

12 Photography and Computers

WHAT IS A DIGITAL COMPUTER?

A digital computer is an electronic device designed to store and process information, such as text or an image, as a set of instructions known as binary code and display it on a screen. This binary code is analogous to a light switch that operates in two states— "on" and "off"—represented by the digits 1 and 0. This code allows a digital image to be easily manipulated and stored.

WHAT IS A DIGITAL IMAGE?

We are familiar with the adage that "history repeats itself." This saying may refer to actual events or may be applied to how people react when confronted with a new experience. During photography's infancy, the French symbolist poet Charles Baudelaire dismissed the medium as "foreign to art," referring to it as a "material science" which required none of the skill or vision of painting. For centuries, painting was considered the preeminent method of producing images. The invention of photography threatened artists' livelihoods and public perceptions about how pictures were made and understood. Although photography has made great strides in being accepted as a legitimate art form, critiques similar to Baudelaire's have been raised about digital imaging. As in the beginnings of photography, the emphasis in digital imaging has largely been as a tool to replicate old ways of working rather than as an independent art form with its own unique characteristics, such as the capability of combining media. Entering the second decade of artistic and public computer imaging, we find that just as it took time for photography to discover its syntax so too is the native language of digital imaging just being uncovered.

Although electronic images can look like analog silver-based photographs, they are intrinsically different. Not only does a digital image exist as numerical information but it is also encoded with new questions about the role and intent of the imagemaker, the veracity of the image, and the craft of the imagemaker. These are not new issues and they have been part of an ongoing dialog about imagemaking for hundreds of years. Just as photography changed the purpose of painting, electronic image manipulation has permanently altered the role of photography. Imagemakers are not only using the computer to modify images and create virtual scenes, but are coming full circle and making digital negatives for analog printing processes. One change is that artists are no longer limiting themselves to either analog or digital modes of making, but are freely moving back and forth between these modes of working to achieve their desired results. As photography's role as a system of representation of physical existence shifts, so must its former vocabulary be reexamined. A new strength of the medium is its ability to assemble the outcome as an act of the artist's imagination.

A BRIEF HISTORY OF DIGITAL IMAGES: 1960 TO 1998

Before the 1990s, computers were known for their ability to process numbers and words. A comparison of the development of electronic imagery to photographic images reveals that in both methods it was necessary for early imagemakers to be scientists as well as artists. The rate of technological innovation limited the types of images that could be produced. Bursts of creativity followed technical innovation, but a true aesthetic required time for visual experimentation and reflection. Hindsight allows us to look at the pioneering images of William Henry Fox Talbot, Nadar, and Julia Margaret Cameron and see how their vision paved the way for future imagemakers. Since there was no tradition for early photographers to use as a foundation, most looked to the established media of drawing and painting for inspiration. They made pictures that overlaid a template that imitated their rules and traditions, but a few innovators recognized the particular characteristics of the camera's vision, took risks, and made images that were uniquely photographic.

A photographic fable relates that on seeing his first daguerreotype the French painter Paul Delaroche allegedly declared, "From today painting is dead!" The ascendance of digital imaging has some latter-day "chicken-little types" crying that photography is finished. Painting is still with us, but has changed and expanded its role in a myriad of ways since the advent of photography. Analogously, photography will continue to exist but the photographs of tomorrow may look as foreign to today's viewers as a Jackson Pollock abstract expressionist canvas would look to a painter of melodramatic history scenes like Delaroche. The good news is that digital imaging offers photography the chance to reinvent itself and begin in new directions without throwing its past into the wastebin of history.

The Start of the Digital Revolution

An article in the March 1949 issue of *Popular Mechanics* predicted that in the future computers would have only 1,000 vacuum tubes and weigh no more than one

Figure 12.1 "In *The Shower Bath of the Patriarchs*, a psychogeography of Buffalo, New York, our objective was to destabilize the spectacle so that viewers no longer desired received media images, but instead were moved to autonomously invent new desires." Nickard and Wallace work from the texts of French essayist and anti-art movement leader Guy Debord to critique how the commodification of consumer capitalism and technology has led to alienation and has reduced people to voyeurs. While the series critiques the saturation of the social environment with manufactured images, Nickard and Wallace explain that while art itself remains incapable of changing the world, it can substantially contribute to changing the consciousness and drives of the people who are themselves capable of changing the world.

© Gary Nickard and Patty Wallace. *Culture Is the Inversion of Life*, from the series *The Shower Bath of the Patriarchs*, 1999. Electrostatic print. 54 × 36 inches. Original in color.

and a half tons. This prophecy was based on the ENIAC computer, the first fully electronic digital computer built in 1946 at the University of Pennsylvania. ENIAC weighed 30 tons and contained 18,000 vacuum tubes, which burned out at an average of one every seven minutes.

Ben F. Laposky made the first electronic image in 1950. His piece, *Oscillon Number*

Four—Electron Abstraction, was an analog wave pattern photographed from an oscilloscope. In 1957, Russell A. Kirsch and colleagues, working at the National Bureau of Standards in Gaithersburg, Maryland, constructed a simple mechanical drum scanner and used it to trace variations in intensity over the surfaces of photographs. They converted the resulting signals into arrays of 176 × 176 binary digits. This data was then fed into a SEAC 1500 word memory computer, which made line drawings. For the first time patterns of light and shade became electronically processable digital information. These experiments, like the first photographic images, were primarily concerned with developing a new technology rather than art making.

From Vacuum Tubes to Transistors: 1960 to 1980

In the early 1960s, scientists at Boeing Corporation coined the term "computer graphics." By 1964, NASA scientists were using digital image-processing techniques to improve photographs of the moon's surface that had been sent back to earth by the Ranger 7 spacecraft. At this time computers were as big as rooms and were the sole domain of the government, military, and large corporations. The development of the transistor and miniaturized circuit in the late 1950s made it feasible to reduce a room-size computer to a silicon chip the size of a pea.

For the digital imaging pioneers access to computers was limited and computer time was expensive and scarce. Artists needed to be programmers or work closely with a programmer to create images with a computer. The first computer images were based on work that could be created using a computer language consisting of algorithms developed for mathematics and science. Artists worked blind because they were unable to see their work until it was outputted. Each image was mapped out in advance. The instructions that made up the image were punched into paper computer cards that could fill several shoeboxes and then fed into a computer one at a time. Usually program mistakes were not discovered until after all the cards had been put into the computer, which meant the

process had to be redone. Since early printout devices were plotters, large Etch-a-Sketch–like machines that could not draw curves, images were composed of lines and broken curves and were generally black-and-white. Experimentation was essential in early electronic imaging and often combined artistic and scientific goals. Geometric shapes dominated the visual language of the work and compositions were frequently made up of rotated and scaled copies.

Moore's Law

In 1965, Gordon Moore, cofounder of Intel Corporation, made one of the most prophetic statements of the computer age. He forecasted that along with decreasing prices for hardware, about every year and a half it would be possible to buy, for the same amount of money, a computer that is twice as fast as one purchased 18 months before. Moore based his prediction on the belief that the transistor density of semiconductor chips would double roughly every 18 months, making computers cheaper and faster. If air travel had developed like computers did, it would now be possible to fly from New York to California in 12 seconds for 50 cents.

The Emergence of Computer-Generated Images

In *Postmodern Currents* (1997) Margot Lovejoy describes the first wave of technical innovations that fostered computer art from 1965 to 1975. In 1963, Ivan Sutherland developed Sketchpad, a program designed to create graphic images directly on a display screen. Sketchpad pioneered the fundamental concepts of graphical computing, which include memory devices to store objects, the capability to zoom in and out on the display, and the ability to make perfect lines, corners, and joints as well as the capacity to stretch and curve lines. Sketchpad was the first truly interactive computer graphics system that allowed users to draw lines and shapes on the screen and manipulate them with a light pen. For the first time artists had a means to interact with a computer.

The 1970s saw the introduction of the mini-computer and the personal computer, which permitted an individual to work outside of the office. In 1970, Xerox Corporation put together a research team at their Palo Alto Research Center (PARC). In the following years this group of scientists developed graphical user interfaces, the first commercial mouse, bit-mapped displays, object-oriented programming, and laser printing, and also laid the groundwork for what was to become the Internet. The adoption of computers by design firms eventually led to the development of graphics software.

Homebrew Computer Club

In the 1970s, personal computers became available as kits and eventually as systems. For early computer users there was no support infrastructure to answer technical questions or to share information. A number of clubs formed around universities to fill this need. The Homebrew Computer Club, which met near the Stanford University campus, was one such group. The club brought together people in the high-tech industry, hobbyists, and students and gave them access to computers and a forum to share information. In 1975, Homebrew member Steve Wozniak brought a circuit board he constructed to a meeting. Friend and fellow Homebrew member Steve Jobs was impressed and proposed a partnership that would become the Apple Computer Company. Working out of Wozniak's garage, the Apple computer was thousands of dollars less expensive than the IBM mainframe computers. More important, the second-generation Apple II computer had color graphics capabilities that were superior to mainframe computers and had spreadsheet software for the business community. It also featured art applications that included graphics plotting, a 3-D graphics system, and Apple World, a program that allowed the creation and display of 3-D line drawings of objects that could be rotated and zoomed in on. The union of art, business, and home applications had been forged. By the end of the 1980s, personal computers were powerful enough to run software that was previously available only to dedicated computer systems, systems designed to specifically complete a single task.

During the 1980s, *computer graphics* started to become a common catchphrase as other computer manufacturers marketed their own personal computers. This competition significantly reduced costs and allowed individuals to obtain a sufficiently sophisticated machine for home, office, and studio use. Computers also began to appear in schools. This produced a surge in the number and diversity of computer users and a parallel interest among manufacturers in developing equipment and software specifically for artists. With many obstacles removed, artists commenced using this new technology. The transition came so easily to some artists that they began to adopt the computer as their primary working tool. By the end of the 1980s, books, magazines, and exhibitions of computer art and digital imaging began to appear.

The 1990s and the Internet

The origins of the Internet and the World Wide Web (WWW) can be traced to 1957 when Russia launched Sputnik, the first successful manmade satellite. In a Cold War response, President Dwight D. Eisenhower formed the Advanced Research Projects Agency (ARPA), consisting of some of America's top scientists, who developed a successful satellite in only 18 months. This team focused on creating a military research and command and control network that could survive a nuclear strike. They devised a decentralized network of computers that were spread across the United States so that if any cities in the country were attacked, the military could launch a nuclear counterattack. The initial network was constructed in 1969 and linked four universities: the University of California at Los Angeles, Stanford Research Institute, University of California at Santa Barbara, and University of Utah. Three years later the first e-mail program was created to allow electronic communication among this group. And so the Internet came into existence.

For the next twenty years the Internet remained a system of text and e-mail. In 1989, computer scientist Tim Berners-Lee published the paper "HyperText and CERN."

The following year he developed the hypertext graphical user interface browser and editor and made up the name "World Wide Web" (WWW) for the program. In 1993, Marc Andreesen, a graduate student at the University of Illinois, created the first graphical browser known as Mosaic. A browser is a program that permits you to navigate on the WWW by reading and displaying Internet files and Web pages. It does this by combining the existing Internet framework with the multimedia applications made available by hypertext and the WWW. In 1992 there were 300,000 host computers connected to the Internet with only 26 reasonably reliable WWW servers; by 1994 there were 1,500 registered servers. That year also marks the commercial use of the WWW as a business conduit to the general public when Pizza Hut accepted its first order for a mushroom and pepperoni with extra cheese pizza over the Net.

By 2000 the Nielsen/NetRating reported that about 150 million people in the United States have access to the Internet at home, up 32 percent from the year before. And the average home user spends about 10 hours online each month, up from little more than 8 hours a year ago.

In 1974, artist Nam June Paik displayed *Collage*, a 1944 *Life* magazine advertisement promoting television as the symbol of postwar prosperity. Below the image was text that asked: "How long will it be before all American homes have a television set?" Paik attached additional text asking, "How long will it be before all American artists have their own television channels?" Currently there are millions of Web sites on the WWW, each capable of displaying images, text, video, and sound, and the number is growing daily. The answer to Paik's question is now just a click or voice command away.

WHY THE COMPUTER?

As a camera converts a three-dimensional subject into a two-dimensional representation, the computer seamlessly combines different media into a virtual representation, which retains the qualities of some media and eliminates the characteristics of others. Any task that can be done with a camera,

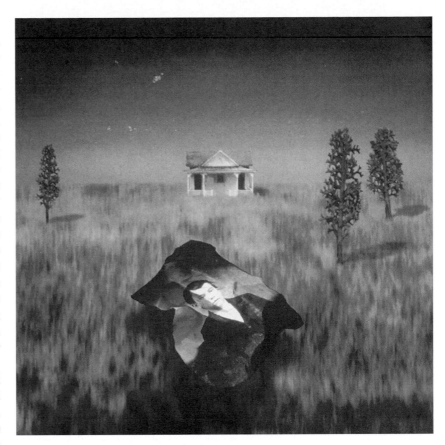

Figure 12.2 Taylor uses her Website (www.maggietaylor.com) to display, promote, and describe her images. Beginning as a collection of individual objects and backgrounds, Taylor scans her images using a flatbed scanner instead of a traditional camera. She assembles the images in layers using PhotoShop® and prints the final image onto watercolor paper using an Iris printer. "My desire is for the viewer to experience a convergence of factual memory and fictional daydream similar to my own internal dialog in creating this work."

© Maggie Taylor. *Home Again*, 1999. Iris inkjet print. 15 × 15 inches.

paintbrush, or drafting tools can be done on a computer.

The computer is a powerful device for experimenting with ideas and design. But the computer is not always the best way to produce an image. Images stored on silver-based film still contain more information than most digital media does. Presently few digital media can compete with film in terms of cost, archival keeping qualities, and economical storage. If no significant image manipulation is being planned, the wisest course of action may be to continue using silver-based methods.

Electronic Imaging: Digital Cameras

Electronic still photographs made their public debut in the 1960s with the NASA

space and lunar landing images. Now electronic and computer technology is utilized in most amateur and professional photographic cameras to carry out functions from focusing to determining flash-fill. The arrival of affordable consumer equipment in the late 1990s, capable of producing photo-quality images, made digital cameras viable replace-

Figure 12.3 The advantages of using a digital camera include the convenience of a reusable film supply and the ability of getting instant feedback after taking a picture. To create this scene, Georgiou photographed a mountain scene made out of cut construction paper in the studio with a digital camera. The captured image was stored on a smart media card inside the camera, transferred to a computer, and manipulated in PhotoShop. The final work was printed on an Epson inkjet printer using Epson inkjet paper. Conceptually, such work raises the issue of what makes up photographic reality and truth in the digital era. (See Color Plate 7.)

© Tyrone Georgiou. *Sunrise Paper Mountain*, 2000. Variable-sized digital file.

ments for film-based models. This shift began in 1986, when Canon introduced its first fully integrated professional still video camera system (SVC). The camera was slightly larger than an equivalent autofocus 35 mm SLR camera and used a floppy disk instead of film to electronically record each exposure. The disks could store 50 field-quality (low-resolution) or 25 high-resolution images. Resolution is the granularity of the display or output and is usually presented in dots per inch (dpi) and pitch (the width of the dots).

Today most camera manufacturers produce digital cameras. Digital cameras, like video cameras, use a charge-coupled device (CCD) to translate brightness (the intensity of reflected light) into electronic signals. The camera's internal converter then digitizes the signals and the picture information is saved on electronic storage media or can be sent directly to a computer connected to the camera.

Although an SVC may resemble a film-based camera, there are major differences that can significantly affect the nature of the image. The CCD sensors in many digital cameras can capture a wider range of colors than color films. Colors such as blues, dark greens, or fluorescent colors, which are difficult to accurately capture on film, are recorded and reproduced more accurately on a CCD. The CCD cells in digital cameras make it possible to photograph in extremely low light without a tripod or additional artificial light. Digital cameras also have enhanced telephoto capabilities. Since the size of the cell area receiving the image signal is much smaller than a typical 35 mm negative, a 50 mm lens for a regular 35 mm camera has the approximate effect of a 200 mm telephoto lens. This quadrupling (4×) effect drastically reduces the cost of telephoto power.

The output resolution of CCDs, which is comparable to edge sharpness or detail in a film image, is determined by the number of light-sensitive pixels that convert light into electrons in the camera's image sensor. A pixel or picture element is one of the tiny points of light that make up the image on a computer or television screen. The greater the number of pixels—that is, the smaller and closer together they are—the higher the resolution. Film is still superior to CCD-

captured images in its ability to deliver high image quality. High-resolution 35 mm color slide film can contain 20 million pixels of information. Current consumer-quality digital cameras have a resolution of about 2,048 × 1,536 pixels, which produces an image of approximately 3.3 million pixels or 3.3 megapixels in size (a megapixel equals a million pixels). Professional digital camera backs currently make images of about 2,048 × 3,072 pixels that produce an image approximately 6.3 megapixels in size. The resolution quality of digital cameras is improving at a rapid rate, and in the near future should surpass film in image quality and cost-effectiveness.

Digital Manipulation

Using a digital camera to take a traditional picture does not take advantage of the medium's inherent strengths. It is the construction and ease of alteration that separate the digital image from the conventional photograph. When we look at digital images, some of the things we take in are these differences.

The camera and the computer are mediated ways of seeing. Historically, the camera was assigned the role of an automatic neutral observer that made no subjective assertions. Its job was to act as a stand-in and report what you would have seen had you been there yourself. The digital image does not act in this capacity. On the contrary, the informed viewer knows that the digital image is predicated on fabrication, which can come from a multitude of sources. This changes the role of the photographer from that of a witness to that of an information designer.

At the beginning of the twentieth century, psychiatrist Sigmund Freud sparked a paradigm shift in how human behavior could be understood with his *The Interpretation of Dreams* (1900) and techniques like free association, which allowed material repressed in the unconscious to emerge to conscious recognition. During the 1920s and 1930s, surrealist artists such as Salvador Dali, Max Ernst, and René Magritte reacted to these ideas and began to incorporate them into their work. Among their practices, these artists distorted time, scale, and perspective while juxtaposing everyday objects in unusual contexts. In these images viewers are pressed to forge connections they would not normally make. Many computer artists are now reacting to how technology is changing our culture. By bending and blending different types of media and altering the context and/or content of images, these artists prompt viewers to make associations that are normally not possible or that are difficult to produce with traditional photographic methods.

The Defining of an Aesthetic

The computer provides a junction between photography, video, animation, illustration, painting, sound, and music in a way that changes the viewer's response to each separate medium. As computers become more omnipresent, the way that people see, think, and work will change and their reaction to computer-generated images will also shift. What was strange and fascinating five years ago may now seem mundane. The forging of an aesthetic involves the discovery of a medium's advantages and limitations, understanding how the public interprets and understands the medium, and how these factors work together.

Although the paths of traditional and digital media are linked, they ask fundamentally different critical questions that require a new digital aesthetic. Just as photography changed how the world was seen and the role of art and the artist, the computer's ability to integrate diverse media is once again altering those definitions.

As a digital aesthetic develops, the notion of craft as well as the knowledge and skill the maker brings to the physical nature of the work is being redefined. In digital work the processes once considered as craft can appear to be appropriated by the machine. This may be the computer's greatest asset and also a source of criticism that can split digital work from the traditional dialogue of art.

Some people still naively consider the computer a magic box that can make them instant artists. It is necessary to understand that computers work by human direction and do not accomplish tasks on their own. Without human guidance the computer

will apply a preprogrammed set of solutions to every problem. Each decision that artists allow computers to make can take them further away from the creative imagemaking equation. Even on a computer, worthwhile images usually take time, effort, and thought. The computer is just another device in the artist's tool kit. As with a hammer, you have to get the proper size and type for the job and then learn how best to hold it and what, where, and when to strike.

The Computer and Popular Reality

The first time digital image manipulation came to public attention was in February 1982 when *National Geographic* magazine repositioned one of the Great Pyramids at Giza to make a horizontal image fit its vertical cover format. Although the editors claimed they did not intend to alter the underlying meaning of the subject, their failure to acknowledge that the image had been reworked upset readers who placed

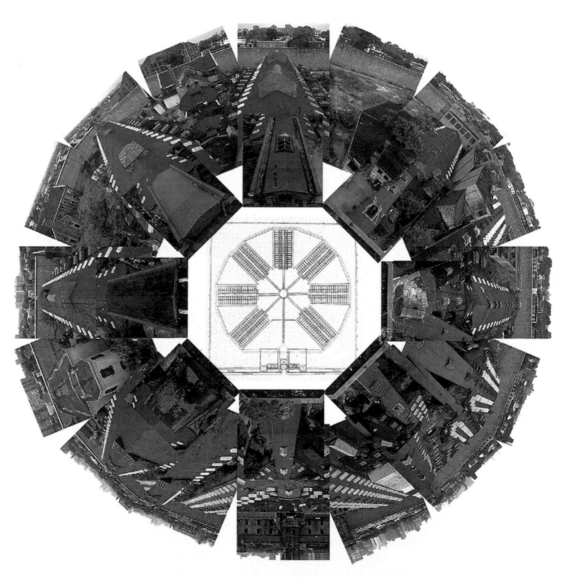

Figure 12.4 Tobia comments that, "Like physicists, photographers work with the space/time continuum. They isolate points in space and moments in time, recording their notations on frames of film or in electronic chips." *Eastern State Penitentiary* demonstrates this concept by creating a 360-degree view of the Eastern State Penitentiary, which was designed in 1827 as a model for reforming prisoners. The now-closed penitentiary was photographed from its central guard tower and 22 separate images were composed in PhotoShop to produce this circular panorama.

© Blaise Tobia. *Eastern State Penitentiary*, from the series *Model of Models*, 1997. Iris inkjet print. 32 × 32 inches. Original in color.

their trust in *National Geographic* to deliver what they considered to be classically accurate photographic representations. This retroactive repositioning cut the photograph from the tethers of Henri Cartier-Bresson's "decisive moment" in which a subject is frozen at a peak of visual drama. Now an image could time travel and not be anchored to a specific space or time. The decisive moment of the future may not be when the picture was made, but when it was modified. A new role of many photographers will be to provide the raw visual material from which a new class of image designers will construct the final content.

In 1988, *Life* magazine displayed the capabilities of digital manipulation by making a nonexistent political event appear to be a reality. This was done by taking three different photographs made by three different photographers at three different times and locations. The photographs were of U.S. President Ronald Reagan, Israeli Prime Minister Yitzhak Shamir, and Palestine Liberation Organization chairman Yasser Arafat. These images were used to create a new second-generation original composite of the three leaders in an apparently friendly get-together. The image conveyed the idea that peace was at hand. Looking at the finished composite in *Life*, the average reader would have had no way of knowing that this was a fictional event if *Life* had not clearly spelled it out in the text accompanying the picture. As a result of these incidents, the public began to question the authority and veracity of the images that appear in newspapers and magazines.

DIGITAL ETHICS AND COPYRIGHT

The outright manipulation of photographic images can be traced back to the dawn of photography with Hippolyte Bayard's *Self-Portrait as a Drowned Man*, 1840, which was a metaphor of his lack of recognition for his photographic discoveries. Before the widespread use of computers the average viewer had an unwavering trust in photographs as accurate representations of reality. Although image manipulation has been common in advertising during the twentieth century, most people accepted it as an illustration of an idea or fantasy and not as a fact. Even though newspapers published photographs that were modified through framing and cropping, readers had confidence that their local publisher could be trusted to bring them a true representation of the event being pictured. Digital editing permits multiple sources to be seamlessly combined and dispenses with a master matrix. This has caused people to question the truth of photographically based images and has produced a crisis of what is real.

The ethical lines of electronic manipulation have just begun to be drawn and the credibility of the photographic image in journalism has forever been changed. Issues of ownership and control of images are still governed by existing copyright laws. Legally, ideas, procedures, or methods, cannot be copyrighted—only a fixed or tangible form of expression is protected by copyright. Generally one can assume that if an appropriated image is so far removed from the original that it is unrecognizable, then the new image is not an infringement of copyright law.

Since October 31, 1988, images no longer need a copyright notice to have copyright protection. Copyright applies to both published and unpublished works. The 1976 Copyright Act gives the copyright owner the exclusive rights to reproduce and display the work publicly. According to federal law, the copyright owner has the exclusive right to reproduce or modify the work and has the right to exclude others from using the work. In addition, certain one-of-a-kind visual arts and numbered limited editions of 200 or fewer copies have additional moral rights in which rights of attribution and integrity are assured. The right of attribution requires that artists are correctly identified with their works and that works created by others are not attributed to them. The right of integrity also allows artists to protect their works against destruction and modifications that are detrimental to their honor or reputation. Even if the artwork is sold the artist maintains moral rights over the work. For further information, request Circular 96, Section 201.25, "Visual Arts Registry," from the Library of Congress, Copyright Office, 101 Independence Ave. S.E., Washington, D.C. 20540.

Photographers have spent the last few decades fighting to define and protect the legal status of the photographic image. With photographic images created in the United States, copyright generally belongs to the

Table 12.1 Policies Regarding Image Manipulation in Journalism

"As journalists, we believe the guiding principle of our profession is accuracy; therefore, we believe it is wrong to alter the content of a photograph in any way that deceives the public. We believe photojournalistic guidelines for fair and accurate reporting should be the criteria for judging what may be done electronically to a photograph. Altering the editorial content of a photograph, in any degree, is a breach of the ethical standards recognized by the NPPA."

—Revised by the NPPA Board of Directors on July 3, 1991

"Never distort news photos or video through digital manipulation of content beyond image enhancement for clarity; montages and photo illustrations should be labeled."

—The Society of Professional Journalists Code of Ethics

"The newspaper should guard against inaccuracies, carelessness, bias or distortion through emphasis, omission or technological manipulation."

—Associated Press Managing Editors Code of Ethics, Revised and Adopted 1995

person who pressed the shutter. In some situations, such as with many photojournalists, the image may belong to the newspaper or client who paid for its production (known as work for hire). During the 1990s, photographers, editors, and publishers have been debating the issues of electronic manipulation of images and creating guidelines governing their use. Professional groups such as the National Press Photographers Association (NPPA), the Society of Professional Journalists, and the Associated Press have included statements about image manipulation in their member's code of ethics.

Even after these codes of ethics were agreed on, manipulated images appearing in newspapers and magazines continued to cause controversy. In June 1994, *Time* magazine placed a darkened image of accused murderer O.J. Simpson on the cover with the headline "An American Tragedy." The magazine's detractors said that *Time* had darkened his face to make him appear more menacing and also imply a racist subtext. This was not the first time *Time* had altered the cover photograph of their magazine. The September 29, 1975, cover of *Time* showed a

recently arrested Patricia Hearst with the headline "Apprehended." The image was taken from a mug shot, but the shadows around her eyes were darkened and lapels were added to her collarless smock (the changes to Hearst's photograph were made without the use of a computer).

On the positive side, digital imaging has brought more people of varied backgrounds into imagemaking, thus expanding creative possibilities, offering more varied cultural viewpoints, and a wider variety of outcomes. Commercially, pictures are more accessible and affordable. Stock picture agencies such as Corbis/Bettmann Archive use CD-ROMs and Web pages to store and disseminate digitized images which can be retrieved or sent directly to a client for inspection and approval. Generally these images are first sent to the client in a low-resolution mode. These images are not suitable for reproduction or have an embedded watermark that cannot be removed from the image until payment is made to the agency; once payment is arranged, high-resolution images can be directly downloaded and used.

Photography is making a momentous technical leap from a chemical process to an electronic one. As technology evolves, so do the ethics and rules of imagemaking. The majority of photographers will have to adapt or be left behind.

CREATING DIGITAL IMAGES

Although programmers attempt to simulate a tactile experience with programs that replicate an airbrush, paintbrush, or pencil, they are still virtual imitations which respond differently than material tools. One problem new digital imagemakers encounter is the inability to apply their real-world intuition to the computer-made image. When working with any new tool, the operator must develop a set of intuitive actions based on interaction with the machine, and the computer is no exception.

Unlike its fixed analog cousin, the digital image is intangible because information on a computer is never truly in a permanent state. Due to its immateriality the computer image is in a constant state of flux, waiting to be changed on command. Only the printed

image can be thought of as being in a fixed form.

Image Resolution

A computer, like film, offers a variety of resolutions for different applications. Films with an ISO of 50 deliver finer grain than films having an ISO of 400, but there is a tradeoff; the lower ISO films require more light, slower shutter speeds, and maybe a tripod. When working with a digital image you exchange image quality for speed and hard drive space. Large, high-resolution images require additional processing time and more hard drive space. Every computer-generated image contains a fixed number of pixels, which are measured in pixel height and pixel width in a Cartesian coordinate system. A Cartesian system mathematically represents the relative position of points in a plane or in space in coordinates that locate a point on an X, Y plane which permits geometric questions to be mechanistically resolved. The total number of pixels is part of the equation that determines the file size, or the amount of data, in the image.

How the Screen Approximates Resolution

The average monitor has a resolution of 72 to 78 pixels per inch (ppi). Image resolution, along with the size and setting of the monitor, determine how large an image appears on-screen. A basic 13-inch monitor displays 640 pixels horizontally and 480 pixels vertically. Larger 17-, 19-, and 21-inch monitors can be set to display a greater number of pixels, for example, from the basic 640 by 480 pixels, where the pixels may appear large, to 1,600 by 1,200 pixels, at which setting the pixels will appear small. Regardless of the resolution of the image, the monitor will not show a resolution greater than 72 or 78 ppi. Most image processing programs will describe the size of an image in terms of a ratio displayed in the title box at the top of the screen. A ratio of 1:2 means each screen pixel equals two image pixels. Although two images may appear as the same size on the screen, their resolution and

therefore their relative size may be different, making cutting and pasting difficult.

Pixels, Lines, and Dots

The building blocks of the digital image, picture elements (pixels) are arranged as a grid on a monitor. Pixels create an image in a very different way than do the dots in a halftone image or the grains of silver in a black-and-white photograph. Like the individual tiles in a mosaic, each pixel is actually a solid color value that the computer creates when it converts an analog image into screen pixels in a process called *rasterization*. Each pixel contains complete information about hue, lightness, and saturation of a particular point of an image. The more pixels that comprise an image the finer the image will appear and the larger the file size will be.

A common point of confusion is to use pixels per inch (ppi) and dots per inch (dpi) interchangeably. When an image is outputted, the printer can only use dots of ink or toner on a printed page (see Chapter 13). The number of dots per inch (dpi) that an output device produces is proportional to, but not the same as, the number of pixels that make up an image on-screen.

Lines Per Inch

Lines per inch (lpi) refers to the resolution used in printing. When images are printed they are screened. Traditionally this was done by laying a transparent halftone screen made up of a dot pattern over film before exposing it. This reduced the continuous-tone image to a series of differently sized dots that could then be printed with text using a single color ink. The dots were arranged in rows or lines, and the term lpi referred to the number of lines per inch. The higher the lpi, the smoother the shades look. Most images are now screened using an imagesetter, but the principle remains the same. An imagesetter is a high-quality printer, usually found at a professional service bureau, that can output on film or photographic paper at resolutions of 2,400 dpi or higher (see Chapter 13).

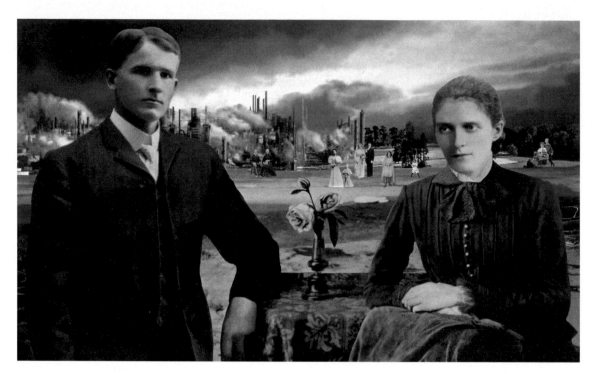

Figure 12.5 Lopez uses the nineteenth-century portrait and landscape, and digital media to communicate her interpretation of the human experience. "By extracting people from their original context and then placing them into fabricated landscapes, I hope to retell a story of their being, one that allows the images to acquire a life of their own." Although Lopez is inspired by her personal experience, she uses images of unknown sitters to tell the story, suggesting that the family album is part of a collective memory. (See Color Plate 8.)

© Martina A. Lopez. *Revolutions in Time 1*, 1994. Dye destruction print. 30 × 50 inches. Courtesy of Schneider Gallery, Chicago. Original in color.

Stochastic Screening

Stochastic screening involves creating dots on film using randomizing software. This software uses a series of mathematical formulas to randomly distribute the dots that make up a printed image under a fixed set of parameters defined by the image. Images printed using stochastic screening more closely resemble continuous-tone originals. Since the dots making up the image are randomly distributed (like the grains of silver in film) moiré patterns are eliminated and greater image detail and smoother tonal gradations are possible. With the moiré pattern problem solved, almost any number and combination of colors can be used to create images. Finally, stochastic image electronic files can be smaller than conventional files, taking up less storage space and still yielding similar results.

Stochastic programs have been in use for years, but require a great deal of computer memory and processing power. This tech-nology has become more practical with today's more affordable and powerful computers.

Bit Depth

Color on a computer is dependent on the number of bits (the smallest unit of information on a computer) available to describe the color and shade of each pixel on the screen. *Bit depth* refers to the number of bits used to define a pixel's color shade. The greater the number of bits (2 4, 8, 16, 24, or 32) the greater the number of colors and tones a computer can simulate.

Bit depth is governed by a special set of memory chips, called video RAM or VRAM, which is dedicated to displaying text and graphics. If a computer does not have enough VRAM to display a particular color it can perform a function called *dithering*. Dithering is only possible if the software permits it and the user selects it. By placing

Table 12.2 Bit Depth and the Number of Possible Colors

Bit Depth	Number of Possible Colors
1	2 shades (black-and-white)
2	4 shades of black-and-white
4	16 shades of black-and-white
8	256 colors
16	65,536 colors
24	16.7 million colors
32	16.7 million colors

different-colored pixels next to one another the computer can produce up to 5,000 colors in a way that is similar to CMYK (cyan, magenta, yellow, black) printers. On a monitor these images often produce a noticeable moiré pattern, which can be distracting.

True Color

The minimum requirement to provide reasonably natural looking color reproduction of complex images is 8 bit. True color, sometimes known as 24-bit color, allows the reproduction of up to 16,777,216 possible colors, well beyond the range of human perception. Many computers offer a 32-bit color mode that is actually 24-bit color with an 8-bit alpha channel. The extra 8-bit (1 byte) alpha channel is used for additional control and special effects information.

Gamma Correction

"It didn't look that way on my computer!" This may sound familiar if you have ever looked at an image made on one computer and viewed on another. The change is more pronounced with images made on different systems (PC, Mac, or Silicon Graphics Systems). In the early days of television it was discovered that the television tubes did not produce a light intensity that was proportional to the input voltage. Since early television cameras produced output voltage proportional to subject intensity, scenes often looked too dark in the mid-tones. Eventually television standards were applied to the camera signal to correct for the nonlinear gamma of television sets. Computer monitors also have a nonlinear response to the voltage sent to the monitor and the intensity

that it produces. Images that appear correct on one brand of display screen might have mid-tones that are too bright or colors that have shifted on a different brand or model. This is due to the difference in each display's gamma. A common symptom of uncorrected gamma is the appearance of dark red flesh-tones on Caucasian subjects.

Standards for the television industry were established almost forty years ago, but it was only in 1993 that a common set of color standards was created for computers by the International Color Consortium (a group of computer hardware and software manufacturers). Some computer systems and displays contain instructions in their hardware that correct for monitor gamma. However, these values do not completely compensate for gamma but only partially compensate to produce a gamma that closely matches the response of a particular default printer. An image gamma correction is necessary to accurately control brightness and color.

COLOR CONVERSION/ COLOR MATCHING

Color management has been a difficult issue to reconcile in desktop printing. Light transmitted from a monitor is perceived differently than light reflected from paper. The intensity is varied, and the colors have a different saturation. To compound these difficulties, diverse imaging devices like display screens, printers, and scanners each use different colors to create images. Monitors and scanners use the additive colors of red, green, and blue (known as RGB) while printers use the subtractive colors of cyan, magenta, yellow, and black (CMYK). As a result, they are only capable of producing or reproducing color within a specific range and cannot exactly reproduce each other's colors. Since each device uses different colors, gamma must be corrected and colors must be converted from one color system to another. Color conversion and color matching are processes of shifting the colors (usually on the monitor) to ensure that they remain faithful from one device to another. Computer operating systems (the program that runs the computer) now include color management programs to assist in color matching, but to get the most accurate color

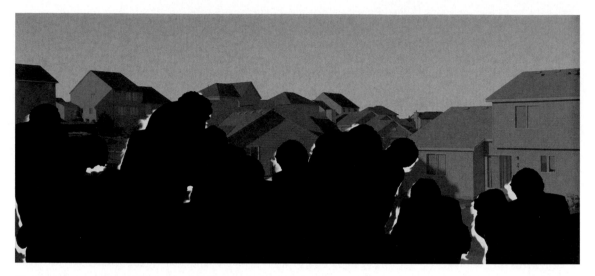

Figure 12.6 Image files moved between computer platforms may result in images that look "off color." Working with the color profiles and color spaces in PhotoShop allows Hallman to maintain the color values of images generated on a Macintosh when they are transferred to a PC for large-format inkjet output. Hallman's work combines the images of idealized suburban homes with the uniform of the business suit to explore masculinity, home and work life, and power. The computer screen acts as the proscenium for this work, fusing photography's articulation of reality with the fluid pixel technology of transformation. (See Color Plate 9.)

© Gary Hallman. *Karoshi Corona*, 1996. Pigmented inkjet on rag paper. 48 × 24 inches. Original in color.

the computer must be calibrated by the user. Software and hardware are available that contain profiles of monitors and output devices and procedures that guide the user in calibrating the computer system.

Color Systems

Depending on the type of machine and monitor, and the amount of video memory or VRAM (see section on memory) available, it is possible to manipulate millions of colors on the computer. Image processing programs allow color manipulation in several distinct ways, the most important being the RGB setting. All video monitors represent color by displaying minute RGB bars. Other on-screen colors are computer simulations or approximations of these color schemes. In addition to color, images can be produced as a gray scale, which produces 256 shades of gray, or images that are purely black-and-white (see the section on Raster/Bit-Mapped Software).

RGB
All monitors use an additive color system in which red, green, and blue (RGB) are added

to make white. Any combination of the light primaries will always produce a lighter result. 24-bit color is really made up of red, green, and blue with 8 bits devoted to each, creating 256 different levels for each color. The secondary and intermediate levels are created by mixing combinations of RGB that result in 16.7 million possible combinations.

HSB, HSL, or HSV
In painting, a palette is a physical surface where an artist mixes colors before applying them to a support which has traditionally been canvas. Digital imaging software has its own set of virtual palettes. One of these is hue, saturation, and brightness (the terms *luma* or *value* can be used interchangeably with brightness). HSB is a mode that allows you to directly adjust the hue, saturation, and brightness by inputting specific values or through a graphical representation of a color wheel. Hue values are often graphed on a circle with pure red as 0 degrees. The other primary and secondary colors are located at 60-degree increments from red. Saturation (defining the extent to which a color is a mixture of white) and brightness are expressed in terms of percentage values on a range of 0 to 100.

CMYK

Process colors cyan, magenta, yellow, and black (CMYK) are the ink colors used in printing presses, inkjet printers, and all other dye- or pigment-based output devices. Values in CMYK mode are expressed as percentages (0–100) of intensity of these pigments. When switching from RGB to CMYK the computer often dulls the screen colors to simulate a subtractive print.

Indexed Color

When an image is converted to indexed color the imaging program builds a color lookup table based on a palette of 256 colors (8 bits per pixel). In this table every pixel is assigned a color number. This allows all pixels with the same number to be changed at the same time by altering only a single variable. If a color in the original image does not appear in the table, the program matches the color to the next closest color in the table. Using indexed color lets you reduce the file size of an image, but limits the range of image manipulation and editing that is possible.

MEMORY

RAM

When a program is begun, its contents are loaded into the primary memory of the computer, also known as Random Access Memory (RAM). RAM is for temporary storage of information and program execution. All data, information, and instructions the computer needs to perform its tasks are stored and sent to be processed in a series of solid-state memory chips. Easily expanded, the amount of RAM in a computer directly affects its capabilities and performance. RAM is volatile, meaning that data in it will disappear if power is interrupted, hence the need to frequently save work in progress.

Many computers and programs allow the use of virtual memory, in which the computer uses the hard disk as RAM. Virtual memory allows computer systems to use large programs and open files that will not totally fit into RAM. This process is extremely slow when compared to using real RAM.

ROM

Permanently installed in the computer, Read Only Memory (ROM) contains the most basic operating instructions for the computer. ROM is nonvolatile and is used to hold instructions that are needed quickly and that must not be lost during power outages, such as instructions for starting the computer and drawing objects on a screen.

Hard Disk

The hard disk is designed for long-term or permanent storage of information such as applications and files and is larger but slower than RAM. Since image files are often larger than the available RAM, some software applications create a "scratch disk" on the hard drive to temporarily store information. The program shuffles information from this hard disk (the scratch disk) into RAM, where it is processed. This enables the program to complete complex operations and functions such as undo and preview. The scratch disk can take up to twenty times as much space as the original image because it stores several different versions of the image. However, the computer's hard disk must have enough free space to accommodate these temporary files.

How Much Memory Do I Need?

Most software applications include minimum memory requirements in their printed material. However, more memory may be required to effectively run a program. It is prudent to research programs before purchasing them and make sure your machine has enough memory to run a program. This is critical when working with more than one program open at a time. One major factor that has made specific computer models inefficient is their inability to add more RAM.

SOFTWARE

Without instructions about what to do, a computer is a blank slate. Software can be divided into two main types: system software (operating system) and application

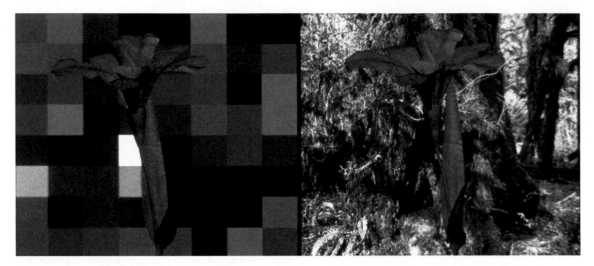

Figure 12.7 The artist team MANUAL uses various software programs to create their images. In *Olympia*, MANUAL scanned a stereo pair of 6 × 7 cm negatives taken in a redwood forest and then reduced one of the images to a pattern using the mosaic filter in PhotoShop. An iris flower form was constructed in the 3D modeling program form•Z and then rendered as a virtual stereo pair of irises. The surface texture of the iris was derived from the crosscut grain of an actual redwood log. MANUAL plays with the contrast between the materialistic view of nature as pure resource and the hyperreal view of the virtual world, which ignores an exhausted, degraded nature and favors the seduction of electronic screen-based systems. (See Color Plate 10.)

© MANUAL (Suzanne Bloom and Ed Hill). *Olympia*, 1999. Iris inkjet print. 17 × 35¼ inches. Courtesy the Moody Gallery, Houston, TX. Original in color.

software (programs). System software, such as Windows®, Mac OS®, or Linux®, provides the basic instructions that determine everything from how images and text appear on the screen to what kinds of programs can be run. Application software includes all the programs that enable you to accomplish tasks such as creating images, word processing, doing your taxes, and sending e-mail.

Images created on a computer do not have to be photo-based. The software program's own internal tools, coupled with devices such as graphic tablets, let you simulate the effects of other media as well as create unique digital images. Since computers are dependent on the instructions contained in software applications to carry out their functions, a variety of software programs may be needed at different stages in the imagemaking process to achieve the desired results.

Imaging applications can be classified under the following categories: animation, draw, interactive multimedia authoring or scripting, image processing, page layout, paint, 3-D modeling and rendering, and video editing. Some software applications specialize in one of these areas, and others combine two or more feature categories. Currently there is no single consumer application software capable of performing all of these functions well. A single application can provide adequate tools for an imaging project, but it is often necessary to combine the strengths and tools of other software to create desired effects.

Raster/Bit-Mapped Software

Most programs that process photo-based pictures operate with raster (bit-mapped) images. Raster or bit-mapped images are made up of a mosaic of color squares (pixels). The advantage of the bit-mapped image is its ability to be edited pixel by pixel. Pixel-based images are created by painting programs such as Adobe Photo-Shop® and Corel Photo Paint®. Photo-based or raster image programs do not keep individual objects as separate entities. Items must be applied to a layer, at which time any alteration will affect surrounding areas, replacing data or leaving holes. Increasing the size of an image increases the number of pixels, spreading out data. Reducing the size

of an image eliminates pixels and may reduce image quality. File sizes for raster/bit-mapped images can be very large compared to vector-based images, depending on the resolution (ppi) and the number of colors in an image.

Vector Graphics Software

Vector graphics (object-oriented) programs offer a wide range of options for manipulating lines and polygons. Designed for drafting and illustration purposes, vector software such as Macromedia Freehand® and Adobe Illustrator® are not ideally suited for photo-realistic images. Using a series of vectors, areas of color can be created by mapping out an area to create a shape such as a line, square, or circle. Vector graphics programs treat objects as separate entities that can be colored, stacked, resized, or moved without affecting the background or any other object. Fonts are drawn with vectors so they can be scaled and colored with ease. File sizes for vector images are small because a large area of color can be described by defining a set number of points that create a shape and coloring it.

MAJOR FILE TYPES

It is essential to know how to store information, and different file types are best suited for specific applications. The following are the major file codes that allow the computer's finder to identify the nature of a particular file.

TIFF

An acronym for Tagged Image File Format, TIFFs are currently the standard in the graphics field. Known as an interchange format, it is usually easily opened on any platform (Mac or PC) and is considered one of the most versatile file formats for storing data and exchanging images between application programs without losing information. TIFF files offer several compression options that may inhibit a file's ability to be opened by other platforms and can cause a loss in image quality.

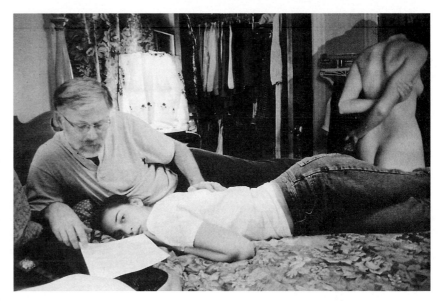

Figure 12.8 "These images are part of a family series which has focused on my younger sister and first cousin. I am both illustrating metaphors of my own coming-of-age story while interpreting theirs. Digital processes have allowed me to pair different times and generations in ways which aptly realize themes of self-awareness, inherited constructs of femininity, and emerging adult strength." Harper combines multiple scanned images using a program called Live Picture that allows her to work with very large files. After all the layers are flattened and the color is calibrated, the images are saved as TIFF files and sent to a digital photographic printer.

© Jessica Todd Harper. *Dad and Becky*. 1999. Chromogenic color print from digital file. 30 × 40 inches. Original in color.

PICT

Encoded in the Macintosh's native graphics language, PICT is the default file format for images on a Macintosh and can also be opened on the PC platform. This file type can hold separate raster and vector layers and easily crosses the border between raster and vector image programs. PICT files may not be the best file format to use in graphics applications because they are prone to corruption and are interpreted by some software applications as color separations. The original PICT format developed by Apple Computer in 1984 supported 8 colors, but the current version handles 32-bit (16 million plus) colors.

EPS

Short for Encapsulated PostScript, EPS files were designed for saving high-resolution illustrations on Adobe software. The EPS format is a vector file that can also contain

raster information. The format uses the Post-Script page description language, a programming language optimized for printing high-quality graphics and text, to draw an image. EPS files are difficult or impossible to alter. EPS files normally include a small, low-resolution TIFF or PICT image (depending on the computer) that serves as a graphic representation of the image as it will appear on a printed page.

EPS files can contain both images and text, but they rely on the fonts installed on the computer. In order to display or print as designed, the same fonts must be installed on the computer that will be opening the EPS file as were on the computer that created the file. If you are using a service bureau, they must have the same fonts on their system before they output the file or you can save or embed fonts in the EPS file when you first save it.

Raw

Raw files are straight binary files with information pertaining only to one color. Raw files can be difficult to work with and may destroy data if not correctly configured. Their main advantage is their ability to open up many unknown file types.

PSD

A program-specific format created by Adobe for PhotoShop, the PSD format can store 1-, 8-, 24-, and 32-bit images. This file type will allow multiple image layers and can be compressed. Images may also be stored as CMYK or RGB data.

Program-specific file types are native formats, written to be opened by a specific software program, that contain the maximum amount of information pertaining to an image. Several times larger than similar files, certain operations can only be conducted on a file saved in its native format. To change the file type to a non-native format, the image must be streamlined, layers combined, and certain formatting information eliminated.

Compression Algorithms

Compression algorithms, a set of program instructions, allow the user to compact or segment a large file into smaller pieces that can more easily fit onto storage media. There are many types of file compression schemes; some cause files to lose information, others compress files without sacrificing information. Before using any type of compression software, be sure you know how it will affect your image.

No Loss Compression

These programs create an archive of a selected file in which the information describing the item is converted to a form that takes up less space. When the file is used again it must be uncompressed, a process that returns the file to its original state. There are a number of these software applications, such as Zip, Compact-Pro® and Stuffit®, and each has its own advantages and disadvantages.

JPEG Compression

The Joint Photographic Experts Group (JPEG) is a 24-bit color and 8-bit gray scale lossy compression, meaning that a compressed image will not be the same as it was before compression. JPEG refers to a group of compression algorithms, not to a specific file format. The JPEG algorithm takes the redundancy out of an image by manipulating tonal values. This compression technique mathematically represents similar tones and filters out an image's high-frequency information as a way of saving space. JPEG offers several choices governing compression size and quality. Repeated compression will cause rapid degradation of image quality. For best results compress an image only once.

GIF 89A

Graphics Interchange Format (GIF) has become the most common compression method for graphics on the World Wide Web. GIF compression does not record information about each individual pixel of an image. Instead it records the information about a pixel, then how many pixels of the same color follow. GIF images must be converted to index color, and GIF works best on images with relatively large areas of solid colors. GIF compression is lossless, meaning that all data is restored when the image is opened. The GIF 89A format can be used for animation effects and allows one color to be specified as transparent. GIFs can also be interlaced so that the image

becomes progressively clearer during downloads, thus allowing users to see something before the entire image has been transferred.

STORAGE MEDIA

In addition to hard drives, there are expandable and portable devices that can aid in the storage and transfer of information. In the 1970s and early 1980s, the 5¼ inch floppy disk and the smaller 3½ inch disk were the standards for storing files. Each 5¼ inch disk held 400 to 800 kilobytes (KB), and the 3½ inch disk stored 1.4 megabytes (MB or 1,433 KB) of information. In that era a word processing file might require 8 KB, so it was possible to keep a software application and a small number of files on a single floppy. Today an image file can easily need 20 MB, which would require most high-quality images to be spread out on multiple disks to be moved. Floppy disks are also not the most reliable storage medium and are not recommended for long-term storage of data. New storage devices are continually being developed and improved. The following have made a major impact on the digital medium.

Magnetic Media

Floppies, Iomega Zip disks, and Imation's 120 MB SuperDisk, among other storage devices, all use high-density magnetic media similar to that found in audiotapes. Newer and larger devices use enhanced read/write heads designed to increase disk capacity. Iomega's Zip and Zip 250 drives which hold 100 MB and 250 MB, respectively, have become the standard for sharing and archiving files.

Magnetic media are not an ideal choice for reliability and long-term data storage as magnetic tape breaks down from exposure to air, heat, and humidity. Research on the longevity of magnetic media predicts an average life span of about 5 to 10 years under normal storage conditions.

CD ROM

Currently compact disk read only memory (CD-ROM) disks hold over 650 MB of data

Figure 12.9 The *Card-Plate Series* is composed of 14 prints, each of which contains 10 to 25 individual "cards" arranged in a grid. Each card is composed of multiple images from the artist's own digitized photographs, drawings, old found photographs, and computer-generated objects created and rendered in 3D. The images, created in a variety of software programs, are assembled in PhotoShop and are kept in up to 20 separate layers so they can be adjusted and manipulated separately. This type of work can create images with very large file sizes. Recordable CD-ROMs are a convenient way to move and store large images.

© Paul Berger. *Card-Plate Series*, 1998/1999. Iris inkjet print. 30 × 22 inches. Original in color.

and are the industry standard for the commercial distribution of software and large amounts of data. CD-ROM writers (CD-R) are available for one-time imprinting of disks where data cannot be altered once imprinted. Newer CD-ROM writers (CD-RW) can write to a single disk up to 99 times. CDs

are one of the most archival means for saving data and allow files to be copied with ease. CD-R and CD-RW have now become popular media for low-volume publishing and distribution of data, as well as mass storage and long-term archiving.

The use of a permanent-marking pen to write on the CD label is not recommended because the solvent in the pen may penetrate the label and protective layer causing deterioration in the layers that contain the digital information.

Magneto Optical

Through the use of a laser, magneto optical (MO) or erasable optical drives can store data by changing the polarity of small portions of the disk. These storage devices, with capacity up to 1.3 gigabytes (GB), have the advantage of being rewriteable and archival. Optical media are susceptible to damage from high humidity, rapid and extreme temperature fluctuations, and contamination from airborne pollution, but MOs are not susceptible to magnetic fields or read/write head crashes, and do not deteriorate like magnetic media. An MO disk may be the best choice for people concerned with archival storage. Some optical disk manufacturers promise life spans of up to 100 years while others estimate a more modest life span of at least 30 years. The MO disk is the only digital medium considered by some conservators to begin to address the issues of archival standards. Media longevity of this length may be a moot point for most people, since the current disks will most likely outlast the software and computer systems capable of reading and displaying information recorded on them. Until an archival digital standard is created that can be read by a machine a hundred years in the future, proper analog storage still reigns supreme.

DVD

A DVD (digital video disc) and a CD look the same, but a DVD's storage capacity is at least six to seven times greater than a CD's. A single DVD can store between 4.7 gigabytes in a single-layer disc, or up to 17 GB in a double-sided disk. This storage capacity is achieved by using both sides of the disk and by storing two layers of data on each side. DVDs have become popular for playing movies with very high-quality video and audio (two to three times greater than with a VCR tape). DVD Read Write (RW) drives are still too expensive for the consumer market, making them an impractical storage solution for most users, but prices will likely fall and their use will increase.

DIGITAL POSSIBILITIES: COMPUTER AS MULTIMEDIA PLATFORM

The Moving Image

In 1824, the English scholar Peter Mark Roget wrote "The Persistence of Vision with Regard to Moving Objects." The paper described how the human eye retains an image for a fraction of a second longer than the image is actually present. Roget's finding led to the development of motion pictures. Moving images address time in a different way than a still image does. With video the viewer tends to be involved within the flow of events, while the still image is an abstraction or distillation of a subject that calls for a more concentrated viewing and interpretation.

Computer programs generally handle moving images in two ways: as cell animation programs as in Macromedia Director®, or as nonlinear video editing programs as in Adobe Premier® and Apple Final Cut Pro®. Most of these programs use a timeline or score that allows the user to jump from one point in the video or animation to another, make cuts, and move clips.

Cell animation programs, which are vector drawing programs, manipulate discrete objects and create the illusion of motion by showing sequential frames with incremental motion. In a vector or object-oriented graphics program an image is made up of individual, mathematically defined objects, rather than a collection of bits. The cell elements can be independently controlled, allowing the background to remain stationary while objects in the foreground display motion.

The assembling and editing of video images on a computer is known as nonlinear video. Software packages edit sound and

video by creating fragments called clips. These clips can be manipulated and saved as computer files such as QuickTime® on the Macintosh platform or AVI (Audio Video Interleave) on Windows. A clip of video can be combined with sound, previewed, and altered. Incorporating a series of compression schemes, QuickTime movies allow moving images and sound (time-based data) to be created, stored, and viewed. Quick-Time movies keep the sound properly synchronized with the picture, compensating for the speed of the computer. With the advent of programs like QuickTime, photography is no longer about a fraction of a second and a particular segment of space, but becomes a compendium of sights and sounds.

The Still Image

Still images can be integrated into a multimedia format. PhotoShop is the software program by which all other still imaging manipulation programs are judged. It is regularly updated and therefore it is desirable to obtain the most current version and its manual for the latest working instructions.

The Three-Dimensional Image

Three-dimensional modeling programs are vector drawing programs that have the ability to render an object and simulate the effects of light. The completed object can be viewed from any angle and direction. Three-dimensional modeling programs are often coupled with an animation component, which allows the piece to be presented as a movie.

HYPERTEXT AND THE WORLD WIDE WEB

Despite the Internet's recent emergence as a medium, more than one-half of all Americans already have some access to the Internet. There is no way to determine the exact number of Internet users, but according to the Reuter's News Agency the number of active Internet users will climb to 350 million by 2003. The Internet has affected

Figure 12.10 Pfahl looked to the eighteenth-century British guidebooks of the picturesque movement for inspiration and instruction on creating this image. Traveling to locations described in the guidebook *The Search for the Picturesque* by Malcolm Andrews, Pfahl created his own variation of the picturesque landscape described in the book. Pfahl photographed with a 4 × 5 inch camera and scanned the resulting images into a computer and manipulated them to simulate the appearance of a picturesque period watercolor drawing. Pfahl also inserted a row of enlarged pixels that span the length of the image to draw attention to its computer-assisted construction. This device prevents these images from becoming a twentieth-century realization of the picturesque ideal. (See Color Plate 11.)

© John Pfahl. *Airey Force, Lake District, England.* 1995/1997. Iris inkjet print. 16½ × 13 inches. Courtesy of Nina Freudenheim Gallery, Buffalo. Original in color.

the way business, commerce, entertainment, publishing, and personal communication are conducted, and all occupations are affected by computers and computer-mediated communication.

Figure 12.11 Beginning with a traditional photograph, Towery digitizes, manipulates, and outputs his images on a large digital plotter using archival inks. Mounted onto canvas or plywood, the images are treated with polyurethane or shellac to protect the surface of the inkjet print from the encaustic, oil paints, and mixed media he uses. "The technique stems from a frustration with the purely digital creative process," Towery explains. "The lack of physical interaction with the pieces prompted this extension of the creative process back into the more traditional painterly process. The combination of traditional painting techniques and digital processes is liberating and exhilarating. You might say they are post-photographic."

© Terry Towery. *Akimboish*, from the series *Figurative Decay*, 1999. Inkjet print with oil paint, charcoal, rust, encaustic, and shellac mounted on canvas. 30 × 40 inches. Original in color.

More artists and scholars are using the Web to share their artwork or information. Some artists see the Web as a burgeoning art form or a new type of artists' book while certain teachers view it as a new site for learning and research. Artistic Websites allow makers to conduct an extended dialogue with viewers. The digital artists' Website book takes that dialogue one step further by including elements of performance through images, sound, text, and video. Engaging Websites get viewers to participate by making choices that alter content or determine the outcome of a work and can be modified with each viewing. Web pages can be created using any word processing program that can write HTML code (see next section). Other programs are designed specifically for designing Web pages and allow the user to work more intuitively.

The basic elements of every Web page are described next.

HTML

HTML (HyperText Markup Language) is a simple generic language used to create platform-independent pages on the World Wide Web. HTML can be read and made viewable on your computer monitor by a Web browser running on any machine or operating system.

Links

A link is either a line of text or an image that the user may click on to go somewhere else on the Web. Links enable you to "turn the pages" of a Website, tie in multiple documents, and reference Websites in other parts of the Internet.

Images

Images destined for the Web can be created using any image-based software application or may be scanned from a photograph or other artwork. For images to be viewed on the Web they must be converted to a format the browser can read such as JPEG or GIF.

THE END OF THE WET DARKROOM?

The reasons for using any process should be embedded in the context and purpose of the work. Any method, including silver-based photography, will continue to be used as long as imagemakers find it a meaningful method of expression. In the future, economic and environmental pressures may make traditional silver-based film hard to find, but by then the technology and the audience also will have changed. The quality and variety of digital images will continue to increase, and as this occurs the digital image will become more embedded in our daily lives.

Digital data is a prelude to a much larger change in consciousness. It marks a shift from the continuum of the Newtonian model to that of the quantum world of discrete packets of energy. Analog photography can be considered in Newtonian terms, which

record the visible world. Digital imaging takes us into an ambiguous quantum universe where the observer becomes part of the outcome, distance is imaginary, and probability is the only sure thing.

Existence becomes both actual and fantastical, with photographers able to forge links among people, events, and objects that do not even exist in the Newtonian world. Photographers will no longer just stop time but will fragment, manipulate, and synthesize it in ways that will make our previous worldview inadequate. Photography will be less rigid and objective and more flexible and subjective. This offers the potential to increase the possibilities of imagining and understanding the world in new and different points of view from that of the mechanical age.

ADDITIONAL INFORMATION

Books

Aker, Sharon Zardetto, et al. *The Macintosh Bible*. Seventh Ed. Reading, MA: Addison-Wesley Publishing Co, 1998.

Bosdogianni, Panagiota. *Image Processing: The Fundamentals*. New York: John Wiley & Sons, 1999.

Grotta, Daniel, and Sally Weiner. *Digital Imaging for Visual Artists*. New York: Windcrest/McGraw-Hill, 1994.

Lovejoy, Margot. *Postmodern Currents, Art and Artists in the Age of Electronic Media*. Second Ed. Upper Saddle River, NJ: Prentice Hall, 1997.

Mitchell, William J. *The Reconfigured Eye: Visual Truth in the Post-Photographic Era*. Cambridge, MA: The MIT Press, 1994.

Ritchin, Fred. *In Our Own Image: The Coming Revolution in Photography*. Second Ed. New York: Aperture Foundation, 1999.

Spalter, Anne Morgan. *The Computer in the Visual Arts*. Reading, MA: Addison-Wesley Publishing Co., 1999.

Weibel, Peter and Timothy Druckery. *Net_condition: Art and Global Media*. Cambridge, MA: MIT Press, 2001.

Weinman, Lynda. *PhotoShop 5.5/Image-Ready 2.0 Hands-On Training*. Berkeley, CA: Peachpit Press, 2000.

Digital Input and Output 13

WHAT IS DIGITAL IMAGING?

This chapter addresses the major practical functions of digital imaging such as the capturing of images and different output options. It does not discuss the vast and volatile area of specific tools used by individual software programs. Some of the topics in this chapter assume basic knowledge of software programs like Adobe PhotoShop®. This text gives some basic instructions on how to open specific menus in the program, but is not designed for novice users. As in the rest of the text, the reader is expected to have a solid working knowledge of a program before undertaking a digital project.

During the 1990s, computers and their users made large economic, technical, and theoretical strides. As computers became less expensive, faster, and easier to use, they began appearing in more businesses and homes. Computers also became a regular feature of the artists' studio. As artists gained experience they no longer had to start from zero on the learning curve with every new software program version. Instead they were able to accomplish more tasks in less time and devote additional energy to thinking about just what this thing called digital imaging is. Many talented artists were able to take their working concept or vision and find the digital means to achieve their goals. By the late 1990s, some of these artists were approaching digital imaging with an outlook of integration. They no longer saw digital imaging solely as a segregated category, but as one of many applications that could also be combined with analog methods to achieve their vision realizations.

INPUT AND OUTPUT

In analog photography a poorly exposed or improperly developed negative will produce an image with inferior contrast, detail, and tones. So too in digital imaging, the quality of the initial capture or scan determines the characteristics of the final image. This next section will help you to get the highest quality from your images.

Digital Cameras

Digital cameras are the most direct method of capturing images for digital manipulation or printing. Combining the mechanics of cameras and the technology of scanners, digitally captured images may be stored on a disk within the camera and later transferred to a computer, or the camera may be directly connected to a computer and the image transferred as the picture is taken. Exposure times in digital cameras can vary from a fraction of a second to several minutes, but depending on the camera and the lighting conditions, the effects of a long exposure to capture movement or light may produce different results in digital cameras

as opposed to film cameras. Digital cameras come in two styles: the all-in-one digital camera or the scanning back. Both of these devices use charged-coupled device (CCD) technology to capture still images just as flatbed and transparency scanners do. Scanning backs connect to traditional large- and medium-format cameras, taking the place of film. The camera makes the exposure and the scanning back converts the image into digital data.

Using a digital camera to take a traditional photograph does not take full advantage of digital imaging's inherent strengths. It is the way the image is made and the ease with which alterations to it can be accomplished that separate digital imaging from analog photography. These differences are taken into consideration when we view, evaluate, and give meaning to digital images.

Video Capture

Internal video cards and other external devices can convert a video signal to a format that the computer can process. These devices can capture (grab) images from broadcast television or videotape. As the individual video image is only on the screen for a moment and does not need to be of high resolution, screen capture images will also generally be low resolution. The exception to this rule is digital video (DV). FireWire (also referred to as IEEE 1394) was originally developed by Apple Computer as an extremely high-speed input/output device for connecting peripherals to a computer. FireWire allows high-quality capture, editing, and playback of video from DV devices such as a digital camcorder or digital camera without the use of an expensive video capture card. Older analog-only equipment can be connected using a converter. Since 1995, digital video camcorders have been made with tiny DV/FireWire connectors.

Using a capture technique, imagemakers can use video cameras to collect original material. Specially designed video capture cameras (often called array cameras) are capable of producing higher-resolution images. Although commercially broadcasted images are copyrighted, artists interested in commenting on popular culture and the media often use these images (see the section in Chapter 12 on copyright).

Scanners

Scanners are input devices that take information from printed or photographic materials in a manner similar to that of a

Figure 13.1 Georgiou combined a scanned NASA image with live capture video images on an Amiga computer. The images portray common household items such as electrical outlets or twist ties to examine how contemporary values become archaeology by succeeding generations.

© Tyrone Georgiou. *Untitled Lunar Landscape Composite* from the series *Discovery*, 1993. Variable-sized digital file.

photocopier. Light is reflected off (or through) an image or object and is interpreted by light sensors. Color scanners use red, green, and blue (RGB) filters to read an image in single or multiple passes. Although the detail captured by scanners is excellent, most scans need to be corrected to adjust color or contrast, or to crop an image.

Flatbed Scanners

Flatbed scanners, capable of digitizing images in a variety of resolutions, are the most common way to digitize a document. Flatbed scanners use a CCD, similar to those in digital cameras, that captures light reflected from the original scene and stores that light as RGB pixels. These devices allow the user to preview the image and make corrections in color balance and contrast before scanning. Although designed to digitize prints, some flatbed scanners have adapters for the scanning transparencies. This adapter provides a light source behind the transparency that enables the scanner to see the image.

Transparency Scanners

Transparency or film scanners allow you to scan 35 mm to 4 × 5 inch film. By transmitting light through an image, these dedicated transparency scanners (they cannot scan flat art) are designed to capture the minute details of film. Using CCD technology, a transparency scanner typically produces high-resolution output of between 2,400 and 4,800 ppi. These devices usually cost more than flatbed scanners, but are designed to treat transparent media with greater precision and care than do flatbed scanners with transparency adapters. High-end transparency scanners have improved and are beginning to come close to the quality of drum scanners (see the following section).

Drum Scanners

Drum scanners were the first electronic devices to digitize images and they are currently the most precise way to digitize flat media. Instead of using a CCD, as do flatbed and film scanners, drum scanners have a set of three Photo Multiplier Tubes (PMTs) which are more accurate than scanners that rely on CCDs. Drum scanners are sensitive to a wider dynamic range (the tones the scanner can record) and can sense the

extremely light or dark tones that CCDs would register as only black or white. During scanning the image is read on a glass drum while being spun at several thousand revolutions per minute. As the drum spins it is slowly advanced past the three PMTs, which register information on the three primary scanning colors (RGB) one row of pixels at a time. These high-end scanners work with both prints and transparencies and can scan color and black-and-white originals at high resolutions (4,000+ dpi). The resolution of a drum scanner is determined by the precision of its optics and mechanics, whereas the resolution of a flatbed scanner is dependent on the density of the optical cells in the CCD sensing array. Another important distinction is that drum scanners can achieve their highest resolution over the entire area of the drum whereas flatbed scanners achieve their highest resolution only in a centrally located area of the scanning bed.

Oil Mounting High-resolution drum scans make any defects in original transparencies more visible. At high magnifications, minor scratches, lint, pits, and surface imperfections become very apparent. In oil mounting a liquid conducts dirt away from the film and saturates dust particles so they become almost transparent and do not refract light. It will also help reduce Newton rings, rainbow-like patterns that are caused by the interference effect of light reflecting within the extremely small space between the highly polished glass drum and the transparency.

Many prepress shops offer oil mounting with scratched or very high-level enlargements. The transparency is mounted between the drum and a sheet of clear acetate sandwiched in a clear silicone oil that has the same refractive index as the film base material. The silicone fills scratches and defects in the transparency so that they do not show in the scan and prevent Newton rings from forming. Mounting oils and gels can flatten the contrast of images, which will have to be corrected after the scan. Because the scanner and the transparency must both be cleaned after the scan, not all prepress shops offer oil mounting.

Scanner Resolution: Optical Resolution

Optical resolution refers to the physical number of pixels per inch (ppi) the scanner

can sample. This is measured, like a grid, by the number of pixels captured on the horizontal and the vertical axes of the scanner bed. The horizontal axis is determined by the light-sensing diode's sensitivity and precision. The vertical axis is determined by the speed at which the scan head moves.

A scanner that has an optical resolution of 600 × 1,200 ppi contains an array of CCD optical cells that are spaced 1/600 inch apart horizontally. During scanning the CCD array is moved down the length of the bed with a stepping motor. In this case, the scanning motor can stop vertically in 1/1,200-inch steps. The actual resolution of this image is really the smaller of the two numbers (600 ppi). More detail doesn't result from scanning more frequently in only one direction. If the user selects a resolution higher than 600 ppi the software will *interpolate* the image to create the greater resolution.

Interpolated or Enhanced Resolution

Interpolated resolution is software-enhanced resolution. Unlike optical resolution, which measures how many pixels the scanner actually samples, interpolated resolution adds pixels to an image through a series of programmed assumptions. Using mathematical algorithms, scanning software generates additional pixels in between each pair of optically scanned pixels. These additional pixels are approximations based on known values of the scanned pixels. Interpolated resolution approximations do not add more detail than optical resolution does and the process, except in the instance of line art, usually diminishes the quality of the scan.

Scanning Basics

Halftones

As discussed in Chapter 12, pixels on a computer monitor create an image in a different way than the dots in a halftone image or grains of silver in a black-and-white photograph. Most printing devices have a problem in reproducing continuous-tone images because they can only create individual dots on paper or film. In a process known as *halftoning* a printing device, such as an inkjet, laser printer, or imagesetter, produces

Figure 13.2 Selter uses a flatbed scanner instead of a camera to create images that examine the relationship between technology and animals. For this image, Selter placed animals on a flatbed scanner and performed a scan at 200 pixels per inch (ppi). The combination of the moving animals and the moving scanner bar results in a unique pattern of motion that Selter says describes "the essence" of that animal. "I began to see that each kind of animal [scanned] produced a pattern somehow typical of its type of locomotion."

© Carol Selter. *Chicks*, 1997. Chromogenic color print. 16½ × 23 inches. Original in color.

shades other than black, white, or solid colors by printing dots in clusters that have white space between them. To simulate various tones, the clusters vary in size with large clusters forming darker tones and smaller clusters, with more white space between dots, creating lighter tones.

What Resolution to Scan?

Knowing at what resolution to scan your images requires that you first know the output resolution of the device you are using to produce your negatives (or prints) as well as the scale of the image. Halftoned images do not use all of the pixels available to create an image. Depending on the tonality of the image, the halftoning process eliminates half or more of the available information in the original image. The rule of thumb for prints that will be output as halftones is to use twice the resolution of the halftone screen.

Images that are going to printed at a larger scale than the original should be scanned at

Figure 13.3 Using a computer, Itagaki combines the traditional with the modern, bringing together Eastern and Western culture. "In contemporary Japan, tradition and technology co-exist side by side in everyday life, often in startling juxtaposition. Geishas wearing elaborate kimonos teach businessmen how to use the Internet in Kyoto. A high-speed bullet-train whizzes past a rice paddy where farmers in straw hats tend to their crops." To produce large images with fine detail Itagaki scans his images with drum and film scanners. Once the images are scanned they are combined in Adobe PhotoShop. He then produces a 4 × 5 inch negative using a film recorder so the images can be printed on chromogenic color paper. (See Color Plate 12.)

© Yoshio Itagaki. *Mushroom Hiroshi meets John Wayne in Cyberspace*, 1996. Digital file. 40 × 30 inches. Original in color.

Figure 13.4 Nettles' autobiographical photographs deal with the poetic impact of certain landscapes on her life, and how these places remain in her memory, resurfacing at unexpected moments. Nettles creates linotronic (imagesetter) film negatives of her images which she contact prints on Luminos 16 × 20 inch charcoal paper. The number of gray tones a halftoning device such as an imagesetter produces is limited by the maximum number of dots per inch (dpi) an output device can produce. Imagesetters measure output in lines per inch (lpi), which refers to the frequency of the screening pattern in a halftone. The lower the lpi, the coarser the look of the image. Nettles outputs her images at 150 lines per inch (equivalent to 2,400 dots per inch), which produces a full 256 shades of gray.

© Bea Nettles. *Geometry*, from the series *Return Trips*, 1999. Gelatin silver print. 16 × 20 inches.

a higher resolution. For example, if you are going to print an image at 200 percent of its original size on a desktop color printer, and want it to have 200 lines per inch (lpi) resolution, you will need to scan at 400 lpi. Alternatively, if you will be printing at 50 percent of its original size, you only need to scan at 100 lpi.

Exposure: The Curve Tool

Most imaging software has a curves function that allows the user to simultaneously control density, boost the contrast between colors, and balance color. Curves can also be used to adjust an image to a specific output

device. Set up as a graph, the horizontal axis of the curves tool represents input levels and the vertical axis represents output levels. By adding points to the line that stretches from the lower left-hand corner (where both input and output are 0) to the upper right-hand corner, you can change the brightness of individual color channels (RGB or CMYK) or alter all channels simultaneously to adjust tonal balance.

What makes the curves adjustment especially powerful is the ability to load and save curves that you have created in the past or load curves that were created by another imagemaker. Using curves created by another imagemaker can be an important learning tool that allows you to see how other imagemakers have corrected for the dichotomy between the way images appear on a monitor and the way they appear when outputted. Individual curves have been created by imagemakers that adjust the image to print out on a variety of machines and processes including inkjet, gelatin silver, and platinum prints. For more information on preparing images, see *Making Digital Negatives for Contact Printing* by Dan Burkholder.

Sharpening

Most images that have been scanned have the tendency to look soft and need to be sharpened. The unsharp mask or sharpen filter can sharpen the image by increasing the contrast between adjacent pixels. This filter allows the imagemaker to adjust the sharpening of the image according to three variables: amount, radius, and threshold.

- *Amount* is like a volume control, determining how much darker and lighter the edge borders become.

- *Radius* controls how far from each pixel the program will look for tone differences. Radius values that are too high can cause halos around objects.

- *Threshold* specifies how far apart adjacent tonal values have to be (values of 0–255) before the unsharp mask effect is applied. Low values have a greater effect because fewer areas are excluded. Higher threshold values exclude areas of lower contrast.

Figure 13.5 As an Indian born in Kuwait and living in the United States, Thomas feels that he is in a continuous cultural negotiation with the dominant culture around him. "I am drawn to those places where borders (both physical and psychological) exist in culture, art, and my constructed identity; I choose to investigate these from the interstices." After scanning his images Thomas adjusts their levels, hue, and saturation. If colors are too dark or light or the mid-tones are weak, the levels adjustment allows him to adjust brightness and contrast, and color-correct an image. Using a graph called a histogram, the level controls allow Thomas to add or subtract light, dark, and mid-tones to an image. In the histogram pixels of the same tonality are stacked on top of each other, and arranged from black on the left, to white on the right. Images with a normal contrast range will have a histogram that extends from full black on the left, to full white on the right.

© Prince V. Thomas. *After Dark Skin, White Mask*, from the series *Interstitial Spaces*, 1999. Chromogenic color print. 21½ × 32 inches. Original in color.

OUTPUT DEVICES: PRESENTING THE DIGITAL IMAGE

Film Recorders

Film recorders take a digital image and download it onto ordinary color or black-and-white photographic film, allowing the images to be handled as a traditional photograph or combined with other imaging techniques. The basic components of film recorders are a flat-faced cathode ray tube (CRT); a color filter wheel with red, green, blue, and neutral filters; a lens to focus the image; and a film transport with a shutter to expose the computer-generated images. The lens and type of CRT used in film recorders allows a broad range of colors to be produced. Most film recorders support between 4,000- and 8,000-line resolution. High-end digital film re-

Figure 13.6 "Fascinated with the enigma of abnormality, I combine parts of different faces and bodies to create characters with peculiar appearances. I look for physical expressions that reveal a sense of truth about my character's state of mind and being. I often create children and adolescents because they exist in a state of disingenuous grace and innocence that evokes compassion and sympathy in the viewer." After manipulating and collaging his images Johan outputs his file to a 4 × 5 inch film recorder that produces traditional 4 × 5 photographic negative film. "I can print the negatives in a traditional darkroom at various sizes using Ilford fiber-based photographic paper and tone them using Berg Sepia Toner. This gives me archival prints and a photographic grain and quality that contributes to a deceptive sense of familiarity and nostalgia that contradicts the general expectations of most computer-manipulated imagery."

© Simen Johan. *Untitled #73*, 1999. Toned gelatin silver print. 19 × 19 inches.

corders electronically compensate for the color shift that occurs when an image from a CRT is scanned onto a piece of film.

Imagesetters

A laser imagesetter is an output device designed for the graphic arts industry to create film that is used to expose printing plates. Imagesetters cannot produce continuous tones—that is, they are unable to make a pixel different shades of gray. Instead they create an electronic version of the traditional halftone screen by applying an electronic dot pattern to the electronic image. The halftone created by the imagesetter is made with a recorder laser beam focused on a point of silver-based negative film or paper. When the paper or film is developed, the area exposed by the laser beam is black. Most imagesetters found in service bureaus are capable of producing films with resolution of between 900 dpi and 4,800 dpi. Imagesetters can output film and images on photographic papers from 8½ × 11 to 12 × 18 inches. Imagesetter negatives printed at 3,600 dpi to 4,800 dpi are comparable to traditionally produced negatives and are ideal for creating negatives for contact printing.

Thermal Printing

Dye sublimation printers produce photorealistic continuous-tone images with RGB, CMYK, and gray scale images using the sublimation process. Sublimation is the scientific term for a process in which solids are converted into a gas without going through an intervening liquid phase. Instead of inks or toner the sublimation process uses solid dyes contained in a ribbon made of a plastic film. A thermal print head, consisting of thousands of heating elements, capable of producing 256 precise temperature variations, moves across the transfer ribbon, turning the dye into a gas and transferring it onto a piece of specially coated paper. The hotter the temperature of the heating elements, the more dye is transferred to the paper and the more intense the color saturation. The colors in a dye sublimation print are not laid side by side as in a halftone process, but are blended to create a continuous-tone print. Depending on the type of dye sublimation printer, support material (paper base), and storage conditions, these prints can last between one and ten years before fading is noticeable.

Printing with Ink: Types of Inkjets

Inkjet printers, as the name implies, work by spraying minute amounts of cyan, magenta, yellow, or black ink onto a page. As with

all plain-paper printers, better-quality paper will yield higher-quality images. Inkjet prints are impermanent and can, without protection, fade within a few months. In the past few years companies such as Lyson Ltd., Luminos, and Ilford have produced pigmented inks for inkjet printers that have been tested to last (without noticeable fading) up to 75 years or more on specific papers. Epson claims a print life of 100 years if displayed indoors and under glass. All print stability will vary depending on atmospheric, display, and humidity conditions as well as light intensity.

Thermal Inkjet

The most popular consumer desktop printers use thermal inkjet printing to produce images. Only certain types of ink may be used in these devices. Inside the print cartridge, ink is super-heated to about 400°F. As the ink heats up it begins to turn into vapor, which expands and explodes to force ultra-fine droplets of ink out of the print head's nozzles and onto the paper. This process is repeated thousands of times per second. Thermal inkjet cartridges contain both the ink supply and the print head.

Piezoelectric Process

The piezoelectric process does not utilize heat, but instead an electrical charge is applied to a small piezo crystal inside the print head. When a current is applied to these crystals, they change shape and squeeze the ink chamber, expelling ink from the nozzle tip. Because heat is not used, printers with piezoelectric print heads can use more archival pigmented and solvent-based ink formulations. These devices also produce very fine drop sizes, producing high resolutions.

Iris Printers

Similar to an inkjet printer, Iris prints are produced by spraying fine dots of CMYK ink onto paper. Created on a spinning drum, these gallery-quality prints can be made on a variety of archival materials that will accept ink. Designed for direct digital proofing for the printing industry, Iris machines can print images as large as 34 × 46 inches. The original inks used in these devices were not intended to be archival, but recently companies such as Nash Editions that spe-

cialize in making artists' prints have led the effort to create more archival dye-based inks for the Iris printer. Currently, depending on the types of inks and paper, Iris images have a life span ranging from as little as one to two years to decades.

Resolution on an inkjet printer is not easily defined. An inkjet printer with a resolution of 1,400 lpi may not produce as fine a print as a dye-sublimation printer at 300 dpi. Depending on the printer, each pixel can be printed as a single spot of color or as a cluster of many smaller spots of color. For inkjet printers, the accuracy with which this is done and the size of the ink drops determine the quality of the print. What makes Iris printers so desirable is their ability to produce up to 32 different-sized dots on a

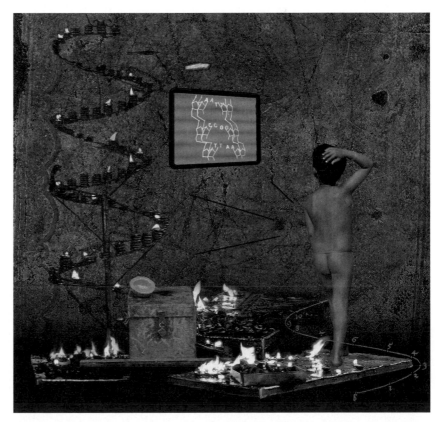

Figure 13.7 Concern with permanence led Parker to send her images to Nash Editions, the world's first fine art digital printmaking studio. Run by musician and photographer Graham Nash, Nash Editions was one of the first commercial printers to address the fading and deterioration of inkjet prints. Parker describes digital imaging as still being in a primitive state. "Now that there is freedom to create almost anything, the question is what to create? Often people are so busy playing with the new toys that the result is a game of 'see how many filters or how many separate images can comprise one picture.' Play is necessary to art, but so are ideas."

© Olivia Parker. *Within and Without, 1999*. Nash Digital inkjet (Iris) print. 28.4 × 29.8 inches. Courtesy of Robert Klein Gallery. Original in color.

page, giving them an effective resolution comparable to an 1,800 lpi printer.

Permanence of Inkjet

Permanent inks are made from pigments, and nonpermanent inks are usually made with dyes. Dyes are made up of organic materials and are more susceptible to fading than are pigments made from inorganic substances. Most of the cyan, magenta, and yellow inkjet inks sold for the consumer market are dye-based and will fade in a relatively short time.

The type of paper an inkjet image is printed on plays a major role in determining the brightness, color saturation, density, ink drying properties, tone, and image permanence. Fully pigmented inks used with matched photo papers have been extensively tested by Henry Wilhelm's Imaging Research and have been shown to last more than 100 years (some more than 200 years) before noticeable fading will occur when displayed

under glass in typical indoor display conditions. These results are only valid with the inks and matched papers; using one without the other can produce images that will begin fading within years or even months of printing. Inks used in inkjet printers, being water-based, remain water-soluble after drying, making them vulnerable to moisture. Print Guard, made by Lyson, is a clear, spray-on lacquer that provides a water-resistant coating and can greatly reduce the fading of magenta inks, which are the most fugitive and most susceptible to UV light. However, Print Guard should not be used with laser and dye-sublimation prints since it contains an isopropanol solvent that will cause these prints to run.

Some inkjet printers employ a six-ink system that uses diluted, low-density magenta and cyan inks along with full-concentration cyan, magenta, yellow, and black inks. This allows a greater number of dots to be laid down in the mid-tones and highlights of an image, enhancing smoothness of tones and color saturation while reducing visible dots in the highlights. However, with certain papers the six-ink systems provide two to three times less image stability than do four-ink printers using the same inks.

Giclée

Giclée is French for "squirt" and has become synonymous with inkjet. Some imagemakers and art dealers who are looking for a term as a reference to fine art printing on inkjet printers have chosen to call their work giclée. Many of these imagemakers use archival papers and inks or matched ink and papers, but the use of this term is not regulated and can be used for prints that have a potential life span of either months or centuries.

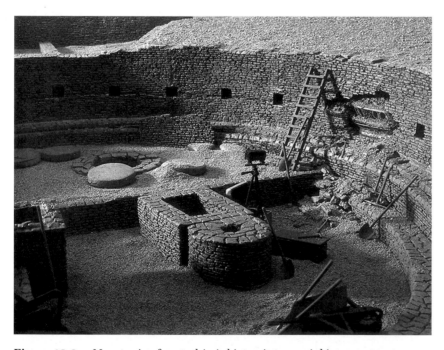

Figure 13.8 Nagatani refers to his inkjet prints as giclée as a way to show that he uses state-of-the-art archival materials, inks, and coatings in his digital work. Dealing with issues of history, archaeology, and how the photograph is recognized as a window on the real, Nagatani explores the elements of archaeological evidence and questions how scientific discourse and the photographic record claim to hold the truth. In this series of images Nagatani is constructing an alternate reading of the past, and alternative stratigraphy of truth and illusion.

© Patrick Nagatani. *BMW, Chetro Ketl Kiva, Chaco Canyon, NM, U.S.A.*, 1997/1998. Giclée (Nash Editions) print. 32½ × 42½ inches. Original in color.

Lightjet and Lambda Prints

Some digital imagemakers wish to manipulate their images on a computer but they also want to produce a print on photographic paper. In the past these imagemakers had to use a film recorder to produce a negative and then go into the darkroom to produce a print. Durst has developed the Lambda printer and Cymbolic Sciences has made the LightJet digital printer, both of which are capable of

Figure 13.9 Continuing their investigation of the struggle between nature, culture, and technology, MANUAL explores the gap between representations of idealized landscapes and the recorded evidence of human ambivalence toward the land. "The masculine arm on the right pulls the curtain aside to reveal nature, but the two figures within the scene are more interested in telecommunications and archeological musings than the realities of their surroundings." MANUAL composited image material in PhotoShop from multiple 6 × 17 cm and 6 × 7 cm negatives and computer-generated elements such as the obelisk topped by a sphere and two large simulated rocks which have been rendered in the software programs form•Z and Bryce 3D, respectively.

© MANUAL (Suzanne Bloom and Ed Hill). *The Well: Scene 1*, 2000. Lambda produced chromogenic color print. 25¾ × 78 inches. Courtesy the Moody Gallery, Houston, TX. Original in color.

producing images on traditional color papers using RA-4 wet-chemistry processing. The machines are capable of producing 50-inch-wide images directly from a digital file on photographic paper using a three-laser (RGB) imaging device. Each system produces a continuous-tone image at up to 400 dpi, and because it uses standard photographic paper and does not use halftone dots, it produces images with an equivalent inkjet printer resolution of 4,000 dpi.

Toner/Electrostatic Printing

Using a laser beam to charge a photoelectric drum, laser printers utilize colored toners in a CMYK halftone process to make an electrostatic image. When the charged toner is attracted to the drum, it is transferred to the paper and sealed by a hot fuser roller. Laser prints produce black-and-white and color prints of photocopier quality (see Chapter 10).

Service Bureaus

Service bureaus, prepress shops, and some copy centers will scan images and download them onto paper, film, or disk. The quality of the output will depend on the skill of the operators as well as the type and maintenance of equipment. Many of the high-end devices that are capable of producing negatives for photographic printing such as imagesetters, film recorders, or Iris printers are available only through service bureaus.

Working with a Service Bureau

It is important to remember that service bureaus exist to serve the offset printing industry and may not be willing to take the extra time to create negatives to the exacting standards of photographic imagemakers. Being flexible and friendly can help in getting the machine operators to produce your negatives or images the way you want them. Most of the staff in these establishments will gladly tell you the capabilities of their machines and their specific requirements for file formats and storage media. Before visiting a service bureau to output a negative you should know the following information:

- *Medium (output) and size:* Do you need output by imagesetter or film recorder? Imagesetters are best suited for large negative output (8½ × 11 up to 11 × 17 inches). Film recorders can print onto 35 mm up to 4 × 5 inch film.

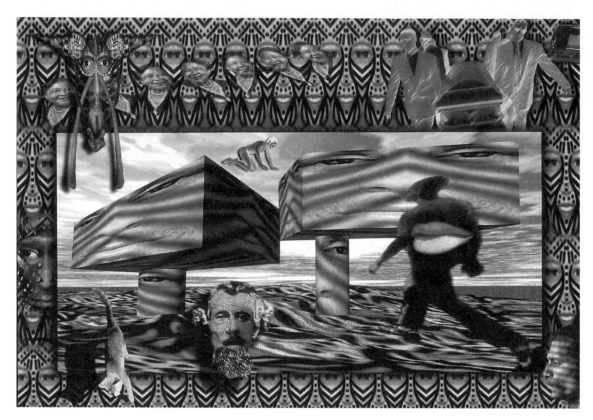

Figure 13.10 Stephen Marc's montages are constructed from photographs, images from the family archives, found antique photos, articles placed directly on the scanner, and objects created in the computer. Working closely with his service bureau, Marc has negatives or transparencies of his image created and printed. "Working digitally provides me with a creative way to extend my autobiographical/African diaspora exploration." Marc's images are held together by rich patterns made with sections of photographs or found objects. "The patterns are used to unite family imagery, relics, and memorabilia in much the same manner as household shrines such as story quilts, wall hangings, displays under the glass of coffee tables and dressers, and other domestic assemblages and installations." (See Color Plate 13.)

© Stephen Marc. *Untitled*, from the series *Soul Searching*, 1997. Dye destruction print. Variable-sized digital file. Original in color.

- *Software:* The service bureau should have the most recent version of the software you are using. In some circumstances the machine operator may need to open your file to make adjustments before printing.

- *Resolution:* For film recorders 4,000 lines is the standard resolution for 35 mm slides while 8,000- and 16,000-line resolution are used for $2\frac{1}{4}$ and 4×5 inch film sizes. Ask for the highest resolution possible and tell the operator that the image is intended for photographic enlargement. For imagesetters ask for 3,600 dpi or the highest resolution possible.

- *Screening (halftoning):* If it is available, ask for stochastic rather than halftoned negatives (see Chapter 12, Stochastic Screening). For photographic-quality images the lines per screen should be between 130 lpi for stochastic negatives at 2,400 dpi output and 300 lpi for a halftoned image at 3,600 dpi output. Remember that stochastic negatives do not require as large line a screen as halftoned negatives.

- *Negative or positive image:* Most photographic applications will require a negative. If you have already reversed your image in your imaging program inform the machine operator that you have done so.

- *Emulsion:* Imagesetters can print on either side of the film. For most applications you will want to print with the emulsion side *down.*

COMBINING DIGITAL AND TRADITIONAL TECHNIQUES

One of the most important innovations in the digital revolution that came at the end of the 1990s was the development of inexpensive, high-quality inkjet printers. In some instances these devices make it possible to go from exposure to final print without entering a darkroom. One of the main advantages to producing digital negatives is the elimination of masking, dodging, and burning during exposure. By using transparency film or paper to produce digital inkjet negatives, imagemakers can fine-tune their negatives not only to the image, but also to the individual process.

Inkjet Transparency: Film or Paper

For the first decade in the history of photography (before the introduction of the wet-plate process) the paper calotype was the only negative material in general use. With nonsilver processes that require exposure by UV light, paper is again the medium of choice. The plastic base of most inkjet transparency material is suitable for silver-based images, but it blocks some of the UV light, making it less suitable for nonsilver printing. Like the early calotype printers, digital imagemakers can use wax, mineral oil, or canola oil to make the paper negatives more transparent (after they go through the printer). It is also possible to print on a film base such as large-format Kodak TRI-X film or Ilford HP5PLUS that has been fixed without hardener and washed.

Waxing Paper Negatives

Following are several materials and methods for making paper negatives more translucent:

- Paraffin wax can be brought just to the melting point in a double boiler, an electric pan, or on a shallow cooking sheet. The back of the negative can be quickly placed on top of the wax and removed. The excess wax can be squeegeed off (an old credit card works well).

- Paper negatives can also be more transparent by ironing paraffin wax on the back of the paper between blotter sheets.

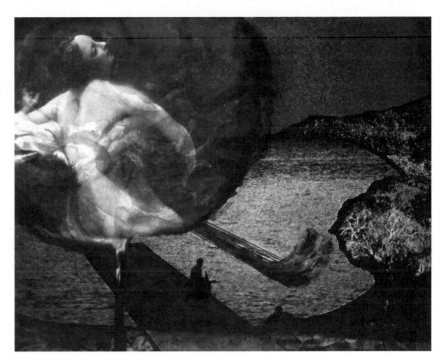

Figure 13.11 Referred to as "foto-projections" Goldring's images depict an Eastern and Western dream that appears to the viewer in the form of an apparition in a small fishing village on the southern coast of Sri Lanka. The images are produced by projecting fragments of slides onto a drawing and rephotographing the projections as layers on the surface of the drawing, thereby melding graphic and photographic information. Goldring uses a scanner to help her create each mask, deriving specifications from the original drawing. In this way she isolates small areas of each slide, which, when projected, correspond precisely to the drawing. The foto-projections are then printed in the darkroom. "Although the role the computer plays in this process is completely invisible, it nonetheless is critical to the end results." (See Color Plate 14.)

© Nancy Goldring. *At Sea, Io*, 1996. Dye destruction print. 30 × 40 inches. Original in color.

- Mineral, peanut, safflower, and sunflower oil can be used to make paper more translucent. Oil can be applied to the image using a cotton ball and the excess can be blotted off using paper towels.

Keep the exposure to heat to a minimum as it can cause accelerated fading in inkjet prints.

Colored Negatives for Monochrome Prints

One of the difficulties with using an inkjet printer to create a negative is the inherent difference between the physical density of grains of silver (used in analog negative materials) and ink. Silver is able to block visible and UV light from reaching a photo-

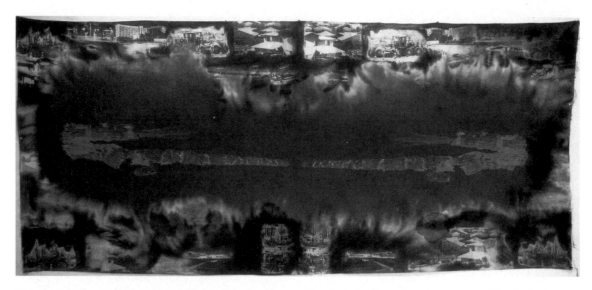

Figure 13.12 To create his large-scale cyanotypes Renfrow had to overcome several logistical difficulties. One of the challenges was making large negatives to be contact printed. After determining the size of the work, Renfrow used a computer to scan and alter the original 35 mm negatives using PhotoShop. The finished image was exported to Adobe Pagemaker and, using the tile option, individual transparency pages were assembled to make the large negative. An exposure was made in direct sunlight in a series of about 20 separate exposures of 9 minutes each. (See Color Plate 15.)

© Robert Renfrow. *The Shroud of Tucson*, 1999. Cyanotype on fabric. 43 × 96 inches. Original in color.

sensitive surface, but building up enough density with ink to produce the same effect can leave a puddle of ink on the negative. Toner from a laser printer has the physical density appropriate for a photographic negative. The problem is that the resolution of most laser printers is low compared to high-quality inkjet printers, which have the ability to produce a stochastic dot pattern and to microweave, a form of computer-generated feathering using inks.

The advantage inkjet printers have is the ability to use color. The primary advantage is that printing with colored ink provides a smoother dot pattern than printing with only black ink. The second advantage comes from the fact that most silver-based printing materials are not sensitive to the orange and red part of the spectrum. A spot of ink on an inkjet negative does not have to block all of the light hitting it, it just has to block the blue portion of the spectrum. Tinting a photograph so that the highlights and the mid-tones are the color of your safelight (or other color of your choosing) will produce spectral density that allows you to control both contrast and exposure. Experimentation is essential to find the hue

that will provide the desired contrast with your individual printer, on a specific printing material, and using a particular type of ink.

Colorizing Desktop Negatives

A gray scale image can be colorized by first converting the image to RGB color. Then select the appropriate color using the color pallet or by clicking the foreground color chooser. Be sure to choose a tone within the gamut of your printer (an out-of-gamut color will not print properly). The overall tone of the image can be changed in PhotoShop by going to the Edit menu and selecting Fill. Under the Contents window select Foreground Color, and under the Blending window set the Opacity at 100% and mode to Color.

For platinum and palladium inkjet negatives, using CMYK poses a different set of problems. Cyan is transparent and magenta is only slightly responsive to platinum and palladium emulsions, leaving black and yellow inks as the only ones that will act as an effective light resist. To create a digital image that will print with only yellow and black, change the mode of the image to

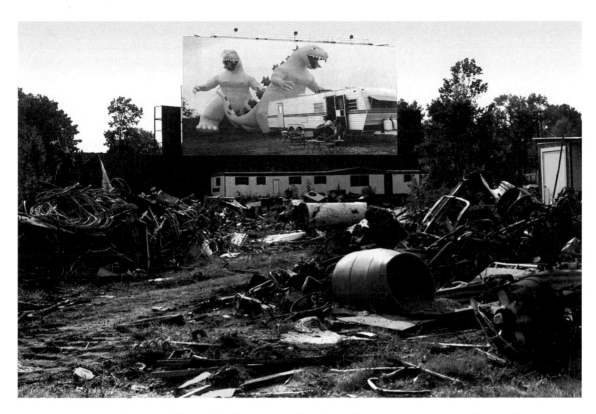

Figure 13.13 Nakagawa tells us that by "Using the PhotoShop, I paste images I have photographed onto the drive-in screen, a major American icon and symbol of the 'good life,' or onto the billboard, upholder of the American lifestyle. I begin with black-and-white photographs that I subtly color enhance to create nostalgic exteriors. The colors I use for these exterior spaces are duo-tones that allude to a sense of past. It is within these exteriors that I interject images onto billboards/drive-in theater screens that call attention to iconic images of American society, thereby creating quiet landscapes that are interrupted by harsh realities. By changing the context of familiar imagery to Americans, the viewer becomes an observer and is asked to question the ideology of the American Dream." (See Color Plate 16.)

© Osamu James Nakagawa. *Godzilla and White Trailer Home*, 1996. Chromogenic color print. 26½ × 40 inches. Original in color.

duotone. As a starting point select 100 percent black as one color and 50 percent yellow as the second color.

Making Desktop Negatives

1. Scan a negative or produce an original work on a computer. The file size of the scanned image (scaled to the same size as the final print) should be twice the resolution of the printed image. Remember: Most scanned images should be sharpened using "Unsharp Masking" in Photo-Shop, by going to Filters, selecting Sharpen, then Unsharp Mask.

2. Manipulate or edit a positive image as desired and adjust the contrast to the level desired in the final print. Some imagemakers add extra room above their image for a photographic step tablet to aid them in their printing or as a reference in creating their own image adjustment curves.

3. Apply a contrast correction curve. Photographic film and photographic emulsions have a nonlinear response to light. Human eyes and computers (and by default your printer) have a linear response to light. To compensate for this you must adjust the image to the way the emulsion "sees." This is referred to as the emulsion's characteristic curve (also known as the transfer function). Imaging programs such as PhotoShop have a way to adjust for the characteristic curve of an emulsion (see Table 13.1). In PhotoShop adjustments to the tonality of the image

can be created, saved, and loaded, with either the Adjust Curves or Transfer Functions tools. Curves made with one tool can be loaded and applied to the other. The Adjust Curves tool (in PhotoShop under Image → Adjust → Curves) can be used to visually alter the image, while the Transfer Functions tool allows an image-maker to enter specific numerical values for thirteen points on the curve. The Transfer Function, accessed through Page Setup, controls the way the printer deposits ink on the printed image. These changes will not be visible on the monitor and will have no effect on the image itself but will be applied when the image is printed. The Adjust Curves tool changes the way images look on the screen and how they are printed.

4. Invert the image. In PhotoShop, under Image → Adjust → Invert.

5. Colorize the inverted image. Choosing the best color for colorizing negatives requires testing. To test for an appropriate color, create a colored step tablet (see below) and print it on your inkjet printer. Contact print the step tablet and print it on your photosensitive paper. Choose the shade on the step tablet that creates the first clean white on your print and colorize your image with that color. For consistent results use the same printer, type of paper, and photographic materials.

6. Print out the negative on the inkjet printer. Print your negatives using color inks, even if they are black-and-white. Use the printer settings for photo-quality glossy film or the setting on your printer

Creating a Step Tablet

A gray scale step tablet can easily be created in PhotoShop. Using the rectangular marquee, select an area on the border of the image where you want the tablet to be created. Fill the selected area using a black-to-white gradient with the gradient tool. Posterize the tablet using the Image → Adjust → Posterize menu. The number of levels selected will determine the number of steps in the tablet. To produce a colorized step tablet, change the mode to CMYK color and repeat the procedure for creating a gray scale step tablet using red (95 percent yellow, 95 percent magenta, 0 percent cyan, and 0 percent black) as a starting point for the foreground color and white as the background color. Other colors can be tested and used as the foreground color to produce different results.

Table 13.1 Creating an Adjustment Curve

By creating a duplicate of the emulsion's curve you can adjust the negative in the opposite direction, bringing the nonlinear response of the emulsion and linear response of the printer into sync.

1. Create a colorized test image consisting of a negative image and large step tablet with at least 13 steps. Save it as "Image A" and print it out with your inkjet printer onto your intended negative material.

2. Save a copy of the test image file and label it "Image B" (File → Save a Copy). You will need to use this as reference in Step 7.

3. Make a contact print from the printed negative. Through testing, determine the proper exposure to get an absolute white and absolute black. Keep processing notes on paper, developer, and timing of your print.

4. Go back to your computer and open Image A and convert it to a positive image (Image → Adjust → Invert). Open the Curves dialog box (Image → Adjust → Curves).

5. Compare the image from your contact print to the image on the screen (Image A). Taking into account the differences between the screen image and the printed image, change the values needed to make Image A look like the print on photographic emulsion. Clicking on the line of the graph will add points to the graph. Dragging downwards on any point will lighten the print, and dragging upwards will darken it.

6. Apply the curve by clicking OK. Convert the image back to a negative (Image → Adjust → Invert).

7. Open the file Image B and place it next to Image A on the monitor.

8. Reopen the Curves dialog box in Image A and adjust the screen image so that it looks like Image B (see step 5).

9. When the two images look alike, save the curve (in the Curves dialogue box). The resulting curve can now be loaded at any time and used to print other images using the same methods and materials. It may be necessary to repeat this procedure several times to achieve the proper curve adjustment.

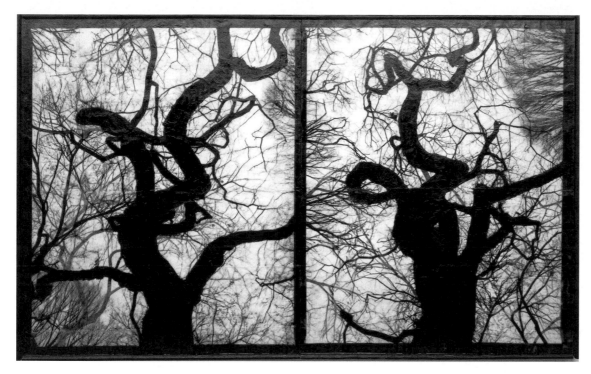

Figure 13.14 Doug and Mike Starn turned to digital printmaking to achieve something they could not realize photographically, the appearance of real light in the sky and a black void in the trees that appears to reach for the light. The team scanned the negative into the computer and used PhotoShop to create two slightly different files of the same negative, printing one on paper and then hand-coating it several times with wax. The other file was printed onto tissue paper, registered exactly with the hand-waxed paper print, and coated with encaustic. The encaustic surface was then carved and manipulated.

© Doug and Mike Starn. *Blot Out the Sun*, 1998–2000. Inkjet print. Lysonic inks, bleached beeswax, encaustic, Thai mulberry paper, lens tissue paper. 84 × 132 inches.

that will deliver the best-quality output. The printer setting for inkjet transparency was intended to prevent dot gain and the puddling of ink on the less-absorbent surface of transparencies. The inkjet transparency setting will provide a lower resolution output than other settings intended for paper output.

7. Contact print an image (using the same material and printer settings used to calibrate your negatives) onto your photographic material just like any other negative in a contact-printer frame. Negatives made on paper will be noticeably slower to print, the paper texture will be more evident, and the image will be grainier than a negative made on transparency materials. Depending on the materials, it is probable that the inkjet negative will change slightly over time. The advantage of digital negatives is that you can print a new copy of the negative in the future.

Multiple Exposure Printing

Sometimes you cannot get the desired tones from the negative. For years the printing industry has tackled this problem with duotone printing. By using two inks instead of one, printers have been able to reproduce tones and colors that lie outside the achievable range of conventional printing. By creating multiple digital negatives, photographic imagemakers can further control the contrast in the highlights, mid-tones, and shadows of their images. This control can be achieved by altering different negatives of the same subject and printing them one after another in register. High-quality inkjet printers use a random (stochastic) dot pattern that eliminates the possibility of moiré patterns being formed by the different negatives. With multiple exposure printing each negative adds to the density of the other negatives. By creating a mixture of high- and low-contrast negatives, imagemakers can

expose for highlights and shadows separately (without burning or dodging). By applying different curves to different versions of a negative, images can take on an even richness not possible with a single negative.

Basic Steps for Multiple Exposure Printing

1. Create negatives with extra room on one of the edges for registration pinholes.

2. Using the negative as a guide, tape registration pins to the printing surface. Align the photosensitive paper to the negative and tape the paper to the printing surface. Place the first negative in the printing frame, using registration pins to guide its placement, and expose the first negative.

3. Without moving the photosensitive paper, remove the first negative, place the second negative down on the registration pins, and make the second exposure. Repeat this step for each negative printed.

4. Process the print normally.

THE FUTURE OF DIGITAL IMAGEMAKING AND THE EXPRESSIVE IMAGEMAKER

We live in a society in which the average couple spends 30 percent more time working than their parents did. As expectations for productivity continue to rise, speed and multitasking become an essential part of daily life. This makes the allure of digital imaging sexy and slightly dangerous. It is fast, efficient, and exciting, but its future potential in the arts is still largely unknown. During this period of chaotic transition we must be careful not to confuse the sense of achieving something new with that of just using the latest technology. It is the creative drive coupled with an inquisitive and questioning mind that can lead to truly authentic work. The French poet and filmmaker Jean Cocteau summed this premise up when he said the role of exceptional art is to "Astound me!"

ADDITIONAL INFORMATION

Adobe Creative Team. *Adobe PhotoShop 5.5 Classroom in a Book*. San Jose, CA: Adobe Press, 1999.

Ang, Tom. *Silver Pixels: An Introduction to the Digital Darkroom*. New York, NY: Amphoto Books, 2000.

Bouton, Gary David, Barbara Mancuso Bouton, and Gary Kubicek. *Inside Adobe PhotoShop 5.5*. Indianapolis, IN: New Riders Publishing, 2000.

Burkholder, Dan. *Making Digital Negatives for Contact Printing*. Second Ed. Carrollton, TX: Bladed Iris Press, 1999.

Davies, Adrian. *The Digital Imaging A-Z*. Boston, MA: Focal Press, 1998.

Davies, Adrian, and Phil Fennessy. *Digital Imaging for Photographers*. Third Ed. Boston, MA: Focal Press, 1998.

Evening, Martin. *Adobe PhotoShop 5.5 for Photographers*. Boston, MA: Focal Press, 2000.

Index